A DOCUMENTARY HISTORY OF ART

Volume II

A DOCUMENTARY
HISTORY OF ART

Volume II

Michelangelo and

the Mannerists

The Baroque and

the Eighteenth Century

Selected and Edited by
ELIZABETH GILMORE HOLT

PRINCETON UNIVERSITY PRESS
PRINCETON, NEW JERSEY

Burgess
N
5303
. D6
1981
C. 1
V. 2

For
Betsy, Jay, and Peter

A *Documentary History of Art, Volume II: Michelangelo and the Mannerists, The Baroque and the Eighteenth Century* is an expansion and revision of the third and fourth sections of *The Literary Sources of Art History*, edited by Elizabeth Gilmore Holt and published by Princeton University Press in 1947. Volume I is an expansion and revision of the first and second sections.

The translations of Michelangelo's poems, "Non ha l'ottimo artista," "Siccome per levar," "Se'l mio rozzo martello," "Negli anni molti," "I'ho gia fatto un gozzo," and "Caro m'e'l sonno," appear in *Complete Poems and Selected Letters of Michelangelo*, translated by Creighton Gilbert, edited by Robert N. Linscott, published by Princeton University Press, and are reprinted by permission of Creighton Gilbert. Copyright © 1963, by Robert N. Linscott and Creighton Gilbert, copyright © 1980 by Creighton Gilbert.

Printed in the United States of America by
Princeton University Press, Princeton, New Jersey
Anchor Books edition, 1958
First PRINCETON PAPERBACK printing, 1982

FOREWORD

The present volume has been compiled in response to the ever increasing demand for the original documents on the arts. Its aim is to add freshness and solidity to the study of the history of art by making available the words of the artists themselves and of other persons concerned.

It is not the personalities of the artists alone that are brought to full life in these letters and journals. The social conditions within which they moved are here restored to them. The form of the work of art must acknowledge as part of its cause the state and temper of patronage and audience, the reigning ideal of beauty, the current esteem of mathematics or mythology. We learn here how Bernini was cherished and patronized by popes and cardinals from earliest charming, prodigious childhood, and how, eagle that he was, he always had his safe and welcoming aerie in the Papal See. The journal and the biography convey to us the sense of intimacy with princes, secular and religious; of the perils that surround such courts as well as the magnificence; of the greatness thrust upon the artist together with the danger; how even an old man was instructed in those days to consider the beauty of risking his life for a monarch. These accounts help to build up finally a realization of art as part of life.

Some of the sources in this book are indeed already comparatively easy of access; for example, Reynolds' Lectures. They were included here because of their importance in such an anthology. But much has never been rendered into English before, or is difficult to obtain because translated long ago and now out of print; and nowhere before has such a body of varied sources been collected into one volume for the enlightenment of the English-speaking student of the history of art.

KATHARINE GILBERT

Duke University

PREFACE TO THE FIRST EDITION

The material assembled here has long been known to serious students of European art and culture. It has been put in this form so that it may be more accessible to persons interested in the cultural development of Western civilization. Documents taken from their places in history vividly reveal the attitudes, needs and ideas of our spiritual ancestors. The lay person, familiar with the monuments of architecture, sculpture and painting, may find the material helpful in completing his impression of the personalities and circumstances which produced them, while the student of art history who has not yet acquired proficiency in medieval Latin, Italian, French and German can now catch something of the flavor of the originals which, in most instances heretofore, had been unavailable in English.

An awareness of the difficulties experienced by teachers, dependent on small departmental libraries, in making documents available to beginning students prompted this undertaking. The inclusion of comments and notes which the more advanced student might wish has been deliberately kept to a minimum. A compilation of this sort, viewed by scholars, has unpardonable omissions, for each will undoubtedly find a favorite document missing. It is hoped that they will bear in mind that this book was prepared not for those who know the original documents and the mass of commentary, but for laymen, teachers and students in colleges and preparatory schools.

ELIZABETH GILMORE HOLT

PREFACE TO THE ANCHOR SECOND EDITION

As this volume is an expansion and revision of the third and fourth sections of *The Literary Sources of Art History*, published by Princeton University Press, the foreword and preface are given in Volume I of the present edition, and only certain paragraphs are given here. I am happy, therefore, to express once more my gratitude to the many scholars and the libraries for the generous assistance given to the preparation of the first edition, especially to Dr. Erwin Panofsky, Dr. Walter Friedländer, Dr. Katharine Gilbert and Dr. Martin Soria.

For this edition, in the selection of texts to be added, as in the preparation of the first edition, this volume has had the benefit of Prof. Rensselaer W. Lee's counsel. I am indebted to Mr. Forsythe Wickes for his generous permission to reproduce the two drawings of Watteau from his collection. Professors John Coolidge, Andrew Keck, Richard Krautheimer and Wylie Sypher gave valuable suggestions. I am grateful to Prof. Seymour Slive for the biographical sketch of Rembrandt and the footnotes for the text, to Prof. Creighton Gilbert for the revision of the translation of Michelangelo's poems, to Miss Emita Brady and Miss Betsy Holt for assistance with the translations of the French texts, and to Miss Agnes Mongan of the Fogg Art Museum for her kind help in the selection of the illustrations. For access to its collections and the assistance of its staff, I thank the Library of Congress.

Acknowledgment for permission to quote from their publications is made to Constable and Co. (London) for the sections from Robert W. Carden, *Michelangelo, A Record of His Life;* to Little, Brown and Co. for the section from Ellen Frothingham's translation of Lessing's *Laocoön;* and to B. Herder Book Co. for the section from H. F. Schroeder, *Canons and Decrees of the Council of Trent.*

ELIZABETH GILMORE HOLT

July 5, 1957
Georgetown, Maine

PREFACE TO THE
PRINCETON PAPERBACK EDITION

The *Literary Sources of Art History* offered for the first time in English under one cover, basic documents essential to an understanding of art history. Its influence in the intervening forty years resulted in many of the included single texts being made the subject of philological and scholarly monographs, for the student specializing in a particular field or time. Despite the publication of some texts in their entirety, the volume remains a valuable introduction to the use of primary sources and documents. The purpose of the volume remains to offer to interested persons easy access to materials and primary sources which will enable them to formulate opinions and make independent judgments.

The reprinting of the volume affirms the traditional policy of the Princeton University Press to serve not only the specialized scholar, but to make available scholarly material in a form that gives a greater public access to it. This reprinting permits me to express again my gratitude to Margot Cutter for her contribution as its first editor, and to P. J. Conkwright for the fitness of its original design.

This present edition includes a bibliography incorporating only a sampling of the literature that has appeared since the initial publication in 1947, of *Literary Sources of Art History*.

<div align="right">ELIZABETH GILMORE HOLT</div>

March 1981
Georgetown, Maine

CONTENTS

I. MICHELANGELO AND THE MANNERISTS

II. THE BAROQUE

ITALY

III. THE EIGHTEENTH CENTURY

LIST OF ILLUSTRATIONS
following page 186

A few works have been cited throughout the volume in abbreviated form. These are:

BLUNT, *Theory* A. Blunt, *Artistic Theory in Italy*, Oxford, 1940.

BOTTARI-TICOZZI, *Raccolta* Bottari-Ticozzi, *Raccolta di lettere sulla pittura, scultura, ed architettura*, 8 vols., Milan, 1922–1925.

LEE, "Ut Pictura Poesis" R. W. Lee, "Ut Pictura Poesis: The Humanistic Theory of Painting," *Art Bulletin*, XXII, 1940, pp. 197–269; also available in paperback, New York, 1967.

PANOFSKY, *Idea* E. Panofsky, "Idea"; *Ein Beitrag zur Begriffsgeschichte der älteren Kunsttheorie* (Studien der Bibliothek Warburg, V), Leipzig/Berlin, 1924.

PEVSNER, *Academies* N. Pevsner, *Academies of Art, Past and Present*, Cambridge, 1940.

SCHLOSSER, *Kunstlit.* J. von Schlosser, *Kunstliteratur*, Vienna, 1924.

SCHLOSSER, *Lett. art.* J. von Schlosser, *La letteratura artistica*, Florence, 1935.

VENTURI, *History* L. Venturi, *History of Art Criticism*, New York, 1936.

SUGGESTED READING

WORKS OF A GENERAL NATURE

Lee, Renssalaer W. *Ut Pictura Poesis*. New York: Norton, 1976.

Panofsky, Erwin. *Idea: A Concept in Art Theory*. Translated by Joseph J. Peake. New York: Harper and Row, 1974.

The Pelican History of Art Series. Editor, Nikolaus Pevsner. New York: Penguin [1953–1978].

Pevsner, Nikolaus. *Academies of Art, Past and Present*. First printed in 1940. Reprinted, New York: DeCapo, 1973.

Sources and Documents in the History of Art Series. General editor, Horst W. Janson. Englewood Cliffs, New Jersey: Prentice Hall, 1965–1980.

Venturi, Lionello. *History of Art Criticism*. First printed in 1936. Reprinted, New York: Dutton, 1964.

Wittkower, Rudolf and Wittkower, Margot. *Born Under Saturn: The Character and Conduct of Artists*. New York: Norton, 1969.

Kris, Ernst and Kurz, Otto. *Legend, Myth and Magic in the Image of the Artist*. New Haven, Connecticut: Yale University Press, 1979.

MICHELANGELO AND THE MANNERISTS

Ackerman, James S. *Palladio*. New York: Penguin, 1977.

Bellori, Giovanni P. *The Lives of Annibale and Agostino Carracci*. Translated by Catherine Enggass. University Park, Pennsylvania: Pennsylvania State University Press, 1968.

Blunt, Anthony. *Artistic Theory in Italy, 1450–1600*. Oxford: Oxford University Press, 1980.

Boase, Thomas S. R. *Giorgio Vasari: The Man and The Book*. Princeton, New Jersey: Princeton University Press, 1979.

Boschloo, Anton W. A. *Annibale Carracci in Bologna: Visible Reality in Art After the Council of Trent*. Translated by R. R. Symondal. Two volumes. The Hague: Government Publication Office, 1974.

Buonarroti, Michelangelo. *Michelangelo: A Record of His Life as Told in His Own Letters and Papers*. Translated by R. W. Carden. New York: Gordon Press, 1976.

Cellini, Benvenuto. *Treatises of Benvenuto Cellini on Goldsmithing and Sculpture*. Translated by C. R. Ashbee. New York: Dover, 1966.

Condivi, Ascanio. *The Life of Michelangelo*. Translated by Alice Sedgwick Wohl. Baton Rouge, Louisiana: Louisiana State University Press, 1976.

Dempsey, Charles G. *Annibale Carracci and the Beginnings of the Baroque Style*. Villa I Tatti Monographs, III. Gluckstadt, 1977.

De Tolnay, Charles. *Michelangelo*. Five volumes. Princeton, New Jersey, 1943–1945. Second edition, Princeton, New Jersey: Princeton University Press, 1969–70.

———. *Michelangelo: Sculptor, Painter, Architect*. Princeton, New Jersey: Princeton University Press, 1975.

Friedländer, Walter. *Mannerism and Anti-Mannerism in Italian Painting*. First printed in 1957. Reprinted, New York: Schocken, 1965.

Gilbert, Creighton and Linscott, R. *Complete Poems and Selected Letters of Michelangelo*. Princeton, New Jersey: Princeton University Press, 1980.

Hauser, Arnold. *Mannerism: The Crisis of the Renaissance and the Origin of Modern Art*. Two volumes. New York: Knopf, 1965.

Hibbard, Howard. *Michelangelo*. New York: Harper and Row, 1975.

Posner, Donald. *Annibale Carracci, A Study in the Reform*

of Italian Painting after 1590. Two volumes. Oxford: Phaidon, 1971.

Puppi, Lionello. *Andrea Palladio.* Translated by Pearl Sanders. Boston: New York Graphic Society, 1975.

Schroeder, H. J., translator. *Canons and Decrees of the Council of Trent.* Reprint of the 1941 edition. Rockford, Illinois: TAN Books and Publications, 1978.

Shearman, John. *Mannerism.* New York: Penguin, 1978.

Smyth, Craig H. *Mannerism and Maniera.* Locust Valley, New York: J. J. Augustin, 1963.

Vasari, Giorgio. *Vasari on Technique.* Translated by Louisa Maclehouse. Edited by G. Baldwin. New York: Dover, 1960.

Wittkower, Rudolph. *Palladio and Palladianism.* New York: Braziller, 1975.

Baroque

Bauer, George C. *Bernini in Perspective.* Englewood Cliffs, New Jersey: Prentice Hall, 1976.

Bazin, Gemain. *The Baroque: Principles, Styles, Modes and Themes.* Boston: New York Graphic Society, 1968.

Blunt, Anthony. *Nicholas Poussin.* Two volumes. Princeton, New Jersey: Princeton University Press, 1966.

Bernt, Walther. *The Netherlandish Painters of the 17th Century.* Three volumes. Oxford: Phaidon, 1970.

Chatelet, J. and Thuiller, J. *French Painting from Fouquet to Poussin.* Translated by Stuart Gilbert. Geneva: Skira, 1963.

Clark, Kenneth. *Rembrandt and the Italian Renaissance.* New York: Norton, 1966.

De Groot, C. Hofstede. *A Catalogue Raisonné of the Works of the Most Eminent Dutch Painters of the Seventeenth Century.* Edited by E. G. Hawke. Three volumes. Reprint of the 1929 edition. Alexandria, Virginia: Somerset House, 1976.

Dempsey, Charles. "Some Observations on the Education

of Artists in Florence and Bologna During the Later Seventeenth Century." *Art Bulletin* 62 (1980), no. 4, 552–569.

Fletcher, Jennifer. *Peter Paul Rubens*. New York: Dutton, 1974.

Friedländer, Walter. *Caravaggio Studies*. Princeton, New Jersey: Princeton University Press, 1955.

Fuchs, Rudolph H. *Rembrandt in Amsterdam*. Translated by P. Wardle and A. Griffiths. Boston: New York Graphic Society, 1969.

Gerson, Horst. *Rembrandt Paintings*. Translated by Heinz Norden. New York: Reynal, 1969.

Haskell, Francis. *Patrons and Painters*. First printed in 1963. Revised edition, New Haven, Connecticut: Yale University Press, 1980.

Held, Julius S. *Rembrandt's Aristotle and Other Rembrandt Studies*. Princeton, New Jersey: Princeton University Press, 1969.

Held, Julius S. and Posner, Donald. *Seventeenth and Eighteenth Century Art: Baroque Painting, Sculpture, and Architecture*. New York: Abrams, 1971.

Kahr, Madlyn M. *Velasquez, the Art of Paintings*. New York: Harper and Row, 1976.

Lavin, Irving. *Bernini and the Unity of the Visual Arts*. New York: Oxford University Press, 1980.

Lopez-Rey, Jose. *Velasquez' Work and World*. Boston: New York Graphic Society, 1968.

Mahon, Denis. *Studies in Seicento Art and Theory*. Reprint of the 1947 edition. Westport, Connecticut: Greenwood Press, 1971.

McComb, Arthur. Baroque Painters of Italy: *An Introductory Historical Survey*. Reprint of the 1934 edition. New York: Russell and Russell, 1968.

Stechow, Wolfgang. *Rubens and the Classical Tradition*. Cambridge, Massachusetts: Harvard University Press, 1968.

Van der Meulen, M. and Strauss, W. *The Rembrandt Documents*. New York: Abaris, 1979.

Waterhouse, Ellis K. *Italian Baroque Painting*. Second edition. Oxford: Phaidon, 1961.

EIGHTEENTH CENTURY

Antal, Frederick. *Hogarth and His Place in European Art*. London: Routledge and Kegan Paul, 1962.

Banks, Oliver T. *Watteau and the North: Studies in the Dutch and Flemish Baroque Influence on French Rococo Painting*. New York: Garland, 1977.

Bernstein, John Andrew. "Shaftesbury's Identification of the Good with the Beautiful." *Eighteenth Century Studies*, Spring 1977, X, 3.

————. *Shaftesbury, Rousseau, and Kant: An Introduction to the Conflict between Aesthetic and Moral Values in Modern Thought*. Rutherford, New Jersey: Fairleigh Dickinson University Press, 1980.

Burke, Joseph. *Hogarth and Reynolds, a Contrast in English Art Theory*. Oxford: Oxford University Press, 1943.

————. *English Art, 1714-1800*. Oxford: Oxford University Press, 1975.

Blomfield, Reginald. *History of French Architecture*. Four volumes in two. Reprint of the 1921 edition. New York: Hacker, 1974.

Foss, Michael. *The Age of Patronage: The Arts in England 1660-1750*. Ithaca, New York: Cornell University Press, 1971.

Fried, Michael. *Absorption and Theatricality: Painting and the Beholder in the Age of Diderot*. Berkeley, California: University of California Press, 1980.

Goethe, Johann Wolfgang von. *Goethe on Art*. Selected, edited, and translated by John Gage. Berkeley, California: University of California Press, 1980.

Harris, John. *Sir William Chambers*. University Park, Pennsylvania: Pennsylvania State University Press, 1971.

Honour, Hugh. *Neo-Classicism*. New York: Penguin, 1968.

Leppmann, Wolfgang. *Winckelmann*. New York: Knopf, 1970.

Levey, Michael. *Rococo to Revolution*. Oxford: Oxford University Press, 1966.

Lindsay, Jack. *Hogarth, His Art and His World*. New York: Taplinger, 1979.

Paulson, Ronald. *Emblem and Expression: Meaning in English Art of the Eighteenth Century*. Cambridge, Massachusetts: Harvard University Press, 1975.

Robson-Scott, W. D. *The Younger Goethe and the Visual Arts*. Cambridge: Cambridge University Press, 1976.

Rosenblum, Robert. *Transformations in Late Eighteenth Century Art*. Princeton, New Jersey: Princeton University Press, 1967.

Schwizer, Niklaus Rudolf. "The ut picture poesis controversy in eighteenth century England and Germany." *European University Papers*, Series XVIII, 2. Bern: Herbert Lang: 1972.

Stutchbury, Howard Edward. *The Architecture of Colen Campbell*. Manchester, England: Manchester University Press, 1967.

Winckelmann, Johann Joachim. *History of Ancient Art*. New York: F. Ungar, 1969.

————. *Writings on Art*. Edited and selected by David Irwin. Oxford: Phaidon, 1972.

I. MICHELANGELO AND THE MANNERISTS

MICHELANGELO BUONARROTI

[Michelangelo Buonarroti (1475–1564) was born at Caprese near Florence. After studying painting with Ghirlandaio for a year, he entered the Medici Gardens, where the famous Medici collection of sculpture was placed and where Bartoldo, Donatello's pupil, gave instruction. From 1490 to 1492 Michelangelo lived in the Medici household, then the most brilliant intellectual center of Europe. During the same period he listened to the sermons of Savonarola. These two influences remained with him throughout his life. Two reliefs, *The Battle of the Centaurs* and the *Madonna of the Stairs,* are works of this period.

With the fall of the Medici in 1494, Michelangelo fled to Venice and then to Bologna, where he carved an angel for the arca of S. Domenico in S. Petronio. In 1496 he was in Rome, where he executed the *Bacchus* and also made for the French Cardinal de Villiers a *Pietà.* The presentation of the subject with only two figures was popular in the Rhineland but almost unknown in Italy. From 1501 to 1505, he worked in Florence on a commission from Cardinal Piccolomini for fifteen statues, of which only four were executed, and on the commission of the *Operai* of the Duomo for statues of the Twelve Apostles, of which only the sketch of the *St. Matthew* was completed. The *David,* the *Madonna of Bruges* and two Madonnas in relief are of this period. In 1504 he painted for his friend Angelo Doni the *Holy Family.* He executed the cartoon of the *Battle of Cascina* in the Palazzo della Signoria, which he was commissioned to paint in 1503.

For Pope Julius II, who called Michelangelo to Rome in 1505, he drew the plans and carved some of the figures for the Pope's tomb, executed a bronze portrait statue of the Pope in Bologna (1508), and frescoed, against his will, the vault of the Sistine Chapel (1508–1512).

Between 1513 and 1534 Michelangelo worked both in Rome and in Florence. The new Pope, Leo X, a Medici, commissioned him to build the façade of S. Lorenzo in Florence and a new sacristy for the same church to serve as a mausoleum for the Pope's two nephews. This was completed in part under the second Medici Pope, Clement VII, for whom Michelangelo built the Laurentian Library in Florence.

In 1534 Michelangelo settled permanently in Rome. For Pope Paul II, he painted (1534–1541) the *Last Judgment* on the end wall of the Sistine Chapel and the *Conversion of St. Paul* and the *Martyrdom of St. Peter* in the Paolina Chapel of the Vatican. At the death of Antonio San Gallo, in 1546, he was commissioned to finish the Farnese Palace, and in the following year he was appointed architect of St. Peter's. The task of completing the cathedral occupied the rest of his life. While working on this enormous task, he also planned and directed the new organization of the Capitoline Hill, and made models for a stairway in the Belvedere Court, a palace façade for Julius II, the church of S. Giovanni dei Fiorentini, the stairway for the Laurentian Library in Florence, and other projects. In the last period of his life he carved two *Pietàs,* the one now in the Duomo of Florence and the other, left unfinished at his death, in the Rondanini Collection.

Michelangelo contemplated writing a treatise on the movements of the human body and anatomy, and possibly Vincenzo Danti's *Il primo libro del trattato delle perfette proporzioni di tutte cose* . . . , Florence, 1567, is derived from notes given to Condivi, Michelangelo's biographer. Of his own writings, the best source from which his conception of beauty can be deduced are his poems. His letters give almost no clues to his theoretical ideas for they show only his relations to his patrons and family.]

CONTRACT FOR THE PIETA[1]

Die VII mensis augusti, 1498.

Be it known and manifest to all who shall read this present writing that the Most Reverend Cardinal di San Dionisio has agreed that Maestro Michelangelo, statuary of Florence, that the said Maestro shall at his own proper costs make a *Pietà* of marble; that is to say, a draped figure of the Virgin Mary with the dead Christ in her arms, the figures being life-size, for the sum of four hundred and fifty gold ducats in papal gold (*in oro papali*), to be finished within the term of one year from the beginning of the work. And the Most Reverend Cardinal promises to pay the money in the manner following: that is to say, *imprimis,* he promises to pay the sum of one hundred and fifty gold ducats in papal gold before ever the work shall be begun, and thereafter while the work is in progress he promises to pay to the aforesaid Michelangelo one hundred ducats of the same value every four months, in such wise that the whole of the said sum of four hundred and fifty gold ducats in papal gold shall be paid within a twelvemonth, provided that the work shall be finished within that period: and if it shall be finished before the stipulated term his Most Reverend Lordship shall be called upon to pay the whole sum outstanding.

And I, Iacopo Gallo,[2] do promise the Most Reverend Monsignore, that the said Michelangelo will complete the said work, within one year, and that it shall be more beautiful than any work in marble to be seen in Rome

[1] The excerpts are from *Michelangelo: A Record of His Life as Told in His Own Letters and Papers,* translated and edited by R. W. Carden, London, 1913. All footnotes are from the text except those in brackets which are by the editor.

See also: Charles Holroyd, *Michael Angelo Buonarroti, with Translations of the Life of the Master by his Scholar, Ascanio Condivi, and Three Dialogues from the Portuguese by Francisco d'Ollanda,* London, 1911. Charles de Tolnay, *Michelangelo,* 6 vols., Princeton, 1943–64. *Michelangelo, Letters,* translated, edited and annotated by E. H. Ramsden, Stanford, 1963. Blunt, *Theory,* pp. 58–61.

[2] Jacopo Galli, a wealthy Roman banker and collector of antiques, bought Michelangelo's *Bacchus.*

today, and such that no master of our own time shall be able to produce a better. And I do promise the aforesaid Michelangelo, on the other hand, that the Most Reverend Cardinal will observe the conditions of payment as herein set forth in writing. And in token of good faith I, Iacopo Gallo, have drawn up the present agreement with my own hand the year, month and day aforesaid. Furthermore, be it understood that all previous agreements between the parties drawn up by my hand, or rather, by the hand of the aforesaid Michelangelo, are by this present declared null and void, and only this present agreement shall have effect.

The said Most Reverend Cardinal gave to me, Iacopo Gallo, one hundred gold ducats of the chamber in gold (*ducati d'oro in oro di Camera*) some time ago, and on the aforesaid day as above set forth I received from him a further sum of fifty gold ducats in papal gold.

<div align="right">

Ita est IOANNES, CARDINALIS S. DYONISII

Idem Iacobus Gallus, *manu proprio*

</div>

CONTRACT FOR THE DAVID

1501, die XVJ augusti.

Spectabiles . . . viri, the Consuls of the Arte della Lana and the Lords Overseers [of the Cathedral][3] being met Overseers, have chosen as sculptor to the said Cathedral the worthy master, Michelangelo, the son of Lodovico Buonarroti, a citizen of Florence, to the end that he may make, finish and bring to perfection the male figure known as the Giant, nine *braccia* in height, already blocked out in marble by Maestro Agostino[4] *grande,* of Florence, and badly blocked; and now stored in the workshops of the Cathedral.

The work shall be completed within the period and term of two years next ensuing, beginning from the first day of September next ensuing, with a salary and payment together in joint assembly within the hall of the said

[3] [The *Operai,* or committee in charge of a building.]
[4] Agostino di Duccio.

of six broad florins of gold in gold for every month. And for all other works that shall be required about the said building (*edificium*) the said Overseers bind themselves to supply and provide both men and scaffolding from their office and all else that may be necessary. When the said work and the said male figure of marble shall be finished, then the Consuls and Overseers who shall at that time be in authority shall judge whether it merits a higher reward, being guided therein by the dictates of their own consciences.

LETTERS

To the Florentine, Maestro Guliano da San Gallo,
Architect to the Pope, in Rome. Florence, May 2, 1506

GULIANO[5] (*sic*),—I learn from a letter sent by you that the Pope was angry at my departure, that he is willing to place the money at my disposal and to carry out what was agreed upon between us; also, that I am to come back and fear nothing.

As far as my departure is concerned, the truth is that on Holy Saturday I heard the Pope, speaking at table with a jeweller and the Master of the Ceremonies, say that he did not want to spend another *baiocco* on stones, whether small or large, which surprised me very much. However, before I set out I asked him for some of the money required for the continuance of my work. His Holiness replied that I was to come back again on Monday: and I went on Monday, and on Tuesday, and on Wednesday, and on Thursday—as His Holiness saw. At last, on the Friday morning, I was turned out, that is to say, I was driven away: and the person who turned me away said he knew who I was, but that such were his orders. Thereupon, having heard those words on Saturday and seeing them afterwards put into execution, I lost all hope. But this alone was not the

[5] [Giuliano da Sangallo (1445–1516), an architect, engineer and sculptor, was active in Florence, Rome, Naples and Milan. He was one of the artists employed by Julius II. The letter deals with Michelangelo's work for the Pope's tomb.]

whole reason of my departure. There was also another cause, but I do not wish to write about it; enough that it made me think that, if I were to remain in Rome, my own tomb would be prepared before that of the Pope. This is the reason for my sudden departure.

Now you write to me on behalf of the Pope, and in similar manner you will read this letter to the Pope. Give His Holiness to understand that I am more eager to proceed with the work than ever I was before, and that if he really wishes to have this tomb erected it would be well for him not to vex me as to where the work is to be done, provided that within the agreed period of five years it be erected in St. Peter's, on the site he shall choose, and it be a beautiful work, as I have promised: for I am persuaded that it be a work without an equal in all the world if it be carried out.

If His Holiness now wishes to proceed, let him deposit the said money here in Florence with a person whose name I will communicate to you. I have a quantity of marble in preparation at Carrara, which I will have sent here, and I will do the same with the marble I have in Rome, although it will entail a considerable loss to me: but I should disregard that if by this means I could obtain permission to carry out the work here. From time to time I would despatch the pieces as they are finished, in such a manner that His Holiness would be as well content as if I were working in Rome—and more, indeed, because he would see the completed works without having any anxiety. With regard to the aforesaid money and work, I will bind myself in any way His Holiness may direct, and I will furnish whatever security here in Florence he may require. Let it be what it may, I will give him full security, even though it be the whole of Florence. There is yet one thing I have to add: it is this, that the said work could not possibly be done for the price in Rome, but it could be done here because of the many conveniences which are available, such as could not be had in Rome. Moreover, I should do better work and take more interest in it, because I should not have to think about a number of other things. However, *Guliano mio carissimo*, I beg of you to

let me have an answer, and quickly. I have nothing fur-
ther to add. This 2nd day of May, 1506.

Your MICHELAGNIOLO,
Sculptor, in Florence

*To Buonarroto di Lodovico
di Buonarrota Simoni,
in Florence.* Bologna, July 6, [1507]

BUONAROTTO,—Learn that we have cast my statue,[6] and
that I was not over fortunate with it, the reason being that
Maestro Bernardino, either through ignorance or misfor-
tune, failed to melt the metal sufficiently. It would take
too long to explain how it happened: enough that my
figure has come out up to the waist. The remainder of the
metal—half the bronze, that is to say—having caked in the
furnace, as it had not melted; and to get it out the fur-
nace must be taken to pieces. I am having this done, and
this week I shall have it built up again. Next week I shall
recast the upper portion and finish filling the mould, and
I believe it will turn out tolerably well after so bad a
beginning, though only as the result of the greatest labour,
worry and expense. I was ready to believe that Maestro
Bernardino could melt his metal without fire, so great was
my confidence in him: but all the same it is not that he is
not a skilled master, or that he did not work with a will.
But he who tries may fail. His failure has been costly to
him as well as to me, for he had disgraced himself to such
an extent that he dare not raise his eyes in Bologna.

If thou shouldst meet Baccio d'Agnolo,[7] read this letter
to him and beg him to inform San Gallo in Rome, and
commend me to him. Commend me also to Giovanni da
Ricasoli and to Granaccio.[8] If this turns out satisfactorily

[6] This letter to his brother refers to the casting of the bronze
statue of Pope Julius II put in a niche on the façade of S.
Petronio, February 21, 1508. It was destroyed in 1511 when the
Bentigoli returned to power.

[7] [Baccio d'Angelo Baglione (1462–1543). As an architect his
work is principally palaces in Florence; as a wood carver he
executed the stalls in S. Maria Novella and wood carving in the
Palazzo Vecchio, Florence.]

[8] [Francesco Granacci (1419–1543), a mediocre painter, was
trained in Ghirlandaio's studio and in the Medici Gardens.]

I hope to be finished with it in from fifteen to twenty days, when I will return to you. If it is not successful I should perhaps have to do it again, but I will keep you informed.

Let me know how Giovansimone is.

On the 6th day of July.

[P.S.] With this I shall enclose a letter for Giuliano da San Gallo in Rome. Send it as securely and as quickly as thou canst: if he should be in Florence, give it into his hands.

To Domenico [*Buoninsegni, in Rome*].

Carrara, [May 2, 1517]

MESSER DOMENICO,—Since I wrote to you lately, I had no time to spare for making models as I said I intended, but the reason would take too long to write. I had already roughed out a smallish one of clay, sufficient for my purposes here, and although it is as twisted as a shaving I intend to send it you, come what may, lest this business may appear to be a fraud.

I have many things to tell you, so I beg of you to read on for a little with patience as it is a matter of importance. Well then, I feel myself capable of carrying out this façade for San Lorenzo in such a way that it shall be a mirror of architecture and sculpture for all Italy; but the Pope[9] and the Cardinal must make up their minds quickly whether they want me to do it or not. If they wish me to do it, they must come to some arrangement, either giving me a contract for the whole work and entrusting everything to my care, or adopting any other plan they may have in mind of which I know nothing. You will understand my reason for this.

As I have already told you, and again since I wrote last, I have placed orders for much of the marble, and have paid out money here and there, setting the men to work in various places. Some of the places on which I have spent money have failed to yield suitable marble, because the work is very misleading, this being especially the case with the large blocks I require, which must come up to my standard of excellence. One block which I had already

[9] [Leo X.]

begun to excavate proved to be faulty at the further end, a circumstance which could not possibly have been foreseen, with the result that the two columns I hoped to cut from it are no use and half the money is wasted. The consequence of these misfortunes is that out of all this marble I have only been able to retain a few hundred ducats' worth: and as I do not know how to keep accounts, I shall in the end only be able to prove that I have spent so much money as is represented by the quantity of marble I shall ultimately consign to Florence. I only wish I could do as Maestro Pier Fantini[10] used to do, but I have not enough ointment. Besides, I am an old man, and I do not think it worth while to save the Pope two or three hundred ducats at the loss of so much time, and seeing that I am being pressed to return to my work in Rome,[11] I shall have to decide what I intend to do.

And this is my decision. Knowing that I have to do the work and arrange the price I should not hesitate about throwing away four hundred ducats, as I have no account to render: I should take three or four of the best men obtainable and make them responsible for all the marble, stipulating that it is to be of the same quality as that I have already quarried—which is excellent, though small in quantity. For this marble and for the money advanced I should obtain good security in Lucca: I should give orders that the marble already quarried is to be taken to Florence, and I should go there to work both for the Pope and for myself. If the above-mentioned arrangement with the Pope is not ratified it will make little difference to me; for I could not, even if I would, have all the marble for my work sent to Florence if I have to take it on again to Rome. But I am obliged to hurry to Rome so as to get on with my work there, because, as I have already said, I have been urged to do so.

The cost of the façade, according to the way I want to carry it out—including everything, so that the Pope may have nothing further to provide for—cannot, according to

[10] A doctor who charged no fee and also supplied the necessary medicine for nothing.
[11] The tomb of Julius II.

my estimate, be less than 35,000 ducats of gold. I would undertake to finish it for this sum within six years, with this condition, that within six months I should be given at least another thousand ducats on account for the marble. Should the Pope not approve of this, one of two things will be necessary: either the expenses I have already begun to incur for the aforesaid work must be charged to my account and I must bear the loss, or else I shall have to restore the thousand ducats to the Pope so that he may appoint someone else to carry on the façade, as at any cost I wish to get away from here, for several reasons.

With regard to the price mentioned, I wish the Pope and the Cardinal so well that as soon as the work is begun, if I were to find that it could be done for less, I would inform them of the fact even more willingly than if I were paying for it myself: indeed, I intend to do the work in such a way that it will cost me more than I am asking for it.

Messer Domenico, I beg of you to let me know definitely what the Pope and the Cardinal wish to do: this would be a very great kindness, greater than all the others I have received at your hands.

To Pope Clement VII, in Rome. Florence, . . . [1524]

MOST HOLY FATHER,—As intermediaries are very often the cause of serious misunderstandings I now ignore their assistance and write boldly to Your Holiness with reference to the tombs for San Lorenzo here. I have to say that I do not know which is preferable, the misfortune which turns to advantage, or the advantage which turns to misfortune. I am quite sure, witless and worthless though I am, that, if I had been allowed to go on as I began, all the marble for the said work would by now have been in Florence, blocked out in conformity with the requirements, and at a less cost than has already been incurred. It would have been a splendid work like the others I have finished.

Now I see that it is being spun out at length, nor do I see where it will end. Therefore I would excuse myself with Your Holiness, so that it may not seem that I also am to blame if things do not go in such a way as to please you, for I have no authority in the matter. And, further,

if I am to do any work for Your Holiness, I beg that none may be set in authority over me in matters touching my art. I beg that full trust may be placed in me and that I may be given a free hand: Your Holiness shall see the work I will do and the account I will give of myself.

Stefano has finished the lantern over the chapel in San Lorenzo, and has uncovered it: everybody is well pleased with it. I trust that it will prove satisfactory also to Your Holiness when you see it. They are now making the ball which is to surmount it, about a *braccio* in height: for the sake of variety I thought of having it made in facets, and this is being done.

> Your Holiness' servant,
> MICHELANGELO,
> Sculptor, in Florence

To Ser Giovan Francesco Fattucci,
in Rome. Florence, [January . . . 1524]

MESSER GIOVAN FRANCESCO,—You ask me in your letter how my affairs stand with regard to Pope Julius. I tell you that if I could claim damages and interest, according to my own estimate I should prove to be the creditor rather than the debtor. When he sent for me to Florence—I believe it was in the second year of his pontificate—I had already undertaken to decorate one half of the Sala del Consiglio in Florence, that is to say, to paint it; and I was to have three hundred ducats for the work. As all Florence knows, I had already drawn the cartoon,[12] so that the money seemed half earned. Besides this, of the Twelve Apostles which I had been commissioned to carve for Santa Maria del Fiore, one had already been roughed out, as may still be seen;[13] and I had already collected the greater part of the marble for the others. When Pope Julius took me away from here I received nothing in respect of one work or the other. Afterwards, when I was in Rome with the said Pope Julius and he had given me the commission for his tomb, which would have required a thou-

[12] For the *Battle of Cascina*—commissioned in 1503.
[13] Commissioned April 24, 1503—only one was begun, the *St. Matthew* now in the Accademia delle Belle Arti, Florence.

sand ducats' worth of marble, he caused the money to be paid over to me, and despatched me to Carrara for the material. There I remained for eight months, seeing the marble blocked out, and I brought nearly all of it into the Piazza di San Pietro, some being left at Ripa. Afterwards, when I had paid all that was due for the transport of the marble, and nothing remained of the money I had received for the work aftersaid, I fitted up the house I had in the Piazza di San Pietro with my own beds and furniture, on the strength of the commission for the tomb: and I summoned workmen from Florence, some of whom are still living, to come and work upon it. These men I paid in advance with my own money. By this time Pope Julius had changed his mind and no longer wished to have the work carried out; and I, not knowing this, went to ask him for money, and was driven from the chamber. Angered by this insult, I immediately left Rome, while everything in my house went to the dogs, and the marbles I had brought together lay about the Piazza di San Pietro, until Leo was elected Pope, suffering considerable damage from one cause or another. Among other things that I can prove, two of my pieces of marble, each of them four and a half *braccia* [?long], were stolen at Ripa by Agostino Ghigi [Chigi]: they cost me more than fifty gold ducats, and could be claimed, because I have witnesses still living. But to return to the marble. More than a year elapsed between the time when I went to quarry it in Carrara and the time when I was driven from the Palace; and for this I never receive anything, but had to pay out some tens of ducats instead.

Afterwards, when Pope Julius first went to Bologna, I was obliged to go with the collar of penitence round my neck and beg his forgiveness: whereupon he commissioned me to execute a statue of himself in bronze, which was to be about seven *braccia* in height, seated. When he asked what the cost would be I said I believed I could cast it for a thousand ducats, but that it was not my trade, and that I did not wish to bind myself. He replied, "Go, and get to work; cast it as often as is necessary until you are successful, and we will give you enough money to satisfy

you." To be brief, it had to be cast twice; and at the end of the two years I spent there I found myself four ducats and a half to the good. During all this time I never had any other money, and the whole of the expenses incurred by me came out of the thousand ducats for which I said I would cast the figure, this money being paid to me in several installments by Messer Antonio da Legnia [Legnano] of Bologna.

Having hoisted the figure up to its position on the façade of San Petronio, I then returned to Rome; but Pope Julius did not yet wish me to go on with the tomb, and set me to paint the vault of the Sistine Chapel, the price of the work being fixed at three thousand ducats. The first design consisted of figures of the Apostles within the lunettes, while certain portions were to be decorated after the usual manner.

As soon as I had begun this work I realized that it would be but a poor thing, and I told the Pope how, in my opinion, the placing of the Apostles there alone would have a very poor effect. He asked why, and I replied, "Because they also were poor." He then gave me fresh instructions, which left me free to do as I thought best, saying that he would satisfy me, and that I was to paint right down to the pictures below. When the vault was approaching completion the Pope returned to Bologna: wherefore I went to him there on two occasions for the money due to me, but it was to no purpose, and all my time was thrown away until he came back to Rome. Upon my return to Rome I set myself to prepare cartoons [Fig. 1] for the said work—for the end walls and sides of the said Sistine Chapel, that it is to say—hoping to receive the money for the completion of the task. I was never able to obtain anything; and one day when I was complaining to Messer Bernardo da Bibbiena and to Attalante, saying that I could not stay any longer in Rome, and that I should be compelled to betake myself elsewhere, Messer Bernardo turned to Attalante and reminded him that, as it happened, he had money to give me. Then he caused me to be paid two thousand ducats of the Camera, which, together with the first thousand I had received for the marble made up the amount that was

set aside for the tomb. I expected to receive more on account of the time lost and the work done. Out of this sum of money I gave a hundred ducats to Bernardo and fifty to Attalante, because they had in a manner restored me to life.

Then came the death of Pope Julius, and in the early days of Leo, when Aginensis[14] wished to increase the extent of the tomb—to make it a more imposing monument, that is to say, than it would have been according to the first design I prepared—we drew up a contract;[15] and when I said I did not wish the three thousand ducats I had received to be considered as settlement for the tomb but that there still remained much more to be paid to me, Aginensis told me I was a cheat.

To Messer Giovan Francesco Fattucci, in Rome.

Florence, [April . . . 1526]

MESSER GIOVAN FRANCESCO,—During the coming week I shall have the figures already blocked out in the Sacristy[16] covered up, because I want to leave the Sacristy free for the marble masons, whom I wish to build up the other tomb opposite the one already erected. It is all squared work, or nearly so. I have been thinking that the vault might be done while this work is in progress, for, given enough men, I think that it could be finished in two or three months, though I do not know much about it. At the end of this coming week His Holiness[17] might send Maestro Giovanni da Udine, if he should wish the work to be done now; I shall be quite ready for him.

During this week four of the columns in the recess have been put up, while another was already in position. The niches are not so well forward: however, I think it will be entirely finished in four months' time. The ceiling could be

[14] Cardinal Lionardo Grosso della Rovere, nephew of Julius II.

[15] July 8, 1516; the tomb was to be finished within nine years. Michelangelo was to receive 16,500 ducats, including 3,500 already received.

[16] The Sacristy of S. Lorenzo on which he began work in 1521.

[17] The Medici Pope, Clement VII.

begun at once, but the lime-wood for it is not yet in the proper condition. We shall do our best to let it be as well seasoned as possible.

I am working as fast as I can, and within a fortnight I shall begin work upon the other Captain;[18] after that the only important works remaining to be done will be the four Rivers. The four figures on the sarcophagi, the four figures on the ground—which are the Rivers—the two Captains, and the Madonna which is to be placed over the tomb at the head of the sacristy—these are the figures I should like to do myself. Six of them are already begun and I am confident that I can finish them in due time, and a part of the others also, which are less important. There is nothing more to tell: commend me to Giovanni Spina and beg him to write to Figiovanni: beg him also not to take away the carters and send them to Pescia, because we should be left without stone. More than this, ask him not to make the stonecutters discontented by saying to them in a kindly way: "These people seem to have but little mercy on you, to make you work until evening in these days when it is dark at the second hour."

It requires a hundred eyes to keep any one man at his work, and even then your efforts may be spoilt by people who are too soft-hearted. Patience! I would to God that things which are not displeasing to Him were not displeasing to me!

To Messer Benedetto Varchi. Rome, [. . . 1549]

MESSER BENEDETTO,—So that it may be clear that I have received your little book,[19] which duly reached me, I will make such a reply as I can to what you ask, although I am very ignorant on the subject. In my opinion painting should be considered excellent in proportion as it approaches the effect of relief, while relief should be considered bad in

[18] The Captains are the seated figures which are placed above the tombs in the Sacristy.

[19] [Varchi's *Due Lezzioni,* in which he published letters received from various artists in reply to his request for opinions on the comparative excellence of the arts. Cf. p. 35. See Blunt, *Theory,* pp. 53–55.]

proportion as it approaches the effect of painting. I used
to consider that sculpture was the lantern of painting and
that between the two things there was the same difference
as that between the sun and the moon. But now that I
have read your book, in which, speaking as a philosopher,
you say that things which have the same end are them-
selves the same, I have changed my opinion; and I now
consider that painting and sculpture are one and the same
thing, unless greater nobility be imparted by necessity for
a keener judgment, greater difficulties of execution, stricter
limitations and harder work. And if this be the case no
painter ought to think less of sculpture than of painting and
no sculptor less of painting than of sculpture. By sculp-
ture I mean the sort that is executed by cutting away
from the block: the sort that is executed by building up
resembles painting. This is enough, for as one and the
other—that is to say, both painting and sculpture—proceed
from the same faculty, it would be an easy matter to
establish harmony between them and to let such disputes
alone, for they occupy more time than the execution of the
figures themselves. As to that man who wrote saying that
painting was more noble than sculpture, as though he
knew as much about it as he did of the other subjects on
which he has written, why, my servingmaid would have
written better! An infinite number of things still remain
unsaid which might be urged in favour of these arts, but,
as I have already said, they would take up too much time
and I have very little to spare seeing that I am old and
almost fitted to be numbered among the dead. For this
reason I beg you to excuse me. I commend myself unto
you and I thank you from the bottom of my heart for the
too great honour you do me—an honour not suited to such
as I am.

<div align="center">Your MICHELAGNIOLO BUONARROTI</div>

To Lionardo di Buonarroti di Simoni,
in Florence. Rome, February 28, 1551
 LIONARDO[20]—From thy last letter I learn that thou hast
as yet done nothing towards getting married. I am not at

[20] Michelangelo's nephew, the son of Buonarroto Buonarroti.

all well pleased, for it is incumbent upon thee to take a
wife, and as I have told thee in writing on several occa-
sions, I do not think—considering thy present position and
all that will eventually come to thee—that thou needst look
for a dowry but only for goodness, health and gentle
breeding. Consider that to marry a girl of good breeding
and good character with soundness of body and nobility of
blood but no money would be an act of charity: and
that if thou doest this thou will be free from all fear of
feminine frivolity and extravagance. The result would be
increased tranquillity within the house. As to the suggestion
that thou desirest to ennoble thyself, as thou saidst in a
former letter, there is no possibility of truth in it, for it is
known that we are descended from the Florentine citizens
of ancient days. Think over all I have said, for fortune has
not favoured thee in face or figure so extensively as to
make thee worthy of the first beauty in Florence. Be very
careful that thou deceive not thyself.

As to the alms I said I wished thee to give away in
Florence; thou writest asking how much I wish to give as
though I were in a position to give away my crowns by
the hundred. The last time thou wast here thou broughtest
me a piece of cloth which I think I understood thee to say
cost from twenty to twenty-five crowns. This piece of cloth,
this piece of cloth (*e questi e questi*) I then thought of
bestowing in Florence in charity for the souls of us all.
Then, when this terrible famine began to spread through
Rome I converted it into bread, and if no relief comes I
doubt whether we shall not all die of starvation.

I have nothing to add. Greet the priest in my name, and
say that as soon as I can I will answer him.

On the last day of February, 1551.

<div style="text-align: right">MICHELAGNIOLO,
in Rome</div>

[*To Messer Bartolomeo Ammannati.*][21]

<div style="text-align: right">Rome, [. . . 1555]</div>

MESSER BARTOLOMEO, DEAR FRIEND,—It cannot be de-

[21] [Bartolomeo Ammannati (1511–1592) studied with Ban-
dinelli, Jacopo Sansovino and Michelangelo. He worked in

nied that Bramante was a skillful architect and the equal
of any one from the time of the ancients until now. It was
he who drew up the original plan of St. Peter's, not full of
confusion but clear and straightforward, with ample light
and detached from the surrounding buildings so that it did
not in any way interfere with the Palace. It was considered
to be a fine design, and there is still evidence that it was
so: indeed, every architect who has departed from Bra-
mante's plan, as Sangallo has done, has departed from the
right way, and that this is true may be seen by anybody
who looks at his model with unprejudiced eyes. In the
first place, the outer ring of chapels he shows will exclude
all the light provided by Bramante in his plan; and not
only this, but he has not provided any fresh means of
lighting, while there are so many gloomy lurking-holes both
above and below that any sort of knavery could easily be
practised, such as the hiding of banished persons, the
coining of false money, the rape of nuns, and other misde-
meanours: and when at night the time comes for shutting
up the church it would require twenty-five men to make
sure that no person remained there in hiding, and it would
be sufficiently difficult to find them. Furthermore, there
would be this other drawback, that in adding this circular
work to the outside of Bramante's plan it would be neces-
sary to pull down the Pauline Chapel, the Offices of the
Piombo, the Ruota, and many other buildings. I do not
think that even the Sistine Chapel would remain intact. As
to the portion of the external ring which has already been
carried out, and which they say has cost a hundred thou-
sand crowns, this is not true, for it could be done for sixteen
thousand; and little would be lost if it were pulled down,
as the prepared stone and the foundations could not be
more welcome, and would be worth two hundred thou-

Venice, Padua and Rome, where, with Vasari and Vignola, he
was employed as an architect. He followed Vasari to Florence
and entered the service of the Medici. He won a competition, in
which Cellini, Giambologna and Danti took part, for the foun-
tain in the Piazza della Signoria. As an architect, he enlarged
the Pitti Palace and constructed the bridge of Santa Trinità,
one of the most beautiful of the period. He returned to Rome
and was employed by Gregory XII and Sixtus V.]

sand crowns and three hundred years of time to the building. This is my opinion, expressed without prejudice, for to gain a victory in this matter would be to my very great loss. If you could let the Pope [Paul IV] know what I think, you would be doing me a service, as I do not feel well enough to write myself.

Your MICHELAGNIOLO

[P.S.]—If the Sangallo model is carried out there would be worse to follow. Let us hope that all the work done in my time may not be ruined, for that would be a grave scandal.

[*To Giorgio Vasari.*] Rome, [May . . . 1557]

MESSER GIORGIO, DEAR FRIEND,—God is my witness how much against my will it was that Pope Paul forced me into this work on St. Peter's in Rome ten years ago. If the work had been continued from that time forward as it was begun, it would by now have been as far advanced as I had reason to hope, and I should be able to come to you. But as the work has been retarded the fabric is much behindhand. It began to go slowly just when I reached the most important and difficult part, so that if I were to leave it now it would be nothing less than a scandal that I should let slip all reward for the anxieties with which I have been battling these ten years. I have written this account in reply to your letter because I have also received one from the Duke which fills me with astonishment that His Lordship should deign to write to me in such kindly terms. I thank both God and His Excellency with all my heart. I am wandering from my subject, for both my memory and my thoughts have deserted me and I find writing most difficult, being, as it is, not my profession. What I wish to say is this: I want you to understand what would happen if I were to leave the aforesaid work and come to Florence. Firstly, I should give much satisfaction to sundry robbers here, and should bring ruin upon the fabric, perhaps causing it to close down for ever: then also I have certain obligations here, as well as a house and other possessions which are worth several thousand crowns, and if I were to depart without permission I do not know what would happen to them: and, finally, my health is in the condition, what

with renal and urinary calculi, and pleurisy, that is the
common lot of all old people. Maestro Eraldo[22] can bear
witness to this, for I owe my life to his skill. You will
understand, therefore, that I have not the courage to come
to Florence and then return once more to Rome; and that
if I am to come to Florence for good and all it is impera-
tive that I should be allowed sufficient time in which to
arrange my affairs so that I should never again have to
bother about them. It is so long since I left Florence that
Pope Clement was still alive when I arrived here, and he
did not die until two years later. Messer Giorgio, I com-
mend myself to you, begging you to commend me to the
Duke and to do the best you can on my behalf, for there
is only one thing left that I should care to do—and that is
to die. What I have said of my state of health is more than
true. I replied to the Duke as I did because I was told to
make some sort of reply, and because I had not the cour-
age to write to His Lordship, especially at such short
notice. If I felt able to sit on a horse I would come to
Florence directly and return here without anyone having
knowledge of it.

<div align="center">MICHELAGNIOLO BUONARROTI,

in Rome</div>

To the Cardinal Ridolfo Pio da Carpi.

<div align="right">Rome, [. . . 1560]</div>

MOST REVEREND MONSIGNORE,—When a plan has di-
verse parts all those which are alike in quality and quan-
tity must be treated according to the one model and in one
style, and the same applies to the parts which pair with
them. But when the whole arrangement of a plan is
changed it is not only permissible but necessary to change
the style of the decorations both in the one and in the
counterpart. Odd features may always be treated inde-
pendently, in the same way as the nose, which stands in
the middle of the face, is not dependent upon either eye,
although one hand must of necessity correspond with the
other, and one eye with the other, because they are
placed at the sides and are in pairs. Wherefore it is very
certain that architectural members ought to follow the

[22] Realdo Colombo, 1520–?, a celebrated doctor.

same rule as the members of the human body. He that has
not mastered, or does not master, the human figure, and
especially its anatomy, can never comprehend it.

MICHELAGNIOLO BUONARROTI

POEMS[23]

Non ha l'ottimo artista[24]

The best of artists never has a concept
A single marble block does not contain
Inside its husk, but to it may attain
Only if hand follows the intellect.

The good I pledge myself, bad I reject,
Hide, O my lady, beautiful, proud, divine,
Just thus in you, but now my life must end,
Since my skill works against the wished effect.

It is not love then, fortune, or your beauty,
Or your hardness and scorn, in all my ill
That are to blame, neither my luck nor fate,

If at the same time both death and pity
Are present in your heart, and my low skill,
Burning, can grasp nothing but death from it.

[23] For the translation of Michelangelo's poems and the ac-
companying notes, I am indebted to Creighton Gilbert. *Michel-
angelo, Complete Poems and Selected Letters,* translated, with
foreword and notes, by Creighton Gilbert, New York, 1963.

[24] This sonnet is the most explicit definition of Michelangelo's
theory of art as relating to his personal twist of the current
theological-philosophical fashions. Reversing metaphor and sub-
ject, it may be phrased: As the beloved contains potentially any
fate for the lover, who according as he is wise and worthy will
extract from her the most favorable of them, so the crude block
of marble potentially contains any statue, but only the best
sculptor can extract the successful work of art. The statue as a
metaphor of potentiality goes back in one form to Aristotle, but
is also connected with a Neoplatonic metaphor of stone sculp-
ture as man who reaches the pure being of the soul (the statue
inside when perfected) by digging away the gross impeding
physical body.

Siccome per levar

Just as we put, O lady, by subtraction,
Into the rough hard stone
A living figure, grown
Largest wherever rock has grown most small,
Just so, sometimes, good actions
For the still trembling soul
Are hidden by its own body's surplus,
And the husk that is raw and hard and coarse,
Which you alone can pull
From off my outer surface;
In me there is for me no will or force.

Se'l mio rozzo martello[25]

If my rough hammer in hard stones can form
A human semblance, one and then another,
Set moving by the agent who is holder
Watcher and guide, its course is not its own.

But that divine One, staying in Heaven at home,
Gives others beauty, more to itself, self-mover;
If hammers can't be made without a hammer,
From that One living all the others come.

And since a blow will have the greatest force
As at the forge it's lifted up the highest,
This above mine to Heaven has run and flown.

Wherefore with me, unfinished, all is lost,
Unless the divine workshops will assist
In making it; on earth it was alone.

[25] The more exalted hammer that is to carve out Michelangelo, finish and refine him, as he carves stones until they have the semblance of human beings, is Vittoria Colonna. This sonnet was composed when she died and flew to heaven, so that her "statue" remained incomplete. She died February 25, 1547.

At the foot of the sonnet Michelangelo appends a continuation of his image: "Earth had this alone in exalting the virtues with great virtue, and it itself had no one to work the bellows. Now in the sky it will have many companions, for there is none there if not those whom virtue pleased; whence I hope, that from up there my hammer will send a blow down here. . . ."

Negli anni molti

Led on through many years to my last hours,
I understand too late your pleasures, Earth.
Repose that is dead before its birth
And peace you do not have, you promise others.
Old age's shame and terrors,
Which the heavens now require,
In me do but refresh
The old delightful errors.
Too long a lifetime there
Murders the soul and hardly helps the flesh.
In Heaven the luck is best—
I say it and I know, the proof is I—
Only for him who, born, could soonest die.

I'ho gia fatto un gozzo[26]

I've got myself a goitre from this strain,
As water gives the cats in Lombardy
Or maybe it is in some other country;
My belly's pushed by force beneath my chin.

My beard toward Heaven, I feel the back of my brain
Upon my nape, I grow the breast of a harpy;
My brush, above my face continually,
Makes it a splendid floor by dripping down.

My loins have penetrated to my paunch,
My rump's a crupper, as a counterweight,
And pointless the unseeing steps I go.

[26] This sonnet, written about June 1511, refers to the vexations of painting the Sistine Chapel ceiling, 1508–1510, and 1511–1512. It is addressed to Giovanni da Pistoia, known for his jocose and bizarre tone in verses addressed to Michelangelo. *The back of my head,* line 6, translates *memoria.* Renaissance physiology distributed the functions of imagination, reason and memory among the anterior, central and posterior brain, respectively. See Spenser, *Faerie Queene,* II, Ix, 47–59. *Syrian bow,* line 14, is a double bend separated by a straight section, not the simple curve of the English longbow.

In front of me my skin is being stretched
While it folds up behind and forms a knot,
And I am bending like a Syrian bow.

And judgment hence must grow,
Borne in the mind, peculiar and untrue;
You cannot shoot well when the gun's askew.

John, come to the rescue
Of my dead painting now, and of my honor;
I'm not in a good place, and I'm no painter.

Caro m'e'l sonno

I prize my sleep, and more my being stone,
As long as hurt and shamefulness endure.
I call it lucky not to see or hear;
So do not waken me, keep your voice down!

GIORGIO VASARI

[Giorgio Vasari (1511–1574) was born in Arezzo, and his early education there by the humanist Pollastro prepared him to become a learned artist, the ideal of his time. He continued his art studies with Michelangelo in Florence. He returned to Arezzo and began to work as a goldsmith when Cardinal Ippolito de' Medici asked him to enter his service. Vasari accompanied him to Rome where he continued his studies. In the service of the Medici he went to Florence and spent the remainder of his life there as a painter, architect and writer. His principal works as a painter—the frescoes of the Sala Regia in the Vatican, and the *Allegories* in the Palazzo Vecchio, Florence—reflect a strong Mannerist tendency, the result of his studies in Rome. As an architect he was more original, even though he was strongly influenced by Michelangelo. Vasari is of greatest importance as the first art historian. His *Lives of the Most Eminent Painters, Sculptors, and Architects,* published first in 1550, with a revised second

edition in 1568, served as a model for such writing for two centuries. It is still the principal source of information on artists living prior to Vasari as well as his contemporaries.]

LIVES OF THE MOST EMINENT PAINTERS, SCULPTORS, AND ARCHITECTS[1]

Preface to the Third Part. Truly great was the advancement conferred on the arts of architecture, painting, and sculpture by those excellent masters of whom we have written hitherto, in the Second Part of these Lives, for to the achievements of the early masters they added rule, order, proportion, draughtsmanship, and manner; not, indeed, in complete perfection, but with so near an approach to the truth that the masters of the third age, of whom we are henceforward to speak, were enabled, by means of their light, to aspire still higher and attain to that supreme perfection which we see in the most highly prized and most celebrated of our modern works. But to the end that the nature of the improvement brought about by the aforesaid craftsmen may be even more clearly understood, it will certainly not be out of place to explain in a few words the five additions that I have named, and to give a succinct account of the origin of that true excellence which, having surpassed the age of the ancients, makes the modern so glorious.

Rule, then, in architecture, was the process of taking measurements from antiquities and studying the ground-plans of ancient edifices for the construction of modern buildings. Order was the separating of one style from another, so that each body should receive its proper members, with no more interchanging between Doric, Ionic, Corinthian, and Tuscan. Proportion was the universal law applying both to architecture and to sculpture, that all bodies should be made correct and true, with the members in proper harmony; and so, also, in painting. Draughtsmanship was the imitation of the most beautiful parts of

[1] The text is from Giorgio Vasari, *Lives of the most eminent Painters, Sculptors & Architects,* translated by G. du C. de Vere, London, 1912, vol. IV, pp. 79–85.

nature in all figures whether in sculpture or in painting; and for this it is necessary to have a hand and a brain able to reproduce with absolute accuracy and precision, on a level surface—whether by drawing on paper, or on panel, or on some other level surface—everything that the eye sees; and the same is true of relief in sculpture. Manner then attained to the greatest beauty from the practice which arose of constantly copying the most beautiful objects and joining together these most beautiful things, hands, heads, bodies, and legs, so as to make a figure of the greatest possible beauty. This practice was carried out in every work for all figures, and for that reason it is called the beautiful manner.

These things had not been done by Giotto or by the other early craftsmen, although they had discovered the rudiments of all these difficulties, and had touched them on the surface; as in their drawing, which was sounder and more true to nature than it had been before, and likewise in harmony of colouring and in the grouping of figures in scenes, and in many other respects of which enough has been said. Now although the masters of the second age improved our arts greatly with regard to all the qualities mentioned above, yet these were not made by them so perfect as to succeed in attaining to complete perfection, for there was wanting in their rule a certain freedom which, without being of the rule, might be directed by the rule and might be able to exist without causing confusion or spoiling the order; which order had need of an invention abundant in every respect, and of a certain beauty maintained in every least detail, so as to reveal all that order with more adornment. In proportion there was wanting a certain correctness of judgment, by means of which their figures, without having been measured, might have, in due relation to their dimensions, a grace exceeding measurement. In their drawing there was not the perfection of finish, because, although they made an arm round and a leg straight, the muscles in these were not revealed with that sweet and facile grace which hovers midway between the seen and the unseen, as is the case with the flesh of living figures; nay, they were crude

and excoriated, which made them displeasing to the eye and gave hardness to the manner. This last was wanting in the delicacy that comes from making all figures light and graceful, particularly those of women and children, with the limbs true to nature, as in the case of men, but veiled with a plumpness and fleshiness that should not be awkward, as they are in nature, but refined by draughtsmanship and judgment. They also lacked our abundance of beautiful costumes, our greater number and variety of bizarre fancies, loveliness of colouring, wide knowledge of buildings, and distance and variety in landscapes. And although many of them, such as Andrea Verrocchio and Antonio del Pollaiuolo, and many others more modern, began to seek to make their figures with more study, so as to reveal in them better draughtsmanship, with a degree of imitation more correct and truer to nature, nevertheless the whole was not yet there, even though they had one very certain assurance—namely, that they were advancing towards the good, and their figures were thus approved according to the standard of the works of the ancients, as was seen when Andrea Verrocchio restored in marble the legs and arms of the Marsyas in the house of the Medici in Florence. But they lacked a certain finish and finality of perfection in the feet, hands, hair, and beards, although the limbs as a whole are in accordance with the antique and have a certain correct harmony in the proportions. Now if they had had that minuteness of finish which is the perfection and bloom of art, they would also have had a resolute boldness in their works; and from this there would have followed delicacy, refinement, and supreme grace, which are the qualities produced by the perfection of art in beautiful figures, whether in relief or in painting; but these qualities they did not have, although they give proof of diligent striving. That finish, and that certain something that they lacked, they could not achieve so readily, seeing that study, when it is used in that way to obtain finish, gives dryness to the manner.

After them, indeed, their successors were enabled to attain to it through seeing excavated out of the earth certain antiquities cited by Pliny as amongst the most famous,

such as the Laocoön, the Hercules, the Great Torso of the
Belvedere, and likewise the Venus, the Cleopatra, the
Apollo, and an endless number of others, which, both with
their sweetness and their severity, with their fleshy round-
ness copied from the greatest beauties of nature, and with
certain attitudes which involve no distortion of the whole
figure but only a movement of certain parts, and are re-
vealed with a most perfect grace, brought about the dis-
appearance of a certain dryness, hardness, and sharpness of
manner, which had been left to our art by the excessive
study of Piero della Francesca, Lazzaro Vasari, Alesso
Baldovinetti, Andrea dal Castagno, Pesello, Ercole Fer-
rarese, Giovanni Bellini, Cosimo Rosselli, the Abbot of
S. Clemente, Domenico del Ghirlandaio, Sandro Botticelli,
Andrea Mantegna, Filippo, and Luca Signorelli. These
masters sought with great efforts to do the impossible in
art by means of labour, particularly in foreshortenings and
in things unpleasant to the eye, which were as painful to
see as they were difficult for them to execute. And although
their works were for the most part well drawn and free
from errors, yet there was wanting a certain resolute spirit
which was never seen in them, and that sweet harmony of
colouring which the Bolognese Francia and Pietro Peru-
gino first began to show in their works; at the sight of
which people ran like madmen to this new and more life-
like beauty, for it seemed to them quite certain that noth-
ing better could ever be done. But their error was after-
wards clearly proved by the works of Leonardo da Vinci,
who, giving a beginning to that third manner which we
propose to call the modern—besides the force and boldness
of his drawing, and the extreme subtlety wherewith he
counterfeited all the minutenesses of nature exactly as they
are—with good rule, better order, right proportion, perfect
drawing, and divine grace, abounding in resources and
having a most profound knowledge of art, may be truly
said to have endowed his figures with motion and breath.

There followed after him, although at some distance,
Giorgione da Castelfranco, who obtained a beautiful
gradation of colour in his pictures, and gave a sublime
movement to his works by means of a certain darkness

of shadow, very well conceived; and not inferior to him in giving force, relief, sweetness, and grace to his pictures, with his colouring, was Fra Bartolommeo di San Marco. But more than all did the most gracious Raffaello da Urbino, who, studying the labours of the old masters and those of the modern, took the best from them, and, having gathered it together, enriched the art of painting with that complete perfection which was shown in ancient times by the figures of Apelles and Zeuxis; nay, even more, if we may make bold to say it, as might be proved if we could compare their works with his. Wherefore nature was left vanquished by his colours; and his invention was facile and peculiar to himself, as may be perceived by all who see his painted stories, which are as vivid as writings, for in them he showed us places and buildings true to reality, and the features and costumes both of our own people and of strangers, according to his pleasure; not to mention his gift of imparting grace to the heads of young men, old men, and women, reserving modesty for the modest, wantonness for the wanton, and for children now mischief in their eyes, now playfulness in their attitudes; and the folds of his draperies, also, are neither too simple nor too intricate, but of such a kind that they appear real.

In the same manner, but sweeter in colouring and not so bold, there followed Andrea del Sarto, who may be called a rare painter, for his works are free from errors. Nor is it possible to describe the charming vivacity seen in the works of Antonio da Correggio, who painted hair in detail, not in the precise manner used by the masters before him, which was constrained, sharp, and dry, but soft and feathery, with each single hair visible, such was his facility in making them; and they seemed like gold and more beautiful than real hair, which is surpassed by that which he painted.

The same did Francesco Mazzuoli of Parma, who excelled him in many respects in grace, adornment, and beauty of manner, as may be seen in many of his pictures, which smile on whoever beholds them; and even as there is a perfect illusion of sight in the eyes, so there is perceived the beating of the pulse, according as it best pleased

his brush. But whosoever shall consider the mural paintings of Polidoro and Maturino, will see figures in attitudes that seem beyond the bounds of possibility, and he will wonder with amazement how it can be possible, not to describe with the tongue, which is easy, but to express with the brush the tremendous conceptions which they put into execution with such mastery and dexterity, in representing the deeds of the Romans exactly as they were.

And how many there are who, having given life to their figures with their colours, are now dead, such as Il Rosso, Fra Sebastiano, Giulio Romano, and Perino del Vaga! For of the living, who are known to all through their own efforts, there is no need to speak here. But what most concerns the whole world of art is that they have now brought it to such perfection, and made it so easy for him who possesses draughtsmanship, invention, and colouring, that, whereas those early masters took six years to paint one panel, our modern masters can paint six in one year, as I can testify with the greatest confidence both from seeing and from doing; and our pictures are clearly much more highly finished and perfect than those executed in former times by masters of account.

But he who bears the palm from both the living and the dead, transcending and eclipsing all others, is the divine Michelagniolo Buonarroti, who holds the sovereignty not merely of one of these arts, but of all three together. This master surpasses and excels not only all those moderns who have almost vanquished nature, but even those most famous ancients who without a doubt did so gloriously surpass her; and in his own self he triumphs over moderns, ancients, and nature, who could scarcely conceive anything so strange and so difficult that he would not be able, by the force of his most divine intellect and by means of his industry, draughtsmanship, art, judgment, and grace, to excel it by a great measure; and that not only in painting and in the use of colour, under which title are comprised all forms, and all bodies upright or not upright, palpable or impalpable, visible or invisible, but also in the highest perfection of bodies in the round, with the point of his chisel. And from a plant so beautiful

and so fruitful, through his labours, there have already spread branches so many and so noble, that, besides having filled the world in such unwonted profusion with the most luscious fruits, they have also given the final form to these three most noble arts. And so great and so marvellous is his perfection, that it may be safely and surely said that his statues are in all their parts much more beautiful than the ancient; for if we compare the heads, hands, arms, and feet shaped by the one with those of the others, we see in his a greater depth and solidity, a grace more completely graceful, and a much more absolute perfection, accomplished with a manner so facile in the overcoming of difficulties, that it is not possible ever to see anything better. And the same may be believed of his pictures, which, if we chanced to have some by the most famous Greeks and Romans, so that we might compare them face to face, would prove to be as much higher in value and more noble as his sculptures are clearly superior to all those of the ancients.

But if we admire so greatly those most famous masters who, spurred by such extraordinary rewards and by such good-fortune, gave life to their works, how much more should we not celebrate and exalt to the heavens those rare intellects who, not only without reward, but in miserable poverty, bring forth fruits so precious? We must believe and declare, then, that if, in this our age, there were a due heed of remuneration, there would be without a doubt works greater and much better than were ever wrought by the ancients. But the fact that they have to grapple more with famine than with fame, keeps our hapless intellects submerged, and, to the shame and disgrace of those who could raise them up but give no thought to it, prevents them from becoming known.

And let this be enough to have said on this subject; for it is now time to return to the Lives, and to treat in detail of all those who have executed famous works in this third manner, the creator of which was Leonardo da Vinci, with whom we will now begin.

LETTER[2]

To Duke Alessandro de' Medici.[3]

As Your Illustratious Excellency, Milord, has greatly praised and is pleased by the picture of the Dead Christ which I executed for the Cardinal,[4] it will be especially pleasing to His Reverend Lordship when he knows that you keep it in your room, having it near you, since out of his goodness he feels and takes pleasure in the fact that my efforts are worthy of people like you, the more so because I shall return to his hands much better than when he left me at his departure. Since Your Excellency is pleased that I execute a picture[5] with the portrait of Lorenzo the Magnificent, the Elder,[6] dressed as he actually was at home, we will see that we take one of those portraits which resemble him most and from that we will pluck the features of the face. The rest I am thinking of executing with this theme, if it would please Your Excellency.

Although you know better than I the gestures of this singular and rare citizen, I desire to surround him in this portrait with all those ornaments which his great qualities had embellished in life. I am portraying him alone since he enhances himself. Therefore I will depict him seated, dressed in a long purple robe lined with white wolf fur. In his right hand he will hold a handkerchief that hangs from a leather belt of antique style which he wears. To

[2] The letter is translated from the text given by Bottari-Ticozzi, *Raccolta*, III, pp. 17 f.

See also: R. W. Carden, *The Life of Giorgio Vasari*, London, 1910, pp. 1–42; Schlosser, *Lett. art.*, pp. 249 ff., and *Kunstlit.*, pp. 253 ff.

[3] Duke Alessandro de' Medici, an illegitimate great-grandson of Lorenzo the Magnificent, was the ruler of Florence until his assassination by his cousin in 1537.

[4] Cardinal Ippolito de' Medici (1511–1535), an illegitimate grandson of Lorenzo the Magnificent, was, at the time, absent in Hungary. He died, presumably poisoned by Duke Alessandro de' Medici.

[5] Our *fig. 2*.

[6] Lorenzo de' Medici (1449–1492) son of Cosimo, was the enlightened ruler of Florence and patron of arts and letters.

this will be fastened a pocket of red velvet used as a purse. He will rest his right arm on a simulated marble pilaster, which supports a porphyry antique. On that pilaster, covered by the hand of Lorenzo the Magnificent, there will be in simulated marble a figure of *Lying* biting its tongue. The pedestal will be carved and there will be these words upon it: *Sicut majores mihi, ita et ego post mea virtute praeluxit.*[7] Above this I have made a very ugly mask representing *Vice* lying down on its forehead. It will be overwhelmed by a fine, delicate vase full of roses and violets [inscribed] with these words: *Virtus omnium vas.*[8] To draw off the water this vase will have a spout which will run through a very beautiful mask, crowned with laurel. On its forehead, or else on the spout, are these words: *Praemium virtutis.*[9] On the other side of the same simulated porphyry will be depicted an antique lamp with a fantastic base and a curious mask on top which shows that oil may be poured between the horns on the forehead, and the tongue sticking out from the mouth of that face forms the wick, and lights. This shows that Lorenzo the Magnificent through his exceptional government, not only by eloquence, but in everything, especially in judgment gave light to his descendants and to this magnificent city. If Your Excellency is pleased, I will send this work to Poggio. May your excellent judgment supply what ever is lacking in my poor ability. I have done the best I could there. I have asked Messer Ottaviano de' Medici,[10] to whom I have given this, to make my excuses to you for I am unable to do anything more. To Your Illustratious Excellency, as much as I know and am able, I recommend myself from my whole heart.

FROM FLORENCE, January [. . . 1533][11]

[7] Just as my ancestors lighted the way for me, so by my virtue, I light the way for my descendants.

[8] Virtue embraces all.

[9] The reward of virtue.

[10] He was a distant cousin of Duke Alessandro.

[11] Kallab, *Vasaristudien* (Quellenschriften für Kunstgeschichte, N.F., XV), Vienna, 1908, p. 50.

BENVENUTO CELLINI

[Benvenuto Cellini (1500–1571), a Florentine whose turbulent life is best described in his *Autobiography,* began his artistic career as a goldsmith. From 1529 to 1535 he was employed as a goldsmith and seal cutter by Clement VII in Rome, where he had an opportunity to study the works of Michelangelo and Raphael as well as antique sculpture. Because of an act of violence, Cellini was obliged to leave Rome in 1540. He went to Paris and, in the employment of Francis I, he worked as a sculptor for the first time. The bronze relief, *Nymph of Fontainebleau,* is all that remains of his work executed in France. When in 1545 Cellini lost the favor of Francis I through the jealous intrigues of Primaticcio, the Italian painter, he returned to Florence, where he received a commission from Cosimo I for a bronze portrait bust and the *Perseus with the Head of Medusa.* On the *Perseus,* which established his fame as a sculptor, Cellini worked for nine years (1545–1554). Although he executed many works as a goldsmith, the *Salt Cellar of Francis I* in Vienna is the only piece that can definitely be ascribed to him. Besides his famous *Autobiography,* he wrote a *Treatise on the Goldsmith's Art and Sculpture,* which contains valuable information on his own methods of working.

The letter quoted below was written by Cellini as a reply to Benedetto Varchi (1503–1565), a typical figure of the sixteenth century, a man of letters and lecturer on Dante and Petrarch at the Florentine Academy, who had requested from the leading artists of the day opinions on the old and ever popular question of the comparative excellence of the arts. Varchi delivered two lectures on the subject before the Academy in 1546, publishing both the lectures and the letters three years later in a volume entitled *Due Lezzioni.* (For Michelangelo's comments on the debate, see p. 15. Cf. also Leonardo *Documentary History of Art,* Vol. I, p. 285.)]

LETTER[1]

To Benedetto Varchi.

I could discuss the nature of so glorious an art much better in words than by writing, for I am a poor dictator and a worse writer. Yet, here I am as I am. I maintain that among all the arts based on design [i.e. the Fine Arts], sculpture is seven times the greatest, because a statue must have eight show-sides and all should be equally good. Therefore it often happens that a sculptor lacking in love for his art is so satisfied with one beautiful side or perhaps two; and in order not to have the trouble of filing something from that one beautiful side, which he values above those six sides which are not so beautiful, [he leaves it, with the result that] his statue will be devoid of harmony. For everyone [who admires it], ten will criticize it, if after the first view they walk around it.

Here is where the excellence of Michelangelo shows, for he recognized the worth of this art and best showed its greatness. Today one recognizes Michelangelo to be the greatest painter ever known among either ancient or modern [artists], only because all that he knows of painting he derived from carefully studied methods of sculpture. Today, I know no one who comes nearer to such truth of art than the able Bronzino. I see the others drowned among nose-gays, and employing themselves with many varicolored compositions which can only cheat the simple.

To return to that great art of sculpture, I maintain that experience shows that if you wish only to make a column, or indeed a vase, which are very simple things, and if you draw them on paper with all the proportion and grace one can show in a sketch, and if then later you want to

[1] The letter is translated from the text given in *Due Lezzioni di M. Benedetto Varchi,* Florence, 1549. The text is also given in Bottari-Ticozzi, *Raccolta,* I, p. 17.

See also: R. H. H. Cust, *The Life of Benvenuto Cellini,* London, 1910; *Treatise of Benvenuto Cellini on Goldsmithing and Sculpture,* translated by C. R. Ashbee, London, 1898; Blunt, *Theory,* pp. 53-55; Schlosser, *Lett. art.,* pp. 315, 327, and *Kunstlit.,* pp. 320, 357.

make from that drawing a column or a vase of the same measurements in sculpture, a work will result which has not the grace or a bit of the charm the drawing shows. It will even appear false and stupid. But make the vase or column in a plastic model and then with or without measurements translate it into a drawing and it becomes very charming. In order to illustrate with an outstanding example, I select the great Michelangelo—there never having been in this art a greater artist. He wishing to show his stonecutters certain windows, made them in clay before he came to other measurements by drawing. I shall not mention the columns, arches, or other beautiful works of his which one sees, which were all made first in this way. The other artists who have followed and follow the profession of architecture take their works from a small sketch made on paper, and from that they make the model. Therefore their works are much less satisfying than those of this Angel [Michelangelo].

I also maintain that one cannot practice this marvelous art of sculpture if the sculptor has not a good knowledge of all the noble arts. Because if he wishes to represent a soldier with those qualities and the gallant vigor that pertain to him, it is necessary that he be very brave and have a knowledge of arms; and if he wishes to represent an orator, it is necessary that he be very eloquent and have a knowledge of the good science of letters; if he wishes to represent a musician, it is necessary that he have ample musical knowledge so that he may know how to place correctly an instrument in the hand of the person playing it. That it is necessary for him to be a poet,— on this subject the worthy Bronzino has written you fully.

There are many and infinite things to say about this great art of sculpture, but for so great an expert as you it is enough for me to have indicated a small part—as much as my small talent allows. I am convinced, and I repeat, that sculpture is the mother of all the arts that are based on design [the Fine Arts] and he who would be an able sculptor with a good style will more easily be good in perspective, a good architect, and a better painter than those who do not possess a good knowledge of sculpture.

Painting is none other than a tree, or man, or another object mirrored in a fountain. The difference between sculpture and painting is as great as that between the shadow and the object which casts the shadow.

As soon as I received your letter, I set about with the pure ardor I feel for you to write these few faulty lines. Thus I end in haste and recommend myself to you. I shall deliver your greetings. Keep in good health and wish me well. From Florence the 28th day of January 1546, always ready at your command.

<div style="text-align: right">BENVENUTO CELLINI</div>

SEBASTIANO SERLIO

[Sebastiano Serlio (1475–1564) began his career as a painter of perspectives in Pesaro. He went to Rome and under the guidance of the architect Baldassarre Peruzzi began his studies of architecture and antiquity. In 1532 he was working as an architect in Venice and there he published in 1537 and 1540, the fourth and third books of his treatise on architecture. He went to France and entered the service of Francis I as an architect. In 1545 he published the first and second books of the treatise, and in 1547 the fifth book. Since Book IV appeared first, it carried as its preface the general plan and introduction to the whole work (see pp. 43–44). When Serlio was supplanted at Fontainebleau by the French architect Delorme, he went to Lyons and completed the treatise with the sixth book—which was rediscovered in 1925—and the seventh book, published posthumously in 1575. He published a short book on portals in 1551. His treatise was widely read and had great influence in stimulating the new classical style of architecture in France. Even though attempting to follow strictly the laws of Vitruvius, Serlio expresses his own tastes and thus makes the treatise valuable for the study of architectural criticism.]

THE ENTIRE WORKS ON ARCHITECTURE AND PERSPECTIVE[1]

THE FIRST BOOKE OF ARCHITECTURE. THE FIRST CHAPTER. How needfull and necessary the most secret Art of Geometrie is for every Artificer and Workeman, as those that for a long time have studied and wrought without the same can sufficiently witnesse, who since that time have attained unto any knowledge of the said Arte, doe not onely laugh and smile at their owne former simplicities, but in the trueth may very well acknowledge that all whatsoever had bene formerly done by them, was not worth the looking on.

Seeing then the learning of Architecture comprehendeth in it many notable Artes, it is necessary that the Architect or Workeman, should first or at the least (if he can not attaine unto any more) know so much thereof, as that hee may understand the principles of Geometrie, that he may not be accompted amongst the number of stone spoilers, who beare the name of workeman, and scarce know how to make an answere what a Point, Line, Plaine, or Body is, and much lesse can tell what harmonie or correspondencie meaneth, but following after their own minde or other blinde conductors that have used to worke without rule or reason, they make bad worke, which is the cause of much uncut or uneven workemanship which is found in many places.

Therefore seeing that Geometrie is the first degree of all good Art, to the end I may show the Architect or so much thereof, as that he may thereby be able with good skill, to give some reason of his worke. Touching the speculations of Euclides and other Authors, that have writ-

[1] The excerpts are from Sebastiano Serlio, *The Entire Works on Architecture and Perspective*, translated by Robert Peake, London, 1611. For a clear presentation of the heretofore obscure chronology of Serlio's publications, see William Bell Dinsmoor, "The Literary Remains of Sebastiano Serlio," *Art Bulletin*, XXIV, 1942, pp. 55–91, 115–154.

See also: Schlosser, *Lett. art.*, p. 353, and *Kunstlit.*, p. 361; Venturi, *History*, p. 109.

ten of Geometrie, I will leave them, and onely take some flowers out of their Garden, that therewith by the shortest way that I can, I may entreat of divers cutting through of Lines, with some demonstrations, meaning so plainely and openly to let downe and declare the same, both in writing and in figures, that every man may both conceive and understand them, advertizing the Reader not to proceed to know the second figure, before he hath well understood and found out the first, and so still proceeding, hee shall at last attaine unto his desire.

THE SECOND BOOKE. *A Treatise of Perspectives, touching the Superficies.* THE SECOND CHAPTER. Although the subtill and ingenious Arte of Perspective is very difficult and troublesome to set downe in writing, and specially the body, or modell of things, which are drawen out of the ground: for it is an Arte which cannot be so well expressed by figures or writings, as by an undershewing, which is done severally: Notwithstanding, see that in my first Booke I have spoke of Geometry, without the which Perspective Arte is nothing: I will labour in the briefest manner that I can in this my second Booke, to shewe the workeman so much thereof, that hee shall bee able to aide and helpe himselfe therewith.

In this worke I will not trouble my selfe to dispute Philosophically what Perspective is, or from whence it hath the originall: for learned *Euclides* writeth darkely of the speculation thereof.

But to proceede to the matter, touching that the workeman shall have cause to use, you must understand, that Perspective is that, which *Vitruvius* called Scenographie, that is, the upright part and sides of any building or of any Superficies or bodies.

This Perspective then, consisteth principally in three lines: The first line is the Base below, from whence all things have their beginning. The second line is that, which goeth or reacheth to the point, which some call sight, others, the horison: But the horison is the right name thereof, for the horison is in every place wheresoever sight endeth. The third line, is the line of the distances, which

ought always to stand so high as the horison is farre or neere, according to the situation, as when time serveth, I will declare.

This Horison is to be understood to stand at the corners of our sight, as if the workeman would shew a piece of worke against a flat wall, taking his beginning from the ground, where the feete of the beholders should stand. In such case it is requisite, that the Horison should bee as high as our eye, and the distance to see or behold that worke, shall be set or placed in the fittest place thereabouts, as if it were in a Hall, or a Chamber, then the distance shall be taken at the entry thereof: but if it bee within, or at the end of a Gallery or Court, then the distance shall be set at the entry of the same place, and if it bee in a Streete against a wall or an house, then you must set your distance on the other side, right over against it. But if in such a case the streete is very narrow, then it were good to imagine a broad distance, lest the shortening fall out to be over-tedious or unpleasant unto you: for the longer or the wyder the distance is, the worke will shew so much the better and pleasanter.

But if you will begin a piece of worke of five or sixe foote high from the ground whereon you stand, then it is requisite that the Horison should stand even with your eyes (as I sayd before) but if a man shall see no ground of the worke, whereon the uppermost part doeth stand (and a man would worke very high) it would not be correspondent with the eyes: In such a case a man must take upon him to place the Horison somewhat higher, by the advice of some skilfull workman, which maketh histories or other things upon Houses, thirtie or fortie foote high above a mans sight, which is unfittingly. But cunning workmen fall into no such errors; for where they have made anything above our sight, there you could see no ground of the same worke, for that the notable Perspective Art hath bridled them: and therefore (as I sayd before) Perspective Art is every necessary for a workeman: And no Perspective workeman can make any worke without Architecture, nor the Architecture without Perspective.

To prove this, it appeareth by the Architectures in our dayes, wherein good Architecture hath begun to appeare and shew itselfe: For, was not *Bramant* an excellent Architector, and was he not first a Painter, and had great skill in Perspective Art, before he applyed himselfe to the Art of Architecture? and *Raphael Durbin,* was not he a most cunning Paynter, and an excellent Perspective Artist, before he became an Architector? And *Balthazar Perruzzi* of *Sienna,* was also a Paynter, and so well seene in Perspective Art, that he seeking to place certaine Pillars and other Antike works perspectively, tooke such a pleasure in the proportions and measures thereof, that he also became an Architector: wherein he so much excelled, that his like was almost not to be found. Was not learned *Ieronimus Genga* also an excellent Paynter, and most cunning in Perspective Arte, as the faire works, which he made for the pleasure of his Lord *Francisco Maria,* Duke of *Urbin,* can testifie; under whom he became a most excellent Architector? *Julius Romanus,* a scholler of *Raphael Durbin;* who, by Perspective Arte and Paynting, became an excellent Architector, witnesseth the same. Then to come to my purpose; I say, that a man must be diligent and vigilant in this Arte, wherein I will begin with small things, and then proceed to greater; untill I have shewed you the full Arte and manner thereof, as I desire.

THE THIRD BOOKE OF ANTIQUITIE. THE FOURTH CHAPTER. Among all the ancient building to bee seene in Rome, I am of opinion that the Pantheon (for one piece of worke alone) is the fayrest, wholest, and best to be understood; and is so much the more wonderful than the rest, because it hath so many members, which are all so correspondent one to the other, that whosoever beholdeth it, taketh great pleasure therein, which proceedeth from this, that the excellent workeman, which invented it, chose the perfitest forme, that is, the round forme, whereby it is usually called, Our Lady of the Round: for within, it is as high as it is broad. And it may be, that the sayd workeman, considering, that all things proceeding orderly, have a principall and onely head, whereon the nether parts depend, was of

opinion, that this piece of worke should have onely but one light, and that, in the highest part thereof, that it might spread abroad in all places alike, as in effect you see it doth: for besides other things which have their perfect light, there are sixe Chappels, which (for that they stand within the thicknesse of the wall) should be darke, yet they have their due light, by the meanes of some drawing windowes, above in the top of the sayd Chappels, which give them second light, taken from the uppermost hole, so that there is not any small thing in them, but it receiveth a part of the light, (and this is not made without great judgement:) for this Temple, in old time, being dedicated to all the gods, by which meanes there stood many Images in it, (which the divers Tabernacles, Seates, and small windowes shew) it was necessary that every one had his due light. Wherefore such as take pleasure to make Images, and other imbossed or graven worke, must consider, that such a Cabinet should have his light from above, that everyone, standing in his place, neede not looke for light to see, but that they may bee seene altogether at one time. But to come to my first speach: For that the Pantheon seemeth unto me to be the perfectest peece of worke that ever I saw, therefore I thought it good to set it first in the beginning of this Booke, and for a principal head of all other peeces of worke. The founder of this Temple (as *Plinie* writeth in more than one place) was *Marcus Agrippa,* to accomplish *Augustus Caesars* last will, who being intercepted by death, could not finish it: and so it was built about foureteene yeeres after the byrth of our Lord, which is about 5203 yeeres from the beginning of the world.

In this Temple (as *Pliny* writeth) the Capitals were of Copper; and hee writeth also, that *Diogenes,* the Imagemaker of Athens, made the excellent Caracters in the Pillars, and that the Images placed above the Frontespicium were much commended, although by the highnesse of the place they could not be so well discerned. This Temple was consumed with lightening, and burnt, about the 12. yeere of the raigne of the Emperour *Traian,* which was about 113. yeeres after the byrth of Christ, and in the 5311. yeere of

the creation of the world: and *Lucius Septimus Severus,* and *Marcus Aurelius Antonius,* repayred it agayne, with all the Ornaments thereto belonging, as it appearth in the Architrave of the sayd frame: which Ornaments, you must presume, were all new made, otherwise the Caracters of *Diogenes* would still have been seene there. But in truth, the workman that made it, was very judicious and constant; for that he proportioned the members thereof very judiciously to the body, and would not suppresse the worke with many cuttings: but as I will shew, when time serveth, how to place and devide them excellent well. Also, in all the worke, hee hath observed the worke of Corinth, and would mixe no other with it: and withall, the measures of all the members are as well observed as ever I saw or measured in any other peece of worke, whereby we may call this Temple an example of workemanship. But leaving this matter (for that it giveth the workeman little, or no instruction to the purpose) I will proceede to the particular measures: and that I may goe forward orderly in these Antiquities, the first Figure shall be the Ichnography. The second, the Orthography. The third, the Sciography.

THE FOURTH BOOKE. *Sebastian Serlius to the Reader.*[2] Loving and friendly Reader, after I had collected certaine rules of Architecture, thinking that not only those of deepe conceyt would understand them, but that also each indifferent man of wit might conceave them, as he is more or lesse addicted to such an Art; which rules are devided into seven Books, as hereunder shall be set downe: but for that this Art requireth it, therefore I thought it requisite to begin with this fourth Booke, and to set it out, first, which is more to the purpose, and more necessary than the rest, for the knowledge of many sorts of Building and ornaments thereof, to the end that every one may have some knowledge of this Art, the which is no lesse pleas-

[2] See Dinsmoor, *op. cit.,* pp. 65–67: "The emphasis on illustration . . . was the ideal which guided Serlio in his published works. It was a conception in architectural history . . . since become so general that we tend to forget that it was an innovation which we owe to him."

ing to the mind of those workmen that thinke upon things they are to make, than also to mens eyes when they are made. Which Art, by the wisedome of the famous and excellent spirits that are now in the world, doth flourish in these dayes, as the Latine tonge did in the time of *Julius Caesar* and *Cicero*. Then with glad and joyfull heart receyve at least my good will, (though the effect ensueth not) which, in trueth, I have (to pleasure and satisfie your minds) in this respect.

In the first Booke, I will entreat of the beginning of Geometry, and of divers cuttings through of lines, in such sort, that the workman may yeeld reason for that he worketh.

In the second Booke, I will shew in Figure, and by reason, as much of Perspective Art, that if the workeman will, he may declare his conceyt or purpose, by reasons and figure.

In the third Booke, workmen shall see the Ichnographie, that is, the ground: the Orthographie, that is, the raysing up of a Building before. The Scenographie or Sciographie, that is, the insight, by shortening of the most part of the Buildings that are in Rome, Italie, &c. diligently measured, and set by them in writing, with the places where they are, and their names.

In the fourth, which is this, I will speake of the five maner of Buildings, and of their ornaments, as Thuscana, Dorica, Ionica, Corinthia and Composita, that is to say, mingled. And by these, the whole Arte is learned.

In the fifth, I will speake of divers kinds of Temples, set downe in divers formes, that is, round, foure-square, six-cornerd, eyght-cornerd, Ovall-wise, and crosse-wise, with their ground, heights and shortenings, diligently measured.

In the sixth, I will speake of all dwellings, which, at this day, may bee used, beginning at the meanest house or cottage, and so from degree to degree, proceeding to the most rich, fayre and princely Palaces, as well in Countrie villages, as in great Cities or Townes.

In the seventh and last, shall be set downe many accidents, which may happen to workemen in divers places, strange maner of situation, repayring of decayed houses,

and how we should helpe our selves with pieces of other buildings, with such things as are to be used, and at other times have stood in worke.

Now then, to proceed readily herein, I will begin with the greatest and rusticke order of Building, that is, the Thuscan, being the playnest, rudest, and strongest, and of least grace and seemelinesse.

THE FOURTH BOOKE. *The Maner of Dorica, and the Ornaments thereof.* THE SIXTH CHAPTER. The Ancients (as we have heard) considering the state of their gods, ordained Dorica worke, and dedicated the same to *Jupiter, Mars,* and *Hercules*: but we build Temples, and dedicate them to *Christ, Paul, Gregory,* and such holy personages, that were not onely professed Souldiers, but also valiently and boldly lost their lives, and shed their bloud for the faith of CHRIST. All such belong to Dorica, and not to their gods onely, but to men of armes, and strong personages, being of qualitie more or lesse: for whom, if a workeman make or build houses or palaces, they must be Dorica: and the nobler the man is for whom such worke is done, the stronger and statelyer they ought to be; and the more effeminate that they are, the more slenderer and pleasanter the building shall be, as I will shew when time serveth. But now we will come to the maner of the worke. *Vitruvius* speaketh of this Dorica worke, in his fourth Booke and third Chapter; but touching Bases of Columnes, hee speaketh thereof in his third Booke; although some are of opinion, that he speaketh & meaneth of the Bases of Corinthia, for that they have bene much used on the Corinthia Columnes, and Ionica. And some also thinke, that Dorica Columnes had no Bases, having respect to many ancient buildings; as the Theater of *Marcellus,* one of the fayrest workes in *Italy,* being the middle downewards Dorica: which Columnes had no Bases, the body of the Columnes resting upon a step, without any other support. There is at *Carcer Tulliano* the signes of a Doricall Temple, the Columnes whereof are without Bases. You may also see in *Verona* an Arch tryumphant, of Dorica worke, where the Columnes are without Bases. Neverthelesse, for that

workeman have in former times made the Corinthia Bases
in another maner, as I will shew hereafter: Therefore I
affirme, that the Bases Atticurga, which *Vitruvius,* in his
third Booke, so nameth, are the Dorica Bases: and this
wee see, *Bramant* hath observed in his Buildings which
he made in *Rome*: which *Bramant,* being the light and
Inventor of good and true Architecture, which from An-
tiquitie to his time (being under Pope *Julius* the second)
had beene hidden, we ought to beleeve. Then this Base
of Dorica shall be the height of halfe the thicknesse of a
Columne: the Plinthus the third part of his height: of the
rest there shalbe foure parts made; one shall be for the
Thorus above: the other three shall be set in 3. even
parts: the one for the Thorus above, the second for the
Trochile or Scotia: but the same being devided in seven
parts, one part shall be the uppermost lift, and another
the undermost. The Proicture or bearing out of the Base,
shall be halfe the height, and so shall the Plinthus of each
Facie hold a thicknesse and a halfe of the columne. And if
the Base standeth below our sight, the corner under the
uppermost Thorus, (being of it selfe darkened) ought to
bee somewhat lower than the other. But if the Base stand-
eth above our sight, the corner above the nethermost
Thorus (also of it selfe darkened) shall be greater than the
other. Thereto also the Scotia, darkened by the Thorus, in
such case shalbe made more then the measure appoynted.
And in such cases the workeman must be judicious and
wary, as *Vitruvius* would have him to bee learned in the
Mathematicall science, that doth study his Booke.

ANDREA PALLADIO

[Andrea Palladio (1508–1580) was born, Andrea di
Pietro, in Vicenza. He apparently worked first as a sculp-
tor before turning to architecture. His talents were early
recognized by a wealthy patron. Trissino, who educated
him and is supposed to have given him the name Palladio.
He followed the usual course of study for an architect,

studying the antique monuments in Rome and the build-
ings of Bramante. His book *Antichità di Roma* (Antiquities
of Rome, 1554), is the result of these Roman studies. As
an architect he was singularly fortunate to find employ-
ment in keeping with his talents in Venice and especially
in and around Vicenza. The two buildings which best
express his ideas are Il Redentore (1578) in Venice and
the Basilica (1550) in Vicenza. His celebrated treatise,
Four Books of Architecture, was published in 1570. Like
all architectural writers of his time, Palladio is dependent
upon Vitruvius, and the first book, containing the prin-
ciples of good architecture, is derived from this writer.
The second book, devoted to private constructions, is the
result of the architect's own experience. The third book
deals with city planning, and the fourth with pagan
temples, a favorite subject of the time, with the require-
ments of Christian churches mentioned only incidentally.
This treatise aroused the greatest interest throughout
Europe and was translated into many languages. His style
forms the basis of much of the French as well as the
English architecture of the seventeenth and eighteenth
centuries.]

THE FOUR BOOKS OF ARCHITECTURE[1]

THE AUTHOR'S PREFACE. My natural inclination leading
me, from my very Infancy, to the Study of *Architecture*, I
resolv'd to apply myself to it: And because I ever was of
opinion, that the ancient *Romans* did far exceed all that
have come after them, as in many other things so particu-
larly in Building, I proposed to myself *Vitruvius* both as
my Master and Guide, he being the only ancient Author

[1] The excerpts are from *The Architecture of A. Palladio, in
Four Books,* translated by G. Leoni, 3rd ed., London, 1742.
Giacomo Leoni was apparently brought to England by Lord
Burlington to prepare a translation of Palladio's writings. Lord
Burlington, through his great admiration of Inigo Jones and
Palladio, did much to establish the Palladian style in England.
Leoni published his Palladio translation in 1715.
See also: Bannister F. Fletcher, *Andrea Palladio*, London,
1902; Schlosser, *Lett. art.*, p. 360, and *Kunstlit.*, p. 369.

that remains extant on this Subject. Then, I betook myself
to the Search and Examination of such Ruins of ancient
Structures as, in spight of Time and the rude Hands of
Barbarians, are still remaining; and finding that they
deserved a much more diligent Observation than I thought
at first Sight, I began with the utmost Accuracy to measure
even the minutest part by itself: And indeed, I became so
scrupulous an Examiner of them (not discovering that any
thing, of this kind, was perform'd, without the justest
Reason and the finest Proportion) that I afterwards, not
once only, but very often, took Journies to several parts of
Italy, and even out of it, that I might be able, from such
Fragments, to comprehend what the whole must needs
have been, and to make Draughts accordingly. Whereupon,
considering how widely different the Building, com-
monly in use, is from the Observations I made on the said
Edifices, and from what I read in *Vitruvius,* in *Leo Baptista
Alberti,* and other excellent Writers since *Vitruvius's* Time,
as well as from Buildings of my own Performance, which
raised my Reputation, and gave no small satisfaction to
those who were pleased to employ me; I thought it an
Undertaking worthy of a Man who considers that he was
not born for himself only, but likewise for the good of
others, to publish to the World the Designs (or Draughts)
of those Edifices, which with equal Expence of Time and
Danger to my Person, I have collected; and briefly to set
down what seem'd to me most worthy to be consider'd in
them; and further, to give those Rules which I have
hitherto follow'd in Building, and which I still follow, to
the end that they who shall read my Books, may be able
to practise whatever they find useful in them, and to supply
what is wanting, as many such things there may be. Thus
Men, by degrees, will learn to lay aside the strange Abuses,
the barbarous Inventions, the superfluous Expences and
(what imports them more than all the rest) to avoid the
various and continual Ruins which have happened in
several Buildings. I have moreover apply'd myself to this
Undertaking with the greater Alacrity, because at this
time I see abundance of others become studious of this
Profession, many of whom are worthily and honourably

mentioned in the Books of that rare Painter and Architect, *George Vasari Aretino*; which makes me hope that the way of Building will be reduced to general Utility, and very soon arrive to that pitch of Perfection, which, in all Arts, is so much desired. We appear to come very near it, in this part of *Italy*, seeing that not only Venice (where all the polite Arts do flourish, and which City alone affords an Example of the Grandeur and Magnificence of the *Romans*) there begin to appear Fabricks of good taste, since that most celebrated Carver and Architect, *Giacomo Sansovino*, first introduced the true manner, as may be seen, not to mention his fine Performances in the new Palace of *Procuracy*, which is perhaps the most sumptuous and the most beautiful Edifice that has been erected since the time of the Ancients; but also in several other Places of less renown, and particularly in the City of *Vicenza*, which tho' of no great Extent, yet full of very refined Genius's and sufficiently abounds in Riches. There I had first occasion to put that in practice, which I now publish for the common Good. . . . But to return to our Subject, having designed to publish to the World the Fruits of those Labours, which, with the greatest Diligence from my Youth upwards, I have been collecting; as also the Searching and Measuring of those Ancient Buildings that any ways came to my Knowledge; and upon this occasion briefly to treat of Architecture in the most orderly and distinct method possible; I thought it most convenient to begin with the Houses of private Persons, as thinking it reasonable to believe, that these in time gave rise to publick Edifices, it being very probable that Men lived first asunder by themselves; and perceiving afterwards that they needed the Aid of others to make them happy, (if indeed there be any Happiness here) they naturally loved and desired the Company of other Men, whence, out of many Houses they made Villages, and out of many Villages Cities, in which they built publick Places and Edifices. Besides, as of all the parts of Architecture, none is more necessary than this for Mankind, nor any more frequently practised by them, I shall therefore in the first place treat of private Houses, and next of publick Edifices.

I shall briefly write of Streets, Bridges, publick Places, Prisons, *Basiliche,* or Courts of Justice; *Xisti* and *Palestre,* (which are Places design'd for bodily Exercises) of Temples, Theatres and Amphitheatres, of Arches, of publick Baths, of Aqueducts, and last of all, the manner of fortifying Cities and Havens. In all these I shall avoid superfluity of Words, and will barely remark such things as shall appear to me most necessary, using those Terms and Names that are in common use with our present Architects. And because I dare make no other boasts of myself than what flow merely from the long and earnest Study, great Diligence, strong Passion and Affection wherewith I have pursued the Knowledge and Practice of what I now offer to the World; if it pleases *God* that I have not *labour'd in vain,* I shall be thankful to his Goodness for it with all my heart; acknowledging myself obliged to those, who, from their fine Inventions and Experiments, have left us the Precepts of this Art; since thereby they have opened a more easy and expeditious way to the making of new Discoveries, and that by their means (which we ought thankfully to acknowledge) we are come to the Knowledge of many things, which otherwise had perhaps remain'd still unknown. This first part shall be divided into two Books; the first will contain the Preparation of the Materials, and being prepared, how, and in what form, to employ them from the Foundations up to the Roof: and here likewise will be contained those general Rules which are to be observed in all Edifices, as well publick as private. In the second I shall treat of the different Qualities of Buildings, so as to make them agreeable to Persons of different Conditions: First of Houses in the City, and next of the most convenient Situations for Country-houses, and how they ought to be most commodiously disposed. But since in this kind, we have but few ancient Originals, by which to be governed, I shall lay before you the Plans of several Houses I have built for Gentlemen in divers places: and lastly, the Ancients Designs of Country-houses, with those parts in them that were most remarkable, in the manner that *Vitruvius* has taught us, and that they themselves built them.

Book I. Chapter X. *Of the Method which the Ancients did practise, in erecting their Stone-Buildings.* Whereas it happens sometimes that Buildings are made, the whole, or a good part of Marble, or of some other great Stones; I think it very proper here to explain what the Ancients did on such occasions; because it is to be observ'd in their Works, that they were so nice in the joining of their Stones together, that sometimes the Joints are difficult to be perceiv'd: which every one ought carefully to consider, who, besides the Beauty, desires also the solidity and last-ingness of the Work. As far as I can understand, they first squar'd and wrought those sides of the Stones, which were to be laid one upon the other, leaving the other sides rough, so that the edges of the Stones being thicker, men might move them with less danger of breaking or bruising them, than if they had been squar'd, and consequently thin-ner, on all sides before. In this manner they made their Stone Buildings *rustick*, or rather rough, till they had quite erected them to the very top; after which they went on working and polishing that face of the Stone which was expos'd to the sight. It is true that the *Roses* which are between the *Modilions,* and such other like Ornaments of the Cornice, which could not conveniently be work'd after the fixing of the Stones, were made before while they lay on the Earth. This may be easily observ'd in several an-cient Edifices, where many Stones remain rough and un-polish'd, just as they were laid. The arch near the old Castle in *Verona,* and all the other Arches and Buildings there, were done in the same manner; as it appears by the very marks of the Tools, which shew how the Stones were wrought. The *Trajan* and *Antonine* Columns at *Rome* were also wrought in the same manner; otherwise they could never have so exactly join'd the Stones, as to meet so closely cross the Heads and other parts of the Figures. The same I say of other Arches that are to be seen. When they went about some great piece of Building, as the *Arena* in Verona, the Amphitheatre of *Pola,* and the like, to save the excessive charge and length of time, which the finishing of such Works would have requir'd, they wrought only the *Imposts* of the Arches, the *Capitels* and *Cornices*:

and left the rest *rustick,* having only regard to the beauty
of the whole Fabrick. But in their Temples, or rather
sumptuous Buildings, which requir'd more Curiousity, they
spar'd no pains nor costs in the working them; polishing
and glazing even to the very *Channelling* or *Flutes* of the
Columns, with great exactness. Therefore in my judgment,
Brick-walls ought not to be *rusticated,* much less the
Mantles of Chimneys, which require the most curious
Workmanship: for besides the misapplying of that sort of
work, it would look as if one had a mind to make a thing,
which naturally ought to be entire, appear to be divided
and made of several pieces. But indeed, according to the
greatness and quality of the Building, it may be made
either *rustick,* or after a more elegant manner: for what
the Ancients did with Reason, when they were necessitated
by the greatness of their Edifices; we ought not to imitate,
when smaller Buildings require neatness.

 Book I. Chapter XX. *Of the Errors and Abuses intro-
duced into Architecture.* Having set down all these Orna-
ments of *Architecture* which consist in the right use of
the five Orders, and having shewn how they ought to be
made by drawing the *Profils* of each of their parts, ac-
cording as I found that the Ancients did practise; it seems
to me not unfit here, to inform the Reader of many
Abuses, which having been formerly introduc'd by *Bar-
barians,* are observ'd even to this day; and this I do, to the
end that the Studious in this Art may avoid them in their
own Works, and be able to take notice of them in those of
others. I say then, that *Architecture* (as all the other Arts)
being grounded upon Rules taken from the imitation of
Nature, admits of nothing that is contrary, or foreign to
that Order which Nature had prescrib'd to all things.
Wherefore we see that the ancient Architects, who begun
to alter their Timber-Buildings, and to make them with
Stones, kept their Columns less at the top than at the
foot, taking example from Trees, all which are less at the
top than in the Trunk, and towards the Roots: likewise,
because it is very natural that those things upon which
any great weight is laid, should be press'd under the Col-

umn they did put a *Base*, which by its *Torus, Cavetto*,
and *Astragal*, seems to represent a swelling caus'd by the
burden over it. So they Brought in the *Cornices, Trigliphs,
Modilions*, and Dentils, to represent the heads of Joysts,
which in the Cieling [*sic*.] are plac'd to bear up the Roof.
The same may be observ'd in all other parts, if one is
curious to examine them. And this being so, what shall we
say of that form of Building, which is so contrary to what
Nature has taught us, that it deviates from that Simplicity
which is visible in things here produc'd, and departs from
all that is good, or true, or agreeable in the way of Build-
ing: for which reason, instead of Columns, or Pilasters,
which are contriv'd to bear a great weight, one ought not
to place those Modern Ornaments call'd *Cartooshes*, which
are certain *Scroles* that are but an eye-sore to the Artists,
and give others only a confused Idea of *Architecture*, with-
out any pleasure or satisfaction; nor indeed do they pro-
duce any other effect than to increase the Expences of the
Builder. For the same reason these *Cartooshes* ought never
to come out of the *Cornice*; for it is requisite that all the
members of it should be made to some end, and to shew
what it would be, if all the work had been fram'd of
Timber. Besides that, as it is requisite to uphold a great
weight with something solid, and fit to support it: so such
non-sensical things, as *Cartooshes*, are altogether super-
fluous, because it is impossible that the Joysts, or any other
Timber whatsoever, could really perform what these repre-
sent; and since they are feign'd to be soft and weak, I
know not by what Rule they can be put under any thing
heavy and hard. But of all Abuses, in my opinion the
most intolerable is, the making certain frontons of Doors,
or Windows, or Galleries, divided in the middle: because
these frontons were contriv'd at first to defend those parts
from Rain, necessity having taught our first Architects to
give them the form of a Roof; so that I know nothing more
contrary to natural Reason, than to divide and open that
part which the Ancients did make whole, in order to de-
fend the Inhabitants of the House, and those that enter
into the same, from Rain, Snow, Hail, and other injuries
of the Air: and altho' variety and novelty should please

all, yet we are not to go against the precepts of Art, and that which Reason demonstrates; whence we see that the Ancients by their several Contrivances have never departed from the general and necessary Rules of Art or Nature, as may be seen in my Book of *Antiquities*. As for the *projecture* of the *Cornice*, and other Ornaments, 'tis not a small abuse to make it too great; because when these Projectures exceed their just measure, especially if the Building is in a close place, it appears the narrower and more uncomely, as well as always frightning those which stand underneath, as if it would fall upon them. One ought also carefully to avoid making the *Cornice* disproportionable to the Columns; for 'tis certain that putting great Cornices upon little Columns, or upon great Columns little *Cornices*, must needs make a very sad Aspect. Again, those sorts of Columns, which are feign'd to be made of several pieces, and jointed together by the means of certain *Rings*, or *Annulets*, in the form of a Rustick, ought also to be no less carefully avoided; because how much the more entire and strong the Columns appear, so much the more they perform the design for which they are plac'd, which is to render the Work above more secure and firm. Many other the like abuses might be reckon'd up, as of some Members which in the *Cornices* are made disproportionable to the rest, as by what I have shown before, and by what is now said, may be easily known. It remains now to come to the disposing of the particular and principal parts of a Building.

BOOK III. PREFACE. Having treated as fully as may be of private Buildings, (or the Houses and other conveniences belonging to particular Persons) and having mention'd all the most necessary directions that ought to be observ'd about the same; having over and above this, given the designs of several of those Houses that have been built by myself, whether within or without the City, and also of those made by the Ancients, according as *Vitruvius* has them: 'tis highly convenient, that turning my Discourse to more excellent and magnificent Fabricks, I

should now proceed to treat of Publick Edifices; wherein (because they consist of larger dimensions, and that they are beautify'd with more curious Ornaments than private ones, as serving for the use and conveniency of every body) Princes have a most ample field to shew the World the greatness of their Souls, and Architects are furnish'd with the fairest opportunity, to demonstrate their own Abilities in excellent and supprizing inventions. Wherefore, as well in this Book, in which I begin my *Antiquities,* as in those others, which (God willing) are to follow, it is my desire, that by so much the greater application may be used in considering the little I shall say, and the designs I shall give; by how much greater fatigue and longer watchings I have been reducing those Fragments that remain of ancient Buildings into such a form, that I hope the lovers of Antiquity may reap pleasure from the same, and the studious of Architecture receive much benefit: especially seeing that much more is learnt in a little time from good Examples, or Originals by measuring of them, and by seeing entire Edifices with all their parts describ'd on a little piece of Paper; than can in a long time be learnt from words, by which the Reader becomes able only in Idea, and not without some difficulty, to attain to a firm and certain knowledge of what he reads, and to bring it afterwards into practice with great fatigue. Every Person who is not altogether depriv'd of Judgment, may very manifestly perceive, how excellent the manner was, which the Ancients used in their Buildings; seeing that after so long a space of time, after so many destructions and mutations of Empires, there still remain in *Italy,* and out of it, the vestiges or ruins of so great a number of their stately Edifices, by the means whereof we come to a certain knowledge of the *Roman* virtue and greatness, which otherwise perhaps had not been believ'd. In this third Book therefore I shall observe the following method, in placing the designs that are contain'd in the same, I shall first give those of Streets, High-ways, and Bridges, as being that part of Architecture which appertains to the Ornament of Cities and Provinces, and which serves for

the general conveniency of all sorts of Men. For, as in other Fabricks made by the Ancients, it's easily discover'd that they spared no expence or labour, to bring them to that height of excellency, allow'd them, even by our imperfection: so they took no small care in the ordering of their Ways, finishing them in such a manner, that thereby, at this very time, may be learnt their greatness and magnanimity; since, to render them commodious and short, they pierc'd Mountains, drained Bogs, and built Bridges, thus making those Passages easy and plain, which were interrupted by uneven Vallies, or rapid Rivers. Next I shall treat of *Forums*, or publick places (according as *Vitruvius* teaches us that the *Greeks* and *Romans* made them) and likewise of those Buildings which ought to be erected about such squares: and since among these, that place is worthy of much consideration, where the Judges administer Justice, call'd by the Ancients a *Basilica*, I shall give the particular designs of the same. But since it is not sufficient that Countries and Cities be ever so well divided into their several districts, and regulated by most wholesome Laws; nor that we have Magistrates, who, as Executors of the Laws, keep the Citizens in obedience; if Men be not also render'd wise by the help of Learning, and strong as well as healthy by the Exercise of their Bodies (so to become capable both to govern others and themselves, and to make good defence against those that would oppress them) this is the principal reason, why the Inhabitants of any Country, being divided at first into many little Cantons, did afterwards unite and founded Cities. And for this reason also (as *Vitruvius* relates) the ancient *Grecians* erected certain Buildings in their Cities, which they call'd *Pelestras*, and *Xystes*, wherein the Philosophers came to dispute and discourse about the Sciences, and the Youth exercis'd themselves every day: as at certain set times the whole People came there together, to see the *Athletes* (or Fencers and Wrestlers) play their prizes; I shall therefore give the designs of these Edifices, and so an end will be put to this third Book, which shall be follow'd by that of *Temples* for the exercise of Religion, without which no civil policy can be possibly maintain'd.

BOOK III. CHAPTER XX. *Of the Basilicas, or Courts of Justice of our own times.* As the Ancients made their *Basilicas* after such a manner, that in the Spring and Summer People might come together there, to treat of their affairs, and to carry on their Law-suits; so in our times every City, both in *Italy* and out of it, do erect certain spacious publick Halls, which may be deservedly term'd *Basilicas*: because that near to them is the residence of the supreme Magistrate, whence they come to be part of the same; and the proper signification of this word *Basilica* is a royal House, as well for the reason now given, as by reason the judges attend there to administer justice to the People. The *Basilicas* of our times are different herein from the ancient *Basilicas*, that the latter were on the ground, or level with the surface of it; whereas the former are over arches, in which Shops are placed for several Arts and Merchants wares; the Prisons being likewise there, and other places for the service of the publick. Moreover, the ancient *Basilicas* had their porticos on the inside, as may be perceiv'd by our draughts; and the modern ones, on the contrary, either have no porticos at all, or they have them on the outside towards the square or open place. Among these modern Halls, there is one very remarkable in *Padua* (a City illustrious for its Antiquity, and famous over the whole world for its University) in which the Gentlemen meet every day, this place serving them for a cover'd square to walk in. The City of *Brescia*, which is magnificent in all its undertakings, has lately built one of those Halls, admirable for its grandeur and ornaments. There is another of them in *Vicenza*, of which alone I have given the draughts, because the porticos around it are of my own invention: and that I make no doubt, but that this Edifice may be compar'd to the ancient Fabricks, and be reckon'd among the noblest and most beautiful Buildings erected since the time of the ancients; as well on account of its largeness and ornaments, as of its matter, which is all hewn Stone, extremely hard, join'd and bound together with the utmost care. There is no need I should particularize the proportions of every part here, because they are all marked in their places on the draughts.

BOOK IV. PREFACE. If Labour and Industry are to be laid out upon any Fabrick, to the end that in all its parts it should have the exactest symmetry and proportion, this, without the least doubt, is to be practised in those Temples, wherein the most gracious and all-powerful God, the Creator and Giver of all things, ought to be ador'd by us; and, in the best manner that our abilities may permit, be prais'd and thank'd for such manifold favours as he continually bestows upon us. For if Men, in the building of their own Houses, use the utmost diligence to find out skilful and excellent Architects, with other capable Workmen; they are certainly oblig'd to be much more diligent in the building of Churches: and, if in the former their principal aim be Convenience, so in the latter they ought to have a regard to the Dignity and Greatness of him that in the same is to be invok'd and worship'd; who being the chiefest good and perfection, it is highly agreeable, that all things dedicated to him should be brought to the greatest perfection we are capable to give them. And indeed, when we consider this beautiful Machine of the World, with how many marvellous Ornaments it is replenish'd, how the Heavens by their continual rounds change the Seasons according to the necessities of Men, and preserve themselves by the sweetest harmony and temperament of their motion: we cannot doubt, but that as these little Temples we raise, ought to bear a resemblance to that immense one of his infinite goodness, which by his bare word was perfectly compleated; so we are bound to beautify them with all the ornaments we possibly can, and to build them in such a manner and with such proportions, that all the parts together may fill the eyes of the beholders with the most pleasing harmony, and that each of them separately may conveniently answer the use for which it was design'd. Wherefore, altho' they are worthy of much commendation, who, being led by the best Spirit, have already built Churches and Temples in honour of the high God, and are still building such; nevertheless, they do not seem to be exempt from all blame, if they have not likewise endeavour'd to make them in the best form and noblest manner, possible for our weakness

to execute. Now since the ancient *Greeks* and *Romans* used a world of diligence in making Temples for their Gods, and that they built them according to the most beautiful Architecture; to the end they might have the greatest Ornaments, and the best proportion, that were agreeable to the God to whom they were dedicated; I shall therefore in this Book shew the form and the ornaments of several ancient Temples, whereof the ruins are yet to be seen, and of which I have made the Designs: that every one may know in what form, and with what ornaments, Churches ought to be built. And tho' of some of these Temples but very little is to be seen above ground, yet from this little consider'd together with the foundations that could be likewise seen, I have made my Conjectures what they must have been, when they were entire. Nor was I in this matter a little assisted by *Vitruvius,* because what I saw, agreeing with what he taught, it was not very difficult for me to come to the knowledge both of their aspects and forms. But as for what concerns the ornaments, that is, the Bases, Columns, Capitels, Cornishes, and such like things, I have intermix'd nothing of my own; but they were measur'd by me with the utmost care and exactness, from divers fragments found in the very places where stood the Temples themselves. Nor do I question, but that such as shall read this Book, and diligently consider the Designs of it, will come to understand many passages in *Vitruvius,* which were reputed extremely difficult: and that their understandings will be directed to discern the most beautiful and best proportion'd forms of Temples, and to draw from them manifold and noble Inventions; of which making use in due time and place, they may shew in their works, how Architects may and ought to vary without quitting the precepts of the Art, and how such variations are often very laudable and graceful. But before I come to the designs, I shall briefly lay down, as I am wont to do, those Directions which are to be observ'd in the building of Temples; I myself having drawn them from *Vitruvius,* and from other most excellent Persons, that have written concerning so noble an Art.

BOOK IV. CHAPTER II. *Of the form of the Temples, and what is becoming to be observ'd about them.* Temples are made round, quadrangular, sexangular, octangular, or with more angles and sides, all which should finish in the capacity of a circle: they are likewise made in the form of a Cross, as of several other fashions and figures, according to the various inventions of Men; but all deserving commendation, whenever they are distinguish'd with fine and convenient proportions, with elegant and beautiful Architecture. But the finest and most regular forms, from which all the others receive their measures, are the round and the quadrangular: and therefore *Vitruvius* speaks only of these two, teaching how they ought to be comparted, as shall be seen when we treat of the compartments of Temples. In all the Temples that are not round (be they of four or six or more angles and sides) diligent care must be taken, that all their angles be equal. The ancients, as we shew'd just now, had not only regard, in the choice of the situation for the erecting of their Temples, to what might be suitable to each of their Gods, but likewise in the choice of the form: for which reason, because the *Sun* and the *Moon* are perpetually describing their Orbs about the World, and with this circular motion produce those effects which are manifest to all Men, they made their Temples round, or at least in such sort that they approach'd roundness. So they built the Temples of *Vesta,* whom they held to be the Goddess of the Earth, which element we know is round. To *Jupiter,* as the Governor of the Air and the Sky, they made Temples uncover'd in the middle, with porticos round them as shall be lower describ'd. In the disposing of their Ornaments also, they used extraordinary consideration to what God they were building: on which account they made the Temples of *Minerva, Mars,* and *Hercules,* of Dorick work; because Fabricks without exquisiteness or softness were suitable, they said, to such Deities, who presided over War. But they maintain'd that to *Venus, Flora,* the *Muses,* the *Nymphs,* and the most delicate Goddesses, Temples ought to be rear'd that agreed best to the bloomy, tender, and virginal Age; wherefore to these they consecrated the Corinthian Order,

being persuaded that the finest work and the most florid, adorn'd with Leaves and Volutas, was agreeable to such an Age. On the other hand, to *Juno, Diana, Bacchus,* and such other Gods (to whom neither the gravity of the first, nor the delicacy of the second, was suitable) they attributed the Ionick Order, which holds a medium between the Dorick and the Corinthian. Thus we read that the ancients were truly ingenious in preserving a decorum in Building, wherein consists the most beautiful part of Architecture. We therefore, who have no false Gods, should, in order to preserve a decorum about the form of Temples, chuse the most perfect and excellent; and seeing the round form is that (because it alone among all figures is simple, uniform, equal, strong, and most capacious) we should make our Temples round, as being those to which this form does most peculiarly belong: because it being included within a circle, in which neither end nor beginning can be found nor distinguish'd from each other, and having all its parts like one another, and that each of them partakes of the figure of the whole: and finally the extreme in every part being equally distant from the center, it is therefore the most proper figure to shew the Unity, infinite Essence, the Uniformity, and Justice of GOD. Over and above all this, it cannot be deny'd that strength and durableness are more requisite in Temples, than in all other Fabricks; in as much as they are dedicated to the most Gracious and Almighty GOD, and that in them are preserv'd the most precious, famous, and authentick records of Towns: for which very reasons it ought to be concluded, that the round figure, wherein there's no corner or angle, is absolutely the most suitable to Temples. Temples ought likewise to be as capacious as may be, that much People may conveniently assist in them at divine service; and of all the figures, that are terminated by an equal circumference, none is more capacious than the round. I deny not but those Temples are commendable, which are made in the form of a Cross, and which, in that part making the foot of the Cross, have the entry over against the great Altar and the Quire; as in the two Isles, which extend like arms on each side, are two

other entries or two Altars; because being built in the form of the Cross, they represent to the eyes of those, who pass by, what wood on which our SAVIOUR was crucify'd. In this form I built myself the Church of *Saint George* the great in *Venice*. Temples ought to have large Porticos, having greater Columns than are necessary in other Buildings: and 'tis certainly fit they should be great and magnificent, and built with great and well proportion'd Parts; but yet not exceeding that proportion, which the extent of the City seems to require. Because all grandeur and magnificence are requisite in the service of God, for which they are destin'd, they ought to have most beautiful orders of Columns, and each order to have its own proper and convenient ornaments. They should be likewise made of the most excellent and precious materials, that with the form, the ornaments, and the materials, the Divinity may be honour'd as much as possible: and were it indeed possible, we ought to make them so admirably beautiful, be dispos'd in such a manner in all their parts, that those that nothing could be imagin'd more so: and they should who enter them should be transported with admiration, and stand amaz'd in viewing their elegance and beauty. Among all colors none is more suitable to Temples than white; by reason that the purity of this colour, express'd in the purity of Life, is highly grateful to GOD. But if they must needs be painted, no such Pictures ought to be in them, as by their meaning might alienate Men's minds from the consideration of divine things: for which reason we should not in Temples depart from gravity, or from those things that, being seen by us, render our minds more fervent in the worship of GOD, and dispose us to welldoing.

THE COUNCIL OF TRENT AND RELIGIOUS ART

[The Roman Catholic Church, in the sixteenth century, restated its old argument in favor of images and paintings, that pictures were "the Bible of the illiterate." At the same

time it insisted that religious art should be the servant of the Church. This came in the wake of unsuccessful attempts to compromise with the Protestant reformers, who tended to regard all such art as idolatrous. The Roman Catholic restatement came as a decree from the twenty-fifth, and last, session of the Council of Trent, which terminated after eighteen stormy years on December 4, 1563.

This Council articulated for the first time the whole of medieval Catholic doctrine. When it discussed religious art its decisions were brief and to the point, so that it remained for self-appointed commentators to elaborate upon them. Through the decisions of the Council, art was made once again the handmaiden of the Catholic Church; humanism declined, artists turned for inspiration from the natural world to that of theory, from subjects of human significance to those with theological import. In a word, the results were nearer in spirit to the Middle Ages than to the Renaissance. Among the iconographic effects of the Council was the proscription of nudity in religious art, as in the case of Michelangelo's *Last Judgment,* although heroic and mythological nudity were tolerated.]

CANONS AND DECREES OF THE COUNCIL OF TRENT[1]

TWENTY-FIFTH SESSION, DECEMBER 3 and 4, 1563. . . . *On Sacred Images.* The holy council commands all bishops and others who hold the office of teaching and have charge of the *cura animarum,* that in accordance with the usage of the Catholic and Apostolic Church, received from the primitive times of the Christian religion, and with the unanimous teaching of the holy Fathers and the decrees of sacred councils, they above all instruct the faithful diligently in matters relating to intercession and invocation of the saints, the veneration of relics, and the legitimate use

[1] The excerpt is from *Canons and Decrees of the Council of Trent,* translated by H. J. Schroeder, St. Louis and London, 1941. Charles P. Parkhurst, Jr., wrote the introductory note and selected the material.

See also: Blunt, *Theory,* chap. VIII; Schlosser, *Lett. art.,* pp. 369 ff., and *Kunstlit.,* pp. 378 ff.

of images. . . . Moreover, that the images of Christ, of the Virgin Mother of God, and of the other saints are to be placed and retained especially in the churches, and that due honor and veneration is to be given them; not, however, that any divinity or virtue is believed to be in them by reason of which they are to be venerated, or that something is to be asked of them, or that trust is to be placed in images, as was done of old by the Gentiles who placed their hope in idols; but because the honor which is shown them is referred to the prototypes which they represent, so that by means of the images which we kiss and before which we uncover the head and prostrate ourselves, we adore Christ and venerate the saints whose likeness they bear. That is what was defined by the decrees of the councils, especially of the Second Council of Nicaea, against the opponents of images.

Moreover, let the bishops diligently teach that by means of the stories of the mysteries of our redemption portrayed in paintings and other representations the people are instructed and confirmed in the articles of faith, which ought to be borne in mind and constantly reflected upon; also that great profit is derived from all holy images, not only because the people are thereby reminded of the benefits and gifts bestowed on them by Christ, but also because through the saints the miracles of God and salutary examples are set before the eyes of the faithful, so that they may give God thanks for those things, may fashion their own life and conduct in imitation of the saints and be moved to adore and love God and cultivate piety. But if anyone should teach or maintain anything contrary to these decrees, let him be anathema. If any abuses shall have found their way into these holy and salutary observances, the holy council desires earnestly that they be completely removed, so that no representation of false doctrines and such as might be the occasion of grave error to the uneducated be exhibited. And if at times it happens, when this is beneficial to the illiterate, that the stories and narratives of the Holy Scriptures are portrayed and exhibited, the people should be instructed that not for that reason is the divinity represented in picture as if it can be seen

with bodily eyes or expressed in colors or figures. Furthermore, in the invocation of the saints, the veneration of relics, and the sacred use of images, all superstition shall be removed, all filthy quest for gain eliminated, and all lasciviousness avoided, so that images shall not be painted and adorned with a seductive charm, or the celebration of saints and the visitation of relics be perverted by the people into boisterous festivities and drunkenness, as if the festivals in honor of the saints are to be celebrated with revelry and with no sense of decency. Finally, such zeal and care should be exhibited by the bishops with regard to these things that nothing may appear that is disorderly or unbecoming and confusedly arranged, nothing that is profane, nothing disrespectful, since holiness becometh the house of God. That these things may be the more faithfully observed, the holy council decrees that no one is permitted to erect or cause to be erected in any place or church, howsoever exempt, any unusual image unless it has been approved by the bishop; also that no new miracles be accepted and no relics recognized unless they have been investigated and approved by the same bishop, who, as soon as he has obtained any knowledge of such matters, shall, after consulting theologians and other pious men, act thereon as he shall judge consonant with truth and piety. But if any doubtful or grave abuse is to be eradicated, or if indeed any graver question concerning these matters should arise, the bishop, before he settles the controversy, shall await the decision of the metropolitan and of the bishops of the province in a provincial synod; so, however, that nothing new or anything that has not hitherto been in use in the Church, shall be decided upon without having first consulted the most holy Roman pontiff.

PAOLO VERONESE

[Paolo Veronese (1528–1588) was born in Verona. After working in Mantua he went to Venice in 1553 where he soon achieved great success and fame as a painter of

large canvas on which, under the guise of any story, the brilliance and magnificence of sixteenth-century Venice was depicted. In 1573 he was called before the Tribunal of the Inquisition to answer to charges of having introduced secular elements unsuitable for religious painting into a so-called "Feast in the House of Simon" executed for the Refectory of SS. Giovanni e Paolo. He offered in defense the claim for poetic license for painting, and finally satisfied his accusers by changing the name of the picture, now in the Accademia in Venice (our *fig.* 3), to "The Feast in the House of Levi," making it clear that the scene was neither the "Last Supper" nor the "Feast in the House of Simon."]

TRIAL BEFORE THE HOLY TRIBUNAL[1]

VENICE, JULY 18, 1573. The minutes of the session of the Inquisition Tribunal of Saturday, the 18th of July, 1573. Today, Saturday, the 18th of the month of July, 1573, having been asked by the Holy Office to appear before the Holy Tribunal, Paolo Caliari of Verona, domiciled in the Parish Saint Samuel, being questioned about his name and surname, answered as above.

Questioned about his profession:

ANSWER. I paint and compose figures.

QUESTION. Do you know the reason why you have been summoned?

A. No, sir.

Q. Can you imagine it?

A. I can well imagine.

Q. Say what you think the reason is.

A. According to what the Reverend Father, the Prior of the Convent of SS. Giovanni e Paolo, whose name I do not know, told me, he had been here and Your Lordships

[1] The account of the trial is translated from the text as given in Pietro Caliari, *Paolo Veronese*, Rome, 1888, pp. 102 ff. A French translation showing slight variations in the text is given in A. Baschet, "Paolo Veronese," *Gazette des Beaux-Arts*, XXIII, 1867, pp. 378–382.

See also: Blunt, *Theory*, p. 116; Percy H. Osmond, *Paolo Veronese*, London, 1927, pp. 68–70.

had ordered him to have painted [in the picture] a Magdalen in place of a dog. I answered him by saying I would gladly do everything necessary for my honor and for that of my painting, but that I did not understand how a figure of Magdalen would be suitable there for many reasons which I will give at any time, provided I am given an opportunity.[2]

Q. What picture is this of which you have spoken?

A. This is a picture of the Last Supper that Jesus Christ took with His Apostles in the house of Simon.

Q. Where is this picture?

A. In the Refectory of the Convent of SS. Giovanni e Paolo.

Q. Is it on the wall, on a panel, or on canvas?

A. On canvas.

Q. What is its height?

A. It is about seventeen feet.

Q. How wide?

A. About thirty-nine feet.

Q. At this Supper of Our Lord have you painted other figures?

A. Yes, milords.

Q. Tell us how many people and describe the gestures of each.

A. There is the owner of the inn, Simon; besides this figure I have made a steward, who, I imagined, had come there for his own pleasure to see how the things were going at the table. There are many figures there which I cannot recall, as I painted the picture some time ago.

Q. Have you painted other Suppers besides this one?

A. Yes, milords.

Q. How many of them have you painted and where are they?

A. I painted one in Verona for the reverend monks at

[2] Osmond, *op. cit.*, p. 68, calls attention to the fact that the report is merely notes, not a verbatim report. Paolo seems to be feigning ignorance and to have little interest in the doctrinal significance of his pictures, as is shown by his mention of omitting Magdalen and then naming the picture "The Last Supper that Jesus took with His Apostles in the house of Simon."

San Nazzaro[3] which is in their refectory. Another I painted in the refectory of the reverend fathers of San Giorgio here in Venice.[4]

Q. This not a Supper. We are asking about a picture representing the Supper of the Lord.

A. I have painted one in the refectory of the Servi of Venice,[5] another in the refectory of San Sebastiano in Venice.[6] I painted one in Padua for the fathers of Santa Maddalena and I do not recall having painted any others.

Q. In this Supper which you made for SS. Giovanni e Paolo, what is the significance of the man whose nose is bleeding?

A. I intended to represent a servant whose nose was bleeding because of some accident.

Q. What is the significance of those armed men dressed as Germans, each with a halberd in his hand?

A. This requires that I say twenty words!

Q. Say them.

A. We painters take the same license the poets and the jesters take and I have represented these two halberdiers, one drinking and the other eating nearby on the stairs. They are placed here so that they might be of service because it seemed to me fitting, according to what I have been told, that the master of the house, who was great and rich, should have such servants.

Q. And that man dressed as a buffoon with a parrot on his wrist, for what purpose did you paint him on that canvas?

A. For ornament, as is customary.

Q. Who are at the table of Our Lord?

A. The Twelve Apostles.

Q. What is St. Peter, the first one, doing?

A. Carving the lamb in order to pass it to the other end of the table.

[3] *The Feast at the House of the Pharisee,* painted for the refectory of SS. Nazzaro e Celso, Verona, *ca.* 1560, Pinacoteca, Turin.
[4] *The Wedding Feast of Cana,* 1562–1563, Louvre, Paris.
[5] *The Feast in the House of Simon, ca.* 1570, Louvre, Paris.
[6] *The Feast at the House of the Pharisee,* 1570, Brera, Milan.

Q. What is the Apostle next to him doing?

A. He is holding a dish in order to receive what St. Peter will give him.

Q. Tell us what the one next to this one is doing.

A. He has a toothpick and cleans his teeth.

Q. Who do you really believe was present at that Supper?

A. I believe one would find Christ with His Apostles. But if in a picture there is some space to spare I enrich it with figures according to the stories.

Q. Did any one commission you to paint Germans, buffoons, and similar things in that picture?

A. No, milords, but I received the commission to decorate the picture as I saw fit. It is large and, it seemed to me, it could hold many figures.

Q. Are not the decorations which you painters are accustomed to add to paintings or pictures supposed to be suitable and proper to the subject and the principal figures or are they for pleasure—simply what comes to your imagination without any discretion or judiciousness?

A. I paint pictures as I see fit and as well as my talent permits.

Q. Does it seem fitting at the Last Supper of the Lord to paint buffoons, drunkards, Germans, dwarfs and similar vulgarities?

A. No, milords.[7]

Q. Do you not know that in Germany and in other places infected with heresy it is customary with various pictures full of scurrilousness and similar inventions to mock, vituperate, and scorn the things of the Holy Catholic Church in order to teach bad doctrines to foolish and ignorant people?

A. Yes that is wrong; but I return to what I have said, that I am obliged to follow what my superiors have done.

Q. What have your superiors done? Have they perhaps done similar things?

[7] Baschet, *op. cit.*, p. 382, has here the following, omitted in this text:

Q. Why did you do it then?

A. I did it because I supposed these people were outside the room in which the supper took place.

A. Michelangelo in Rome in the Pontifical Chapel painted Our Lord, Jesus Christ, His Mother, St. John, St. Peter, and the Heavenly Host. These are all represented in the nude—even the Virgin Mary—and in different poses with little reverence.

Q. Do you not know that in painting the Last Judgment in which no garments or similar things are presumed, it was not necessary to paint garments, and that in those figures there is nothing that is not spiritual? There are neither buffoons, dogs, weapons, or similar buffoonery. And does it seem because of this or some other example that you did right to have painted this picture in the way you did and do you want to maintain that it is good and decent?

A. Illustrious Lords, I do not want to defend it, but I thought I was doing right. I did not consider so many things and I did not intend to confuse anyone, the more so as those figures of buffoons are outside of the place in a picture where Our Lord is represented.

After these things had been said, the judges announced that the above named Paolo would be obliged to improve and change his painting within a period of three months from the day of this admonition and that according to the opinion and decision of the Holy Tribunal all the corrections should be made at the expense of the painter and that if he did not correct the picture he would be liable to the penalties imposed by the Holy Tribunal. Thus they decreed in the best manner possible.

THE CARRACCI

[Annibale Carracci (1560–1609) was the most talented of the famous Bologna family of artists. After preliminary studies in Bologna, he went to Venice where he joined his brother, Agostino (1558–1602), and studied the Venetian painters. On their return to Bologna, they founded with their cousin Lodovico (1556–1619) the *Accademia degli Incamminati* (1582), which became the most popular

studio in Bologna. The course of instruction included some theoretical studies as well as painting and drawing. As a reaction to Mannerism and as a result of their study in Venice they establish an eclecticism whose elements are given in Agostino's Sonnet. For ten years, Annibale, assisted by his brother, worked in Bologna, engaged principally with the decoration of two palaces. In 1595 they went to Rome where Annibale secured the commission to decorate the gallery of the new Palazzo Farnese. Annibale's decorative scheme became the model for a century of decorators, and equally influential was his treatment of figures in landscape, originating the classical landscape developed later by Poussin. In 1600 Agostino returned to Bologna where he died two years later. Receiving only the ridiculous sum of five hundred lire for the decoration of the Farnese Gallery, Annibale left (1603–1604) the service of the Cardinal and did little work until his death in 1609.]

LETTER FROM ANNIBALE CARRACCI TO LODOVICO[1]

MAGNIFICENT COUSIN! Parma, April 18, 1580
 This letter is to bring you my greetings and to inform Your Excellency of my arrival in Parma at about the seventeenth hour yesterday. I stopped at the Sign of the Rooster, where I intend to stay at little expense, much pleasure, and free from obligations and constraint. I did not come here to stand on ceremony, but to enjoy my freedom to study and to sketch; therefore, for the love of God, I pray Your Excellency to excuse me.
 I must inform Your Excellency that Corporal Andrea came to see me yesterday evening and showed me much

[1] The letter is translated from the text given in C. C. Malvasia, *Felsina pittrice. Vite dei pittori bolognesi*, Bologna, 1841, I, p. 268. It is also given in Bottari-Ticozzi, *Raccolta*, I, p. 118. The footnotes are by the translator. The authenticity of this letter has been questioned. W. Friedländer holds the opinion it is authentic; see *Art Bulletin*, XXIV, 1942, p. 192.
 See also: A. McComb, *The Baroque Painters of Italy*, Cambridge, 1934, pp. 9–20 (which contains a valuable bibliography); and Pevsner, *Academies*, pp. 75–79.

courtesy and politeness. He asked whether I had any letters to give anyone; or a letter for him from Your Excellency, since you had written commending me to him. He intended to take me away from this place immediately, as he said it was not suitable for persons like us. He wished to take me to his home; this he said would not inconvenience him at all, as he had prepared the same room which you occupied once, so that it would not cause him the slightest inconvenience. He talked so much about it that I did not know what to say except to thank him repeatedly and deny that I had a letter because I wished my freedom. To make a long story short, with great difficulty I finally freed myself, but if Master Giacomo—that is the name of the innkeeper—had not greatly helped me I should not have been able to escape from him. I beg Your Excellency not to take this amiss and excuse me to him as you think best, for when he left he appeared to be somewhat annoyed. Then I could not wait any longer and went immediately to see the great cupola[2] you had praised to me so many times. Indeed I remained speechless on seeing such a mighty work. Every detail is so well contrived; the foreshortening, when you look up, is done with great precision. But everything is done in good taste and with such grace and with coloring that the figures seem to be real flesh. By Heaven, neither Tibaldi[3] nor Nicolino,[4] nor, I dare say, Raphael himself ever created anything equal to it!

I do not know how many things I have seen this morning except the altarpiece showing St. Jerome and St. Catherine,[5] and the painting of the Madonna with the Bowl on the Flight into Egypt.[6] By Heaven, I would not want to exchange any of them for the *St. Cecelia*![7] Say

[2] The great cupola of the Duomo decorated by Correggio with frescoes depicting the Assumption of the Virgin.

[3] Pellegrino de' Tibaldi (1532–1596).

[4] Niccolò dell' Abbate to whom Agostino directed his sonnet.

[5] This picture by Correggio is known as the *Madonna and St. Jerome* or *The Day*. The figure of Mary Magdalen is mistaken for a St. Catherine. The picture is in the Royal Gallery, Parma.

[6] This picture by Correggio is known as the *Madonna della Scodella*. It is in the Royal Gallery, Parma.

[7] He refers to the picture by Raphael in Bologna.

yourself if the grace of St. Catherine who bows her head with such charm over the foot of that beautiful Christ Child is not more beautiful than Mary Magdalen? And that beautiful old man, St. Jerome, has he not more grandeur and also more tenderness than has the *St. Paul* of Raphael, which at first seemed a miracle to me and now seems a completely wooden thing, hard and sharp? Moreover, can one not say so much that even your Parmegianino[8] has to put up with these remarks, for I know now that he has attempted to imitate the grace in the pictures of this great man, but he is still far from having obtained it. The *putti* of Correggio breathe, live and laugh with such grace and truth that one must laugh and be gay with them.

I am writing my brother that it is absolutely necessary for him to come here, where he will see things which he never would have believed possible. For the love of God, urge him to dispatch quickly those two tasks in order to come here at once. I shall assure him that we shall live together in peace. There will be no quarrelling between us. I shall let him say anything he wants and shall busy myself with sketching. Also I do not fear that he will not do the same and abandon talking and sophistry, all of which is a waste of time. I have also told him that I shall try to be at his service, and when I have come to be known somewhat I shall inquire and look for opportunities.

Since the hour is late and the daylight has disappeared in writing to him and my father, I shall wait until the next mail to tell you of things in more detail. I kiss Your Excellency's hand.

AGOSTINO CARRACCI'S SONNET IN PRAISE OF NICCOLÒ BOLOGNESE[9]

Whoever a goodly painter seeks to be
Should take the Romans' drawing to his aid,
Movement from the Venetians, and their shade,
And worthy coloring from Lombardy,

[8] Parmegianino (Francesco Mazzola) (1503–1540).
[9] Translated from the text as given in Malvasia, *op. cit.*, p. 129, by Creighton Gilbert, with the following note: "From the

The awesome Michelangelo must see,
The truth to nature Titian has displayed,
The pure and sovereign style Correggio had,
And of a Raphael just symmetry,

Tibaldi's basis, and his decoration,
Invention of learned Primaticcio's own,
And just a little grace from Parmigianino.

But leaving so much study and vexation,
Set him to imitate those works alone
Which here were left us by our Niccolino.

GIOVANNI PAOLO LOMAZZO

[Giovanni Paolo Lomazzo (1538–1600) began as a painter in Milan, but, becoming blind at thirty-three, he turned to literary pursuits. He published three works; the first, *Trattato dell'arte della pittura* (Treatise on the Art of Painting, Milan, 1584), is divided into seven books which treat the theory of proportion, motions as they reflect the emotions, color, light and shade, linear perspective, the practice of painting, and subject matter or iconography. The *Treatise*, translated into English and French, was widely read and used until the nineteenth century and is of great importance for an understanding of Mannerism. In 1587 appeared Lomazzo's *Verses*, also divided into the mystical number of seven books and containing, besides the verses, his autobiography. His *Idea del tempio della pittura* (The Idea of the Temple of Painting, 1590), also divided into seven parts, is a fantastic mixture of astrology

point of view of literary style, this sonnet is mere doggerel, with words not essential to the meaning introduced to fit the rhyme-scheme. No attempt has been made to preserve these latter, but analogous ones have been inserted freely, and the whole translation left in a crude state as far as its poetic character is concerned. The ideas, critical terms, and logical structure have been preserved intact." See Denis Mahon, *Studies in Seicento Art and Theory*, The Warburg Institute, University of London, 1947, pp. 208–212, for a summary of the questions regarding the genuineness of the sonnet.

and scholasticism, in which the seven pillars of the temple (Michelangelo, the Milanese painters Gaudenzio Ferrari and Polidoro, Leonardo, Raphael, Mantegna, and Titian) are related to the seven planets and derive from them certain celestial influences. It is through Lomazzo's writings that the Neoplatonism of Marsilio Ficino enters into the theory of art. They are also important in establishing the authority of the Academy to teach precepts and the requirement that the artist be a learned man.]

TREATISE ON THE ART OF PAINTING[1]

PROEMIO. PART II. *The Division of the Whole Worke.*[2] There is a two-folde proceeding in all artes and sciences: The one is called the order of nature and the other of teaching. . . .[3]

Whereupon I purposing to handle the Art of painting in this present discourse, meane to follow the order of Teaching. And because I might, perchance, commit an absurdity, if in ripping it up to high, I should beginne to define unto the reader what maner of thing Qualitie is, and howe many kindes thereof there be; to teach him what Habitus and Dispositio, what *forma* and *figura* is; and how painting by diverse considerations is comprehended under that species

[1] The first five books of Lomazzo's *Treatise* were published in an English translation by Richard Haydock just fourteen years after the appearance of the first Italian edition. It is the only translation of Lomazzo's writings in English and is given here (see note 2 below) as it presents the material in the English of the period. The excerpts from books of the *Trattato* not included in Haydock's work, and from the *Idea*, have been translated by the editor (see notes 6, 8, and 9 below). These translations Dr. Erwin Panofsky has kindly checked.

See also: Lee, "Ut Pictura Poesis," pp. 198 ff.; Blunt, *Theory*, pp. 137–159; Schlosser, *Lett. art.*, p. 344 and *Kunstlit.*, p. 352; Venturi, *History*, p. 110.

[2] The excerpts from "The Division of the Whole Worke" and "The First Booke" of the *Treatise on the Art of Painting* are taken from *A Tracte Containing the Arts of Curious Painting . . . , written in Italian by Jo. Paul Lomatius . . . and Englished by Richard Haydock*, Oxford, 1598.

[3] Lomazzo's presentation of the order of Nature is omitted here as not pertinent to the subject at hand.

of Qualitie (which appertaineth rather to a logician or a
Philosopher than to a Painter) therefore I (observing
Horace's precept, who woulde not have a man beginne the
history of the Trojan warre at the two egges of Leda, that
is, that in handling a matter he ought not to take his
beginning too farre off from the present matter in hand)
meane first to beginne with the definition of Painting,
which is the first, most generall, and immediate principle,
as most properly offering it selfe to our consideration:
wherein afterwards I purpose to shew the true *genus*
thereof, which is the first part of the definition, and con-
sequentlie al the differences concurring to the same, for
the restraining of the *genus* which is a species of quality
called Arte and maketh the most speciall kinde of Qualitie
called *painting*: And because the differences which make
painting a particular and distinct *Arte* from all others are
fine: viz. *Proportion, Motion, Colour, Light* and *Perspec-
tive*: I wil orderly handle each of them in a several book:
so that the first shall intreate of Proportion, which is the
first difference of painting, the second of Motion, the third
of colour, the fourth of *Light*, and the fifth of that part of
perspective, which is necessary for a Painter: and so in
these five bookes I wil observe the order to Teaching, which
beginneth with the most universall and immediate prin-
ciples of Painting, namely the Definition: and afterwardes,
I will come to the five partes which limit out the arte of
painting. But considering with my selfe that all young
practitioners in this arte shall hardly bee able to make
use of these contemplative and philosophicall preceptes
delivered in these five first bookes, where I have handled
the essentiall and principall partes of painting by generall
rules, which are not familiar to our sense, and therefore
(not easie for everyman to discerne under what generall
heade this or that particular is placed) I wholy intending
the profite and commoditie of the learner, have added a
sixth booke, wherein I will handle that *Practically,* which
in the five former bookes is taught *Theorically,* because
the order of Teaching requireth, that the Practise should
follow the *speculation.* And because the young *Practitioner*
hath neede not only of the rules of Arte, but also of the

precepts of *Judgement* and of *discretion,* immediately before the discourse it selfe of the *Practise,* I have prefixed a compendium of the rules of Arte, together with a collection of the preceptes of *Discretion* and *Judgement,* which an artisane ought to use in Painting: For it sufficeth not that he can paint well, except he can also performe it with Judgement and Discretion. And last of all I have laid downe certaine examples for their more ready practise and experience in the Arte of Painting.

Now although in the sixe bookes the whole perfection of Painting be contained, yet notwithstanding, considering with my selfe that *Historie* is an accident most necessarily accompanying the same, to the ende the Painter mighte proceede in his practise with the more Judgement; I thought good to ease him of the labour of turning and perusing many bookes, by adding a seventh booke wherein is handled all such *Historie* as is necessarie for a *Painter*: beginning at Heaven and so proceeding unto Hell: by teaching the way howe Gods and Angels have beene expressed, and in what forme and habite antiquity was wont to paint the *Planets,* the *Elementes,* and other thinges: For the knowledge whereof the reading and perusing of Infinite volumes, was otherwise necessarily required. All which I have done without any regarde of my private profit and commodity, to the ende I might benefite men of my profession, who ought in reason (as I hope they will) to esteeme and regarde my paines undertaken aswel for their good, as for the amplifying of this Arte, considering the little helpe and light which other mens labours could afforde me, in so much as this matter hath beene touched of by so few, that I may boldly say without arrogancie, my self was the first that beganne to write hereof in so artificiall, and methodicall sort; having now opened a ready way, whereby other men maie the more speedily attaine thereunto.

THE FIRST BOOKE.[4] *Of Proportion.* . . . Farthermore the Painter ought to observe an order and method in these proportionable lines: therein imitating Nature in her pro-

[4] See note 2.

ceedinges: who first presupposeth matter being a thing voide of *forme, beauty, bound* or *limite,* and afterwardes bringeth in the *forme,* which is a beautifull and limited thing. In like sorte the Painter taking a table (in the surface whereof there is nothing but a flat and plaine superficies, without beautie or limitation of parts) he *trimmeth, primeth* and *limiteth* it by tracing thereon a man, a horse, or a *Columne,* forming and tricking the true proportion thereof, and (in a word) imitating by lines the nature of the thing to be painted in breadth, length, and thicknesse.

And because in this place there falleth out a certaine precept of *Michaell Angelo* much for our purpose, I wil not conceale it, leaving the farther interpretation and understanding thereof to the judicious reader. It is reported then that *Michaell Angelo* upon a time gave this observation to the Painter *Marcus de Sciena* his scholler: *that he should alwaies make a figure Pyramidall, Serpentlike, and multiplied by one, two and three.* In which precept (in mine opinion) the whole mysterie of the arte consisteth. For the greatest grace and life, that a picture can have, is, that it expresse *Motion:* which the Painters call the *spirite* of a picture: Nowe there is no forme so fitte to expresse this *motion,* as that of the flame of fire. Which according to *Aristotle* and the other Philosophers, is an elemente most active of all others: because the forme of the flame thereof is most apt for motion: for it hath a *Conus* or sharpe pointe wherewith it seemeth to divide the aire, that so it may ascende to his proper sphere. So that a picture having this forme will bee most beautifull.[5]

Now this is to bee understoode after two sortes: either that the *Conus* of the *Pyramis* bee placed upwardes and the *base* downe-wardes, as in the fier; or else contrary wise, with the *base* upwardes and the *Conus* downe-wardes: In the first it expresseth the width and largenesse of a picture, about the legges and garmentes belowe; shewing it slender above *Pyramidall-wise,* by discovering one shoulder and hiding the other, which is shortened by the turning of the body. In the seconde, it sheweth the figure biggest in the upper partes; by representing either both the shoulders,

[5] Quoted by Hogarth; see below, p. 263.

or both the armes, shewing one legge and hiding the other, or both of them after one sorte, as the skillfull Painter shall judge fittest for his purpose. So that his meaning is, that it shoulde resemble the forme of the letter S placed right, or else turned the wronge way as Ƨ; because then it hath his beauty. Neither oughte hee only to observe this forme in the whole body, but even in every part: so that in the legge, when a muscle is raysed outwardes on the one side, that which answereth directly on the contrary side, must be drawne in and hid (as may be seene in the life).

The last parte of *Michaell Angelo* his observation was, that a picture ought to bee *multiplied by one, two and three*. And heerin consisteth the chiefest skill of that proportion, whereof I meane to intreate more at large in this booke. For the Diameter of the biggest place, between the knee and the foote is double to the least, and the largest parte of the thigh triple. . . .

BOOK VI. CHAPTER IV. *Rules for the Motions of the Body.*[6] Having discussed in great part the movements which may be produced in the body by the different emotions of the soul, it is fitting that we should also speak of the movements of this body as such, so that when one makes the body move in various ways, one will not make it appear to be crippled, nor to stretch out its limbs in a manner in which it could not actually stretch them, and which would not be within the limits of its powers. These movements must spring from the relation of length, breadth and proportion in the limbs, and from their counteraction on one another, their twisting and working together according to their nature and possibilities; as well as from their twisting, turning and stretching as their structure and their joints actually make it possible for them to do. I maintain with certainty that these movements are of such importance that in them lies all the importance of art; and that all the praise that may be attached to the figures depends upon them and also, on the other

[6] Book VI, Chapter IV, is translated from the text as given in G. P. Lomazzo, *Trattato dell'arte della pittura*, 1584 (new edition, Milan, 1844).

hand, all the blame. For because these [movements] have not been truly observed there come about and are seen in many works of art so many disjointed bodies, so many soldiers in combat, absurd and malformed, so many figures in the air that seem to stand [on the ground], and so many of the ground that do not stand on their feet; and also similar misfits, having twisted, crippled limbs, turning their heads, contorting their arms and their bodies, raising their legs, and moving their feet and bending their arms and their knees as they could never actually do.

And in order to give a certain rule of a reasonable procedure in the representation of these movements, I would say that they result from the eight ways in which a body is able to move: upward, downward, to the right, to the left, striving in this direction, coming from that, turning in gyratory fashion, stopping. And when one wishes to represent a figure, I further say that, whenever a man puts all his weight upon one foot, this foot, comparable to the base of a column, is always perpendicularly beneath the pit of the throat. I am speaking of the instep of the foot; and it was this position that the ancient Polycletus was the first to discover following in the footsteps of nature. Further, these ancients were always careful to see that the face of the model was turned in the same direction as the foot points. And by such study it was further found that the movements of the head are so disposed that a man never makes an effort to turn in any direction without having some part of the rest of the body beneath it, by which so heavy a part may be supported or without advancing, as in a scale, another member in the opposite direction so as to counter-balance the weight.[7] The same thing may be observed when one holds a weight in one outstretched hand; the other foot is firmly set, and all the rest of the

[7] This passage is a literal borrowing from Alberti's *Trattato della pittura*. See H. Janitschek, *Leone Battista Alberti's kleinere kunsttheoretische Schriften* (Quellenschriften für Kunstgeschicte, XI), Vienna, 1877. See *Documentary*, pp. 125–126. *History of Art*, Vol. I, pp. 207–218. This is but one instance of many which can be cited to illustrate Lomazzo's dependence on Alberti's treatise, a question which is in need of further study.

body is thrown to the opposite side so that it may equalize the weight. And therefore one must take great care to remember not to represent a figure which could by no means maintain itself on its feet, because there is no member under the head; or others which could not be supported by their legs because they throw their whole weight forward; and the same [is true if they throw their whole weight] backwards or to the sides.

. . . But with [all] this we must also consider that these movements are altered by the quality of the bodies [as such]; in the figure which stands straight upon one foot, the members, on the side where it stands, are higher than on the other. Again, all these above-mentioned movements, as well as all the others which may be made, should always be represented in such a way that the body may have some serpentine motion to which nature readily disposes it, apart from the fact that it was always used by the ancients and by the moderns. This means that, whatever poses the body might make, you should always see the turns of the body so represented that on the right side the arm is always thrust forward, or in whatever attitude it occurs to you to place it, while the other part of the body recedes, and that the left arm is subservient to the right arm; and likewise the left leg should come forward and the right leg recede. I should have to observe the same rule, if, on the contrary, I should wish to make the left arm thrust forward and accordingly the left leg, because then the right arm must be subservient to the left arm and the other side of the body must recede. This takes place in every action that can be produced in such postures: running, flying, fighting, lying prostrate, kneeling, in short, in every attitude a body may assume. Unless it has this serpentine form—as Michelangelo used to call it—this body will always lack grace. And the face must always be turned, according to its [intended] effect, or else toward the action of the hands. Moreover, for a large heavy body it is not possible to achieve extreme movement with its members except in so far as it approaches, through suppleness and proportion, the well proportioned and beautiful figure. Even so it will lag behind because of its weight,

whereas on the other hand a disproportionately long and
thin body will seem to make a greater effort, even going
further than those of which we have just spoken. Bold
attitudes are suitable for soldiers and fighters, humble
ones for virgins and saints, slow and lazy movements which
are less serpentine for the aged, checked, hampered and
limited motions for figures especially thick-set and fat.
Straight lines and sharp angles should always be avoided.
This rule ought to be observed as far as possible since it
was given by Buonarroti.

THE IDEA OF THE TEMPLE OF PAINTING

CHAPTER XXV. *The Last Section of Painting, and its
Division.*[8] Form, the last part according to order, but the
most important for knowledge and practice in our art, is
that by which the external shapes are indicated; these
must be mastered by anyone who wants to represent in
orderly fashion all that may enter the imagination or be
seen by the eye. There are many kinds of form, namely:
anatomy, the contemplative [form], the significant, the
visible, the natural, the fanciful, the [form] pertaining to
handicraft, the spiritual, and the phenomenal.

Anatomy is that which in the human or any other body,
makes up the members, bones, and everything needful to
form it perfectly.

The contemplative [form] is that which through con-
templation and through the study of sacred writings,
teaches the harmonious form of the very shape of the
Angels, of the Nine Choirs, of the Heavenly Host, of the
Powers, Intelligences, and Guardians, of living beings, of
the Virgin Mary and the men and women Saints with their
grace and other attributes.

The significant [form] contains the form of the world,
of the celestial constellations, of the twelve signs [of the
Zodiac], of Saturn, Jupiter, and the other wandering stars

[8] Translated from G. P. Lomazzo, *L'idea del tempio della
pittura*, Bologna, 1590, as quoted in Saxl, *Antike Götter in der
Spätrenaissance* (Studien der Bibliothek Warburg, VIII), Leip-
zig/Berlin, 1927, pp. 122 ff.

which we call planets; and likewise of all the shapes of the elements, which are innumerable, and many of which I discuss elsewhere.

The visible [form] contains the form of man, woman, quadrupeds, birds, aquatic creatures, reptiles, monsters, land, rivers, seas, and all contained in them, metals, plants, flowers, fruits, herbs, stones and fires.

The fanciful [form] is that which concerns the pagan gods and other things to be found in our imagination, such as Pans, Fauns, and Nymphs.

The [form] pertaining to handicraft shows us (according to the various nationalities and the different ancient and modern periods) the form of buildings; poor, middling, and superb, secular and religious, according to the nature of each. Moreover, it teaches the forms of clothing, weapons, war machines, ancient as well as modern, musical instruments and everything necessary and convenient to life and art.

The kind of form called spiritual is of the devils of earth and Hell, of the Furies, of Cerberuses, of Charons, of Lucifer, and of all those other creatures better left below.

The last kind, called phenomenal, is the form of thunderbolts, lightning, rays, fires, comets, thunders, prodigies, omens, and the like, which are seen in extraordinary circumstances and read of in tales.

All these kinds of forms serve to produce in painting the universal representation of things divine, heavenly, terrestrial, fancied, thought of, done, infernal, and miraculous. These things cannot be known or considered without very close study in the books of Scripture, of mathematics, of poetry, hieroglyphics, history, architecture, anatomy, and many other fields of science and art; they fill the mind of the naturally endowed painter with invention, which is, in painting, properly speaking, the unfolding of all the things that can come under the imagination and representation of the aforesaid forms.

CHAPTER XXVI. *The Method of Knowing and Establishing Proportions according to Beauty.*[9] Now it remains

[9] Translated from G. P. Lomazzo, *L'idea del tempio della pittura,* Bologna, 1590, as quoted in Panofsky, *Idea,* pp. 126 ff.

for me to consider the general ways of arranging rationally all the parts into which art is divided, beginning with proportion, which is the first of all these divisions. According to common opinion proportion is that immaterial thing which in bodies holds all the parts together and yet is brought about within these bodies by the parts. Although this proportion is potentially one and the same it can yet be recognized and established in many ways, with due regard for the nature of beauty (to which proportion serves in painting), so as to represent the truth beheld in bodies. This is achieved in many ways according to the diversities found in bodies, as much through the beauty of the soul as through the temperament of the body—as is fully discussed by the Platonists.

First[10] *we must realize that beauty is nothing else than a certain living and spiritual grace which through divine ray infuses itself first into the angels; in these are seen the figures of each sphere, which in them are called exemplars and ideas. Beauty then passes into the souls, where the figures are called reasons and thoughts, and finally into matter, where they are called images and forms. There beauty gives pleasure to all by means of reason and sight, but more or less depending upon reason, which will be discussed below. This beauty shines from the one, self-same face of God into three mirrors placed in this order: the angel, the soul, and the body. In the first mirror, because of its nearness to God, it shines brightest; in the second, farther away, it is less bright; in the third, the farthest, it is very obscured.*

Because the angel is not impeded by a body, he reflects himself in himself and contemplates his own beauty sculptured in himself. The soul, created with the condition that it be surrounded by an earthly body, stoops to the service of the corporeal. Burdened by this condition, the soul forgets the beauty hidden in itself and, once enfolded within the earthly body, devotes itself to the use of this body; it adapts to it the senses, and sometimes even reason. Conse-

[10] The italicized passages are literal borrowings from Marsilio Ficino, *Sopra lo amore o ver Convito di Platone*, Florence, 1544, v, 3–6, pp. 94 ff. See Panofsky, *Idea*, pp. 126 ff.

quently the soul does not behold the beauty which shines continually in it, until the body is fully grown and the reason awakened; with the aid of this [reason], *the soul considers that beauty which shines from the universe into the eyes and abides in the former.*

Finally, the beauty of the body is nothing else than a certain action, liveliness, and grace, which shine therein thanks to the influence of its idea, and this influence does not descend into matter unless this [matter] *is most fittingly prepared. Such preparation of the living body is accomplished by three things: namely, order, mode, and species. Order signifies the difference of the parts; mode, the quantity; and species, the lines and colors. In the first place, it is necessary that each one of the parts be in its proper place: the eyes, for example, equally near the nose and the ears equidistant from the eyes. But this parity of distance that pertains to order is not enough unless there is added the mode of the parts, which attributes to each part its proper size in relation to the proportion of the whole body, as will be more amply discussed later on. Besides these two, species is necessary in order that the skillful design of the lines and the splendor of the lights may adorn the order and the mode of the parts. Although these three things are found in matter, they can by no means be any part of the body;* this Ficino affirms in discussing the Symposium of Plato, saying that *the order of the parts is not any one member, because the order is in all the members and no single member is found in all the members together. It should be added that order is nothing else than the suitable distance of the parts, and distance is either nothing, or a vacuum, or a segment of line. Nor can lines be bodies, for they lack the width and depth necessary to a body. Moreover, the mode is not a quantity but the limit of quantity, and the limits are surfaces, lines, and points, which things lack depth and therefore ought not to be called bodies. Finally, the species also is not located in matter, but in the agreeable consonance of lights, shadows, and lines. For this reason, beauty is proven to be so far removed from corporeal matter that it does not even start from matter unless this* [matter] **is**

conditioned by those three preparations which have been said to be incorporeal. Inasmuch as our body is very similar to Heaven, the substance of which is balanced, the basis of these three is the balanced mixture of four elements. When the body does not rebel at the formation of the soul because of some excess in the humors, these celestial splendors will easily appear in the body, which is then similar to Heaven and to that perfect form of man which possesses a soul embodied in quiet and obedient matter.

Coming to the temperament of the bodies, it can be inferred from the qualities by reason of which all our bodies come to differ from one another; and these qualities transform themselves into one another more or less, as it is explained at length by the mathematicians [*scil.* Astrologers] and as we also see from experience. Yet, there can not be more than four principal kinds of dissimilitude, according to the number of the elements and the strength of their quality which the mathematicians affirm to be the foundations of all forms and kinds of human bodies. The fundamental quality of fire is hot and dry; and because the first of these expands and the second hardens, it follows that Martial bodies have large, strongly modelled, hardy, hairy limbs. Air is basically humid and takes on some warmth from fire, which, however, causes less expansion inasmuch as moisture makes soft; therefore the Jovial bodies come to be not as large in limb as the Martial ones, but are well-tempered, delicate to touch and well-modelled. Water is basically cold and in the air partakes of humidity; and since the cold contracts things and makes them hard and humidity softens, the Lunar bodies are smaller than the Jovial ones and are disproportioned, hard, and weak. Earth finally is by its nature basically dry through the effect of fire, and cold because of an admixture of water; since cold and dryness are extremely harsh, the Saturnian bodies are essentially still harder than the Martian ones, and they have thin and concave limbs. All other shapes arise from these four qualities. . . .

FEDERIGO ZUCCARO

[Federigo Zuccaro (1542–1609) was a Manneristic painter whose mediocre work is found in the cupola of the Duomo in Florence, in the Vatican, and in the Ducal Palace in Venice. He also worked in Spain, Holland, and England. In the field of theoretical writing his *Idea dei scultori, pittori e architetti* (Idea of the Sculptors, Painters and Architects, 1607) is a significant document of the philosophy of the art of the period. Here the antique concept of *disegno* is analyzed as two concepts: the *disegno interno* corresponding to the "idea" pre-existent in the mind of the artist, and the *disegno esterno* corresponding to the form the idea assumes in passing into matter. Zuccaro founded the Academy of St. Luke in Rome and is the first example of the academic official, a type which persists until the nineteenth century.]

THE IDEA OF SCULPTORS, PAINTERS AND ARCHITECTS[1]

BOOK I. CHAPTER III. Before one treats of anything whatever, it is necessary to define its name, as the prince of philosophers, Aristotle, teaches in his *Logic*; otherwise it would be like walking along an unknown road without a guide or entering the labyrinth of Daedalus without a thread. Therefore, beginning from that point I shall explain what I mean by this term *disegno interno*,[2] and, following

[1] The excerpts are translated from Federigo Zuccaro, *L'idea dei scultori, pittori e architetti*, as quoted in Panofsky, *Idea*, pp. 101, 106, 107, 109. Dr. Panofsky very kindly checked this translation by the editor and supplied footnotes 2 and 8 below. The entire text is given in Bottari-Ticozzi, *Raccolta di lettere sulla pittura, scultura, ed architettura*, Rome, 1768, VI, pp. 35–199.

See also: Panofsky, *Idea*, pp. 39–53; Blunt, *Theory*, pp. 137–45; Pevsner, *Academies*, pp. 25–66; Schlosser, *Lett. art.*, p. 338, and *Kunstlit.*, p. 345.

[2] The *disegno interno* might be translated by "Inward Design" and may be defined as the sum total of *a priori* concepts inherent in any thinking and productive mind; primarily in the mind of God, secondarily in the mind of the angels, tertiarily

the common interpretation accepted by scholars as well as by ordinary people, I shall say that by Inward Design is meant the concept formed in our mind which enables us to apprehend any object and to do practical work in accordance with this concept. In that way we painters wishing to draw or paint some suitable subject, as for example the Angelic Salutation to the Virgin Mary (wherein the Angel announced to her that she would be the Mother of God), first form in our mind as much of a conception as is possible at the time of what occurred in Heaven as well as on earth; and this with respect to the Angel who was sent, as well as with respect to the Virgin Mary to whom he gave his message, and with respect to God Who sent him. Then, in agreement with this inner conception, we proceed to shape and draw with the pencil on paper, then with brushes and colors on canvas or walls. It is true, though, that by this term Inward Design I do not mean solely the concept formed in the mind of the painter, but also that concept which is formed in any intellect; but for the sake of greater clarity and for the better understanding of my fellow artists, I have defined in the beginning this term Inward Design for our profession alone. If we wish to define the term completely and universally, we shall say that it is the concept and the idea formed so as to understand and to put into practice any object. In this treatise, I discuss this inner concept formed of any object under the particular term Design. I do not use the term "intention" as employed by the logicians and philosophers, or "exemplar" or "idea" as used by the theologians, because I discuss this as a painter and I discuss it principally for painters, sculptors, and architects, for whom the knowledge and guide of the Design is necessary in order to work well. All educated persons know that terms should be employed that correspond to the profession under discussion. Let no one wonder then, that I leave the other terms to the logicians, philosophers, and theologians, and use this term Design in a discussion with my professional colleagues.[3] . . .

in the mind of man, in which case the concepts are individualized and need to be clarified by sensory experience.

[3] Panofsky, *Idea*, p. 106; Bottari, *op. cit.*, pp. 38 ff.

And I declare from the outset that Design is neither matter nor body nor the accident of any substance, but is the form, idea, rule, and object of the intellect in which the things comprehended are expressed. This Design one finds in all external objects, divine as well as human, as we shall shortly explain. Now, following the teachings of the philosophers, I declare that the Inward Design in general is an idea and form in the intellect which precisely and distinctly represents the thing comprehended by the intellect, and which is the intellect's ultimate goal and object. In order to understand this definition better, one must observe that there are two kinds of operations: namely, one external, like drawing, delineative, lineative, shaping, painting, sculpturing, and building; and the other internal, like comprehension and volition. Inasmuch as it is necessary that all external operations have an ultimate goal, . . . thus it is also necessary that the internal operations have an ultimate goal in order that they, too, may be complete and perfect. That ultimate goal is none other than the thing comprehended. For example, if I wish to comprehend what kind of thing a lion may be, it is necessary that the lion known to me be the ultimate goal of my intellective process. I do not mean the lion that runs through the forest and hunts other animals in order to live, for that one is outside me; but I mean an immaterial form shaped in my intellect which represents to it precisely and distinctly the nature and form of "the lion." In that form or image of the mind the intellect clearly sees and recognizes not only the single lion in his form and character, but also all lions. From this one sees not only the agreement between the internal and external operations, that each has a separate goal in order that they may be complete and perfect, but also, and more particularly, their difference, which is more *à propos*. And whereas the goal of the external operation is a material thing, like the figure drawn or painted, the statue, the temple, or the theater, the goal of the internal operation of the intellect is an immaterial form representing the thing comprehended.[4]

[4] Panofsky, *Idea*, p. 107; Bottari, *op. cit.*, p. 40.

BOOK I. CHAPTER XI. . . . The following shows how the mind stands in need of the senses in order to comprehend and especially in order to form its Inward Design. Because illustrations facilitate things, I shall use one to show in what way the Design is formed in our mind.

So I may say that in order to make fire, the steel strikes the flint, from the flint issue sparks, the sparks light the tinder, then the tinder, approaching the matches, lights the lamp. Similarly, the intellectual faculty strikes the flint of concepts in the human mind, and the first concept like the spark ignites the tinder of the imagination and stirs the fancy and the notions. This first concept is undefined and confused and is not comprehended by the faculty of the soul or by the active and potential intellect. But little by little this spark develops into a form, idea, real fancy, and spirit formed by the speculative and formative soul. Then the senses, like matches, are ignited and light the lamp of the active and potential intellect, which, when it is lighted, diffuses its light in clarifying and classifying everything. Whence arise clearer ideas and more certain judgments, and in company of these the intellective intelligence in the mind grows towards the cognition or formation of the objects. From the forms arise order and rule, and from order and rule, experience and practice; and so this lamp becomes luminous and clear.[5] . . .

BOOK II. CHAPTER VI. . . . But I do insist, and I know I speak true, that the art of painting does not derive its basic principles from the mathematical sciences and needs no recourse to them in order to learn rules or methods for its practice or even for its theoretical discussion. For this art is assuredly not the daughter of mathematics, but of nature herself and of Design. The first shows it the form, the second teaches it to operate. Thus the painter becomes competent, apart from the basic principles and teachings acquired from his predecessors or from nature herself, through the careful exercise of his innate judgment and the observance of the good and the beautiful without further aid or the necessity of mathematics.

[5] Panofsky, *Idea*, p. 109; Bottari, *op. cit.*, pp. 44 ff.

I shall also maintain, for it is true, that in all bodies produced by nature there is proportion and measure, as Aristotle affirms; but were one to set himself to investigate all things and to comprehend them by means of theoretical and mathematical speculation, and work according to the latter, such an enterprise would be not only unbearably tiresome, but also a waste of time without any fruitful results. This was clearly demonstrated by one of our very able artists who according to his own fancy wished to construct human bodies by a mathematical rule. According to his own fancy, I say; not, however, from a belief in being able to teach artists to work from such a rule; that would have been vanity and positive foolishness, incapable of producing any good or, indeed, anything but harm. If we leave out of account the foreshortenings and the form of the invariable spherical body, such rules are not at all useful nor are they suitable for our kind of work; for the mind must be not only clear but free, and the imagination unrestricted and not thus hemmed in with mechanical dependence on rules of this sort. This truly noble profession demands that judgment and good practice be its rule and norm of working well. So my dear brother and predecessor told me when showing me the first rules and measures of the human figure, pointing out that the perfect and graceful proportions must be of so many heads and no more. But it is necessary, he said, that you make yourself so familiar with the practical rules and measurements that you have the compass and ruler in your eyes, and judgment and practice in your hands.[6] Thus these mathematical rules and restrictions are not and can not be either useful or good as a method after which one could work. Instead of increasing the skill, the spirit, and the liveliness, they would take it all away, since the intellect would deteriorate, judgment would be smothered, and

[6] Zuccaro's brother probably misquoted Michelangelo's well-known remark given by Vasari: "It was necessary to have the compasses in the eyes and not in the hand, because the hands work and the eyes judge" (*The Lives* . . . , translated by G. du C. de Vere, London, 1912–1915, IX, p. 105). Cf. Du Fresnoy, p. 172

all grace, all spirit, and all zest would be taken away from art.

So I think that Dürer went through all that work, which was not a little, in order to derive pleasure and diversion therefrom and in order to give entertainment to intellects that put more emphasis on theory than on practice and to show that the Design and the spirit of the painter is capable of all that it sets out to do. Equally fruitless and lacking in substance was the other work left in drawings together with writings in mirror script, by another man of our profession[7]— very competent but too much of a sophist in leaving mere mathematical precepts for moving and turning the figure by means of perpendicular lines, with the aid of rulers and compasses; certainly all very ingenious things, but fantastic and without fruit or substance. However, if anyone thinks differently every man may work according to his own taste. I insist, though, that these rules must be left to such sciences and speculative disciplines as geometry, astronomy, arithmetic, and the like, which quiet the mind with their demonstrations. But we professors of Design do not have need of any rules other than those which nature herself gives for imitation. So that we—desirous that our profession, too, may have a mother as do all the other speculative and practical sciences—assert the truth that the art of painting does not have any other mother than nature herself. With great care and observation, the art of painting imitates nature in order to show herself to be her legitimate, dear, and virtuous daughter. Likewise, the art of painting has no progenitor worthy of her other than Inward, Practical and Artificial Design [8] which is nature's own and peculiar to her, begotten and produced by nature.[9]

[7] He refers to Leonardo da Vinci.

[8] For the expression "Inward, Practical and Artificial Design," see Panofsky, *Idea,* p. 49: the Design is called "Practical" in contradiction to "Speculative," and "Artificial" (*artificiale*), viz., pertaining to all kinds of human production (not only to the "Fine Arts"), in contradiction to "Moral" (*morale*) which means pertaining to all kinds of human behavior.

[9] Panofsky, *Idea,* p. 101; Bottari, *op. cit.,* pp. 133 ff.

II. THE BAROQUE

ITALY

GIOVANNI PIETRO BELLORI

[Giovanni Pietro Bellori (1615–1696) was born in Rome. His uncle, the antiquarian Francesco Angeloni (1652), was secretary to the apostolic protonotary, Hippolito Aldobrandini, a nephew of Pope Clement VIII. In the intellectual environment of these men Bellori developed into a literary figure, an antiquarian and a connoisseur. He apparently studied painting for his own enjoyment and as a painter became associated with the Academy of St. Luke in Rome. He served as antiquarian and librarian for Queen Christina of Sweden, who took up permanent residence in Rome, and he was named "antiquarian of Rome" by Clement X.

Bellori wrote many antiquarian works, but his two writings primarily responsible for his influence are: *Descrizione della immagini dipinte da Rafaelle d'Urbino nelle camere del Palazzo Vaticano* (Description of Paintings by Raphael in the Vatican Palace, 1696), which strengthened the Raphael cult, and *Vite de' pittori, scultori et architetti moderni* (The Lives of Modern Painters, Sculptors and Architects, 1672). It is dedicated significantly to Colbert, the founder of the Académie française; in its preparation Bellori had the assistance of his intimate friend, Nicholas Poussin. In marked contrast to earlier and contemporary art history, Bellori's method is the selection of men and works of outstanding quality, the comprehensive treatment of the few artists chosen, and the appreciation and interpretation of the best works of those men on the basis of the quality and character of the individual work itself.

The introduction to the *Lives*, "The Idea of the Painter, Sculptor and Architect" given as a lecture before the Academy of St. Luke in 1664, is the most complete single statement of Bellori's artistic program. The "Idea" is that reasoned consideration which, applied to nature and imitated in painting, sculpture, and architecture, gives to the work of art adequate formal and contentual abstraction to make it endure.

In his interest in preserving, reproducing, and explaining works of ancient art, in his belief and statement of a rational artistic and aesthetic program, in his emphasis on Raphael, Annibale Carracci and Poussin, Bellori states directly the ideals of both the Roman Academy of St. Luke and the French Academy. Through Shaftesbury and Reynolds his ideas are found in the English Academy, and through Winckelmann, survived in every academy in Europe in the late eighteenth and early nineteenth centuries.]

THE LIVES OF MODERN PAINTERS, SCULPTORS AND ARCHITECTS[1]

THE IDEA OF THE PAINTER, THE SCULPTOR, AND THE ARCHITECT CHOSEN FROM THE HIGHER NATURAL BEAUTIES OF NATURE. When that high and eternal intellect, the creator of nature, made his marvelous works by reflecting deeply within himself, he established the first forms called *Ideas*. Each species was derived from that first *Idea*, and so was formed the admirable web of created

[1] The selection is translated from Bellori, *Vite de' pittori, scultori et architetti moderni*, Rome, 1672, by Kenneth Donahue. Unless otherwise indicated, the quotations made by Bellori are translated by the translator. Mr. Donahue is very grateful to Dr. Ulrich Middeldorf of the University of Chicago for his painstaking corrections of the translation. In writing the biographical note, the editor was assisted by Kenneth Donahue's thesis, *Notes on Gio. Pietro Bellori*, Institute of Fine Arts, New York University, New York.

See also: Panofsky, *Idea*, pp. 130 ff.; Lee, "Ut Pictura Poesis," pp. 207 ff.; Pevsner, *Academies*, pp. 79–96 *passim*, 111, 188; Schlosser, *Lett. art.*, p. 403, and *Kunstlit.*, p. 416; Venturi, *History*, p. 118.

things. The celestial bodies above the moon, not being subject to change, remained forever beautiful and in harmony; and because of their measured spheres and because of the splendor of their appearance we recognize them to be in all eternity of the highest perfection and beauty. On the other hand, sublunar bodies are subject to change and to ugliness and, although nature always means to produce excellence in its workings, nevertheless forms are altered through the inequality of matter, and human beauty in particular is muddled, as we see from the countless deformities and disproportions that are in us.

For this reason the noble painters and sculptors imitate that first creator, and form in their minds also an example of superior beauty and, reflecting on it, improve upon nature until it is without fault of color or of line.

This *Idea*, or we might say goddess of painting and sculpture, after opening the sacred curtains of the exalted genius of men like Daedalus and Apelles, unveils herself to us, and descends upon the marbles and canvases. Originating from nature, she rises above her origin and becomes herself the original of art; gauged by the compass of the intellect, she becomes the measure of the hand; and animated by imagination, she gives life to the image. Certainly according to the opinions of the greatest philosophers there exist in the souls of artists the Exemplary Causes which without uncertainty and for eternity remain most beautiful and most perfect.

The *Idea* of the painter and sculptor is that perfect and excellent exemplar in the mind, with an imagined form, which by imitation, the things that appear to human sight resemble; such is the definition of Cicero in the Book of the Orator for Brutus: *Vt igitur in formis, et figuris est aliquid perfectum et excellens, cuius ad excogitatam speciem imitando referuntur ea quae sub oculis ipsa cadunt, sic perfectae eloquentiae speciem animo videmus, effigiem auribus quaerimus.*[2] Thus the *Idea* constitutes the perfection of natural beauty, and unites the true to the semblance

[2] Cicero, *Orator*, III, 9: "Accordingly, as there is something perfect and surpassing in the case of sculpture and painting— an intellectual ideal by reference to which the artist represents

of things present to the eye; she always aspires to the best and the wonderful, whereby she not only emulates but surpasses nature and manifests to us as elegant and accomplished the creations which nature is not wont to show perfect in every part.

Proclus confirms this high opinion in the Timaeus, saying that if you take a man made by nature, and one made by the art of sculpture, the natural one will be less excellent, because art works more accurately. Zeuxis, who selected five virgins to form the famous image of Helen that is proffered as an example by Cicero in the *Orator*, teaches the painter and the sculptor alike to keep in mind the *Idea* of the best natural forms and to make a selection from different bodies, choosing what is most elegant in each. For Zeuxis did not believe that he could find in one body only all the perfections that he sought for the beauty of Helen, because nature does not make any particular thing perfect in all its parts. *Neque enim putauit omnia, quae quaereret ad venustatem, vno in corpore se reperire posse, ideo quod nihil simplici in genere omnibus ex partibus natura expoliuit.*[3] Also Maximus Tyrius holds that when the painters create an image by choosing from diverse bodies, a beauty is brought forth that is not to be found in any single natural body, close as this might come to beautiful statues. Parrhasius admitted the same to Socrates, namely, that the painter desiring natural beauty in each form ought to take from diverse bodies all that which in each single one is most perfect, and ought to join it together since it is difficult to find a single one that is perfect.

More than that, nature for this reason is so much inferior

those objects which themselves appear to the eye—so with our minds we conceive the ideal of perfect eloquence, but with our ears we catch only the copy." The standard text as found in the Loeb Library, 1939, pp. 313 ff., is a different one from that used by Bellori. See Panofsky, *Idea*, pp. 60 f., 74, and W. Friedländer, *Jahrbuch für Kunstwissenschaft*, VI, 1928, p. 63.

[3] Cicero, *De Inventione*, II, i, 3: "Nor did he think that he could find all that he wanted for beauty in one body, because nature has not created anything perfect in a simple genus."

to art that the copying artists, that is, those who scrupulously imitate bodies without discrimination and regard to the *Idea*, were reproved. Demetrius was remarked upon for relying too much on nature; Dionysius was blamed for having painted men like unto us, and was commonly called ἀνθρωπόγραφος, that is, painter of men. Pauson and Peiraeikos were condemned, mainly for having depicted the worst and vilest, as Michelangelo da Caravaggio in our times was too naturalistic; he painted men just as they are; and Bamboccio worse than they are.

Lysippus, likewise, used to reprove the mass of sculptors that they made men as they are found in nature, and prided himself on forming them as they ought to be, following the basic precept given by Aristotle to poets as well as to painters. Phidias, on the other hand, was not accused of this failing, who evoked wonder in spectators by the forms of the heroes and gods, in which he imitated the *Idea* rather than nature. And Cicero, speaking of him, affirms that Phidias, when he carved Jupiter and Minerva, did not contemplate any object from which to take the likeness, but considered in his mind a form full of beauty on which he concentrated, and to the likeness of which he directed his mind and hand. *Nec vero ille artifex cum faceret Iouis formam aut Mineruae, contemplabatur aliquem, a quo similitudinem duceret, sed ipsius in mente insidebat species pulchritudinis eximia quaedam, quam intuens, in eaque defixus ad illius simili[tu]dinem artem et manum dirigebat.*[4] Wherefore to Seneca, although a Stoic, and a rigorous judge of our arts, it appeared a fine thing, and he was amazed, that this sculptor, without ever seeing either Jupiter or Minerva, nevertheless was able to conceive in his mind their divine forms. *Non vidit Phidias Iouem, fecit tamen velut tonantem, nec stetit ante oculos eius Minerua, dignus tamen illa arte animus, et concepit*

[4] Cicero, *Orator*, ii, ii, 9: "Nor indeed did that same artist [Phidias], when he made the image of Jupiter or Minerva, contemplate any person of whom he should draw a likeness; but in his own mind there dwelt an exalted species of beauty; staring at which and intent upon it, he directed his art and his hand to produce its likeness."

Deos, et exhibuit.[5] Apollonius of Tyana teaches us the same, that imagination renders the painter wiser than does imitation, because the latter makes only the things that it sees, while the former makes even the things that it does not see, relating them to those that it sees.

Now, to join to the precepts of the ancient philosophers the best maxims of our modern ones, Leon Battista Alberti teaches that in all things one should love not only the appearance, but principally the beauty, and that one ought to select the most praised parts from the most beautiful bodies. Thus Leonardo da Vinci instructs the painter to form this *Idea,* and to think about what he sees and question himself about it, so as to select the most excellent part of each thing. Raphael of Urbino, the great master of those who know, thus writes to Castiglione of his Galatea: *Per dipingere vna bella mi bisognerebbe vedere più belle, ma per essere carestia di belle donne, io mi seruo di vna certa Idea, che mi viene in mente.*[6]

Likewise Guido Reni, who in grace has surpassed every other artist of our century, when sending to Rome the painting of St. Michael the Archangel for the church of the Capuchins, wrote to Monsignor Massani, major-domo of Urban VIII: *Vorrei hauer hauuto pennello Angelico, o forme di Paradiso, per formare l'Arcangelo, e vederlo in Cielo, ma io non hò potuto salir tant' alto, e in vano l'hò cercato in terra. Si che hò riguardato in quella forma che nell' Idea mi sono stabilita. Si troua anche l'Idea della bruttezza, ma questa lascio di spiegare nel Demonio, perchè lo fuggo sin col pensiero, nè mi curo di tenerlo a mente.*[7]

[5] Seneca the Elder, *Rhetorica,* x, cont. 5: "Phidias saw not Jupiter, yet he made him as the Thunderer, neither did Minerva stand before his eyes; yet his mind, worthy of that art, conceived the gods and shaped them."

[6] Bottari-Ticozzi, *Raccolta,* I, p. 116: "In order to paint a beautiful woman, it would be necessary for me to see many beautiful women, but since there is a scarcity of them, I make use of a certain Idea which comes to my mind." A complete English translation is found in E. McCurdy, *Raphael Santi,* London, 1917, p. 47.

[7] "I should like to have had an angelic brush, or forms of Paradise to fashion the Archangel, and to see him in Heaven,

Thus Guido boasted that he painted not beauty as it was visible to the eye, but like that which he saw in the *Idea*, whence his beautiful *Helen Abducted* was celebrated as equal to the ancient one of Zeuxis. But in reality Helen was not so beautiful as they [Guido and Zeuxis] made her, and in her there were imperfections and shortcomings. It is also held that she never was shipped to Troy, but that her statue was brought in her place, and that the ten years' war was waged for the sake of its beauty. It is suspected that Homer in his poems celebrated a woman who was not divine, in order to gratify the Greeks and to render more renowned his subject of the Trojan War, in the same way that he exalted Achilles and Ulysses in strength and in wisdom. Wherefore Helen with her natural beauty did not equal the creations of Zeuxis and of Homer; neither was there ever any woman who possessed so much beauty as the Cnidian Venus or the Athenian Minerva called "the Beautiful" [*la bella forma*], nor is there today any man who equals in strength the Farnese Hercules of Glycon or any woman who equals in beauty the Medici Venus of Cleomenes.

For this reason the best poets and orators, who wish to celebrate some superhuman beauty, have recourse to comparison with statues and with paintings. Ovid, describing the beautiful centaur Cyllarus, extols him as next in perfection to the most praised statues:

> *Gratus in ore vigor, ceruix, humerique, manusque*
> *Pectoraque Artificum laudatis proxima signis.*[8]

And in another place he sang exaltedly of Venus, that if Apelles had not painted her, she would still remain submerged in the sea, which had given birth to her:

but I have not been able to rise so high, and in vain I have searched for him on earth. So that I have looked upon that form which I have established for myself in the *Idea*. The *Idea* of ugliness is also found here, but this I leave to be expressed of the Devil, because I shun it even in thought and I do not care to retain it in my mind."

[8] Ovid, *Metamorphoses*, xii, 397–398: "He had a pleasing sprightliness of face; and his neck, shoulders, breast, and hands

Si Venerem Cois nunquam pinxisset Apelles
Mersa sub aequoreis illa lateret aquis.[9]

Philostratus exalts the beauty of Euphorbus as like statues of Apollo and says that Achilles surpasses the beauty of Neoptolemus, his son, by as much as beautiful people are surpassed by statues. Ariosto in describing the beauty of Angelica describes her, bound to the stone, almost as though she were modelled by the hand of an industrious artist:

> *Creduto hauria, che fosse stata finta,*
> *O d'alabastro, ò d'altro marmo illustre,*
> *Ruggiero, o sia allo scoglio così auuinta*
> *Per artificio di scultore industre.*[10]

In which verses Ariosto imitated Ovid describing the same Andromeda:

> *Quam simul ad duras religatam brachia cautes*
> *Vidit Abantiades, nisi quod leuis aura capillos*
> *Mouerat, et tepido manabant lumina fletu,*
> *Marmoreum ratus esset opus.*[11]

Marino, praising the Magdalen painted by Titian, applauds the painting with the same praises and exalts the *Idea* of the artist above natural things:

(and all his human parts) you would praise as equal to an artist's perfect work."

[9] Ovid, *Artis Amatoriae*, II, 401–2: "If Apelles had never painted Venus for the Coans, she would still be lying hidden in the sea's depths."

[10] Ariosto, *Orlando furioso*, Canto x, 96: "Ruggiero would have believed her fashioned of alabaster or some other illustrious marble, to the stone thus bound by an industrious sculptor's art."

[11] Ovid, *Metamophoses*, IV, 672–5 (trans. F. J. Miller, Loeb Library, London, 1926, I, 226): "As soon as Perseus saw her there bound by the arms to the rough cliff—save that her hair gently stirred in the breeze, and the warm tears were trickling down her cheeks, he would have thought her a marble statue."

Ma cede la Natura, e cede il vero
A quel che dotto Artefice ne finse,
Che qual l'hauea ne l'alma, e nel pensiero,
Tal bella, a viua ancor qui la dipinse.[12]

Wherefore it appears that Aristotle, on Tragedy, is unjustly blamed by Castelvetro[13] who maintains that the value of painting does not consist so much in making the image beautiful and perfect but in making it similar to the natural, whether beautiful or deformed, as if the excess of beauty would deprive it of the likeness. This reasoning of Castelvetro is restricted to slavishly imitative painters and to makers of portraits who do not use any *Idea* and are victims to the ugliness of the countenance and of the body, who are neither able to attach beauty to them, nor to correct natural deformities, without depriving them of the likeness, otherwise the portrait will be more beautiful and less similar.

The philosopher [Aristotle] does not refer to this slavish imitation, but he teaches the tragic poet the usage of the best, on the example of good painters and makers of perfect images, who use the *Idea;* and these are his words: *Since Tragedy is the imitation of the best, we must imitate the good painters because they when expressing the form proper to their subjects, in making them similar make them more beautiful,* ἀποδιδόντες τὴν οἰκείαν μορφήν, ὁμοίους ποιοῦντες, καλλίους γράφουσιν. Therefore, to make men more beautiful than they normally are and to select the perfect is proper to the *Idea.*

Now the *Idea* of this beauty is not single, but rather its forms are diverse, strong and magnanimous, pleasant and delicate, of every age and sex. We do not, therefore, praise only soft Venus as Paris did among the delights of Mt. Ida,

[12] Marino, *La Galleria del Cavalier Marino distinta in pittura e scultura,* Milan, 1620, stanza XIV, I, 1–4, p. 82: "But nature and reality ought to cede to that which the learned artist makes of them; that which he had in soul and thought, so beautiful and alive he has painted here."
[13] Lodovico Castelvetro, *Poetica d'Aristotele vulgarizzata et sposta per . . . ,* Basel, 1576, pp. 41, 343, 386.

nor only acclaim tender Bacchus in the gardens of Nysa, but we also admire quiver-bearing Apollo and the archeress Diana on the strenuous mountain ridges of Maenalos and of Delos. Jupiter's beauty in Olympia, Juno's in Samos, were certainly different, and also Hercules' in Lindus and Cupid's in Thespiae. Thus different forms suit different subjects, for beauty is nothing else but that which gives to things their appropriate quality to perfection; the best painters choose it by considering the form of each.

We ought to further consider that, since painting is representation of human action, the painter ought to retain in his mind the type of effects suitable to these actions, as the poet preserves the idea of the irascible, the timid, the sad, the glad, that is of laughter and weeping, fear and hardihood. These emotions ought to be permanently fixed in the soul of the artist through continued study of nature, because it is impossible for his hand to portray them from nature, if he has not first conceived them in his imagination; and to this the greatest attention is necessary, since the emotions are never seen unless in transition and for a few fleeting moments. Thus when the painter or the sculptor undertakes to imitate the workings of the soul, which spring from passions, he cannot see them in the model which poses before him, since it is unable to hold the expression of passion for any length of time, but will languish in spirit as in limb in the pose which it has to hold at the bidding of someone else. So it is necessary that that artist form for himself an image of them from nature by observing human emotion and associating bodily movements with the emotions of the soul, as they depend reciprocally upon each other.

Incidentally, not to leave out architecture, it also makes use of its most perfect *Idea*: Philo says that God, as a good architect, contemplating the *Idea* and the pattern which He had conceived, made the empirical world on the model of the ideal and rational world. So that architecture too, because of its dependence on an exemplar, rises above nature; thus Ovid, in describing the cave of Diana, states that nature in making it undertook to imitate art:

Arte laboratum nulla, simulauerat artem
Ingenio Natura suo.[14]

Torquato Tasso perhaps had this in mind when he described the garden of Armida:

Di natura arte par, che per diletto
L'imitatrice sua scherzando imiti.[15]

Building, moreover, is so excellent that Aristotle argues that if construction were a thing not unlike the method of architecture, to give it perfection nature would be obliged to use the same rules [the architect does]; just as the very habitations of the gods were depicted by poets as bearing the work of architects, and furnished with arches and columns. Thus were described the Palace of the Sun and of Love, and architecture was carried to the heavens.

The antique cultivators of wisdom formed this *Idea* and deity of beauty in their minds, always referring to the most beautiful parts of natural things; most ugly and vile however is that other Idea which is generally based on habit. For Plato argues that the Idea should be one perfect cognition of a thing based on nature. Quintillian teaches us that every thing perfected by art and by human genius has its beginnings in nature itself, from which the true *Idea* is derived. Therefore, those who do not know the truth, and do everything according to habit, create empty shells instead of figures; nor is it different with those who borrow genius and copy the ideas of others; they make works that are not daughters but bastards of Nature, and appear to have sworn by the brush-strokes of their masters. Combined with this evil is the other that they, through poverty of genius, and not knowing how to select the best parts, choose the defects of their teachers and mold the *Idea* on the worst. On the other hand, those who glory in the name of Naturalists do not carry in mind

[14] Ovid, *Metamorphoses*, III, 158–159 (trans. F. J. Miller, *op. cit.*, p. 135); "Wrought by no artist's hand. But nature by her own cunning had imitated art."

[15] Tasso, *Gerusalemme liberata*, XVI, 10: "It seems nature's own art, and that for her amusement, she playfully imitates her imitator."

any *Idea*; they copy the defects of bodies and accustom themselves to ugliness and errors; they also swear by a model as their teacher; if this is withdrawn from their eyes, together with it all art departs from them.

Plato compares these first painters to the Sophists, who take as their foundation not truth but the false fancies of opinion; the second ones are like Leucippus and Democritus, who would compose bodies of vain atoms at random.

Thus the art of painting is degraded by those painters to a matter of personal opinion and a practical device, as Critolaus argued that oratory was a practice of speaking and a skill to please, τριβὴ and κακοτεχνία, or rather ἀτεχνία, a habit without art and without reason, thus negating the function of the mind and leaving everything to the senses. Wherefore they believe to be a merely individual way of working, what really is the highest intelligence and *Idea* of the best painters and thus they would attach ignorance to wisdom; but the highest spirits, who concentrate their thought on the *Idea* of the beautiful, are carried away by it alone, and consider it as a thing divine. The populace refer everything to the sense of the eye; they praise things painted naturalistically because it is usual to see pictures so made; they appreciate beautiful colors but not the beautiful forms which they do not understand; they are bored by elegance and approve of novelty; they disdain reason and follow opinion, and wander far away from the truth of art, on which, as on its own base, is dedicated the most noble image of the *Idea*.

We should now explain that it is necessary to study the most perfect of the antique sculptures, since the antique sculptors, as we have already indicated, used the wonderful *Idea* and therefore can guide us to the improved beauties of nature; we should explain why, for the same reason, it is necessary to direct the eye to the contemplation of other most excellent masters. But this matter we assign to a special treatise on imitation, so as to convince those who condemn the study of antique statues.

As for architecture, we say that the architect ought to conceive a noble *Idea* and to establish an understanding that may serve him as law and reason; since his inventions

will consist of order, arrangement, measure, and eurythmy of whole and parts. But in respect to the decoration and ornaments of the orders, he may be certain to find the *Idea* established and based on the examples of the ancients, who as a result of long study established this art; the Greeks gave it its scope and best proportions, which are confirmed by the most learned centuries and by the consensus of a succession of learned men, and which became the laws of an admirable *Idea* and a final beauty. This beauty, being one only in each species, cannot be altered without being destroyed. Hence those who with novelty transform it, regrettably deform it; for ugliness stands close to beauty, as the vices touch the virtues. Such an evil we observe unfortunately at the fall of the Roman Empire, with which all the good Arts decayed, and architecture more than any other; the barbarous builders disdained the models and the *Ideas* of the Greeks and Romans and the most beautiful monuments of antiquity, and for many centuries frantically erected so many and such various fantastic phantasies of orders that they rendered it monstrous with the ugliest disorder. Bramante, Raphael, Baldasarre [Peruzzi], Giulio Romano, and finally Michelangelo labored to restore it from its heroic ruins to its former *Idea* and look, by selecting the most elegant forms of the antique edifices.

But today instead of receiving thanks these very wise men like the ancients are ungratefully vilified, almost as if, without genius and without invention, they had copied one from the other. On the other hand, everyone gets in his head, all by himself, a new *Idea* and travesty of architecture in his own mode, and displays it in public squares and upon the façades: they certainly are men void of any knowledge that belongs to the architect, whose name they assume in vain. So much so that they madly deform buildings and even towns and monuments with angles, breaks and distortions of lines; they tear apart bases, capitals, and columns by the introduction of bric-a-brac of stucco, scraps, and disproportions; and this while Vitruvius condemns similar novelties and puts before us the best examples.

But the good architects preserve the most excellent forms of the orders. The painters and the sculptors, selecting the most elegant natural beauties, perfect the *Idea,* and their works go forward and become superior to nature; this, as we have proved, is the ultimate excellence of these arts. Here is born the admiration and the awe of men towards statues and images, here is the reward and honor of artists; this was the glory of Timanthes, of Apelles, of Phidias, of Lysippus, and of so many others celebrated by fame, who all rose above human forms and aroused admiration with the *Ideas* and their works. So one can indeed then call this *Idea* perfection of nature, miracle of art, foresight of the intellect, example of the mind, light of fancy, rising Sun that from the East inspires the statue of Memnon, fire that warms into life the image of Prometheus. This induces Venus, the Graces, and the Cupids to leave the Idalian garden and the shores of Cythera, and to dwell in the hardness of marbles and in the vanity of shadows. By her virtue the Muses on the slopes of Helicon mix immortality into the colors, and for her glory Pallas disdains Babylonian cloth and proudly boasts of Daedalian linen. But because the *Idea* of eloquence falls as far below the *Idea* of painting as sight is more potent than words, I here lack for speech and am hushed.

FILIPPO BALDINUCCI

[Filippo Baldinucci (1624–1696) was a Florentine employed by the Cardinal Leopold de' Medici and Cosimo III to put in order the Medici collection of drawings. Baldinucci studied the lives of the artists and wrote the *Notizie de' professori del disegno da Cimabue in qua* (Accounts of Professors of Design) of which three volumes were published in 1681 and three more posthumously in 1781. This work, which corrects and continues Vasari's *Lives,* is the first universal history of the figurative arts in Europe. He wrote the first history of engraving and etching (Florence, 1686) and the first dictionary of artistic

terms (Florence, 1686). Queen Christina of Sweden commissioned him to write the biography of Bernini. It appeared in 1682, two years after the death of the artist.]

LIFE OF CAVALIERE
GIOVANNI LORENZO BERNINI[1]

Marvelous, and almost like a miracle, is the force of that hidden seed which nature, always a wise conserver of its finest elements, prudently infuses into spirits of the finest temper and highest aspirations, as into receptive and obedient matter. Nor, in my opinion, must it seem very strange to those who look at the essence of things with subtlest discernment that his seed is of heavenly origin and wedded to our spirits. So this seed, because of its place of origin and the immortality which was bestowed on it, can boast of the closest kinship with Heaven. It is reasonable that such a seed implanted in our minds, as in a suitable field, should settle there with all its force and thrive in the same way as we observe a real seed sown in good and favorable soil, soon to sprout above the earth and then produce a rich cluster of numberless ears of corn. Although one can observe its presence more or less generally in all, it is doubtless more obvious and apparent in those destined and chosen by nature to accomplish great and miraculous deeds. And to tell the truth, whether their spirits be jewels of greater brilliance and higher value than others, or whether it be that, in those of finer clay and gentler substance, the jewels set, as it were, in gold shine through the body just as light shines through glass, there appear occasionally those whose eyes even from infancy flash out the sparks from their soul in such profusion and so brilliantly that the

[1] The excerpts are translated from Alois Riegl, *Filippo Baldinucci's Vita des Gio. Lorenzo Bernini mit Übersetzung und Kommentar,* Vienna, 1912, by the editor. Prof. A. T. MacAllister, Princeton University, kindly checked the translation. All except the bracketed footnotes are from the text. See also: Schlosser, *Lett. Art.,* p. 405, and *Kunstlit.,* p. 420; Venturi, *History,* p. 123; S. Fraschetti, *Il Bernini,* Milan, 1900; Baldinucci, Filippo, *The Life of Bernini,* tr. C. Enggass, University Park, Pa., 1966; R. Wittkower, *G. L. Bernini, the Sculptor of the Roman Baroque,* 2d ed., London, 1966; H. Hibbard, *Bernini,* Penguin, 1965.

beholder can scarcely endure not only the direct light, but even its reflection.

It seems then in reality as if the whole soul, showing itself through the windows of the face, disdains to mix with matter and, despite the body, wants to show by its actions, glances, words, and gestures a sample of its hidden beauties.

Such extraordinary vivacity and spirit fell in our time to the lot of Giovanni Lorenzo Bernini, a man who in the arts of painting, sculpture, and architecture was not only great but exceptional, and would have ranked with the most brilliant and renowned masters of the ancient and modern world had he not had the misfortune of being born in the wrong age.

The marble blocks which, thanks to his chisel, live and speak in Rome and in many other parts of the world would perhaps be silent and alone in the maternal rocks if the master's hand had not subjected them to the torment of his industrious chisel. Likewise, in my opinion, the great creative talents of Bernini would have been dissipated in the frivolous pleasures and habits of youth if he had not placed himself at an early age under the discipline of incessant industry and severe studies, thereby showing that great talent uncontrolled is like the most spiritual substance of flowers, which, when pressed into an essence and poorly sealed in vases, evaporates in a few hours and vanishes because of its extreme volatility.

How judiciously Bernini utilized the splendid gifts of the soul, bestowed upon him through special grace, is shown clearly enough by the great number of his works and the excellence of their execution. If one were to measure his life by them, one could consider it to have been very long; if measured by the number of years that he lived it was not short, but, measured by the desire of men and the entire world, it was exceedingly short indeed.

Wherefore, although he created a living history unto himself so that to bear witness to future generations there is no need of written testimony, nevertheless it is commendable to relate something of his life to our descendants as much for encouragement as for fitting praise of ability.

This task I have undertaken to do as briefly as possible. I did this not so much to gain renown for my pen as to place in my debt future generations who will, I am convinced, be envious of the fortune that is ours in having seen, thanks to Bernini, the three noblest arts maintained in legitimate possession of their ancient dignity. These arts, which nearly met with complete degeneration and ruin, were reinstated in their proper place by the never sufficiently praised Michelangelo.

Pietro Bernini, the father of the Cavaliere, was a man of unusual reputation in painting and sculpture. In order to learn these arts, he left his native town of Florence when quite a young man and went to Rome, where, under the direction of Cavaliere Giuseppe d'Arpino, he worked in a praiseworthy manner in both fields, in the service of Alessandro Cardinal Farnese[2] and many others. Because others have already written of his works and because what he accomplished is so well known, it is not necessary to speak of them.

Tempted by the hope of greater advantages, Pietro went to Naples. There he married Angelica Galante, a Neapolitan, who in addition to their other children, on the 7th of December, 1598, bore a son to whom he gave the name of Giovanni Lorenzo. This is the person of whom we shall now speak. In truth he was born through divine dispensation to fill two centuries with his brilliance for the benefit of our Italy.

It seemed as if nature had employed all the strength of her skill in this boy. She granted to him a beautiful and vivacious charm, a sparkling and impressive talent, and she made it exceedingly easy for him to learn his father's art, which he loved beyond all measure, so that when he was eight years old he executed in marble a small head of a child to the wonder of all. . . .

But since the father's fame was daily spreading through Italy, when Paul V[3] planned to have a marble group executed for the façade of the Pauline Chapel, he desired

[2] He was employed for the decoration of the Villa of Caprarola.
[3] Paul V (1552–1621).

the services of such a master and obtained them from the Viceroy. Therefore when Pietro came to Rome with his numerous family and established his home here in this most celebrated capital of the world, a larger opportunity opened itself for the happy ascent of Giovanni Lorenzo's genius. For only in this city can one see the famous works of both ancient and modern painters and sculptors, as well as the priceless remains of ancient architecture, which braving time, no mean enemy, still stood as wonderful and glorious ruins. Thus it was easy for Bernini, through serious and continual study of the most noteworthy art works, especially those of the great Michelangelo and Raphael—in which is found an epitome of all that is exquisite and choice—to develop, in accordance to his talent, inspirations comparable to the lofty ones of those sublime spirits.

For this purpose he spent three continuous years from sunrise to Ave Maria closeted in the rooms of the Vatican, there drawing the finest and rarest things, trying with all his ability to attain a similarity to his models, the old masters. He immediately rose to such fame that in the academies of Rome one spoke of him as something incredible and never before seen.

The first work that came from his chisel in Rome was a marble head, now located in the church of S. Pudenziana.[4] He was just ten years old at that time.

For this reason, the Pope, Paul V, filled with admiration at the outcry that greeted such ability, desired to see the youth. He had him brought before him and then asked Bernini in jest if he knew how to make a pen sketch of a head. Giovanni Lorenzo asked what head His Holiness wished. The Pope said that if this is so he can draw any head and ordered him to draw a head of St. Paul. In half an hour, Bernini had finished it with boldly drawn outlines, to the great delight of the Pope.

Then the Pope earnestly desired that the still delicate and youthful talent of Giovanni Lorenzo be guided by

[4] In S. Prassede. Baldinucci confused the churches. It is on the tomb of Bishop Santoni. It is questionable that he executed it at the age of ten, as Fraschetti suggests. See Riegl, pp. 42 ff.

some authoritative hand in order that it might reach that degree of perfection of which it already gave promise. Therefore he entrusted the lad to the care of Cardinal Maffeo Barberini, who was fortunately in Rome at that time and who was a great lover and patron of letters and the arts. The Pope strictly ordered the Cardinal not only to watch zealously over the studies of Bernini but furthermore to see that they were done with fire and enthusiasm and made him answerable for the brilliant success that was expected of Bernini.

After encouraging the boy with affectionate words to continue with good spirit the career he had begun, the Pope gave him twelve gold medallions, which was as many as he could hold with both hands. Turning to the Cardinal, he said prophetically: "We hope that one day this boy will become the Michelangelo of his century."

The boy, instead of growing conceited over the fortunate success of his efforts and the praise of the great—as is the custom of only small spirits who are destined for everything else but the acquisition of true glory—indefatigably subjected himself to new and continuous studies. But what cannot an able spirit accomplish when fostered by wise and careful guidance! He showed his beautiful efforts to his father, who pointed out to him both the good and the bad. He praised the drawings but told his son that he would not again execute such good things, almost as if he thought that the perfection of the first work was due rather to a stroke of fortune than to his son's skill. It was indeed a clever idea, for in this way he induced the boy to carry on a constant competition with himself. Thus it is not to be wondered at that Bernini from then on was possessed by so great a zeal and an eagerness to surpass himself that, as he confessed when he become older, whenever he compared a work with another executed later or with some new ideas that he had conceived and desired to execute, he was never entirely satisfied.

At this time the boy Bernini was so enamored of art that not only did it occupy all his intimate thought, but furthermore, to associate with artists of the greatest reputation was his greatest pleasure. It happened one day that

he was in the Basilica of St. Peter with the celebrated Annibale Carracci and other masters. After all had performed their devotions and were leaving the church, the great master turned again to the tribuna and spoke these words: "Believe me, some prodigious genius must come, whenever it may be, who shall create two great works in correct proportion to the vastness of this temple: one here in the middle and the other at the end." So much and no more sufficed to enflame Bernini with the desire that he might execute them. Unable to arrest an inner impulse, he said with all the passion of his heart: "O, would that I were he!" And so unawares, he interpreted Annibale's prophecy and himself later fulfilled it, as we shall see when we come to speak of the wondrous things that he executed for those places. . . .

In the meantime, when he was fifteen, Bernini did a *St. Lawrence on the Grill* for Leone Strozzi which was placed in his villa. For the . . . Cardinal Borghese he executed a group, rather more than life-size, of Aeneas carrying the aged Anchises. It was the first large work he had done. Although something of the manner of Pietro, his father, is recognizable, one can perceive how from this time on by following his own excellent taste he approached more and more the sensitive and the true. This is especially evident in the head of the old man.

It is no wonder, then, that this same Cardinal immediately ordered from him a *David* of the same size as the first group. In this work Bernini far surpassed himself. He executed it in the space of seven months, thanks to the fact that even at that youthful age, as he later used to say, he was able to devour the marble and never make a useless stroke. Such a mastery is not usual even in men long expert in the art; but belongs only to those who have raised themselves above the art itself. The magnificent head of this figure, in which he portrayed his own features, the vigorous downward-drawn and wrinkled eyebrows, the fierce fixed eyes, the upper lip biting the lower, expresses marvelously the righteous anger of the young Israelite taking aim at the forehead of the giant Philistine with his sling. The same resoluteness, spirit, and strength is

found in every part of the body, which needs only movement to be alive. It is also worth noting that while Bernini was working on it in his likeness, the Cardinal Maffeo Barberini came often to Bernini's studio and held the mirror for him with his own hand. . . .

At this time Cardinal Maffeo Barberini was elevated to the Papacy [on August 6, 1623] with the name of Urban VIII. After having previously been a colleague of Gregory Ludovici in the College of the Clerics of the Apostolic Chamber, he now became his fortunate successor in this highest of offices.

Thus the widest opportunity opened itself to Bernini. For this great Pontiff had scarcely ascended the Holy Chair when he had Bernini called to him and after receiving him in an affectionate manner spoke to him in the following way: "Great is your fortune, Cavaliere, to see the Cardinal Maffeo Barberini as Pope, but far greater is ours to have Bernini living in our Pontificate. . . ."

From the time when His Holiness, Paul V, had entrusted the supervision of this lofty genius to the Cardinal, he had lived in the expectation that Bernini would accomplish great things. Also he had conceived the ambition that Rome during his pontificate and under his influence should produce another Michelangelo. This desire was increased because he already had the magnificent suitable project in mind for the high altar in St. Peter's at the place that is called the Confessional; and also for the painting of all the Loggia della Benedizione. For this reason the Pope had given Bernini to understand that it was his wish that the artist devote a large part of his time to the study of architecture and painting in order that he might add to his other eminent gifts the knowledge of these arts. The youth was not slow in listening to the advice of his friend, the Pontiff, and undertook these studies without other masters than the ancient statues and buildings of Rome, for, he was wont to say, as many of them are found in that city as masters paid for by the young scholars.

For the space of two continuous years Bernini devoted himself to the study of painting; that is, skill in the handling of color, for he had already mastered by his intensive

study the great difficulties of drawing. During this time, without neglecting the study of architecture, he executed a large number of pictures both large and small, which are splendidly exhibited today in the most celebrated galleries of Rome and other worthy places; but we will speak in detail of these in another place.

The Pope determined then to carry out his great plan for the decoration of the above-mentioned Confessional of St. Peter and St. Paul in the Vatican Basilica, and gave Bernini the commission, allowing him three hundred *scudi* monthly for this purpose.

Now it would seem to be my duty to give a description of the great work Bernini undertook; of the four wonderful bronze columns that support the Baldachin crowned with the beautiful ornament and finally with the cross. But I believe I need not describe either this or the other works in that church that may still be seen and that were executed by Bernini himself or from his designs. . . .

The Cavaliere used to say that it was due to chance that this work came out so well. He wished to infer that artistic ability alone would not have been able to supply the correct measurements and proportions under such a large dome and in so vast a space and among piers of such enormous size, had it not been that the genius and the mind of the artist knew how to conceive without any rule what that correct measure ought to be.

I must not pass over, at this point, the fountain that Bernini executed[5] in the Piazza di Spagna at the suggestion of Pope Urban, because in it, in his customary fashion, he demonstrated the brilliance of his genius. Because of the fact that there was not sufficient pressure for a fountain in the Piazza, a monument which was to give the impression of either richness or magnificence presented no small problem to any artist, no matter how skillful he might be. Bernini, therefore, made a large, beautiful basin that was to be filled with the water from the fountain. In the middle of the basin, almost as if floating on the waves of the sea, he placed a noble and gracious ship from several points of which, as from so many gun barrels, water was made to

[5] 1640.

spring forth in abundance. This idea appeared so beautiful
to the Pope that he deigned to express it in the following
beautiful verses:

Bellica Pontificum non fundit machina flammas,
Sed dulcem, belli qua perit ignis, aquam.[6]

. . . But since we speak of fountains, I shall say that it
was always Bernini's opinion that in designing fountains
a good architect ought to give them some real significance,
or at least an illusion of something noble taken from either
reality or imagination. Even during the lifetime of Pope
Urban, this principle was practiced by Bernini, as is seen
in the beautiful fountain of Piazza Barberina executed
from his design and by his chisel, in which three dolphins
support a basin above which is a beautiful figure of Triton
blowing a shell from which water gushes. . . .

But the Pope, whose opinion of Bernini grew with every
day, desired, so to speak, to immortalize him and con-
tinually urged him to marry, not so much in order that
some of his children might remain in Rome as heirs of his
skill as to have someone who would look after Bernini's
needs so that the artist would have more time and quiet for
the practice of art. Although the Cavaliere disdained the
idea, saying that his statues would be his children which
would keep his memory alive in the world for many cen-
turies, he finally decided to give in to the Pope's advice
and reconciled himself to marriage. In the course of the
year 1639, he chose from among the many excellent offers
made to him the daughter of Paolo Tezio, secretary of the
Congregation of the Santissima Nunziata, a good and able
man. Bernini lived with his wife thirty-three years and had
numerous children.

But to return, so many were the works that he executed
during the lifetime of that great Pope, that in order not to
tire the reader we will discuss them with brevity and
without binding ourselves to chronological order. He made
the designs for the Palazzo Barberini, for the Campanile
of St. Peter, and for the façade of the Collegio de Propa-

[6] "The warlike machine of the Pontiff does not pour out
flames but sweet water by which it extinguishes the flames of
war."

ganda Fide. This building, which was threatening to collapse, was reinforced by Bernini by such artistic means that the ornament itself served as support for the building —a thing that no one ignorant of the fact would ever suspect. . . .

Ordinarily as often as a man loses what he has grown accustomed to have, or fails to obtain what he wishes, he gives way to violent feelings which, like enemies assailing a city, destroy his peace and keep him in continual torment; wherefore those are esteemed the wisest who permit themselves to be carried away the least by such passions. It seemed necessary, therefore, that a man like Bernini should be subjected to the ordeal of persecution, and that he should for a while be denied that acclaim which his talents were wont to receive, so that the world might learn thereby the constancy and other qualities of his character. These were brilliantly demonstrated both by the fortitude with which he bore so many blows and by the complete control of his feelings which enabled him to live quietly and at the same time produce the most beautiful works of his career.

These were in the first place, the design for the chapel of the Cardinal Federigo Cornaro in the Church of S. Maria della Vittoria of the Barefooted Carmelites, not far from the Porta Pia, and surpassing all, the admirable group of St. Teresa with the Angel who, while she is transported into sweetest ecstasy, wounds her heart with the arrow of divine love. This is a work which, because of its great delicacy and all its other qualities, was always an object of admiration. I shall not exert myself in praising it and shall only say that Bernini himself was accustomed to say that this was the most beautiful work that ever came from his hand. . . .

So strong was the sinister influence[7] which the rivals of Bernini exercised on the mind of Innocent X that when he planned to set up in the Piazza Navona the great obelisk brought to Rome by the Emperor Antonino Caracalla,

[7] [As a result of the necessary demolition in 1646 of the two bell towers which Bernini had built for St. Peter's, he incurred the disfavor of Innocent X.]

which had been buried for a long time at Capo di Bove, for the adornment of a magnificent fountain, the Pope had designs made by the leading architects of Rome without giving an order for one to Bernini. But how eloquently does true ability plead for its possessor, and how effectively does it speak for itself! Prince Niccolò Lodovisio, whose wife was a niece of the Pope and who was at that same time an influential friend of Bernini, persuaded the latter to prepare a model. In it Bernini represented the four principal rivers of the world, the Nile for Africa, the Danube for Europe, the Ganges for Asia and the Rio della Plata for America, with a mass of broken rocks that supported the enormous obelisk. Bernini made the model and the Prince arranged for it to be carried to the Casa Pamfili in the Piazza Navona and secretly installed there in a room through which the Pope, who was to dine there on a certain day, had to pass as he left the table. On that day, which was the day of the Annunciation, after the procession, the Pope appeared and when the meal was finished he went with Cardinal Pamfili and Donna Olimpia, his sister-in-law, through that room and, on seeing such a noble creation and the sketch for such a vast monument, stopped almost in ecstasy. Being a Prince of the keenest judgment and the loftiest ideas, after admiring and praising it for more than half an hour, he burst forth, in the presence of the entire privy council, with the following words: "This is a trick of Prince Lodovisio. It will be necessary to employ Bernini in spite of those who do not wish it, for he who desires not to use Bernini's designs must take care not to see them." He sent for Bernini immediately. With a thousand demonstrations of esteem and affection and in a majestic way, almost excusing himself, he explained the reasons and causes why Bernini had not been employed until that time. He gave Bernini the commission to make the fountain according to the model. . . .

The sun had not yet set upon the day which was the first of Cardinal Chigi in the Highest Pontificate, when he summoned Bernini to him. With expressions of affectionate regard, he encouraged Bernini to undertake the great and lofty plans that he, the Pope, had conceived of for the

greater embellishment of the Temple of God, the glory of the pontifical office, and the decoration of Rome.[8]

This was the beginning of a new and still greater confidence that during this entire pontificate was never to be ended. The Pope wished Bernini with him every day mingling with the number of learned men he gathered around his table after dinner. His Holiness used to say that he was astonished in these discussions how Bernini, alone, was able to grasp by sheer intelligence what the others scarcely grasped after long study.

The Pope named him his own architect and the architect of the Papal Chamber, a thing which had never before happened to Bernini because each former pope had had his own family architect on whom he wished to confer the post. This practice was not observed by popes after Alexander VII because of the respect they had for Bernini's singular ability, so that he retained the office as long as he lived.

. . . Bernini, with a monthly provision of 260 *scudi* from the Pope, began to build the Portico of St. Peter, which in due time he completed. For the plan of this magnificent building he determined to make use of an oval form,[9] deviating in this from the plan of Michelangelo. This was done in order to bring it nearer to the Vatican Palace and thus to obstruct less the view of the Piazza from that part of the palace built by Sixtus V with the wing connecting with the Scala Regia. The Scala Regia is also a wonderful work of Bernini and the most difficult he ever executed, for it required him to support on piles the Sala Regia and the Paolina Chapel, which lay directly over the stairs, and also to make the walls of both rest on the vault of the stairs.[10] Furthermore, he knew how to bring, by means of a charming perspective of steps, columns, architraves, cornices, and arches, the width of the beginning of the stairway most beautifully into harmony with the narrowness at its end. Bernini used to say that this

[8] [Sant' Andrea al Quirinale. *Fig.* 4]
[9] [See our *fig.* 15]
[10] [See Panofsky, "Die Scala Regia im Vatikan und die Kunstanschauungen Berninis," *Jahrbuch der preussischen Kunstsammlungen*, XL, 1919, Berlin, p. 241.]

stairway was the least bad thing he had done, when one considered what the stairway looked like before. The supporting of these walls was the boldest thing he had ever attempted, and if, before he applied himself to the task, he had read that another had done it, he would not have believed it.

It is wonderful how at this same time Bernini was able to carry forward the great work of the Portico and to apply himself also, at the order of Alexander VII, to the execution of the Cathedra of St. Peter, filling the end of that great basilica with the mighty monument in accordance with the above-mentioned prophecy of Annibale Carracci. The Cathedra was supported by four great bronze colossi representing the four doctors of the church: the two Greeks, Gregorious of Nazianzen and Athanasius, and the two Latins, Augustine and Ambrose. With a singular grace they support a base on which the Cathedra lightly rests. Here one must admire the incomparable patience of Bernini, who, having made with his own hands all the clay models of this great work, found that the colossal figures were too small and did not hesitate to remake it in the exact size in which the figures now appear.

In the year 1664 of the Roman calendar, before the end of March, His Majesty the King of France, Louis XIV, decided to restore and enlarge the Louvre with regal magnificence. Plans and projects had already been made by his own architects, but wishing to satisfy his own exquisite taste, impossible unless the plan met the approval of even the most cultured eye, he wanted the opinion of our architect. M. Colbert, one of his principal ministers, was directed to write the following:

Monsieur:

The rare products of your genius which make you admired throughout the world and of which the King, my master, has a perfect knowledge, would not permit him to finish his superb and magnificent edifice, the Louvre, without showing the plans to a man as excellent as yourself and obtaining your opinion. Thus it is that he has commanded me to write these

lines to request you particularly to give a few of those
hours you spend with such glory in the embellishment
of the first city of the world to view the plans which
will be presented to you by Monsignor the Abbot
Ellipidio Benedetti. His Majesty hopes that you will
not only give him your opinion of these plans, but
will also put on paper some of those admirable ideas
that occur so frequently to you, and of which you have
given such ample proof. He desires you to give com-
plete credence to all the Abbot will tell you about this
subject. I assure you in these few lines that I am truly,
 Monsieur,
 Your Most Humble and Obedient Servant,
 Colbert

Since he had received such an order, Bernini studied
the plans and went to work on designs of his own which
he sent to the King, meanwhile continuing his work on the
Cathedra and the Portico of St. Peter's. In proof that his
design for the palace greatly pleased the King, I shall not
cite the very valuable gift of his portrait studded with
diamonds worth three thousand *scudi*, for to attempt to
evaluate the King's esteem by this gift would be an obvious
mistake, since it might better be interpreted as a token of
the King's great generosity. The real proof of the King's
esteem lies rather in the letter which he sent to the artist
and still more in that written to the Pope. Both letters I
shall quote . . . :

Letter of His Majesty the King.

Signor Cavaliere Bernini:
 I have so high a regard for your merit that I have a
great desire to see and know better so illustrious a
personage, provided that my wish is compatible with
the service you are rendering our Holy Father, and
with your own convenience. My desire prompts me to
send this by special courier to Rome, to invite you to
honor me with a journey to France when the Duke of
Crequi, my Cousin and special Ambassador, returns.
He will tell you about the urgent cause which makes
me wish to see you and discuss with you your beauti-

ful plans which you have sent me for the building of
the Louvre. As to the rest, my Cousin will let you
know my good intentions. I pray God that he may
have Signor Bernini in his Holy custody.

From Lyon

Written in Paris, April 11, 1665
Louis

Letter of the Most Christian King to the Pope.

Most Holy Father:

Having already received by order of Your Holiness
two plans for my edifice, the Louvre, by so celebrated
a hand as the Cavaliere Bernini's, I should thank you
for that favor rather than demand others of you. But
as it is a question of a building that for many cen-
turies has been the principal residence of Kings who
are the most zealous in all Christendom for the Holy
See, I believe I may dare approach Your Holiness
with every confidence. I implore you, (if his service
permits him) to command the Cavaliere to travel
here to finish his work. The Holy Father could not
grant me a greater favor under the circumstances. I
shall add that there will never be anyone who will
show him more veneration and sincere respect than I,
Most Holy Father,

Your most devoted son,
Louis

His Majesty's letters arrived at a time when the Duke
of Crequi, Royal Ambassador to Rome, had already taken
leave of His Holiness and was on the point of departure.
It was necessary for him to reappear at the Palace with
the customary ceremony to present the letters. He went to
Bernini with the same pomp, explaining that His Majesty
wished him to journey to France, not only for the sake of
the Louvre, but also because of his great desire for a por-
trait bust by him.[11] At such a great summons, Bernini felt
joy and fear at the same time. His joy persuaded him to go
and reap the fruits of his long and unceasing efforts to
attain this great honor the Monarch offered by calling him

[11] [Our fig. 5]

to his own service, but his heart failed him at the thought of exposing himself at the age of sixty-eight to the dangers of such a long journey. His great anxieties were quickly dispelled by the care, the eloquence, and the affectionate love of his dearest friend, Father Gianpaolo Oliva, General of the Company of Jesus, who was as much a credit to that noblest of all orders as he is the glory of our century. Obeying his own dictates, desiring to please the King, and urged by Cardinal Antonio Barberini in the King's name, Father Oliva persuaded Bernini to accept the invitation. He quieted with hope the Cavaliere's just fears and confirmed the belief that to obey such a summons was a beautiful act, even at the cost of one's life. Therefore we see Bernini, hesitating no longer, determined upon and ready for the journey. . . .

But before speaking of Cavaliere Bernini's last illness, and of his death, which appeared to our eyes truly like his life, it should be stated here that although until his fortieth year—which was the year he married—he had been entangled in certain youthful affairs, it was, however, without any consequences which could have been prejudicial to his studies of art and to what the world calls "prudence." We may say with truth that not only did his marriage put an end to that manner of living, but from that time he began to behave like a religious rather than a secular man, and with such sincerity, according to what was reported to me by those who knew him well, that he might have been admired by the most perfect monastics.

The idea of death he kept always present before his mind and on this subject he often held long discussions with his nephew, P. Marchesi, the priest of the congregation of the oratory of the Chiesa Nuova, a man who is well known for his goodness and learning. With such desire did Bernini always long for the happiness of this last step that, for this sole end, he continued for forty years to frequent the special devotions celebrated for this purpose by the Jesuits in Rome. Here, too, he went twice a week to partake of the sacrament. He increased the alms which from an early age it had been his custom to give.

He lost himself in contemplation of this thought of death

and in the expression of the most profound reverence and understanding that he always had of the efficacy of Christ's blood, in which he was wont to say he hoped to drown his sins. For this same reason he drew and then had printed an image of Christ crucified from whose hands and feet gushed rivers of blood which formed almost a sea while the great Queen of Heaven stands there offering it to the Eternal Father. This same sacred meditation he also had painted on a great canvas which he wished to have hung always before his bed in life and in death.

When the time had come, I know not if I should say whether because of the great loss of strength which was to be expected or because of his longing for the eternal repose so long desired, he fell ill of a slow fever which was followed at the last by a stroke of apoplexy which then deprived him of life.

He was about to breathe his last when he made a sign to Mattia de' Rossi and Giovanni Battista Contini, who had been his pupils in architecture. Almost jokingly he expressed as best he could his amazement that they could not think of some contrivance to draw the catarrh from his throat, and pointed with his hand to a mathematical instrument for raising exceedingly heavy weights. His confessor then questioned him about the state of his soul and asked if he had any fears. He replied: "My father, I have to account to a Lord who in bestowing His goodness does not count His farthings." Then he observed that his right arm and side were somewhat incapacitated by apoplexy and added: "It is fitting that this arm should rest somewhat before death because it has worked so hard in life."

Meanwhile Rome wept for her great loss and his house was filled with persons of high rank and people of every kind seeking news of him and wishing to visit him. The Queen of Sweden, many Cardinals and the ambassadors of many princes came in person or sent messengers at least twice a day. Finally His Holiness sent Bernini his blessing, and about midnight, early on the twenty-eighth day of November, after fifteen days of illness, Bernini passed from this life to another, just nine days short of eighty-two years of age.

FRANCE

PAUL DE FRÉART, SIEUR DE CHANTELOU

[Paul de Fréart, Sieur de Chantelou (1609–1694), was the youngest of the three Fréart brothers prominent in the intellectual and court life of France in the seventeenth century. He was a well-known connoisseur of art and possessed an excellent collection of paintings. Accompanying his cousin, Sublet des Noyers, Superintendent of Buildings (see p. 147, note 14), he spent three years in Rome (1640–1643) where he met Poussin and Bernini. The letters written him by Poussin (see below) are a testimony to their friendship. As *Maître d'Hôtel* for Louis XIV, Chantelou was chosen by the King to meet Bernini when he came to France and accompany him during his stay. Some years later, at the request of his brother, Jean de Fréart (1604–1674), he wrote from his notes, in the familiar, current style of the court, the diary of Bernini's journey in France.

The Sieur de Chantelou is sometimes confused with his brother, Rolland de Fréart, Sieur de Chambray (1606–1676), a writer and connoisseur of art. He published notes from Leonardo's writings and was also a friend of Poussin.]

DIARY OF CAVALIER BERNINI'S JOURNEY IN FRANCE[1]

June 6th [1665]. On the sixth, while the tables were being made and other things necessary for drawing were

[1] The excerpts are translated from *Journal du voyage du Cavalier Bernin en France*, Paris, 1930. The text was first published by L. Lalanne, "Journal du voyage du Cavalier Bernin en France," *Gazette des beaux-arts*, xv–xxxi, 1877–1885.

See also: Henri Chardon, *Les Frères Fréart de Chantelou*, Le Mans, 1867; L. Mirot, "Le Bernin en France," *Mémoires de la société de l'histoire de Paris et de l'Île-de-France*, xxxi, 1904, pp. 161 ff.

being prepared, the time was passed in conversation. As the Cavalier Bernini is a man with a famous name and a great reputation, I, in agreement with you, my very dear brother, have deemed it a useful thing for our common study and for our amusement to preserve some record of what I have heard said by him. You who have never seen him will perhaps be glad if I make a rough draft, or as the Italian painters say, a *schizzo*, of him and his character.

So I will tell you that the Cavalier is a man of short stature but well-proportioned, thin rather than fat, and of a fiery temperament. His face resembles an eagle's, especially the eyes. He has very long eyebrows and a large forehead that is a little caved in toward the middle and rises gently from the eyes. He is bald, and what hair he has is curly and white. By his own admission, he is sixty-five. Nevertheless, he is vigorous for that age, and walks firmly as though he were only thirty or forty. One might say that his mind is one of the most perfect nature has ever formed, for, without having studied, he has almost all the gifts which the sciences give a man. Besides, he has a fine memory, a lively and quick imagination, and his judgment seems clear and sound.

His enunciation is very beautiful and he has a special talent for explaining things with words, expressions, and gestures, and for making them vivid as well as the greatest painters have been able to do with their brushes. No doubt this is why he has succeeded so well with the comedies he has written. They have won, it is said, universal approval, and they caused a great stir in Rome because of the decorations and the astonishing contraptions he introduced, which deceived even those who had been forewarned. On every occasion Bernini likes to quote Pope Urban VIII, who loved and cherished him from his early youth. One of the first things I remember his telling me is that the Pope, at that time only a cardinal, was once at the house of Bernini's father, who was also a sculptor. After seeing a work that the Cavalier had finished at the age of eight, Cardinal Barberini (for so Urban VIII was then called) laughingly said to Bernini's father: "Signor Bernini, take care! That child will surpass you and doubtless will be more skillful

than his master." He said that his father replied brusquely, "Your Eminence knows that in this game, he who loses wins."

Speaking of sculpture and of the difficulty of achieving success, especially in obtaining a resemblance in marble portraits, he told me one remarkable thing, and this he has since repeated on all occasions: that if some one whitened his hair, beard, eyebrows, and, if it were possible, the pupils of his eyes and his lips, and in that state showed himself to those who are wont to see him every day, they would scarcely recognize him. In order to prove this he added: when a person faints, the pallor alone which spreads over his face makes him almost unrecognizable, and it is often said "He no longer seems himself." It is equally difficult to achieve a likeness in a marble portrait, which is all of one color. He said another thing even more extraordinary: sometimes in order to imitate the model well it is necessary to introduce in a marble portrait something that is not found in the model. This seems to be a paradox, but he explained it thus: in order to represent the darkness that some people have around the eye, it is necessary to deepen the marble in the place where it is dark in order to represent the effect of that color and thus make up by skill, so to speak, the imperfection of the art of sculpture, which is unable to give color to objects. However, he said, the model is not the same as the imitation. Afterwards, he added a rule which, according to him, should be followed in sculpture, but of which I am not as convinced as of the preceding ones. He said: a sculptor creates a figure with one hand held high and the other hand placed on the chest. Practice teaches that the hand in the air must be larger and fuller than the one resting on the chest. This is because the air surrounding the first alters and consumes something of the form or, to express it better, something of the quantity of the form. I myself believe that this diminution would take place in nature itself; therefore it is not necessary to represent in the figure what is not in nature. I did not tell him so and since then I have thought that the ancients followed a rule of making the columns which they placed at the corners of the temples one-

sixteenth larger than the others, because, as Vitrivius says, being surrounded by a large quantity of air, which consumes their quantity, they would have appeared less large than their neighbors, even though they were not so in reality.

Then, speaking of painting as compared to sculpture, each having its partisans who have disputed at length in recent centuries, as much as in the time of the Greeks, the question to which of the two arts must be given precedence and the place of honor, the Cavalier endeavored to show by well-contrived arguments that painting is much easier and that a great deal more effort is required to attain perfection in sculpture. In order better to prove his proposition, he offered an example: "The King wants a beautiful work of sculpture, and discusses it with a sculptor to whom he allows the liberty of choosing the subject after his taste. For the task, His Majesty gives the sculptor one, two or three years, in short as much time as he may desire to perfect his work. The King makes the same proposition to a painter for a work of painting and allows the painter the same freedom of time and of subject. If the painter is asked, when the time has expired and his work is finished, whether he has put all the perfection of art of which he was capable into his work, he can freely answer in the affirmative since he has been able to put into his painting what he knew when he began the work, but also to add what he acquired in studying his subject during the entire time he had for the execution, whether six months, a year, or longer. The same is not true of the sculptor, the Cavalier said, for when his work is completed and he, too, is asked if it represents the best he could do, he might answer negatively, and be right, that it only represents what he knew when he began the work and that what he has learned since he could not add to this work, for he could neither change the pose he had decided to choose at the beginning nor correct it in accord with the progress he was making through study in his profession.

Afterwards he went from his room, where we were, onto his gallery. There he told me that he has a gallery almost exactly like this one in his house at Rome and that it is

there that he creates most of his compositions as he walks around; that he notes on the wall with charcoal the ideas as they come to him; that it is usual for agile and imaginative minds to pile up thought upon thought on a subject. When a thought comes to them, they draw it; a second comes, and they note it also; then a third and a fourth; without discarding or perfecting any, they are always attached to the last idea by the special love one has for novelty. What must be done to correct this fault is to let these different ideas rest without looking at them for one or two months. After that time one is in a condition to choose the best one. If by chance the work is urgent and the person for whom one works does not allow so much time, it is necessary to have recourse to those glasses that change the color of objects or those that make objects seem larger or smaller, and to look at them [the sketches] upside down, and finally to seek through these changes in color, size, and position to correct the illusion caused by the love for novelty, which almost always prevents one from being able to choose the best idea.

August 19th. On the nineteenth, having come to the house of the Cavalier, I learned that M. Colbert had just left; that he had brought back the plans of the Louvre and had left a memorandum of the things necessary in the apartments for the convenience of the King, the two queens, the Dauphin, and the officers of their retinue; and others in charge of the kitchens, provisions, glasses, the five pantries, the offices and rooms for the tables of the Grand Maître, chamberlain, maîtres, etc.; also of the things necessary for the construction of a water reservoir from which water could be pumped in case of fire, and of room for storing the implements necessary in case of such an accident; a plan for the banquet and ballrooms, and for the adaptation of the theater room; for a large armory in the Louvre. . . .

At noon M. Villeroi[2] came to see the bust (our *fig.* 5) in the southern apartment and served as an advance courier for the King, who came subsequently with a great

[2] Marshal of France: Nicolas de Villeroi (1598–1685).

crowd. The Cavalier had begun to give form to the nose, which was as yet only blocked in. M. de Crequi came forward to whisper in the King's ear. The Cavalier said laughingly, "These gentlemen have the King with them at their pleasure all day and they do not wish to leave him to me even a half-hour; I am tempted to do a caricature portrait of one of them." No one understood the remark. I said to the King that those were portraits in which the resemblance was in the ugly and the ridiculous. Monsignor Butti took up the conversation and remarked that the Cavalier was excellent at that sort of portraiture and that one should be shown to His Majesty. As a portrait of a woman was mentioned, the Cavalier said, "One must make a caricature of women only at night." M. de Prince, who was there, affirmed that under the hand of the Cavalier the resemblance of the bust to the King increased from one time to the next. The Marshal de Villeroi agreed. After three quarters of an hour, His Majesty left, saying to the Cavalier that he would not come back the next day but that on the following Thursday he would sit for him two or three hours. As he left the room, Madame de la Baume approached the King, who stationed himself near a window and gave her an audience of a good quarter of an hour. Then M. Colbert gave her a long audience too, after which he came to see the bust and remained in the room for some time. I told him that I had taken the Cavalier to Vincennes and that he was pleased by it, that he had said that the King was nowhere so well lodged and that he had thought the woodcarving, the gilding and the pictures very beautiful.

After Colbert had gone, the Cavalier said it would be enough for the King to come twice more; however, if His Majesty wished to come more often, the bust would not only resemble him but would be a speaking image of him. I forgot to say that Varin was there the entire time the Cavalier was working. Every one questioned Varin about the bust. He said to me that he believed the Cavalier had removed too much from the forehead and that it was impossible to replace marble. I assured him that this was not so and that the Cavalier's intention was to make the part

of the forehead above the eyes very high, it being so in the model apart from the fact that one sees this treatment of the forehead in all the beautiful antique heads; and that the Cavalier and I had discussed the point at the beginning of the work.

In the afternoon, M. le Nonce came. Lefebvre, the painter, came with him. They admired the resemblance of the bust. After having studied it from all sides, Lefebvre exclaimed that even in the back there was a resemblance. Hearing this, the Cavalier said something worthy of note: that in the evening, if a candle is placed behind some one in such a way that his shadow falls on a wall, one will recognize the person from the shadow, for it is true that no one's head is set on his shoulders in the same way as another's. The same is true of the rest of the body. The first thing the artist must consider in working for a resemblance is the general impression of the person rather than the details.

In the morning, the Cavalier had told me he had observed, while working on the King's nose, that His Majesty's was of a peculiar shape, the lower part which joins the cheek being narrower than the front of the nose. This observation would aid in the resemblance. . . .

September 5th. On the fifth the Cavalier worked as usual, and in the evening he went to the Academy.[3] MM. du Metz, Nocret, and de Sève, as delegates of the group, came to receive him at the street door. The Cavalier went first to the place where one draws from the models, who when they saw him assumed the poses assigned them. After remaining there some time, he went into the hall where the academic lectures are held. The place of honor was offered him, but he did not wish to occupy it. The assembly was very large. M. Eliot, counselor at the *Cour des aides,* was there. The Cavalier glanced at the pictures in the hall which did not happen to be of the greatest value. He also looked at some bas-reliefs by some sculptors of the Academy. Afterwards, standing in the center of the hall surrounded by all members of the entire Academy, he

[3] Pevsner, *Academies,* pp. 82–101.

said that in his opinion there should be in the Academy casts of all the beautiful antique statues, bas-reliefs, and busts for the instruction of the young students, who should be required to draw in the antique style in order to form first from these works the idea of beauty which would then serve them all their life. The students would, in his opinion, be ruined if at the beginning they were set to draw from nature, for nature is almost always feeble and trifling. As a result, their imagination being filled only with the model in nature, they would never be able to produce anything great or beautiful which is not found in nature. Those who make use of nature should be sufficiently skillful to recognize its defects and correct them. Young people with no background are incapable of doing this. To prove his contention, he said that sometimes parts in the model that appear in relief should not be so and other parts that should be in relief do not appear so at all. He who possesses a good sense of design, disregards what the model shows when it should not appear in the work of art and emphasizes what ought to be there but does not appear in the model. He also said that a young man who has never possessed a knowledge of the beautiful is not capable of doing this. The Cavalier said that when he was very young he often drew from the antique and that in the first figure he did, when he was not sure of something he went to consult the Antinous as his oracle, and he noticed from day to day beauties in this figure which he had never seen and never would have seen had not he himself been working with a chisel. For this reason he always advised his students and all others not to abandon themselves so much to drawing and modelling that they did not work at the same time either in sculpture or painting, combining production and copying, or, so to speak, action and contemplation—from which procedure progress results. I cited as an example, the better to confirm that actual work with the material is absolutely necessary, the late Antoine Carlier, known to most of the Academy, who had spent a good part of his life in Rome modelling in an incomparable fashion all the beautiful antiques, and I made them [the Academicans] confess that, as he had begun too late to

work from his imagination, his genius had become sterile through the slavery of imitation, and it then became impossible for him to produce any original work. With regard to painters, the Cavalier added that besides drawings that could be made from antique bas-reliefs and statues, it was also necessary to help the students by providing copies of the artists who painted in the grand manner, like Giorgione, Pordenon, Titian, and Paul Veronese, rather than Raphael, even though he was the most correct of all. It has been said of this painter that no one else was comparable to him in composition because he had had for friends Bembo and Balthazar Castiglione, who helped him by their knowledge and their genius. Then the Cavalier said that it was an academic question whether a painter should allow a picture to be seen as soon as it was finished, or whether it would not be better to put it away for awhile, and then look at it again before exhibiting it to the public. It was Annibale Carracci's choice to exhibit a picture immediately in order to learn its faults—whether it was too dry, too hard or had other errors—in order to correct them. The Cavalier added that in order to stimulate competition in the Academy it was good to give prizes as Cardinal Barberini gave in the Academy in Rome, of which he [Bernini] was a member. The prize to whoever does the best drawing ought to be an order for a picture from the drawing, and it should be liberally paid for and similarly the sculptor who made the best model should receive an order for a statue for the Louvre and should be well paid for it. And then he said that, having worked nearly sixty years, he could give a little advice. I answered that it was true and that a man of his genius and experience who would speak frankly would do more good in an hour of instruction than many years of research and study. M. Le Brun arrived at that moment. The Cavalier greeted him courteously and went on to say that three things were necessary for success in sculpture and painting: to see the beautiful early and accustom oneself to it, to work hard, and to have good advice. A man who had worked hard was able with very few words to save one a lot of trouble

and to point out corrections and short-cuts. He repeated that Annibale Carracci believed in exhibiting a picture to public criticism as soon as it was completed, for the public was not deceived, did not flatter, and never failed to say, "It is dry, it is hard," when it was. He added that it was necessary for each person to correct the fault he may have by its opposite, the sober by the easy going, the meager and feeble by the bulky and substantial, the airy by the sober. Some one then showed him the *Crucifixion* by Sarrazin, which he contemplated and then said that it was beautiful, but it was done in such a way that one seems to see a body slumping under the impact of torture. From the Scripture, one learns that the body of Our Lord was pulled with ropes to stretch it; thus the body could not slump as it does in that crucifix.

Then he returned to the place where the models were and saw the drawing of two or three academicians, among others, one by a young boy ten or twelve years old which he found very advanced. He said to me, in a low voice, that one should not study by lamp in the summer because of the heat, but by the light of day.

Afterwards, he took leave of the entire Academy, which descended to see him out, and among the others MM. du Metz and Perrault, who had arrived in the meantime.

October 6th. On the sixth, I did not go to the Cavalier's house until the afternoon. He was still resting, I found a great crowd looking at the bust, among others Madame Colbert. I had given the order for the King's carriage to come to the Cavalier's house as he had requested.

. . . The Nuncio and the Ambassador having left, we went to the Louvre. There the Cavalier requested me to learn if the King was in council so that he might see, if His Majesty had gone out, whether there would be an advantageous place for the bust in his apartment. The King was in council; so we went to the new apartment of the Queen Mother, where Bernini had planned to place the bust on the platform for the audiences and the little Christ in the cabinet behind. From there we went to see

the Queen and then the Cavalier came back, as M. Per-
rault[4] had sent word that he would come at five o'clock.
Not finding him there, Bernini asked me to go with him
to the Feuillants. When we returned we found M. Per-
rault. My brother, who desired to be present, was with us.
The Cavalier said that he hoped the foundation [of the
Louvre] would be ready on Saturday so that the first stone
could be laid. M. Perrault replied that the coins [to be
buried in the foundation] would not be ready for that day.
The Cavalier replied that they would go under other stones,
that he wished to leave the following Tuesday because of
the cold. M. Perrault talked to him of the arches of the
kitchen court façade and the difficulty there would be in
closing them. The Cavalier took a pencil and showed in
what manner it should be done. I said that these were little
difficulties that were not pressing and there would be time
to think of them in three or four years; that in the new
apartment of the Queen Mother were similar arches for
which frames had been made. Perrault replied that this
had been done with the greatest difficulty. I repeated
that these were all minor matters that were in no way
pressing, that all was clear in the plan. M. Perrault told
me that he had a notebook full of the difficulties which
were to be faced. The Cavalier had the plan brought so
that Perrault could show the things he wished explained.
There was one matter that deserved explanation, Perrault
said: not only he but a hundred others would like to know
why this part of the new pavilion on the river side is
smaller than the other, that being contrary to symmetry
and having no relation to the dome in the middle of this
façade. From Perrault's pointing to the plan, and from
what he [Bernini] had understood of the conversation,
although he does not know French, he had grasped that
Perrault was talking of his work and asserting that there
was a fault in the design. He looked at two Italians who

[4] Claude Perrault (1613–88) succeeded Bernini. His plan for
the columned façade of the Louvre was adopted. See R. Blom-
field, A History of French Architecture, 1667–1774, London,
1921, 1, pp. 68–83; A. Blunt, French Art and Architecture,
1500–1700, Penguin, Harmondsworth, 1957, pp. 189–190.

were there and told them to go away. Then he took the pencil and said that if he had drawn this new part of the pavilion on the level of the angle of the façade it would have been a gross error; it sufficed that there should be a relation between this part of the pavilion and the other, although this part was not so large; he wished Perrault to know that it was not for him to make these difficulties; he was ready to listen to discussions on the convenience of the palace, but for the composition of the design, it must be someone cleverer than he (the Cavalier pointed with his finger to himself) who tried to correct it; in this matter Perrault was not worthy to clean the soles of his shoes; but this was not the question of the moment; his design had pleased the King; he would make his complaints to the King, and presently he was going to M. Colbert to tell him of the insult he had received. M. Perrault, seeing that the Cavalier took the matter in this way, was very much alarmed. He begged me to soothe the Cavalier and to make him understand that he did not seek to find fault with the Cavalier's work, but to have some reply ready for those who would make the same objection. This I told the Cavalier. I begged him to consider that if he brought the matter to this point he would deprive a young man of his career, and I implied that the Cavalier was too good to wish to be the cause of M. Perrault's disgrace. His son and Signor Mathie, who were there, tried to appease him, but it was useless. He went into the other room, saying that he was going to see now M. Colbert, now the Nuncio. M. Perrault begged me to make the Cavalier understand that he had had no intention of hurting him. "That a man of my sort," said the Cavalier to himself, "I, whom the Pope treats with consideration and for whom he has respect, that I should be treated thus! I will complain of it to the King; even if my life is at stake, I shall leave tomorrow. I do not know why I should not take a hammer to the bust after such an insult. I am going to see the Nuncio." As he walked away I begged Signor Mathie to stop him. He told me in a low voice to let him spend his anger; that I should trust him to smooth things over. Signor Paul also made excuses to the Cavalier for Perrault when he implored

him to do so, saying that what Perrault had said was without any intention of giving offense. Finally the Cavalier, instead of leaving to go to the Nuncio as was his intention, was led upstairs. My brother and I went to accompany M. Perrault to M. Colbert's house. He told us he was going to inform him of the Cavalier's anger. I replied that he had better refrain from doing so, and that he should find out first if the affair could be quieted. He should not speak of it to anyone and my brother and I would not speak of it either. He begged us to leave it this way.

October 10th. On the tenth when I went to the Cavalier's house, I found Signor Paul leaving to see M. Colbert. On his return, he said M. Colbert was going to the Louvre. The Cavalier, having heard from someone that the Prince was here, wished to go to his lodgings to see His Highness, but he was not in Paris, and the Duke had just left for Chantilly to see his father. From there we went to the Gobelins, where M. Le Brun received the Cavalier. First he gazed intently at a tapestry design of an *Endymion in the Arms of Sleep.* He said it was in good taste and praised it highly. Then he saw the two great pictures of the *Battle of the Granicus* and the *Triumph of Alexander.* After the Cavalier had studied them intently, M. Le Brun had the picture of the *Battle of the Granicus* taken in the courtyard, as he had done when the King was at the Gobelins. The Cavalier looked at it for a long time, withdrawing from it as far as he could. Afterwards he said several times, "It is beautiful, it is beautiful." Canvas had been placed above as a ceiling to focus the vision. He had it removed and looked at the picture again for a long time. He had previously seen the great picture by Paolo Veronese[5] which the Venetians gave to the King and which was formerly at the Servites Convent in Venice. He returned to look at it and found some admirably painted heads, which he said were portraits of the Senators of that time and even of the Doge. He praised its grand execution, but he found in this work several bungled parts, and some poorly drawn hands. He said the Magdalen at the feet of

[5] *Feast in the House of Simon.* See p. 68, note 5.

our Lord was painted with marvelous plasticity but from the waist down the figure was not well drawn; the leg of Christ nearest the beholder was entirely wrong, and the arm and right hand were equally bungled. He admired above all a figure seated at the table near Christ, which one only sees from the rear. M. Le Brun pointed out to me that there were several points of view in the picture and that, even though the horizon is lower than the table, one nevertheless sees the top of the table; that the buildings were not correctly drawn in relation to this horizon and that they were not painted by Paolo Veronese. He said the King on seeing this picture praised the Magdalen and found the right part of the picture the most beautiful, which is correct. Afterwards, we saw another picture by Paolo Veronese, which had belonged to M. Fouquet, in which is portrayed an *Andromeda Rescued by Perseus*. It is well painted, as are most of the works by this painter. But the Cavalier thought that the Perseus is in a strange position, as though squatting. I pointed out that the left leg of the Andromeda seemed very badly drawn.

The Cavalier drew Le Brun to one side, gave him some information, then said to him, "I have told you this honestly, for to a man who possesses eighteen out of twenty parts one can say what one sees, but to those who lack eighteen out of twenty one has nothing to say. Annibale Carracci was right in saying often: 'One should speak to him who knows, not to him who doesn't know.'" The Cavalier went on to say that a rather talented sculptor one day begged Michelangelo Buonarroti to come to his studio to see a figure he had made. While Michelangelo looked at it—the light not being as the sculptor would have desired —he now shut one window, then opened another, and because of the sun did not find a light such as he would have wished to illuminate his figure. Michelangelo, seeing this, said to him: "There is no light better than in the place where the statue will stand. There the people will see it and they will say whether it is good."

The Cavalier was shown the drawings copied from the *Triumph of Alexander* by an eleven-year-old boy. He found them very good and was astonished that at that age

the lad should be so advanced. They brought him some of
the boy's original drawings, which amazed him even more.
The Cavalier said that the boy should be helped, sent to
Italy and kept there for nine or ten years. After the boy
showed him some of his academy drawings, the Cavalier
said, "It spoils young men to make them draw so soon
from life when they are not yet capable of choosing the
beautiful and leaving the ugly, the more so since the
models available in France are not very good." He said
that the King should send for some models and that they
should be chosen from the Levantine slaves. He said that
the Greeks had the best-formed bodies and that they could
be bought. Turning to me, he told me he had forgotten to
put that in his recommendations for the Academy, and that
it should be added to them. The Cavalier sent Signor
Paul, who had accompanied him, to see the places where
the Gobelins are made.

"Do you think," I asked him, "a picture of Annibale
Carracci would not be more praiseworthy?" The Cavalier
replied that it would be, and by far; that if Annibale had
lived at the time of Raphael, he would have given cause
for jealousy to him and, with greater reason, to Paolo
Veronese, Titian, and Correggio, all of whom had been
colorists. Michelangelo was right in saying that God had
not permitted these men to know how to draw, for then
they would have been supermen. The Cavalier added that
if the pictures of all the masters were compared to those
of Raphael it would be seen that Raphael's were of uniform
excellence, whereas in those of the others there would be
many parts worth consideration. Raphael had precision
in drawing, clever composition, dignity in drapery, grace,
beautiful adornments, beautiful and symmetrical disposi-
tion of figures according to perspective, none of which the
others had had. In truth Raphael had lacked the beautiful
color of the Lombards, but they on their part lacked
proportion, drawing and dignity in drapery. One sees that
Poussin, who was the most learned and the greatest painter,
after having imitated Titian for a time finally focussed on
Raphael, thereby showing that he esteemed Raphael above
the others. Monsignor Butti said that he had seen Poussin's

beautiful picture *Germanicus*.[6] The Cavalier said, "You should see those M. Chantelou has: they are something different. He has seven representing the 'Sacraments'[7] which I could look at for six months without tiring." Monsignor Butti asked their size. He said, "Of ordinary size with figures two feet in height. Nothing is more beautiful than that. There is a man who based his study on the antique and who in addition had great genius. I have always held him in high regard and because of it I have made enemies in Rome. You must see them," the Cavalier continued to Monsignor Butti, "he has done, however, some things since that are not equal to those: the picture of the *Adulterous Woman*, the *Flight into Egypt* that I saw at that merchant's, and your *Samaritan*[8] (turning toward me) no longer have this force. A man should know when to stop."

I forgot to mention that he said that Paolo Veronese and Titian sometimes took their brushes and executed things they had not planned, letting themselves be carried away by a kind of frenzy of painting; that was the cause of the marked differences among their works; those of them which had been carefully handled were incomparable while others sometimes were only color without composition or thought. The Queen of Sweden had nine or ten good and bad Paolo Veroneses, and there were only three truly good ones among them.

The Cavalier said that as most of the time nature is not beautiful, he had had brought to him from Civitavecchia and from the Marches of Ancona some of those Levantines to serve as models, and he considered himself fortunate to have found them. There was a general rule to give to those who were drawing from nature: to be on their guard and examine the model well, to draw the legs long rather than short, for the little more you give them augments the beauty, and the little less makes the figure awkward and heavy; it is always necessary to add a little more width

[6] *Death of Germanicus* painted for Cardinal Barberini, The Minneapolis Institute of Arts. Exact dating disputed, c. 1627.

[7] 1644–1647, second series painted for Chantelou, now in Bridgewater House, London.

[8] These pictures are no longer extant.

to the shoulders of the man, rather than depict the narrowness observed in nature; to make the head a little smaller rather than large; in women, the shoulders should be a little narrower than one sees in nature, God having given to men width in the shoulders for strength and for work, and width in the hips to women so they may be able to carry us in their flanks. One should make feet small rather than too large; this is observed in beautiful models and in the ancient ones. He repeated that the King should have some models brought from Greece. He would put it on the list of recommendations he had made for the Academy. Furthermore, the heads of the Academy should give lectures for the instruction of the young students and should vary them according to the different classes, of which there should be three. He said, speaking of the students' drawings which he had just seen, that he had found through his study one factor of the greatest importance in the posing of figures: namely, their distribution of weight; rarely does a man, if he is not too old, put his weight on both legs, one should therefore represent the weight of the body as really resting on one leg and the shoulder on the side of the supporting leg should be lower than the other shoulder, and if an arm has been raised it should always be on the opposite side to the leg which supports the body; otherwise there is no grace in the drawing, and nature is forced. In his studies of the beautiful antique statues, he had found them all posed thus.

M. du Metz, who was there, said he would remember these beautiful observations. I said it was of great benefit to those who studied art to have such good teaching, for it would shorten the years that they would have to devote, perhaps fruitlessly, to their studies; that there were few persons who were not jealous of their particular knowledge; the general rules of art were taught enough, but the ones the particular artist had made for himself were never or very rarely taught; we were greatly obliged to the Cavalier for speaking so openly. The Cavalier replied that what we have is given us by God and to teach it to others is to return it to Him; there are three things: "to see, to listen to great men, and to practice."

The little Blondeau showed him some of his academy studies. The Cavalier found them quite good for a young man. "But you must go to Rome," he said to him. "At this age young men should go to Rome, for the trip must be made before they are twenty, but they should not be too young either." He said Annibale Carracci had advised him when he himself was young to draw for at least two years from the *Judgment* of Michelangelo in order to learn the rhythm of the muscles; later when he was drawing from nature at the Academy, Scivoli, watching him draw, said, "You are a clever one. You do not draw what you see. This is from Michelangelo." It was the result of the study he had done before. . . .

NICOLAS POUSSIN

[Nicolas Poussin (1594–1665) was born in Normandy and began his career as a painter in Paris. In 1624 he went to Rome, where with the sculptor Duquesnoy he studied antique reliefs and sculpture and painted in the studio of Domenichino. Through Cardinal Antonio Barberini, who gave him commissions, Poussin met Cassiano del Pozzo, the leader of the antiquarians of Rome. He probably employed Poussin as one of his draughtsmen in making drawings from the ancient monuments. This laid the basis for his subsequent style. He soon became the leading exponent of classicism in Rome. Louis XIII appointed him *Premier Peintre Ordinaire*. Summoned by M. de Noyers, Poussin returned to Paris in 1640, accompanied by Paul de Fréart, Sieur de Chantelou. During his stay in Paris, Poussin provided decorations for the Grand Gallery of the Louvre, some cartoons for Gobelin tapestries, drawings for the frontispieces to editions of Virgil, Horace and the Bible, and was commissioned to paint two pictures for the royal chapels at St.-Germain-en-Laye and Fontainebleau. Finally disgusted by the intrigues of the court, he returned to Rome, where he remained until his death.

It is impossible to underestimate the importance of Pous-

sin's influence on the art and art theory of his time. His house in Rome was the meeting place for all those who followed the classicistic idea exemplified by the French Academy of Le Brun. He intended to write a treatise on art, and a few fragmentary notes taken from his reading for the purpose were published by Bellori in *Vite de' pittori* (1672).]

OBSERVATIONS ON PAINTING[1]

On the Example of the Greater Masters. Even if instruction in practical methods is subsequently added to theory, even then the precepts do not leave in the mind that habit of working which should be the result of effective knowledge, unless they are confirmed by authority; and unless the efficient guide of good examples points out to the student shorter methods and more concrete aims, [those precepts] lead the young student by long and devious paths, and seldom do they achieve their final goal.

Definition of Painting and on the Manner of Imitation. Painting is nothing else than the imitation of those human actions which are imitable actions in a proper sense. The

[1] The "Observations on Painting" are translated from Ch. Jouanny, *Correspondance de Nicolas Poussin* (Archives de l'art français, N.S.,V), Paris, 1911, pp. 492 ff. These observations are given in Bellori, *Vite de' pittori, scultori, et architetti moderni,* Rome, 1672. Dr. Erwin Panofsky kindly checked these translations and supplied footnotes 4 and 6. The letters are translated from Ch. Jouanny, *op. cit.* I am grateful to Mrs. D. J. Janson for the assistance that her translation of some of the letters gave me, and to Dr. Leo Spitzer for checking this translation. All footnotes except those in brackets are from the text.

These notes Poussin made from his reading rather than his own writings. A. Blunt has identified the source of many of them; see A. Blunt, *sub. cit.,* p. 345. All footnotes followed by B. refer to this article.

See also: W. Friedländer, *Nicolas Poussin: A New Approach,* New York, 1966; A. Blunt, *The Painting of Nicolas Poussin,* Critical Catalogue, London, 1966; A. Chastel, *Nicolas Poussin,* Paris, Éditions du Centre National de la Recherche Scientifique, 1960, 2 vols.

other actions are not intrinsically but accidentally capable of reproduction, and not as principal parts but as accessory ones. In this fashion one may also imitate not only the actions of animals, but all natural objects.

How Art Surpasses Nature. Art is not something different from nature, nor can it pass the bounds of nature. For that light of instruction which by a natural gift is scattered here and there, and appears in different men, in different places, and [at different] times, is gathered together by art; and all of this light, or [even] the greater part of it, can never be found in one single individual.[2]

How the Impossible is the Climatic Achievement of Painting and Poetry. Aristotle[3] wishes to show by the example of Zeuxis that the poet is permitted to tell impossible things, provided they are better. For it is impossible with nature that one woman possesses all those collected elements of beauty which the image of Helen had; this [image] was most beautiful and, consequently, better than that which is possible. See Castelvetro's[4] treatment of this point.

The Limits of Design and Color. Painting will possess elegance when its farthest limits[5] are joined with the nearest by means of intermediate ones in such a way that they do not come together too awkwardly, or with roughness in line or color. Here one may thus speak of the amicable or inimical relations of colors, and of their limits.

Action. There are two instruments which affect the souls of the listeners: action and diction. The first, in itself, is of such value and so efficacious that Demosthenes gave it predominance over the arts of rhetoric. Cicero calls it the language of the body, and Quintilian attributes such strength and power to it that he considers concepts, proofs,

[2] See letter to Chantelou, June 27, 1655 (*Correspondance,* p. 434). B. p. 345.
[3] Aristotle, *Poetics,* xxv, 26-28. B. [There is no mention of Helen, only: "It may be impossible that there should be such people as Zeuxis used to paint, but it would be better if there were."]
[4] This is copied from Castelvetro, *Poetica d' Aristotele* (ed. Basel, 1576, p. 668). B., p. 346.
[5] [i.e. extreme values.]

and expressions as useless without it. And without it, lines and color are likewise useless.[6]

On Some Characteristics of the Grand Manner; On Subject, Concept, Structure and Style. The grand manner consists of four elements: subject or theme, concept, structure, and style. The first requirement, fundamental to all the others, is that the subject and the narrative be grandiose, such as battles, heroic actions, and religious themes. But, if the subject which the painter endeavors to treat be grandiose, his first care should be to avoid minute details as much as he possibly can, in order not to violate the fitness of the theme, passing over the large and magnificent objects with a rapid brush by virtue of having neglected himself over vulgar and frivolous ones. Thus the painter not only must possess the art of selecting his subject, but judgment in comprehending it, and must choose that which is by nature capable of every adornment and of perfection. Those who choose base subjects find refuge in them because of the feebleness of their talent. Artists should thus scorn the sordidness and baseness of subjects far from every artistry that might be used therein. As for concept, it is a pure product of the mind which applies its efforts to the task. Such was Homer's and Phidias' concept of the Olympian Jupiter, who moves the universe with a gesture. The design of the objects, however, should be of a similar nature as are the expressions for the concepts of these same objects. The structure or composition of the parts should not be laboriously studied, nor *recherché,* nor labored, but true to nature. Style is a particular manner and skill of painting and drawing, born from the particular genius of each painter in the application and use of his ideas. This style, manner, or taste is a gift of nature and genius.

On the Idea of Beauty. The idea of beauty does not infuse itself into matter which is not prepared to the utmost. This preparation consists of three things: order, mode, and form or *species.* Order means the spacing of the parts; mode has to do with quantity; species [form] consists in lines and colors. Order and spacing of the parts is not

[6] The substance of this passage is in Quintilian (*Inst. Orat.* XI, iii, 1–6). B., 345.

sufficient, nor is it enough that all the limbs of the body should have their natural position, unless mode is also added, giving to each limb its due size in proportion to the body, and unless species cooperates therewith so that the lines are drawn with grace and with a pleasing harmony of the lights adjacent to the shadows. From all this it is evident that beauty is far removed from the matter of the body. This matter will not approach beauty unless it is disposed to it by means of this incorporeal preparation. We must conclude, therefore, that painting is nothing but an idea of incorporeal things; and that, if it portrays bodies, it represents only the order and the mode of the species of things and is more concerned with the idea of beauty than with any other idea. Some people have therefore asserted that this [idea of beauty] alone is the mark and, as it were, the goal of all good painters, and that painting is the lover of beauty and the queen of the arts.[7]

On Novelty. Novelty in painting does not consist principally in a subject never seen before, but in a good and novel disposition and expression. Thus a theme which is common and old becomes rare and new. One can here adduce the *Communion of St. Jerome* of Domenichino in which the expressions and movements are different from that other invention by Agostino.[8]

How to Compensate for Weakness of the Subject. If the painter wishes to arouse wonder in other souls although he does not deal with a subject capable of evoking it in itself, he should not introduce anything new, bizarre or irrational, but should strain his talent to make his work wonderful by the excellence of its manner, so that it may be said, "The work surpassed the material."[9]

On the Form of Things. The form of every thing is

[7] This note, as Panofsky has pointed out (*Idea,* p. 126), is almost identical with a passage from Marsilio Ficino, *Sopra lo Amore o ver Convito di Platone,* which Lomazzo used in *Idea del Tempio della Pittura,* B., p. 347. [See above, pp. 84–85.]

[8] [This picture, painted in 1614, now in the Pinacoteca, Vatican, can almost be regarded as a correction of Agostino Carracci's which is in the Pinacoteca, Bologna. See McComb, *op. cit.,* p. 22.]

[9] Ovid, *Met.* II, 5. B., p. 346, n. 2.

characterized by its own effect or aim; certain things provoke laughter or terror, and these are their "forms."

On the Blandishments of Painting. The colors in painting are, as it were, blandishments to lure the eyes, as the beauty of the verses in poetry is a lure for the ears.

LETTERS

To Chantelou.[10] Rome, April 28, 1639

MONSIEUR, I shall wait until God grants me the privilege of being with you to repay my obligations, not merely with words, but with deeds, if you find me worthy of so doing. At the moment I shall not bore you with long discourses; I shall only inform you that I am sending you your picture of *The Manna*[11] via Bertholin, the Lyon courier: I crated it carefully and believe that you will receive it in good condition. Accompanying it is another little one which I am sending to M. Debonaire, since this is the only chance I have of getting it to him. Kindly permit him to take it, since it is his.

When you receive yours, I beg of you, if you like it, to provide it with a small frame; it needs one so that, in considering it in all its parts, the eye shall remain concentrated, and not dispersed beyond the limits of the picture by receiving impressions [?] of objects which, seen pell-mell with the painted objects, confuse the light.

It would be very suitable if the said frame were gilded simply with dull gold, as it blends very softly with the colors without clashing.[12] Furthermore, if you can remember the first letter I wrote you concerning the movements of the figures which I promised to depict, and if you consider the picture at the same time, I think you will be able to recognize with ease which figures languish, which ones are astonished, which are filled with pity, per-

[10] Paul de Fréart, Sieur de Chantelou (1609–1694), a friend and patron of Poussin, and the author of the *Journal du voyage du Cav. Bernin.* [See p. 124.]

[11] [*The Israelites Gathering Manna,* Louvre.]

[12] Chantelou told Bernini in 1665 (Ph. de Chennevières, *La peinture française,* p. 270), that Poussin always asked that only simple dull frames be put on his pictures.

form deeds of charity, are in great need, seek consolation, etc. The first seven figures on the left side will tell you everything that is written here, and all the rest is much to the same effect: study the story and the picture in order to see whether each thing is appropriate to the subject.

And if after having studied the picture more than once, you find some satisfaction in it, write it to me if you please, without hesitation so that I may be happy to think that I had been able to please you on the first occasion that I had the honor of serving you. If you are not satisfied, we hold ourselves ready to make any improvement you desire. Begging you to remember once more that the spirit is willing and the flesh is weak. . . .

To Seigneur Commandeur Carlo del Pozzo at Rome.[13]

Trusting myself to the usual kindness with which Your Excellency has always treated me, I feel it my duty to tell you of the outcome of my trip, as well as my situation and the place in which I find myself, in order that you, my patron, shall know where to deliver your orders to me. I made the trip from Rome to Fontainebleau in good health and was received with the greatest honors at the palace by a gentleman who had been commissioned to do so by M. de Noyers, and passed three days splendidly; then I was conducted to Paris in the carriage of this gentleman and immediately on arrival I met M. de Noyers,[14] who embraced me cordially in token of his joy at my arrival. In the evening, by his orders, I was conducted to the place which he had chosen for my residence. It is a little palace, for so it must be called, in the middle of the Tuileries Gardens. It contains nine rooms in three stories, not counting the lower apartments, which are separate and which consist of a kitchen, a place for the guard, a stable, a place to keep the jasmine in winter, and

[13] Carlo Antonio del Pozzo, the brother of Cassiano del Pozzo, the patron of Poussin.

[14] [François Sublet de Noyers (1578–1645) served Louis XIII in various capacities, first in finances, then in charge of fortifications; in 1636 he was Secretary of State for War; in 1638, Superintendent of Buildings. He was disgraced and left the court in 1643.]

three other rooms which are convenient for many other necessary things. In addition, there is a large and lovely garden, full of fruit trees, flowers, and the most varied assortment of vegetables and also three little fountains and a well; furthermore, there is a fine court which contains some more fruit trees. I have open vistas on all sides, and I think that it must be a veritable paradise in the summertime. Upon entering I found the whole middle story prepared and nobly furnished, with provisions of all the necessities including fire wood and a cask of two-year-old wine; and for three days my friends and I were well entertained at the King's expense. The following day I was escorted by the aforementioned M. de Noyers to His Grace, who, with extraordinary benevolence, embraced me, and taking me by the hand, showed that he had great pleasure at seeing me. Three days later I was taken to St.-Germain to be presented to the King by M. de Noyers, but since the King was indisposed, I was introduced the next morning by M. le Grand,[15] the King's favorite. The King, great and noble prince that he is, deigned to embrace me and spent a half hour asking me many questions; and turning to his courtiers he said, "Now Vouet [16] has met his match." Next he himself ordered me to make the big pictures for his chapels at Fontainebleau and St.-Germain. When I had returned to my house, they brought me, in a beautiful pocketbook of blue velvet, 2000 gold crowns of the latest minting: one thousand for my salary, and one thousand for my trip, in addition to all my expenses. It is true that money is greatly needed in this country because everything is extraordinarily expensive. At present I am thinking of the many works which are to be done, and I think I shall undertake some tapestries. I shall be eager to send you something of the first of them which will see the light, simply as a testimony of my devotion to you. As soon as our baggage has arrived, I hope to be able to

[15] [Cinq-Mars (1620–1642), favorite of Louis XIII, executed for treason.]

[16] Simon Vouet (1590–1649) was called by the King from Italy in 1627 where he had lived for fifteen years. He headed the opposition to Poussin.

divide my time in such a way that I shall be able to devote part of it to serving the Cavalier, your brother. The copies of those lists of the books by Pirro Ligorio[17] have been sent to Piedmont. I entrust my few interests and my house to you, since you so graciously deign to look after them during my absence, which, if I have my way, will not be long. Since you seem born to be gracious to me, I beg that you will react to these importunities with that generosity which is part of your nature, being satisfied in return by the warmth of my devotion. May God grant you a long and happy life, while I am your devoted servant.

Paris, January 6, 1641

POUSSIN

To Chantelou. Paris, June 29, 1641

. . . Since the design for the arms of Monseigneur has met with his approval, I am making a little of the molding to give to M. le Claire so that the execution may be accomplished more easily and gracefully. I have not yet received the measurements for the picture[18] for the Noviciate of the Jesuit fathers, nor even chosen the subject for said picture; but I shall apply myself to it diligently, the more so since I shall finish the picture of the *Last Supper*[19] today, and while it is drying I shall work on the cartoons for the Grande Galerie, which is going very well, thank God. I have made some wax models which I have delivered to Monsieur Parlan in order to have the pedestals of these ornaments for the gallery modelled. It should be possible to begin painting and gilding right away, and I think it will undoubtedly be finished soon; the stucco workers even boast that, with the help of three or four others, they will have the whole thing finished from end to end in five, or at the most six, years. This evening at six o'clock I have an appointment with M. de Mauroy to

17 Pirro (Pyrrhus) Ligorio, architect, antiquarian and forger.
18 [*The Miracle of St. Francis Xavier*. See Friedländer, *op. cit.*, p. 60.]
19 [*Last Supper* for the chapel in St.-Germain-en-Laye, now in the Louvre. See Friedländer, *op. cit.*, p. 156.]

discuss what should be done to the floor of Monseigneur's room to make it match the fireplace. . . M. Meslen is working on the frontispiece of the Virgil, and if I could have sent you the sketch of the idea I have had for the binding of the Bible, as I promised you, I should have been very happy; but that will have to wait until the first opportune moment. I believe that I have forgotten nothing I should have told you but the assurance that you will have in me a very devoted and humble servant.

<div style="text-align: right">POUSSIN</div>

To Chantelou. Paris, August 3, 1641

MONSIEUR, If I had not known how busy you are all the time with important matters, I should not have waited until today to write to you; now that you may perhaps have time to read this letter, I hasten to assure you that I am better, thank God, and that our work is in good shape. The Grande Galerie is coming along quickly, even though there are few workers, and I am in hopes that you will be astonished at the progress upon your return, I have been constantly occupied with the cartoons, which I am obliged to vary for every window and pier, having decided to represent a series from the life of Hercules, a matter which is certainly big enough to occupy the entire time of a good designer, especially since the said cartoons have to be done in both large and small sizes for the convenience of the workmen, and so that the work may be better. At the same time I have to invent something new every day to give diversity to the stucco relief, for otherwise the men would have to remain idle; and you know how important it is in this country to use the time of the fine weather. All this has been the reason why I have not as yet been able to finish the picture for St.-Germain, which has to be largely retouched because of the ravaging effects of the humidity last winter; however, since Monseigneur again ordered me to do the picture for the Jesuit Noviciate by the end of November, I have nevertheless decided to turn my hand to it and complete it for that date, if my feeble health should permit; and while the canvas is being prepared, I can retouch the above-men-

tioned *Last Supper,* instead of enjoying myself at d'Angu or some other place, as Monseigneur, out of courtesy, invited me to do. I assure you, Monsieur, as long as I am able, I have no other pleasure than to serve him. This takes the place of walks, games, relaxations and pleasures. I shall be satisfied to take a journey to some place in the outskirts of Paris only to breathe a little for a day or two. In the meantime, I am sending Monseigneur the sketch for the frontispiece of the Bible, but without corrections, for I want you to see it before I finish it, so that you can let me know if there is anything to be changed in the idea or the composition as a whole, or the placing of the individual figures. The winged figure represents History; she is writing with her left hand so that it will come out on the right in the print; the other veiled figure represents Prophecy; "Biblia Regia" will be written on the cover of the book which she holds. The Sphinx which is on it represents the obscureness of Things Enigmatic. The figure in the middle represents the Eternal Father as author and Prime Mover of all good things. But the whole explanation will be given to you by M. du Fresne. . . .

To Cassiano del Pozzo.[20] Paris, September 20, 1641
ILLUSTRIOUS AND REVEREND SIGNOR ABBOT: I hope that Your Most Illustrious and Reverend Lordship will believe that every time I reach for a pen to write to you, I sigh, blush and am uneasy only because your servant is here, and it is true that the yoke which I have placed on my shoulders prevents my showing my affection and indebtedness to you. But I hope to cast it off soon to be able to serve in freedom and without interruption my dear Lord and Master.

I am working now at one thing, now at another; I should gladly undergo these fatigues were it not that these works which should require much time must be done in a great rush. I swear to Your Excellency that,

[20] [Cassiano del Pozzo (1584–1657), for whom Poussin painted the first series of the *Seven Sacraments,* 1634–1640. They are in Belvoir Castle, England, except for *Penance,* which was burned. See Friedländer, *op. cit.,* pp. 56–57.]

were I to remain in this country for a long time. I should be forced to become a "hackworker"[21] like all the others who are here. Studies and valuable observations from the antique or other sources are here completely unknown, and a man who is inclined to study and to do well must necessarily deviate from those sources. I have had the paintings and stuccos of the Grande Galerie begun according to my designs, albeit with little personal satisfaction (it please these animals though), because I find no one who grasps my idea even a little, although I make the drawings in both large and small scale. . . .

To Chantelou. Paris, April 7, 1642

MONSIEUR, I have lately had the honor of receiving a letter from Monseigneur dated March 23, in which at the beginning were these exact words: "Poussin's genius wishes to act so freely that I must explain to him what the King's (genius) demands of his." Monsieur, I have never known what the King wishes me, who am his very humble servant, to do, and I don't believe that anyone has ever told him what I am good for. In addition, he says that His Majesty would be pleased if I were to give general orders to M. Le Maire[22] about the conducting of the work on the Grande Galerie under my direction. I shall gladly do so, since I wish him well, he will profit thereby, and maybe he will lose some weight in the process. Nevertheless, I am not sure that I clearly understand, without great confusion, what Monseigneur wants me to do, inasmuch as it is impossible for me to attend to the frontispieces of the books, to the picture of the Virgin for the Congregation of St. Louis, to all the designs for the Gallery, and to the designs for the royal tapestries. I have but one hand and one feeble head, and have no one to help or relieve me. He says that I should distract my beautiful mind in making the aforementioned *Virgin*, and the *Purification of*

[21] *Strapazzone*: a slovenly, careless worker.
[22] [Jean Le Maire (1597–1655), lived in Rome twenty years. He worked on the decorations at the Chateau du Rael for Richelieu. He returned to Rome with Poussin in 1642. He was called "fat Le Maire."]

Our Lady. That amounts to the same thing as telling me, "You will make such and such a design in your spare time." But let us get back to M. Le Maire. If he is ready to do what I tell him, I shall inform him of what he has to do as soon as he is ready to undertake it. But I don't want to have anything to do with it after that. But if I have to wait until I have completed the orders which Monseigneur mentions, there is no use talking about other enterprises since, as I have mentioned several times, it is all that I can do, and, even after I have finished, the tapestries will be quite enough to worry me. You will excuse me, Monsieur, for speaking so freely. My nature constrains me to seek and to love well-ordered things, and to flee confusion, which is as much my antithesis and my enemy as light is to dark. I tell you this in confidence, relying upon the kindness of your nature, and because you control Monseigneur's mind, especially in matters of this sort. . . .

To Chantelou. Rome, August 26, 1645
 . . . The terrible heat of the summer has put me behind with my work since I have been able to do nearly nothing from the beginning of June until now, for we are suffocating. The great sickness and mortality current now has been the reason I have thought of nothing but of safeguarding my health. That is why, if I finish your picture of the *Confirmation*[23] before the end of the year, I shall think that I have done a great deal. It contains twenty-four figures, but almost entirely without architecture in the background, so that it will not take less than five or six months to finish it well, and, Monsieur, if you will stop to consider it, these are not things that can be done at the crack of a whip, like [the work of] your Parisian painters who make a sport of turning out a picture in twenty-four hours. I think I have done a great deal when I make one head in a day, providing it gives the proper effect. That is why I beg of you to put your French impatience aside, because if I were in such haste as those who press me, I should do nothing well. . . .

[23] [1644–1645, the third in the series of the *Seven Sacraments.*]

To Chantelou. Rome, April 7, 1647

. . . Your last letter of March 15th made the same impression on me as have all the others, and even more, because in this one you let me know without any pretense or disguise the feeling which the last picture [*The Baptism*]²⁴ I sent you aroused. I am not saddened by the fact that I am taken to task and criticized. I have been accustomed to that for a long time because nobody has ever spared me. On the contrary, I have often been the object of slander—not merely of reproof. This, in truth, has brought me not a little advantage because it has kept me from being blinded by presumption and has made me proceed cautiously with my work, which is a thing I should like to continue all my life. And even if those who criticize me cannot teach me to do better, they are nonetheless the cause for my being able to find the means to do so myself. One thing only I shall always desire, and shall never have, and I dare not even mention it for fear of being blamed for being too ambitious. I shall, therefore, go on to say that at the time when I decided to paint the above-mentioned picture in the manner I chose, I guessed the judgment that would be passed upon it. There are reliable witnesses here who will assure you of this. I am not unaware that the average painter pretends that he changes his style as soon as he forsakes, however little, his usual manner; for [today] the poor quality of painting is reduced to the *cliché*. It would be even more appropriate to speak of a burying of painting (which nobody has ever seen come alive except at the hands of the ancient Greeks). . . .

To Chantelou. Rome, November 24, 1647

. . . If you feel affection for the picture of *Moses Found in the Waters of the Nile*,²⁵ which belongs to M. Pointel, is that a proof that I made it more lovingly than I did yours? Do you not see that, along with your own disposi-

²⁴ [1646–1647, the fourth in the series of the *Seven Sacraments.*]

²⁵ [1645–1646, now in the Louvre. See Friedländer, *op. cit.*, p. 184.]

tion, in the nature of the subject lies the cause of this effect, and that the subjects which I am treating for you have to be done in a different manner? All artifice in painting depends upon this. Pardon me the liberty that I take in saying that you have shown yourself hasty in the judgment you have made of my works. To judge well is very difficult, if one does not possess both the theory and the practice of this art. Not only our compulsions, but our reason should judge.

That is why I wish to bring to your attention one important thing that will teach you what to observe in the subjects depicted.

Our wise ancient Greeks, inventors of all beautiful things, found several Modes by means of which they produced marvellous effects.[26]

This word "Mode" means actually the rule or the measure and form, which serves us in our productions. This rule constrains us not to exaggerate by making us act in all things with a certain restraint and moderation; and, consequently, this restraint and moderation is nothing more than a certain determined manner or order, and includes the procedure by which the object is preserved in its essence. [See our *fig. 6.*]

The Modes of the ancients were a combination of several things put together; from their variety was born a certain difference of Mode whereby one was able to understand that each one of them retained in itself a subtle variation; particularly when all the things which entered into combination were put together in such a proportion that it was made possible to arouse the soul of the spectator to various passions. Hence the fact that the ancient sages attributed to each style its own effects. Because of this they called the Dorian Mode stable, grave, and severe, and applied it to subjects which are grave and severe and full of wisdom.

And proceeding thence to pleasant and joyous things, they used the Phrygian Mode, in which there are more

[26] [This comparison of the different methods of painting with the modes of ancient music is copied from Zarlino, the Venetian writer on music; see Blunt, *op. cit.*, p. 349.]

minute modulations than in any other mode, and a more clear-cut aspect. These two styles and no others were praised and approved of by Plato and Aristotle, who deemed the others superfluous; they considered this [Phrygian Mode] intense, vehement, violent, and very severe, and capable of astonishing people.

I hope, before another year is out, to paint a subject in this Phrygian Mode. The subject of frightful wars lends itself to this manner.

They [the ancients] also decided that the Lydian Mode lends itself to tragic subjects because it has neither the simplicity of the Dorian nor the severity of the Phrygian.

The Hypolidian Mode contains a certain suavity and sweetness which fills the souls of the spectators with joy; it lends itself to subjects of divine glory, and paradise.

The ancients invented the Ionic, with which they represented bacchanalian dances and feasts in order to achieve a festive effect.

The good poets used great care and marvellous artifice in order to fit the words to the verses and to dispose the feet in accordance with the usage of speech, as Virgil did throughout his poem, where he fits the sound of the verse itself to all his three manners of speaking with such skill that he really seems to place the things of which he speaks before your eyes by means of the sound of the words, with the result that, in the portions where he speaks of love, one finds that he has skillfully chosen such words as are sweet, pleasant and very delightful to hear; whereas, if he sings of a feat of arms or describes a naval battle or a storm, he chooses hard, rasping, harsh words, so that when one hears or pronounces them, they produce a feeling of fear. Therefore, if I had made you a picture in which such a style were adhered to, you would imagine that I did not like you. . . .

To Chantelou. Rome, November 25, 1658
MONSIEUR, The various inconveniences from which I suffer and which multiply with age prevent me from writing you more often than I do. I promised to explain to

you that arc at the bottom of the last picture[27] which I
made for you. Here is the explanation. A Procession of
Priests with tonsured heads, crowned with wreaths, and
dressed according to their habit, with tambourines, flutes,
trumpets, and hawks on poles. Those who are beneath
the portico carry the casket inscribed *Soro Apis* which
contains the bones of Serapis, the god of the temple
towards which they are proceeding. The rest that appears
behind the woman dressed in yellow is a building con-
structed as a retreat for the bird Ibis, which is repre-
sented there, and the tower with the concave roof and
the great basin to collect the dew. All this is not what I
have imagined, but is taken from the famous temple of
Fortune at Palestrina.[28] Its pavement is made of fine
mosaic and depicts truthfully the natural and cultural his-
tory of Egypt and Ethiopia, and by a good hand. I put
all these things into the picture to be a source of delight
by reason of their novelty and variety, and to show that
the Virgin represented is in Egypt.

I have made a new composition for the *Fall of St.
Paul*[29] as I had a new idea different from the first. I ask
time of you for finishing this work which will be a great
effort for me.

I do not write to Madame because my trembling hand
makes it difficult for me. I ask her pardon and kiss her
hands. I do the same to you and shall remain always your
humble and obedient servant,

POUSSIN

To M. de Chambray. Rome, March 1, 1665[30]

MONSIEUR, At last I must try to arouse myself after so
long a silence and recall myself to you while my pulse

[27] *Flight into Egypt,* now in the Dulwich Gallery. [See
Friedländer, *op. cit.,* p. 43.]

[28] Palestrina was the property of the Barberini. Their palace,
built on the ruins of the ancient temple of Fortune, enclosed
this famous mosaic discovered in 1638.

[29] [For this drawing, see Friedländer, *op. cit.,* pp. 82, 84,
fig. 82.]

[30] Poussin died eight months later, November 19, 1665.

still beats. I have had ample leisure to read and examine your book on the perfect idea of painting which was like a sweet pasture to my afflicted heart. I am glad you are the first among Frenchmen to have opened the eyes of others who, unable to see with their own eyes, were led astray by a false common opinion. You warm and make easy a subject cold and difficult to understand. As a result of this one might be able to find someone who, under your guidance, might be able to contribute his share to painting.

After having considered the divisions which Seigneur François Junius[31] makes of this fine art, I have dared to state briefly here what I learned from his work:

First of all, it is necessary to know what is meant by that kind of imitation, and to define it.

Definition

It is an imitation made on a surface with lines and colors of everything that one sees under the sun. Its end is to please.

Principles that Every Man Capable of Reasoning Can Learn[32]

Nothing is visible without light.
Nothing is visible without a transparent medium.
Nothing is visible without boundaries.
Nothing is visible without color.
Nothing is visible without distance.
Nothing is visible without instrument.
What comes after this cannot be learned.
It pertains to the painter.

[31] [François Junius (1598–1677) was born in Heidelberg, educated at Leyden, and applied himself to the study of letters. He served for thirty years as librarian to the Earl of Arundel, the famous collector of antiquities. Junius' *De Picturâ Veterum*, Amsterdam, 1637, is a monumental work on antiquity comparable to Winckelmann's work a century later.]

[32] [These principles are copied from Alhazen; see Blunt, *op. cit.*, p. 350. Cf. Ghiberti, *Documentary History of Art*, Vol. 1, p. 151.]

But first and foremost as to subject matter:

It should be nobly conceived: not fashioned by man, in order to give the painter free scope for his genius and industry. The subject matter must be chosen so as to be capable to receive treatment of the most excellent form; one should consider first the disposition, then the ornament, the decoration, beauty, grace, vivacity, costume, verisimilitude, and above all, good judgment. These last things depend on the painter and cannot be learned. It is the Golden Bough of Virgil, which no one can find or pluck unless he be led to it by Fate.

These nine principles contain many beautiful ideas which deserve to be written by good and learned hands, but I beg you to consider this little sample and to tell me your feeling without standing on ceremony. I know very well that you not only know how to snuff out the lamp but also how to fill it with good oil. I should say more but now when I set my forehead on fire with great effort of thought I feel ill. Moreover, I am always ashamed when I talk with men whose worth and merit are as much above my own as the star of Saturn is above our heads. The effect of your friendship is that you see me greater than I am. I am forever grateful to you for this and am, Monsieur,

Your very humble and very obedient servant,

POUSSIN

CHARLES LE BRUN

[Charles Le Brun (1619–1690) began his study of art in Paris with the painter Simon Vouet and early attracted royal attention. By 1638 he was designated *Peintre du Roi*. A long sojourn in Rome (1642–1646) brought him under the influence of Raphael, the Bolognese School, and Poussin. On his return to Paris he became, in 1648, the co-founder of the Royal Academy, which he dominated for many years, delivering discourses on art similar to the

one published in 1698 entitled *Méthode pour apprendre à dessiner les passions proposée dans une conférence sur l'expression générale et particulière* (A Method of Learning to Draw the Passions as Proposed in a Lecture on Expression, in General and in Particular). This small book, which was widely read and often translated, gives the two basic principles of art as practiced by the Academy: drawing and expression. For aid in the correct depiction of expression, the various facial expressions of anger, fear, etc., are drawn (our *fig.* 7). Henri Testelin describes these same expressions in his elaborate "Table of Rules," a book of lectures given at the Academy published in 1680 under the title, *Sentiments des plus habiles peintres sur la pratique de la peinture et sculpture mis en table de préceptes* (Opinions of the Ablest Painters on the Practice of Painting and Sculpture arranged in Tables of Rules).

Louis XIV raised him to the nobility and named him *Premier Peintre du Roi* in 1662. The following year he was placed in charge of the royal collection and made director of the royal tapestry and furniture factory. With the support of his patron, the minister Colbert, Le Brun soon acquired unlimited power in all fields pertaining to art. The scope of his own artistic activity was tremendous. He decorated the Gallery of Apollo in the Louvre (1661) and the Châteaux of Sceaux (1674) and Marly (1681–1686). At Versailles he decorated the Galerie des Glâces (1679–1684) and furnished sketches for the sculpture and fountains in the gardens. He also furnished drawings for tapestries and designed the royal furniture and gold service.

After the death of his patron, Colbert, in 1683, Le Brun was deprived of his offices and died in poverty and obscurity seven years later.]

CONCERNING EXPRESSION IN GENERAL AND IN PARTICULAR[1]

SIRS: At the last assembly you approved the plan which I adopted to discuss *expression* with you. It is therefore necessary first to know in what it consists.

Expression, in my opinion, is a naive and natural resemblance [true to nature] of the things which are to be represented. It is necessary and appears in all aspects of painting and a picture could not be perfect without expression. It is expression that marks the true character of each thing; by means of it is the nature of bodies discerned, the figures seem to have movement and all that is pretense appears to be truth.

Expression is present in color as well as in drawing; and it must also be present in the representation of landscapes and in the arrangement of figures.

It is this, Sirs, that I have tried to call to your attention in past lectures. Today I shall try to make you see that expression is also a part that shows the emotion of the soul and makes visible the effects of passion.

So many learned persons have discussed the passions that one can only say what they have already written. Therefore I should not repeat their opinion on this subject were it not that, in order to explain better what concerns our art, it seems necessary to me to touch upon several things for the benefit of young students of painting. This I will try to do as briefly as I can.

In the first place, passion is an emotion of the soul, which lies in the sensitive part [of the body]. It pursues what the soul thinks is good for it, or flees what it thinks bad for it; ordinarily whatever causes passion in the soul evokes action in the body.

[1] The excerpts are translated from the text as given in H. Jouin, *Charles Le Brun*, Paris, 1889, pp. 371–372, 374, 379, 387. The lecture was given in 1667 in Paris and published in Amsterdam in 1698. The footnotes are by the translator.
See also: Pevsner, *Academies*, pp. 82–109; Lee, "Ut Pictura Poesis," pp. 216–261 *passim*; Schlosser, *Lett. art.*, pp. 547–551, and *Kunstlit.*, p. 551.

Since, then, it is true that most of the passions of the soul produce bodily action, we should know which actions of the body express the passions and what those actions are.

Action is nothing else than the movement of some part and only changes because of a change in the movement of the muscles; muscles are moved only by the ends of the nerves which pass across them; the nerves are moved only by the spirits contained in the cavities of the brain, and the brain can only receive the spirits from the blood, which passes continually through the heart and is there changed and purified so that it produces a certain subtle fluid which is carried to the brain and fills it. . . .

It would not therefore be inappropriate to say something of the nature of these passions in order to understand them better before speaking of their exterior movements. We shall begin with *admiration*.

Admiration is a surprise which causes the soul to consider attentively the objects which seem to it rare and extraordinary. This surprise is so powerful that it sometimes impels the spirits toward the site[2] of the impression of the object and causes it to be so occupied in considering that impression that there are no more spirits passing into the muscles, so that the body becomes motionless as a statue. This excess of admiration causes astonishment and astonishment can come upon us before we even know whether this object suits us or not. . . .

THE COMPOSITE PASSIONS. *Admiration.* As we have said, admiration is the first and mildest of all the passions and the one which causes the least disturbance to the heart.

The face also changes little, and if there is any change it lies only in the raising of the eyebrows, but the elevation will be equal on both sides, and the eye may be a little more open than usual, the pupil centered between the lids and motionless, fixed on the object which will cause admiration. The mouth will also be partly open, but will show no more expression of suspense than the

[2] According to Descartes, "animal spirits" carry impulses to and from the pineal gland [site] which is the "seat of the soul." See S. V. Keeling, *Descartes,* London, 1934.

other parts of the face. This passion produces only a sus-
pension of movement so that the soul may have time to
ponder on what it has to do and to consider carefully the
object of its admiration; for rare and extraordinary esteem
is born of the first simple emotion of admiration [our
fig. 7].

Anger. When anger takes possession of the soul, he
who experiences this emotion has red and inflamed eyes,
a wandering and sparkling pupil, both eyebrows now
lowered, now raised, the forehead deeply creased, creases
between the eyes, wide-open nostrils, lips pressed tightly
together, and the lower lip pushed up over the upper,
leaving the corners of the mouth a little open to form a
cruel and disdainful laugh. He seems to grind his teeth,
his mouth fills with saliva, his face is swollen, pale in spots
and inflamed in others, the veins of his temples and fore-
head and neck are swollen and protruding, his hair bris-
tling, and one who experiences this passion seems more
to blow himself up rather than to breathe because the
heart is oppressed by the abundance of blood which
comes to its aid.

Rage and despair sometimes follow anger.

CHARLES ALPHONSE DU FRESNOY

[Charles Alphonse Du Fresnoy (1611–1668) was a
French painter who after beginning his studies in Paris
went to Rome, where he remained twenty years studying
antiquity and copying the works of the Carracci and Titian.
In 1653 he went to Venice for a year to study the Venetian
painters. He returned to Paris in 1656. His fame is due to
a poem, *De arte graphica* (The Art of Painting), rather
than to his painting. The poem, written over a period of
twenty years, was translated and published posthumously
by Roger de Piles in 1668. In some five hundred verses it
expresses the principles of the Roman School according to
French taste: design and the ancient art are the basis of
art, while nature is the best teacher and the color of the

Venetians is desirable. In his emphasis on color, Du Fres-
noy led the way, reinforced later by de Piles, to the
support of Rubens' art as opposed to that of Poussin. The
poem was widely read and translated, especially in Eng-
land.]

THE ART OF PAINTING[1]

Painting and Poesy are two Sisters, which are so like in
all things, that they mutually lend to each other both their
Name and Office. One is call'd a dumb Poesy, and the
other a speaking Picture. The Poets have never said any-
thing, but what they believ'd would please the Ears. And
it has been the constant endeavour of the Painters to give
Pleasure to the Eyes. In short, those things which the
Poets have thought unworthy of their Pens, the Painters
have judg'd to be unworthy of their Pencils. For both
"those Arts, that they might advance the sacred Honours
of Religion," have rais'd themselves to Heaven; and,
having found a free admission into the palace of *Jove* him-
self, have enjoy'd the Sight and Conversation of the Gods;
whose "awful Majesty they observe, and whose Dictates
they communicate to Mankind," whom at the same time
they inspire with those Cœlestial Flames, which shine so
gloriously in their Works. From Heaven they take their
passage through the World; and "with concurring Studies"
collect whatsoever they find worthy of them. They dive
(as I may say) into all past Ages; and search their His-
tories, for Subjects which are proper for their use: with
care avoiding to treat of any but those, which by their
Nobleness, or by some remarkable accident, have de-
serv'd to be consecrated to Eternity; whether on the Seas,
or Earth, or in the Heavens. And by this their Care and
Study, it comes to pass, that the Glory of Heroes is not
extinguish'd with their Lives: and that those admirable

[1] The excerpts are taken from C. A. Du Fresnoy, *The Art of
Painting*, translated by John Dryden, 2nd ed., London, 1716.
 See also: Lee, "Ut Pictura Poesis," pp. 197 (note 5), 225–
226; Schlosser, *Lett. art.*, p. 548, and *Kunstlit.*, p. 554.

Works, those Prodigies of Skill, which even yet are the objects of our Admiration, are still preserv'd. So much these Divine Arts have been almost honour'd: and such Authority they preserve amongst Mankind. It will not here be necessary to implore the succour of *Apollo*, and the Muses, for the Gracefulness of the Discourse, or for the Cadence of the Verses: which containing only Precepts, have not so much need of Ornament, as of Perspicuity.

I pretend not in this Treatise to tye the Hands of Artists, "whom Practice only directs;" Neither would I stifle the Genius, by a jumbled Heap of Rules: nor extinguish the Fire of a Vein which is lively and abundant. But rather to make this my Business, that Art being strengthened by the Knowledge of Things, may at length pass into Nature by slow Degrees; and so in process of Time, may be sublim'd into a pure Genius, which is capable of choosing judiciously what is true; and of distinguishing betwixt the Beauties of Nature, and that which is low and mean in her; and that this original Genius, by long Exercise and Custom, may perfectly possess all the Rules and Secrets of that Art.

Precept I. *Of what is Beautiful.* The principal and most important part of Painting, is to find out, and thoroughly to understand what Nature has made most Beautiful, and most proper to this Art; and that a Choice of it may be made according to the Taste and Manner of the Ancients: Without which, all is nothing but a blind, and rash Barbarity; which rejects what is most beautiful, and seems with an audacious Insolence to despise an Art, of which it is wholly ignorant; which has occasion'd these words of the Ancients: *That no man is so bold, so rash, and so overweening of his own Works, as an ill Painter, and a bad Poet, who are not conscious to themselves of their own Ignorance.*

We love what we understand; we desire what we love; we pursue the Enjoyment of those things which we desire; and arrive at last to the Possession of what we have pursu'd, if we warmly persist in our Design. In the meantime, we ought not to expect, that blind Fortune shou'd infallibly throw into our Hands those Beauties. For though

we may light by Chance on some which are true and natural, yet they may prove either not to be decent, or not to be ornamental. Because it is not sufficient to imitate Nature in every Circumstance, dully, and as it were literally, and minutely; but it becomes a Painter to take what is most beautiful, as being the Sovereign Judge of his own Art; "what is less beautiful or is faulty, he shall freely correct by the Dint of his own Genius," and permit no transient Beauties to escape his Observation.

II. *Of Theory and Practice.* In the same manner, that bare Practice, destitute of the Lights of Art, is always subject to fall into a Precipice, like a blind Traveller, without being able to produce anything which contributes to a solid Reputation: So the Speculative part of Painting, without the assistance of manual operation, can never attain to that Perfection which is its Object: But sloathfully languishes as in a Prison: for it was not with his Tongue that *Apelles* perform'd his Noble Works. Therefore though there are many things in Painting, of which no precise Rules are to be given (because the greatest Beauties cannot always be express'd for want of Terms) yet I shall not omit to give some Precepts, which I have selected from among the most considerable which we have receiv'd from Nature, that exact School-mistress, after having examin'd her most secret Recesses, as well as those Masterpieces of Antiquity, which were the chief Examples of this Art: And, 'tis by this means that the Mind, and the natural Disposition are to be cultivated; and that Science perfects Genius; and also moderates that Fury of the Fancy which cannot contain itself within the Bounds of Reason; but often carries a Man into dangerous Extremes. *For there is a Mean in all things; and certain Limits or Bounds wherein the Good and the Beautiful consist; and out of which they never can depart.*

III. *Concerning the Subject.* This being premis'd, the next thing is to make choice of a Subject beautiful and noble; which being of it self capable of all the Charms and Graces, that Colours, and the Elegance of Design can possibly give, shall afterwards afford, to a perfect and consummate Art, an ample Field of matter wherein to ex-

patiate it self; to exert all its Power, and to produce somewhat to the Sight, which is excellent, judicious, and ingenious; and at the same time proper to instruct, and to enlighten the Understanding.

"At length I come to the Work itself; and at first find only a bare strain'd Canvas, on which the Sketch is to be disposed by the strength of a happy Imagination;" which is what we properly call *Invention.*

Invention the first Part of Painting. INVENTION is a kind of Muse, which, being possess'd of the other Advantages common to her Sisters, and being warm'd by the Fire of *Apollo,* is rais'd higher than the rest, and shines with a more glorious, and brighter Flame.

IV. *The Disposition, or Oeconomy of the whole Work.* 'Tis the Business of a Painter, in his Choice of Attitudes, to foresee the Effect, and Harmony of the Lights and Shadows, with the Colours which are to enter into the whole; taking from each of them, that which will most conduce to the Production of a beautiful Effect.

V. *The Faithfulness of the Subject.* Let "there be a genuine and lively Expression of the Subject," conformable to the Text of ancient Authors, to Customs, and to Times.

VI. *Whatsoever palls the Subject to be rejected.* "Whatever is trivial, foreign, or improper, ought by no means to take up the principal Part of the Picture." But herein imitate the Sister of Painting, Tragedy: which employs the whole Forces of her Art in the main Action.

This part of Painting, so rarely met with, is neither to be acquir'd by Pains or Study, nor by the Precepts or Dictates of any Master. For they alone who have been inspir'd at their Birth with some Portion of that heavenly Fire which was stolen by *Prometheus,* are capable of receiving so divine a Present. . . .

VII. *Design the second part of painting.* An Attitude therefore must be chosen, according to their[2] Taste: The Parts of it must be great and large, "contrasted by contrary Motions, the most noble Parts foremost in sight, and each Figure carefully poised on its own Centre.

[2] The Greeks.

"The Parts must be drawn with flowing gliding Outlines, large and smooth, rising gradually, not swelling suddenly, but which may be just felt in the Statues, or cause a little Relievo in Painting. Let the Muscles have their Origin and Insertion according to the Rules of Anatomy; let them not be subdivided into small Sections, but kept as entire as possible, in imitation of the Greek Forms, and expressing only the principal Muscles." In fine, let there be a perfect Relation betwixt the parts and the whole, that they may be entirely of a piece.

Let the Part which produces another Part, be more strong than that which it produces; and let the whole be seen by one point of Sight. Though Perspective cannot be call'd a perfect Rule "for designing," yet it is a great Succour to Art, and facilitates the "Dispatch of the Work;" tho' frequently falling into Error, it makes us behold things under a false Aspect; for Bodies are not always represented according to the Geometrical Plane, but such as they appear to the Sight. . . .

XIX. *That we must not tie ourselves to Nature; but accommodate her to our Genius.* Be not so strictly ty'd to *Nature,* that you allow nothing to Study, and the bent of your own *Genius.* But on the other side, believe not that your *Genius* alone, and the Remembrance of those things which you have seen, can afford you wherewithall to furnish out a beautiful Piece, without the Succour of that incomparable School-mistress, *Nature*; whom you must have always present as a Witness to the Truth. "Errors are infinite," and amongst many ways which mislead a Traveller, there is but one true one, which conducts him surely to his Journey's end; as also there are many several sorts of crooked lines; but there is One only which is straight.

XX. *Ancient Figures; the Rules of imitating Nature.* Our business is to imitate the Beauties of Nature, as the Ancients have done before us, and as the Object, and Nature of the thing require from us. And for this reason we must be careful in the Search of *Ancient Medals, Statues, Gems, Vases, Paintings, and Basso Relievo's*: And of all other things which discover to us the Thoughts and Inventions

of the *Græcians*; because they furnish us with great Ideas, and make our Productions wholly beautiful. And in truth, after having well examin'd them, we shall therein find so many Charms, that we shall pity the Destiny of our present Age, without hope of ever arriving at so high a point of Perfection.

XXVII. *The Graces and the Nobleness.* Let a Nobleness and Grace be remarkable through all your work. But to confess the Truth, this is a most difficult Undertaking; and a very rare Present, which the Artist receives rather from the hand of Heaven, than from his own Industry and Studies.

XXVIII. *Let every thing be set in its proper Place.* In all things you are to follow the order of Nature; for which Reason you must beware of drawing or painting Clouds, Winds and Thunder towards the Bottom of your Piece, and Hell, and Waters, in the uppermost Parts of it: You are not to place a Stone Column on a foundation of Reeds; but let every thing be set in its proper Place.

XXIX. *Of the Passions.* Besides all this, you are to express the Motions of the Spirits, and the Affections or Passions whose Centre is the Heart: In a word, to make the Soul visible, by the means of some few Colours; this is that, in which the greatest Difficulty consists. Few there are whom *Jupiter* regards with a favourable Eye in this Undertaking. So that it appertains only to those few, who participate somewhat of Divinity it self, to work these mighty Wonders. 'Tis the business of *Rhetoricians,* to treat the Characters of the Passions: and I shall content my self, with repeating what an excellent master has formerly said on this Subject, *That a true and lively Expression of the Passions, is rather the Work of Genius than of Labour and Study.*

XXX. Gothique *Ornaments are to be avoided.* We are to have no manner of Relish for *Gothique* Ornaments, as being in effect so many Monsters, which barbarous Ages have produc'd; during which, when Discord and Ambition, caus'd by the too large extent of the *Roman Empire,* had produc'd Wars, Plagues and Famine through the World, then I say, the stately Buildings and Colosses fell

to Ruin, and the Nobleness of all beautiful Arts was totally extinguish'd. . . . From hence it comes to pass, that the Works of those great *Græcians* are wanting to us; nothing of their Painting and Colouring now remains to assist our modern Artsists, either in the Invention, or the manner of those Ancients. Neither is there any Man who is able to restore the CHROMATIC part, or COLOURING, or to renew it to that point of Excellency to which it had been carri'd by *Zeuxis*: who by this Part, which is so charming, so magical, and which so admirably deceives the Sight, made himself equal to the great *Apelles*, that *Prince of Painters*; and deserv'd that height of Reputation, which he still possesses in the World.

And as this part, which we may call the utmost Perfection of Painting, is a deceiving Beauty, but withall soothing and pleasing; So she has been accus'd of procuring Lovers for her Sister, and artfully engaging us to admire her. But so little have this Prostitution, these false Colours, and this Deceit, dishonour'd Painting, that on the contrary, they have only serv'd to set forth her Praise, and to make her Merit farther known; and therefore it will be profitable to us, to have a more clear Understanding of what we call Colouring. . . .

XLIII. *The choice of Light.* 'Tis Labour in vain to paint a High-noon, or Mid-day Light in your Picture: because we have no Colours which can sufficiently express it; but 'tis better Counsel, to choose a weaker Light; such as is that of the Evening with which the Fields are gilded by the Sun; or a Morning Light, whose whiteness is allay'd; or that which appears after a shower of Rain, which the Sun gives us through the breaking of a Cloud; or during Thunder, when the Clouds hide him from our View, and make the Light of a fiery Colour.

LV. *Things which are vicious in Painting to be avoided.* Remember to avoid Objects which are full of hollows, broken in Pieces, little, and which are separated, or in Parcels: shun also those things which are barbarous, shocking to the Eye, and party-colour'd, and which are all of an equal Force of Light and Shadow: as also all things which are obscene, impudent, filthy, unseemly,

cruel, fantastical, poor, and wretched; and those things which are sharp to the Feeling: In short, all things which corrupt their natural Forms, by a Confusion of their Parts which are entangled in each other: *For the Eyes have a Horror for those things, which the Hands will not condescend to touch.*

LVI. *The prudential Part of a Painter.* But while you endeavour to avoid one vice, be cautious, lest you fall into another: for *Extremes are always vicious.*

LVII. *The Idea of a beautiful Piece.* Those things which are beautiful in the utmost Degree of Perfection, according to the Axiom of ancient Painters, ought to have somewhat of Greatness in them; and their Outlines to be noble: they must be disentangled, pure, and without Alteration, clean, and knit together; compos'd of great Parts, yet those but few in number. In fine, distinguish'd by bold Colours; but of such as are related and friendly to each other.

LVIII. *Advice to a young Painter.* And as it is a common saying, that *He who has begun well, has already perform'd half his work*; so there is nothing more pernicious to a Youth who is yet in the Elements of Painting, than to engage himself under the Discipline of an ignorant Master; who depraves his Taste, by an infinite number of Mistakes, of which his wretched Works are full, and thereby makes him drink the Poyson, which infects him through all his future Life.

Let him, who is yet but a Beginner, not make so much haste to study after Nature, every thing which he intends to imitate; as not in the mean time to learn Proportions, the Connexion of the Joints, and their Out-lines: And let him first have well examin'd the excellent Originals, and have thoroughly studied all the pleasing Deceptions of his Art; which he must be rather taught by a knowing Master, than by Practice; and by seeing him perform, without being contented only to hear him speak.

LIX. *Art must be subservient to the Painter.* Search whatsoever is aiding to your Art, and convenient: and avoid those things which are repugnant to it.

LX. *Diversity and Facility are Pleasing.* Bodies of divers

Natures, which are aggroup'd (or combin'd) together, are agreeable and pleasant to the Sight; as also those things which seem to be slightly touch'd and perform'd with Ease; because they are ever full of Spirit, and appear to be animated with a kind of Cœlestial Fire. But we are not able to compass these things with Facility, till we have for a long time weigh'd them in our Judgment, and thoroughly consider'd them: By this means the Painter shall be enabled to conceal the Pains and Study which his Art and Work have cost him, under a pleasing sort of Deceit: For the greatest Secret which belongs to Art, is to hide it from the Discovery of Spectators.

LXI. *The Original must be in the Head, and the Copy on the Cloth.* Never give the least touch with your pencil, till you have well examin'd your Design, and have settled your Out-lines; nor till you have present in your Mind a perfect Idea of your Work.

LXII. *The Compass to be in the Eyes.* Let the Eye be satisfy'd in the first Place, even against, and above all other Reasons, which beget Difficulties in your Art, which of it self suffers none; and let the Compass be rather in your Eyes, than in yours Hands.[3]

LXIII. *Pride an Enemy to good Painting.* Profit your self by the Counsels of the Knowing: And do not arrogantly disdain to learn the Opinion of every Man concerning your Work. All Men are blind as to their own Productions; and no Man is capable of judging in his own Cause. But if you have no knowing Friend, to assist you with his Advice; yet length of Time will never fail; 'tis but letting some Weeks pass over your Head, or at least some Days, without looking on your Work: and that Intermission will faithfully discover to you the Faults, and Beauties. Yet suffer not your self to be carried away by the Opinions of the Vulgar, who often speak without Knowledge; neither give up your self altogether to them, and abandon wholly your own Genius, so as lightly to change that which you have made: For he who has a windy Head, and flatters himself with the empty Hope of deserving the Praise of the common People (whose Opinions are inconsiderate, and

[3] Cf. Zuccaro, p. 91.

changeable) does not injure himself, and pleases no Man.

LXIV. *Know your self.* Since every Painter paints himself in his own Works (so much is Nature accustom'd to produce her own Likeness), 'tis advantageous to him, to know himself: to the end that he may cultivate those Talents which make his Genius, and not unprofitably lose his Time, in endeavouring to gain that, which she has refus'd him. As neither Fruits have the Taste, nor Flowers the Beauty which is natural to them, when they are transplanted into an unkindly or foreign Soil, and are forc'd to bear before their Season, by an artificial Heat: So 'tis in vain for the Painter to sweat over his Works, in spite of Nature and of Genius; for without them, 'tis impossible for him to succeed.

LXV. *Perpetually practice, and do easily what you have conceiv'd.* While you meditate on these Truths, and observe them diligently, by making necessary Reflections on them; let the Labour of the Hand accompany the Study of the Brain; let the former second and support the latter; yet without blunting the Sharpness of your Genius, and abating of its Vigour, by too much Assiduity.

LXVI. *The Morning most proper for Work.* The Morning is the best, and most proper part of the Day for your Business; employ it therefore in the Study and Exercise of those things which require the greatest Pains and Application.

LXVII. *Every Day do something.* Let no day pass over you, without a line.

LXVIII. *The Passions which are true and natural.* Observe as you walk the Streets, the Airs of Heads; the natural Postures and Expressions; which are always the most free, the less they seem to be observ'd.

LXIX. *Of Table-books.* Be ready to put into your Table-book (which you must always carry about you) whatsoever you judge worthy of it; whether it be upon the Earth, or in the Air, or upon the Waters, while the Species of them is yet fresh in your Imagination.

Wine and good Cheer are no great Friends to Painting: they serve only to recreate the Mind, when 'tis opprest and spent with Labour; then indeed 'tis proper to renew

your Vigour by the Conversation of your Friends. Neither is a true Painter naturally pleas'd with the Fatigue of Business; and particularly of the Law; but delights in the Liberty which belongs to the Bachelor's Estate. Painting naturally withdraws from Noise and Tumult, and pleases it self in the Enjoyment of a Countrey Retirement: because Silence and Solitude set an edge upon the Genius, and cause a greater Application to Work and Study: and also serve to produce the Ideas, which so conceiv'd, will be always present in the Mind, even to the finishing of the Work; the whole Compass of which, the Painter can at that time more commodiously form to himself, than at any other.

Let not the covetous Design of growing rich, induce you to ruin your Reputation; but rather satisfy your self with a moderate Fortune: and let your Thoughts be wholly taken up with acquiring to your self a glorious Name, which can never perish, but with the World; and make that the Recompense of your worthy Labours.

The Qualities requisite to form an excellent Painter, are, a true discerning Judgment, a Mind which is docible, a noble Heart, a sublime Sense of things, and Fervour of Soul; after which follow, Health of Body, a convenient Share of Fortune, the Flower of Youth, Diligence, an Affection for the Art, and to be bred under the Discipline of a knowing Master.

And remember, that whatsoever your Subject be, whether of your own Choice, or what Chance or good Fortune shall put into your Hand, if you have not that Genius, or natural Inclination, which your Art requires, you shall never arrive to Perfection in it, even with all those great Advantages which I have mention'd. For the Wit and the manual Operation are things vastly distant from each other. 'Tis the influence of your Stars, and the Happiness of your Genius, to which you must be oblig'd for the greatest Beauties of your Art. . . .

LXX. *The Method of Studies for a young Painter.* You will do well to begin with *Geometry*, and after having made some Progress in it, set your self on designing after the *Ancient Greeks*: and cease not Day or Night from

Labour, till by your continual Practice you have gain'd
an easy habitude of imitating them in their Invention, and
in their Manner. And when afterwards your Judgment
shall grow stronger, and come to its maturity with Years,
it will be very necessary to see and examine one after the
other, and Part by Part, those Works which have given
so great a Reputation to the Masters of the first Form in
Pursuit of that Method, which we have taught you here
above, and according to the Rules which we have given
you; such are the *Romans,* the *Venetians,* the *Parmesans,*
and the *Bologneses.* Amongst those excellent Persons,
Raphael had the Talent of *Invention* for his Share, by
which he made as many Miracles as he made Pictures. In
which is observ'd a certain Grace which was wholly natural
and peculiar to him, and which none since him have been
able to appropriate to themselves. *Michael Angelo* possess'd
powerfully the Part of *Design,* above all others. *Julio
Romano* (educated from his Childhood among the *Muses*)
has open'd to us the Treasures of *Parnassus*: and in the
Poetry of Painting has discover'd to our Eyes the most
sacred Mysteries of *Apollo,* and all the rarest Ornaments
which that *God* is capable of communicating to those
Works that he inspires; which we knew not before, but
only by the Recital that the *Poets* made of them. He seems
to have painted those famous Wars "in which Fortune has
crowned her triumphant Heroes; and those other glorious
Events which she has caus'd in all Ages, even with more
Magnificence and Nobleness, than when they were acted
in the World.

"The shining Eminence of *Corregio* consists in his laying
on ample broad Lights encompass'd with friendly Shadows,
and in a grand Style of Painting, with a Delicacy in the
management of Colours." And *Titian* understood so well
the *Union* of the *Masses,* and the Bodies of Colours, the
Harmony of the Tints, and the Disposition of the whole
together, that he has deserv'd those Honours and that
Wealth which were heap'd upon him, together with that
Attribute of being sirnam'd the *Divine Painter.* The labori-
ous and diligent *Annibal Caracci,* has taken from all those
great Persons already mention'd whatsoever Excellencies

he found in them, and, as it were, converted their Nourishment into his own Substance.

LXXI. *Nature and Experience perfect Art.* 'Tis a great means of profiting your self, to copy diligently those excellent Pieces, and those beautiful Designs; But *Nature* which is at present before your Eyes, is yet a better *Mistress*: For she augments the Force and Vigour of the Genius, and she it is from whom *Art* derives her ultimate Perfection, by means of sure *Experience*; I pass in Silence many things which will be more amply treated in the ensuing commentary. . . .

ROGER DE PILES

[Roger de Piles (1635–1709), one of the most influential art historians and theoreticians of his time, was born in Clamecy and educated in Paris. He became interested in painting and made the acquaintance of the leading artists and art theoreticians of his time. He was a tutor to Michel Amelot, whose father was president of the Great Council, and later accompanied his former pupil, as his secretary, to his several diplomatic posts. De Piles was also employed by Louis XIV for various diplomatic missions. While on such a mission, he was arrested and detained in Holland for four years. De Piles' travels enabled him to study the arts in all Europe.

Although de Piles had studied painting and was perhaps also an engraver, he was admitted to the French Academy as a *Conseiller Honoraire Amateur* and considered himself a theoretician rather than an artist.

His first literary effort was the translation of Du Fresnoy's poem, *De arte graphica.* This was followed by a series of his own works among which the most important are *Dialogue sur le coloris* (Dialogue on Color, 1673), *Dissertation sur les ouvrages des plus fameux peintres, avec la vie de Rubens* (The Works of the Most Famous Painters, with the Life of Rubens, 1681), *Abrégé de la vie des peintres. Idée du peintre parfait* (The Lives of Painters. Idea of the

Perfect Painter, 1699), and *Cours de peinture par principes avec une balance des peintres* (The Principles of Painting with a Balance of Painters, 1708). This last book contains the essence of his theory. Although his ideas are expressed within the conventional framework of an academic treatise, he extended te definition of history-painting —considered as the highest form by the Academy—to include all subject matter. In opposition to the doctrine of the Academy he asserted that color, light and shade had equal value with drawing and recognized the value of genius, enthusiasm, and imagination in producing a work of art.]

THE PRINCIPLES OF PAINTING[1]

OF LANDSKIP. Landskip is a kind of painting that represents the fields, and all the objects that belong to them. Among all the pleasures which the different talents of painting afford to those who employ them, that of drawing landskips seems to me the most affecting, and most convenient; for, by the great variety of which it is susceptible, the painter has more opportunities, than in any of the other parts, to please himself by the choice of his objects. The solitude of rocks, freshness of forests, clearness of waters, and their seeming murmurs, extensiveness of plains and offskips,[2] mixtures of trees, firmness of verdure, and a fine general scene or opening, make the painter imagine himself either a-hunting, or taking the air, or walking, or sitting, and giving himself up to agreeable musing. In a word, he may here dispose of all things to his pleasure, whether upon land, or in water, or in the sky, because there is not any production either of art or nature, which may nȯt be brought into such a picture. Thus painting,

[1] The excerpts are from Roger de Piles, *The Principles of Painting*, translated by a Painter, London, 1743. The material for the biographical sketch is taken from Florence B. Wiggin's paper, "Roger de Piles," written for Dr. Walter Friedländer.
See also: L. Mirot, *Roger de Piles, peintre, amateur, critique*, Paris, 1924; Lee, "Ut Pictura Poesis," pp. 197–269; Schlosser, *Lett. art.*, pp. 551, 602, and *Kunstlit.*, pp. 553, 604.
[2] Offskips are *les lointains*, i.e. distant views.

which is a kind of creation, is more particularly so with regard to landskip.

Among the many different styles of landskip, I shall confine my self to two; *the heroick,* and *the pastoral* or *rural*; for all other styles are but mixtures of these.

The heroick style is a composition of objects, which, in their kinds, draw, both from art and nature, everything that is great and extraordinary in either. The situations are perfectly agreeable and surprising. The only buildings, are temples, pyramids, ancient places of burial, altars consecrated to the divinities, pleasure-houses of regular architecture: And if nature appear not there, as we every day casually see her, she is at least represented as we think she ought to be. This style is an agreeable illusion, and a sort of inchantment, when handled by a man of fine genius, and good understanding, as *Poussin* was, who has so happily expressed it. But if, in the course of this style, the painter has not talent enough to maintain the sublime, he is often in danger of falling into the childish manner.

The *rural style* is a representation of countries, rather abandoned to the caprice of nature than cultivated: We there see nature simple, without ornament, and without artifice; but with all those graces with which she adorns herself much more, when left to herself, than when constrained by art.

In this style, situations bear all sorts of varieties: Sometimes they are very extensive and open, to contain the flocks of the shepherds; at others, very wild, for the retreat of solitary persons, and a cover for wild beasts.

It rarely happens, that a painter has a genius extensive enough to embrace all the parts of painting: there is commonly some one part that pre-engages our choice, and so fills our mind, that we forget the pains that are due to the other parts; and we seldom fail to see, that those whose inclination leads them to the *heroick style*, think they have done all, when they have introduced into their compositions such noble objects as will raise the imagination, without ever giving themselves the trouble to study the effects of good colouring. Those, on the other hand, who practise the pastoral, apply closely to colouring, in order to rep-

resent truth more lively. Both these styles have their sectaries and partisans. Those who follow the heroick, supply by their imagination, what it wants of truth, and they look no farther.

As a counterbalance to heroick landskip, I think it would be proper to put into the pastoral, besides a great character of truth, some affecting, extraordinary, but probable effect of nature, as was *Titian's* custom.

There is an infinity of pieces wherein both these styles happily meet; and which of the two has the ascendant, will appear from what I have just been observing of their respective properties. The chief parts of landkip are, I think, their openings or situations, accidents, skies and clouds, offskips and mountains, verdure or turfing, rocks, grounds or lands, terraces, rabricks, waters, foregrounds, plants, figures and trees: Of all which in their places.

Of Openings or Situations. The word *site,* or situation, signifies the view, prospect or opening of a country: It is derived from the *Italian* word *sito*; and our painters have brought it into use, either because they were used to it in Italy, or because, as I think, they found it to be very expressive.

Situations ought to be well put together, and so disengaged in their make, that the conjunction of grounds may not seem to be obstructed, tho' we should see but a part of them.

Situations are various, and represented according to the country the painter is thinking of: As, either open or close, mountainous or watery, tilled and inhabited, or wild and lonely; or, in fine, variegated by a prudent mixture of some of these. But if the painter be obliged to imitate nature in a flat and regular country, he must make it agreeable by a good disposition of the *claro-obscuro,* and such pleasing colouring as may make one soil unite with another.

'Tis certain, that extraordinary situations are very pleasing, and cheer the imagination by the novelty and beauty of their makes, even when the local colouring is but moderately performed; because, at worst, such pictures are only look'd on as unfinish'd, and wanting to be completed

by some skilful hand in colouring: Whereas common situations and objects require good colouring and absolute finishing, in order to please. It was only by these properties, that *Claude Lorrain* has made amends for his insipid choice in most of his situations. But in whatever manner that part be executed, one of the best ways to make it valuable, and even to multiply and vary it without altering its form, is properly to imagine some ingenious accident in it.

Of Accidents. An accident in painting is an obstruction of the sun's light by the interposition of clouds, in such manner, that some parts of the earth shall be in light, and others in shade, which, according to the motion of the clouds, succeed each other, and produce such wonderful effects and changes of *claro-obscuro*, as seem to create so many new situations. This is daily observed in nature. And as this newness of situations is grounded only on the the shapes of the clouds, and their motions, which are very inconstant and unequal, it follows that these accidents are arbitrary; and a painter of genius may dispose them to his own advantage, when he thinks fit to use them; for he is not absolutely obliged to do it. And there have been some able landskip-painters, who have never practised it, either thro' fear or custom; as *Claude Lorrain,* and some others. . . .

Of the Claro-Obscuro. The knowledge of lights and shades, which painting requires, is one of the most important and most essential branches of the art. We only see by means of light, and light draws and attracts the eye with more or less strength, as it strikes the objects of nature; for this reason the painter, who is the imitator of these objects ought to know and chuse the advantageous effects of light, that he may not lose the pains he may have taken in other things, to be an able artist.

This part of painting includes two things, the incidence of particular lights and shades, and the knowledge of general lights and shades, which we usually call the *claro-obscuro*. And tho', according to the force of the words, these two things seem to be the same, yet they are very

different, because of the ideas we are used to entertain of them.

The incidence of light consists in knowing the shadow which a body, placed on a certain plane, and exposed to a given light, ought to make upon that plane; a knowledge easily attained from the books of perspective. By the incidence of lights we therefore understand the lights and shades proper to particular objects. And by the word *claro-obscuro* is meant the art of advantageously distributing the lights and shades which ought to appear in a picture, as well for the repose and satisfaction of the eye, as for the effect of the whole together.

The incidence of light is demonstrated by the lines which are supposed to be drawn from the source of that light to the body enlightened; and this the painter must strictly observe; whereas the *claro-obscuro* depends absolutely on the painter's imagination, who, as he invents the objects, may dispose them to receive such lights and shades as he proposes in his picture, and introduce such accidents and colours as are most for his advantage. In short, as particular lights and shades are comprised in general ones, we much [must] consider the *claro-obscuro* as one whole, and the incidence of particular light as a part which the *claro-obscuro* presupposes.

But in order to understand thoroughly the meaning of this word, we must know, that *claro* implies not only any-thing exposed to a direct light, but also all such colours as are luminous in their natures; and *obscuro*, not only all the shadows directly caused by the incidence and priva-tion of light, but likewise all the colours which are naturally brown, such as, even when they are exposed to light, main-tain an obscurity, and are capable of grouping with the shades of other objects: Of this kind, for instance, are deep velvets, brown stuffs, a black horse, polished armour, and the like, which preserve their natural or apparent obscu-rity in any light whatever.

It must be further observed, that the *claro-obscuro*, which contains and supposes the incidence of lights and shades, as the whole includes a part, respects that part in a particular manner; for the incidence of light and shade

tends only to point out precisely the parts enlightened and shaded; but the *claro-obscuro* adds to this preciseness the art of giving objects more relief, truth, and apparency; as I have elsewhere demonstrated.

But more plainly to discover the difference between the *claro-obscuro,* and the incidence of light; the former is the art of distributing advantageously the lights and shades, both in particular objects, and generally throughout the picture; but it more particularly implies the great lights, and great shades, which are collected with an industry that conceals the artifice. And in this sense, the painter uses it for setting objects in a fine light, and reposing the sight, from distance to distance, by an artful distribution of objects, colours, and accidents; and these are the three ways which lead to the *claro-obscuro,* as we shall further illustrate.

The Distribution of Objects. The distribution of objects forms the masses of the *claro-obscuro,* when, by an industrious management, we so dispose them, that all their lights be together on one side, and their darkness on the other, and that this collection of lights and shades hinder the eye from wandering. *Titian* called it *the bunch of grapes,* because the grape, being separated, would have each its light and shade equally, and thus dividing the sight into many rays, would cause confusion; but when collected into one bunch, and becoming thus but one mass of light, and one of shade, the eye embraces them as a single object. This instance must not be understood literally, either as to the order, or the form, of a bunch of grapes; but only, as an obvious comparison, to shew a conjunction of lights, and also of shades.

The Bodies of Colours. The distribution of colours contributes to the masses of lights, and to those of shades, whilst direct light is of no other assistance in this respect, than as it makes the objects visible. This depends on the painter's management, who is at liberty to introduce a figure cloathed in brown, which shall remain dark, notwithstanding any light it may be struck with; and the effect will be the greater, as the artifice will not appear. The same management and effect may be understood of

all other colours, according to the degree of their tones, and the painter's occasion for them.

Accidents. The distribution of accidents may be of service in the effect of the *claro-obscuro,* whether in light or in shade. Some lights and shades are accidental: Accidental light is what is but accessory to a picture, or proceeds from some accident, as the light of a window or flambeau, or other luminous cause, which is nevertheless inferior to the original light. Accidental shades are, for example, those of the clouds in the landskip, or of some other body supposed to be out of the picture, and giving advantageous shades. But in the case of these flying shadows, we must take care, that the supposed cause of them be probable.

These seem to me to be the three ways of practising the *claro-obscuro*; but all I have said will be to little purpose, unless I make the student sensible of the necessity of the *claro-obscuro,* both in the theory and practice of painting.

But of the many reasons for this necessity, I shall chuse to mention four, which seem to me to be the most important.

The first is taken from the necessity of making a choice in painting.

The second proceeds from the nature of the *claro-obscuro.*

The third from the advantage which the *claro-obscuro* yields to the other parts of painting. And

The fourth is drawn from the general constitution of all beings.

THE BALANCE OF PAINTERS. Some persons, curious to know the degree of merit of every painter of established reputation, have desired me to make a kind of balance, where I might set down, on one side, the painter's name, and the most essential parts of his art, in the degree he possessed them; and, on the other side, their proper weight of merit; so as, by collecting all the parts, as they appear in each painter's works, one might be able to judge how much the whole weighs.

This I have attempted, rather to please myself, than to bring others into my sentiments: Opinions are too various

in this point, to let us think, that we alone are in the right. All I ask is, the liberty of declaring my thoughts in this matter, as I allow others to preserve any idea they may have different from mine.

The method I have taken is this: I divide my weight into twenty parts, or degrees. The twentieth degree is the highest, and implies *sovereign perfection*; which no man has fully arrived at. The nineteenth is the highest degree that we know, but which no person has yet gained. And the eighteenth is, for those who, in my opinion, have come nearest to perfection; as the lower figures are for those who appear to be further from it.

I have passed my judgment only on the most noted painters, and in the ensuing catalogue have divided the chief parts of the art into four columns; to wit *Composition, Design, Colouring* and *Expression*. By *Expression*, I mean not the character of any particular object, but the general thought of the understanding. And thus, against each painter's name, we see his degree of merit in all the aforesaid four divisions.

We might introduce, among the most noted painters, several *Flemings*, who have very faithfully shewn truth of nature, and been excellent colourists; but we thought it better to set them by themselves, because their taste was bad in other parts of the art.

It now only remains to be observed, that as the essential parts of painting consist of many other parts, which the same master have not equally possessed; 'tis reasonable to set one against another, in order to make a fair judgment. Thus, for instance, *Composition* arises from two parts; *viz. Invention* and *Disposition*. Now a painter may possibly be capable of inventing all the objects proper to a good composition, and yet not know how to dispose them, so as to produce a great effect. Again, in *Design*, there is taste and correctness; and a picture may have one of them only, or else both may appear jointly, but in different degrees of goodness; and by comparing one with another we may make a general judgment on the whole.

For the rest: I am not so fond of my own sentiments as to think they will not be severely criticized: But I must

give notice, that in order to criticize judiciously, one must
have a perfect knowledge of all the parts of a piece of
painting, and of the reasons which make the whole good;
for many judge of a picture only by the part they like, and
make no account of those other parts which either they
do not understand, or do not relish.

A CATALOGUE of the Names of the most noted Painters, and
their Degrees of Perfection, in the Four principal Parts of
Painting; supposing absolute Perfection to be divided into
twenty Degrees or Parts.

THE NAMES[3] OF THE BEST KNOWN PAINTERS	COMPOSI- TION	DRAW- ING	COL- OUR	EXPRES- SION
A				
Albani	14	14	10	6
Albrecht Dürer	8	10	10	8
Andrea del Sarto	12	16	9	8
B				
Barocci	14	15	6	10
Bassano, Jacopo	6	8	17	0
Sebastiano del Piombo	8	13	16	7
Bellini, Giov.	4	6	14	0
Bourdon	10	8	8	4
Le Brun	16	16	8	16
C				
P. Caliari Veronese	15	10	16	3
The Carracci	15	17	13	13
Correggio	13	13	15	12
D				
Dan. da Volterra	12	15	5	8
Diepenbeck	11	10	14	6
Domenichino	15	17	9	17
G				
Giorgione	8	9	18	4
Guercino	18	10	10	4
Guido Reni	—	13	9	12
H				
Holbein	9	10	16	13

[3] The customary spelling of the names is given by the editor.
The Balance is that as given in Roger de Piles, *Cours de pein-
ture par principes*, Paris, 1708.

THE NAMES OF THE BEST KNOWN PAINTERS	COMPOSITION	DRAWING	COLOUR	EXPRESSION
J				
Giov. da Udine	10	8	16	3
Jac. Jordaens	10	8	16	6
Luc. Jordaens	13	12	9	6
Josepin (Gius. d'Arpino)	10	10	6	2
Giulio Romano	15	16	4	14
L				
Lanfranco	14	13	10	5
Leonardo da Vinci	15	16	4	14
Lucas van Leyden	8	6	6	4
M				
Michelangelo Buonarroti	8	17	4	8
Michelangelo Caravaggio	6	6	16	0
Murillo	6	8	15	4
O				
Otho Venius (Oct. van Veen)	13	14	10	10
P				
Palma Vecchio	5	6	16	0
Palma Giovane	12	9	14	6
Parmignianino	10	15	6	6
Paolo Veronese	15	10	16	3
Fr. Penni, il Fattore	0	15	8	0
Perino del Vaga	15	16	7	6
Pietro da Cortona	16	14	12	6
Pietro Perugino	4	12	10	4
Polidoro da Caravaggio	10	17	—	15
Pordenone	8	14	17	5
Pourbus	4	15	6	6
Poussin	15	17	6	15
Primaticcio	15	14	7	10
R				
Raphael Sanzio	17	18	12	18
Rembrandt	15	6	17	12
Rubens	18	13	17	17
S				
Fr. Salviata	13	15	8	8
Le Sueur	15	15	4	15
T				
Teniers	15	12	13	6
Pietro Testa	11	15	0	6
Tintoretto	15	14	16	4
Titian	12	15	18	6

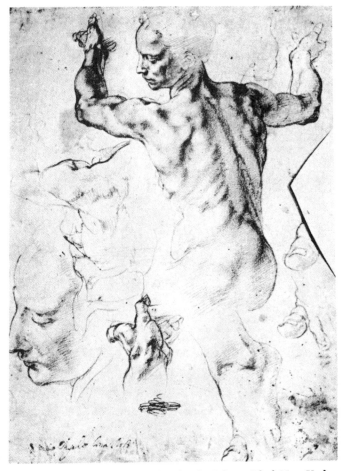

FIG. 1. Michelangelo, Studies for the Libyan Sibyl. New York,
The Metropolitan Museum of Art

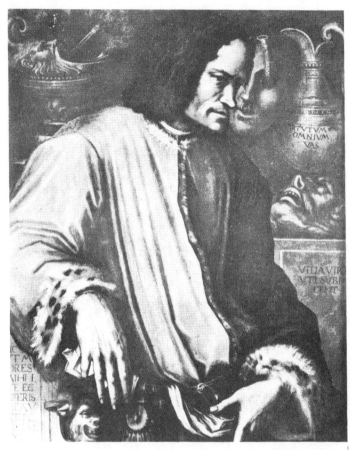

FIG. 2. Vasari, Portrait of Lorenzo de' Medici. Florence, Uffizi (phot. Alinari)

FIG. 3. Veronese, Feast in the House of Levi. Venice, Accademia

FIG. 4. Bernini, Sant' Andrea al Quirinale. Rome (phot. Alinari)

FIG. 5. Bernini, Portrait Bust of Louis XIV. Versailles (phot. Alinari)

FIG. 6. Poussin, Rebecca and Eleazer. Paris, Louvre

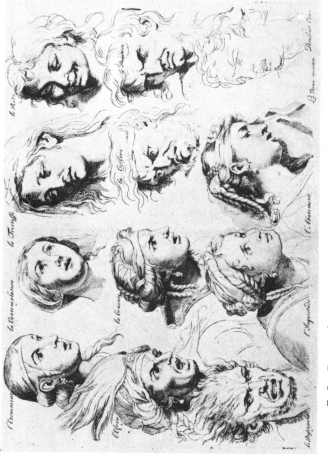

FIG. 7. Le Brun, The Expressions. From the *Traité des passions*, Paris, 1698

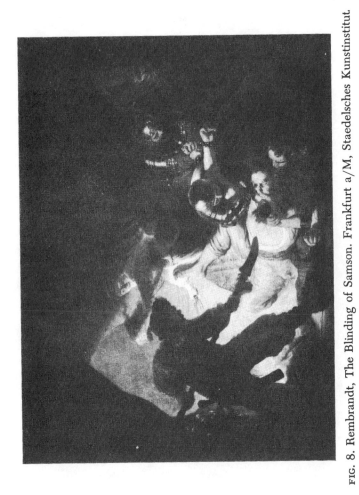

FIG. 8. Rembrandt, The Blinding of Samson. Frankfurt a/M, Staedelsches Kunstinstitut.

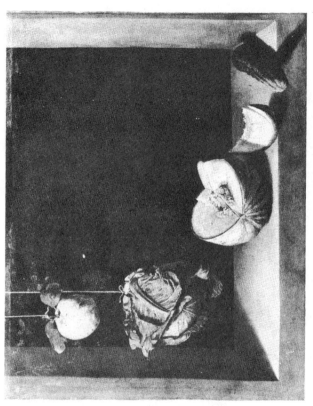

FIG. 9. Juan Sánchez Cotán, Quince, Cabbage, Melon and Cucumber. San Diego, The Fine Arts Gallery

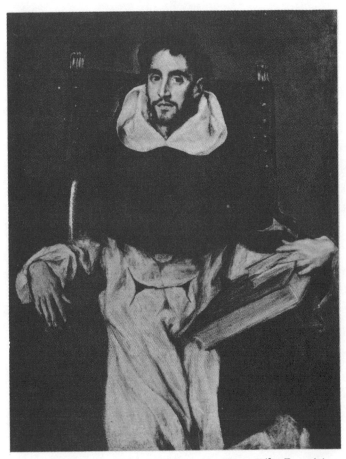

FIG. 10. El Greco, Portrait of Friar Hortensio Félix Paravicino.
Boston, Museum of Fine Arts

FIG. 11. Velázquez, The Servant. Chicago, The Art Institute, Robert Alexander Waller Memorial

FIG. 12. Gribelin after Paolo de Matteis, The Judgment of Hercules. From Shaftesbury, *Characteristics*, III, 1714

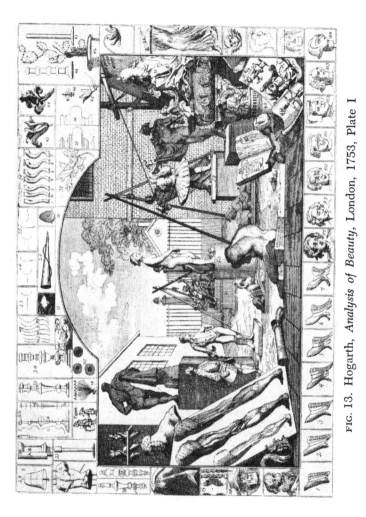

FIG. 13. Hogarth, *Analysis of Beauty*, London, 1753, Plate I

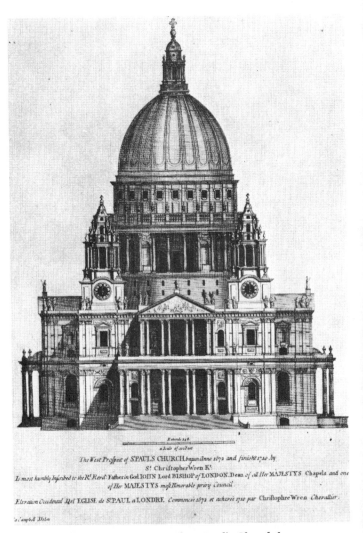

The West Prospect of ST PAUL'S CHURCH begun Anno 1672 and finishd 1710 by
ST Christopher Wren KT.
Is most humbly Inscribed to the RT Revrd Father in God IOHN Lord BISHOP of LONDON Dean of all Her MAJESTYS Chapels and one
of Her MAJESTYS most Honorable privy Council.

Elevation Occidental del EGLISE de ST PAUL a LONDRE Commencée 1672 et achevée 1710 par Christophre Wren Chevallier.

FIG. 14. The West Prospect of St. Paul's Church begun . . .
and finished . . . by Sir Christopher Wren. From Colen
Campbell, *Vitruvius Britannicus*, London, 1717

The Elevation of St. PETERS CHURCH at ROME *Founded by* CONSTANTIN *the Great Anno* 310. *The present Fabrick was begun by*
POPE IULIUS *the II conducted by* BRAMANTE *Anno* 1513 *to whom* SANGALO *and the Famous* MICHEL ANGELO BONAROTI *succeeded.*
The Frontispiece and Body of the CHURCH was Erected by P. PAUL *the V. under the direction of* CARLO MADERNO *1613. and the Baluftrade and*
other Ornaments were added by CAVALIER BERNINI *1640 .*

L'Eglise De St. PIERRE *a* ROME .
This plate is most humbly inscrib'd to His Grace of Duke of Roxburgh &c.
C. Campbell Delin.

FIG. 15. The Elevation of St. Peter's Church at Rome . . .
From Colen Campbell, *Vitruvius Britannicus,* London, 1717

This new Design of my Invention for a Church in Lincolns in Fields is most humbly Inscribed to the Rev.ᵈ Dᴿ Lancaster Vicar of Sᵗ Martins in the Fields Arch Deacon of Midlesex and Prov.oᵗ of Queens Colledge Oxon.

Elevation d'un Nouveau Desin de mon Invention pour une Eglise dans la place de Lincolns in Fields a Londres

FIG. 16. This new Design of my Invention for a Church in Lincolns in Fields . . . From Colen Campbell, *Vitruvius Britannicus*, London, 1717

FIG. 17. Tower of *Taa*. From Chambers, *Designs of Chinese Buildings, Furniture, Dresses, Machines, and Utensils,* London, 1757, Plate V, Fig. 1

FIG. 18. Chinese House, a section thrown into perspective. From Chambers, *Designs of Chinese Buildings, Furniture, Dresses, Machines, and Utensils*, London, 1757, Plate IX

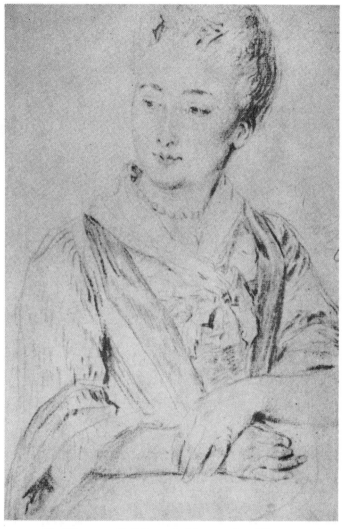

FIG. 19. Watteau, Half-Length Figure of a Woman with
Her Hands Folded. By courtesy of Forsythe Wickes

FIG. 20. Greuze, The Son's Punishment. Paris, Louvre (phot. Giraudon)

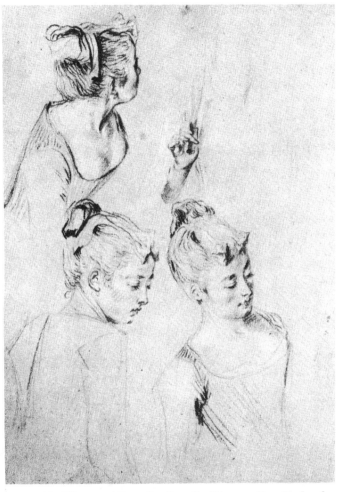

FIG. 21. Watteau, Three Studies of a Woman, One Study of
a Woman's Hand with Fan, and Faint Outline of a Woman.
By courtesy of Forsythe Wickes

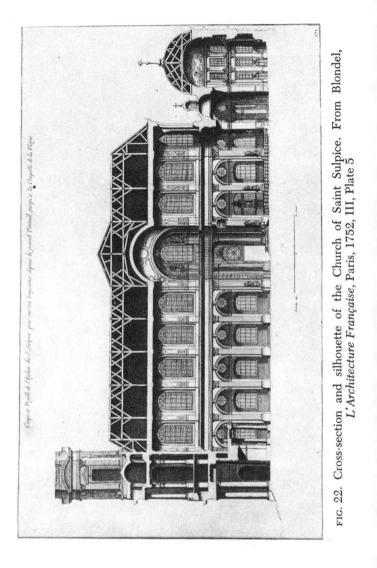

Coupe et Profil de l'Eglise de S.Sulpice pris sur sa longueur depuis le crand Portail jusqu'a la Chapelle de la Vierge

FIG. 22. Cross-section and silhouette of the Church of Saint Sulpice. From Blondel, *L'Architecture Française*, Paris, 1752, III, Plate 5

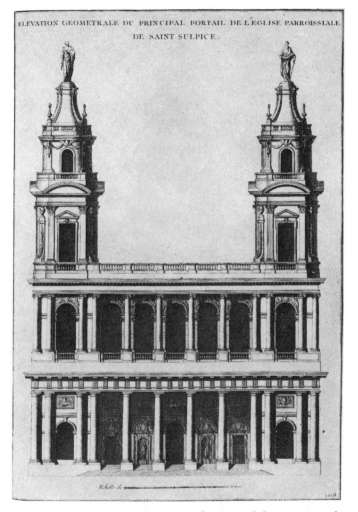

ELEVATION GEOMETRALE DU PRINCIPAL PORTAIL DE L'EGLISE PARROISSIALE
DE SAINT SULPICE.

FIG. 23. Servandoni, Geometric elevation of the main portal
of the Parish Church of Saint Sulpice. From Blondel,
L'Architecture Française, Paris, 1752, III, Plate 2

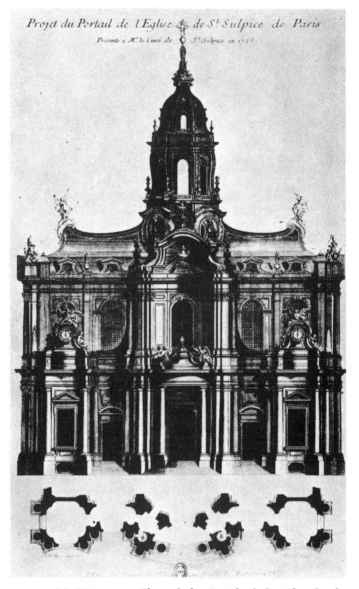

FIG. 24. Meissonier, Plan of the Portal of the Church of
Saint Sulpice of Paris. From *Oeuvres*, Paris (n.d.), Plate 27

THE NAMES OF THE BEST KNOWN PAINTERS	COMPOSI-TION	DRAW-ING	COL-OUR	EXPRES-SION
V				
Van Dyck	15	10	17	13
Vanius	15	15	12	13
Z				
Taddeo Zuccaro	13	14	10	9
Fed. Zuccaro	10	13	8	8

THE NETHERLANDS

PETER PAUL RUBENS

[Peter Paul Rubens (1577–1640), the son of a Flemish lawyer, was born in Westphalia, where his Protestant parents had fled to escape the persecutions of the Spanish in Antwerp. After the death of his father, his mother was reconverted to Catholicism and moved the family back to Antwerp.

As a boy, Rubens received a thorough grounding in Latin, classical mythology and history. His interest in these subjects continued throughout his life. After a brief period as a page in a noble household, Rubens served as an artist's apprentice and was admitted to the guild of painters in 1598.

In 1600 Rubens went to Venice, where he studied the works of Titian, Veronese and Tintoretto. After a short time in Venice, he entered the employment of the Duke of Mantua, in whose service he remained for eight years making copies of pictures in the ducal collection, then one of the finest in Europe, and executing works of his own. During this period, Rubens repeatedly visited Rome, where he studied the works of Michelangelo, Raphael, Caravaggio, and the brothers Carracci. The Duke sent him to Spain to deliver a present of pictures to the Spanish king. In 1607 he visited Genoa and studied its magnificent palace architecture.

Receiving word in 1608 of the illness of his mother, Rubens hurried back to Antwerp, but she died before his arrival. He had intended to return to Italy, but the Regents of the Netherlands, Duke Albert and Duchess Isabella, made him their court painter in 1609 and he decided to stay. Shortly afterwards he married Isabella Brant and settled permanently in Antwerp.

During the following years, 1609–1612, marked by his painting of the two famous altarpieces, *The Elevation of the*

Cross and *The Descent from the Cross* in the Cathedral of Antwerp, Rubens established himself as the leading painter in Flanders and soon headed a large workshop and school. His fame was widespread. Maria de' Medici, the widow of Henry IV, commissioned him in 1621 to paint a series of canvases depicting episodes from her life for the Luxembourg Palace. He supplied the designs for the ceiling of the Banquet Hall, Whitehall, London, Philip IV commissioned him to paint a series of hunting pictures. Rubens' marvelous inventive talent and creative genius and efficient workshop enabled him to produce these pictures and many more.

He combined his artistic activity with various diplomatic missions. Isabella, who after the death of her husband became Regent of the Netherlands, employed him as her agent in negotiations for the general truce during the Thirty Years War. In the same capacity Rubens went to Spain in 1628, where he also had time to study the paintings of Titian, whose use of color played such an important role in the last period of Rubens' work. Philip II sent him as Secretary to the Secret Council of the Netherlands to conclude the terms of the peace with Charles I of England. In recognition of his services as a diplomat and an artist, Charles knighted him in 1630 just before he returned to Antwerp.

On his return he married Helen Fourment—Isabella Brant died in 1624—and purchased (1635) the medieval Castle Steen, where he lived surrounded by his famous art collection and paintings until his death in 1640.]

LETTERS[1]

To Sir Dudley Carleton.[2] Antwerp, April 18/28, 1618

MOST EXCELLENT SIR: By the advice of my agent, I have learnt that Y. E. is much inclined to make some bargain with me about your antiques; and it has made me hope well of this business, to see that you go earnestly about it, having named to him the exact price that they cost you: in regard to this, I wish wholly to confide on your knightly word. I am also willing to believe you purchased them with perfect judgement and prudence; although persons of distinction are wont usually, in buying and selling, to have some disadvantage, because many persons are willing to calculate the price of the goods by the rank of the purchaser, to which manner of proceeding I am most averse. Y. E. may be well assured I shall put prices on my pictures, such as I should do were I treating for their sale in ready money; and in this I beg you will be pleased to confide on the word of an honest man. I have at present in my house the very flower of my pictorial stock, particularly some pictures which I have retained for my own enjoyment; nay, I have some re-purchased for more than I had sold them to others; but the whole shall be at the service of Y. E., because brief negotiations please me; each party giving and receiving his property at once; and, to speak the truth, I am so overwhelmed with works and commissions, both public and private, that for some years, I cannot dispose of myself. Nevertheless, in case we shall agree, as I anticipate, I will not fail to finish as soon as possible all those pictures that are not yet entirely

[1] The letters are from W. Noel Saintsbury, *Original Unpublished Papers, Sir Peter Paul Rubens,* London, 1859. The footnotes within brackets are by the editor, the others from the text.

See also: Max Rooses, *Rubens,* London, 1904; R. A. M. Stevenson, *Peter Paul Rubens,* New York, 1939; Ruth Magurn, trans. and ed., *The Letters of Peter Paul Rubens,* Cambridge, Mass., 1955.

[2] Sir Dudley Carleton, Baron Imbercourt, Viscount Dorchester (1573–1631/32) served Charles I as ambassador at various European courts, Venice, Paris and The Hague. He was an admirer, collector and connoisseur of the fine arts. [See Rooses, *op. cit.*, pp. 253–278.]

completed, though named in the herewith annexed list, and those that are finished I would send immediately to Y. E. In short, if Y. E. will make up your mind to place the same reliance in me that I do in you, the thing is done. I am content to give Y. E. of the pictures by my hand, enumerated below, to the value of six thousand florins, of the price current in ready money, for the whole of those antiques that are in Y. E. house, of which I have not yet seen the list, nor do I even know the number, but in everything I trust your word. Those pictures which are finished I will consign immediately to Y. E., and for the others that remain in my hand to finish, I will name good security to Y. E., and will finish them as soon as possible. Meanwhile I submit myself to whatever Y. E. shall conclude with Mr. Francis Pieterssen, my agent, and will await your determination, with recommending myself, in all sincerity to the good graces of Y. E., and with reverence I kiss your hands.

From Your Excellency's most affectionate servant,

PETER PAUL RUBENS

To the most excellent, most esteemed, Sir Dudley Carleton, Ambassador of the most serene King of Great Britain to the States of the United Provinces, at The Hague.

LIST OF PICTURES WHICH ARE IN MY HOUSE

500 florins. 1. A Prometheus bound on Mount Caucasus,[3] with an Eagle which pecks his liver. Original, by my hand, and the Eagle done by Snyders.

600 florins. 2. Daniel amidst many Lions, taken from the life. Original, the whole by my hand.

600 florins. 3. Leopards, taken from the life, with Satyrs and Nymphs. Original, by my hand, except a most beautiful Landscape, done by the hand of a master skilful in that department.

500 florins. 4. A Leda, with Swan and a Cupid. Original, by my hand.

500 florins. Crucifixion, large as life, esteemed perhaps the best thing I have ever done.

1200 florins. A Last Judgment, begun by one of my scholars, after one[4] which I did in a much larger form for the most serene Prince of Neuberg, who paid me

[3] 1613/14. It is now in the Philadelphia Museum of Art.

[4] 1615/16. [It is now in the Alte Pinakothek, Munich, Rooses, *op. cit.*, p. 201.]

three thousand five hundred florins cash for it; but this, not being finished, would be entirely retouched by my own hand, and by this means will pass as original. 500 florins. 5. St. Peter taking from the fish the money to pay the tribute, with other fishermen around; taken from the life. Original, by my hand. 600 florins. 6. A Hunt of men on horseback and Lions, commenced by one of my pupils, after one[5] I made for His most Serene [Prince], of Bavaria, but all retouched by my hand. 50 florins each. The Twelve Apostles,[6] with a Christis, done by my scholars, from originals by my own hand, which the Duke of Lerma has, each having to be retouched by my hand throughout. 600 florins. A picture of an Achilles clothed as a woman,[7] done by the best of my scholars, and the whole retouched by my hand, a most brilliant picture, and full of many beautiful young Girls. 300 florins. 8. A St. Sebastian, naked, by my hand. 300 florins. 9. A Susanna, done by one of my scholars, the whole, however, retouched by my hand.

To Sir Dudley Carleton. Antwerp, May 2/12, 1618

MOST EXCELLENT SIR: Your very agreeable letter of the 8th instant reached me yesterday evening, by which I perceive Y. E. to have in part changed your mind, wishing pictures for the half only of the price . . . marbles, and for the other half tapestries . . . ready money, because I shall not find these, *non mediantibus illis,* and this appears to proceed from the want of pictures on my list, having taken only the Originals, with which I am perfectly content; yet Y. E. must not think that the others are mere copies, but so well retouched by my hand that with difficulty they would be distinguished from originals, notwithstanding which they are put down at a much lower price: but I am unwilling to persuade Y. E. to this by fine words, because persisting in your first opinion I could still furnish until . . . of pure originals, but in order to treat . . . I imagine that not . . . such a quantity of pic-

[5] [It is now in the Alte Pinakothek, Munich.]

[6] These copies are now in the Rospigliosi Palace, Rome.

[7] Rubens took this picture to Spain in 1628 and sold it to Philip. It is now in the Prado, Madrid.

tures. The reason . . . I would treat more willingly in
pictures is clear, because they do not exceed their just
price in the list, nevertheless they cost me nothing, as every
one is more prodigal of the fruits which they grow in their
own garden, than of those that they buy in the market;
and I have expended this year some thousands of florins
on my buildings,[8] nor am I willing for a caprice to exceed
the bounds of a good economist. In fact, I am not a prince,
sed qui manducat laborem manuum suarum. I wish to infer
that if Y. E. wishes to have pictures to the full amount,
be they originals, or be they well retouched copies (which
show more for their price) I would treat you liberally, and
am always willing to refer the price to the arbitration of
any intelligent person. If, however, you resolve on having
some tapestries, I am content to give you tapestries to your
satisfaction to the amount of two thousand florins and four
thousand florins in pictures; that is, three thousand florins
for the originals chosen by you, namely, the Prometheus,
the Daniel, the Leopards, the Leda, the St. Peter, the
St. Sebastian, and for the remaining thousand florins you
can choose from the other pictures comprised in our list;
and in truth I pledge myself to give you such originals
by my hand for that sum as shall be deemed satisfactory
by you, and if you will believe me you will take that Hunt
which is on the list, which I will make of equal excellence
with that which Y. E. had by my hand, which should
match excellently together, this being of . . . European
huntsmen, and that of lions . . . à la Moorish and Turk-
ish, very singular . . . this I would do at six hundred
florins: in addition to this the Susanna, similarly finished
by my hand to your satisfaction; would be *à propos* with
some *galanterià* by my hand, attached by way of compli-
ment, for the hundred florins to complete the four thou-
sand florins. I hope you will be satisfied with this so reason-
able an arrangement, *consideratis considerandis,* that I
have accepted your first offer with frankness, and that this
change comes from Y. E. and not from me. I certainly could
not increase my terms for many reasons; . . . To conclude,

[8] [See Rooses, *op. cit.,* pp. 147–155.]

I kiss Y. E.'s hand with all my heart, to whom *in omnem eventum nostri negotii*, I shall always be the most devoted servant. Mr. Francis Pieterssen has not yet sent me the list of your marbles, and I should wish even, in case we come to terms, that list with the names which you write to me that you have found.

PETER PAUL RUBENS

I beg, if the affair be concluded that you will continue . . . to procure free passage for them, and if you still have the packing cases in which these marbles have been conveyed from Italy, being . . . useless to you, they would be to me a great convenience, . . .

To Sir Dudley Carleton. Antwerp, May 16/20, 1618

MOST EXCELLENT SIR: I have given all the correct measurements of the whole of the pictures to that Man of Y. E.'s who came to take them by order of Y. E. to have the frames made, although you had not mentioned this to me in your letter. For some time I have not given a single stroke of the brush, unless it be for the service of Y. E., so that all the pictures, even the Hunt and the Susanna, together with that sketch which closes our account, as well as those of our first agreement, will by divine aid be finished on the precise day of the 28th inst., agreeable to my promise. I hope you will be content with these works of mine, both as regards the variety of the subjects, and for the love and desire which urge me to serve Y. E. with so much zeal. I doubt not in the least that the Hunt and the Susanna will appear amongst the originals. The third is painted on panel, about three feet and a half in length, by two feet and a half in width, altogether original. It is a subject as it were neither sacred or profane, although taken from Holy Writ; namely, Sarah in the act of scolding Hagar,[9] who, pregnant, is leaving the house in a feminine and graceful manner, with the assistance of the Patriarch Abraham. I did not give the measure of this to your man

[9] This small replica of the picture in Leningrad which Rubens painted for Sir Dudley now belongs to the Duke of Westminster.

to have a frame put about it; it is done on panel, because little things succeed better on it than on canvas, and being so small in size it will be transportable. I have engaged, as is my custom, a very skillful man[10] in his pursuit, to finish the landscapes, solely to augment the enjoyment of Y. E.; but as to the rest be assured I have not suffered a living soul to put hand on them, from the desire not only of most punctually abiding by my promise, but to increase that obligation of desiring to live and die Y.E.'s most devoted servant. I cannot, however, affirm so precisely as I could wish the exact day when all these pictures will be dry, and to speak the truth, it appears to me better that they should go away altogether, because the first are newly retouched; still, with the aid of the sun, if it shines serene and without wind (the which stirring up the dust is injurious to newly painted pictures) will be in a fit state to be rolled up with five or six days of fine weather. For myself, I should wish to be able to consign them immediately, being ready to do everything that shall be agreeable to you; but I should be very sorry indeed, if from too much freshness they were to suffer any injury on the way, which might cause some regret to Y. E., in which I should in a great degree participate.

In respect to the tapestries, I can say little, because to confess the truth, at present there are no very fine things, and as I wrote, they are rarely to be found without having them wrought on purpose; yet the History of Camillus not pleasing you, I do not think that man of yours had any disinclination towards the one of Scipio and Hannibal, which might perhaps better please Y. E. (and to speak frankly, in all these things the selection is arbitrary) without dispute of great excellency. I will send Y. E. the whole measurements of my cartoons of the History of Decius Mus,[11] the Roman Consul who devoted himself for the success of the Roman people; but I shall write to Brussels to have them correct, having given everything to the master of the Works. Meanwhile recommending myself

[10] Probably Jan Wildens (1586–1653).
[11] [These cartoons were done for the tapestries for the Genoese family, Pallavicini. See Rooses, *op. cit.*, pp. 265–272.]

strongly to the good offices of Y. E., and with humble affection, I kiss your hands.

From Your Excellency's most devoted servant,

PETER PAUL RUBENS

The two thousand florins shall be punctually paid at the pleasure of Y. E. I confess to feeling a great desire to see these marbles, the more so that Y. E. assures me of their being things of price.

To Francis Junius.[12]

Antwerp, July 22/August 1, 1631

SIR: You will be much surprised not to have received, long before this, any tidings of the receipt of the book which, as appears from yours of May 24, was destined for me. Yet I pray you to be good enough to believe that the aforesaid book was remitted only fourteen days ago, through one of this city, named Leon Hemselroy, with many excuses for so late attention to it. This is the reason why I have not answered your letter, as I wished first to see and also to read the book, which I have now done attentively. To say the truth, I think that you have much honoured our art by this immense treasure of the whole of antiquity, recovered with so much diligence, and publicly arranged in the most beautiful order. For this book, as I would tell your Honour, in one word, is a rich storehouse, most fruitful in all manner of examples, opinions, and rules, which, relating to the dignity and illustration of the pictorial art, scattered throughout the ancient writings, have been preserved to our time, and consecrated, as it were, to our great advantage. Thus I perceive in the title and argument of the book, *De Pictura Veterum* (On the Painting of the Ancients), that the object is attained by your honour to a nicety, and even the axioms and rules, opinions and examples, which afford the greatest information to us are inserted here and there, expressed with a certain admirable erudition, elegant style of expression, and in correct order. The whole of this work being perfectly digested and polished with the greatest care, even to the

[12] [See above, p. 58, note 31.]

cover. But since these examples of the ancient painters are only shadows, and for the apprehending of which we may follow more or less closely, I could wish that some such treatise of the paintings of the Italian masters were executed with the same diligence. Their examples or prototypes are to this day publicly sold, and can be pointed out with the finger, and I should say there are such.

For those things which fall under the senses are the most deeply impressed upon the mind, remain the longest, require more careful examination, and afford material more fruitful in instruction to students, than those things which only present themselves to us in imagination like dreams, and foreshadowed in words only, being grasped at in vain (as the shadow of Eurydice *evaded* Orpheus), often elude and frustrate each one in his hope. We speak from experience, for how few of us would attempt to subject to ocular demonstration any renowned work of Apelles or Thimantes, graphically described by Pliny or other ancient writers, for fear of indignity; would it afford anything not insipid or not averse to the majesty of the Ancients, but each indulging his own fancy, would draw out most from that sweetly bitter Opimium [i.e., would produce something new in place of the original], and would offer an injury to those illustrious dead, whom I follow with the greatest veneration, and rather adore the footsteps of those who have preceded me, than ingenuously profess that I am capable of following them, even in thought alone.

I pray you, my dear Sir, to receive well those things, which I have been taking the infinite liberty of saying, in hope that you, after such good promises, will not refuse us the crowning of the feast which we altogether much long after; for hitherto, no one has satisfied our appetite, of all those who have treated on such matters: for, as I said, it behoves to come to individual cases. Wherefore I commend myself, with my whole heart, to your good favour, and sincerely thanking you for the honour you have done me by the presentation of your book and friendshop, I remain, in sincerity, Sir,

Your humble and affectionate Servant,
PETER PAUL RUBENS

At Antwerp, in haste, and standing on one foot, the 1st
of August, 1631. To Mr. Francis Junius,
At the Court of Earl Marshall Arundel, at London.

REMBRANDT VAN RIJN

[Rembrandt van Rijn (1606–1669), the son of a miller,
was born at Leyden. He studied at the Latin school and
was enrolled for a few months at the University of Leyden
in 1620. His parents then apprenticed him to a minor
painter, Jacob Isaacksz. van Swanenburgh, for three years.
More important for Rembrandt's development were the
six months around 1624–1625, he spent in Amsterdam
with Pieter Lastman, who, it seems, inspired him to be-
come a painter of the religious and historical subjects
Rembrandt concentrated on when he returned to Leyden.
He moved to Amsterdam in 1631 and his reputation as
a portrait painter was immediately established by the
Anatomy Lesson of Dr. Tulp (1632). In 1634 Rembrandt
married Saskia van Uylenburgh who brought him a hand-
some dowry. Five years later, he bought a large house
which he filled with a distinguished and expensive collec-
tion of art works. Rembrandt painted the *Night Watch* in
1642 and received a high fee, about 1600 guilders, for the
picture. It is a myth that this picture was refused and that
Rembrandt's unorthodox treatment of the group portrait
was responsible for a shift in his reputation. The tragedy,
however, that did occur in 1642 was Saskia's death, leav-
ing Titus, a nine-month-old baby. It is tempting to see a
relationship between her death and the search Rembrandt
then began for ways to express inner emotion without re-
sorting to the dramatic movement and emphatic gestures
used in earlier pictures like the *Blinding of Samson*.[1] This
search led to the creation of his late masterpieces like
Jacob's Blessing (1656), *The Syndics* (1662) and the
Prodigal Son (cir. 1669) which rank with the most pro-
found expressions of the human spirit.

[1] [Our *fig. 8*]

Rembrandt achieved international acclaim before he died; however, his personal life during his last years was not a tranquil one. Numerous documents show the church authorities' disapproval of his relationship with Hendrickje Stoffels, the housekeeper who came to live with him around 1645 and whom he never married, for under the terms of Saskia's testament he would lose the income from her estate if he remarried. Rembrandt was in need of money during the last decades of his life. In 1656, he declared himself insolvent; he sold his great house, furnishings and art collection and moved to a poor quarter of Amsterdam. Hendrickje died shortly after 1660, and Titus in 1668. Rembrandt died eleven months later.

There is reason to believe that Rembrandt never liked to write or talk about art. Some of his rare comments on his own work are scattered through a handful of letters written to Constantin Huygens while he was working on a Passion series for Prince Frederick Henry of Orange.]

LETTERS[2]

First letter to Huygens.[3]

MY LORD, my gracious Lord, I hope that you will be so kind as to tell His Excellency [Prince Frederic Henry] that I am diligently engaged in completing the three Pas-

[2] The translations are from the text as given in C. Hofstede de Groot, *Die Urkunden über Rembrandt* (1575–1721), The Hague, 1906, Nos. 47, 65, and 67, by Miss Charlotte van der Veer, Cleveland Museum of Art. Dr. Seymour Slive kindly wrote the biographical sketch and supplied the footnotes. See also J. Rosenberg, *Rembrandt*, London, 2 vols., 3d ed., 1968; S. Slive, *Rembrandt and His Critics: 1630–1730*, The Hague, 1953; L. van Eeghen and Y. Ovink, *Rembrandt: Seven Letters*, The Hague, 1961.

[3] Seven letters to Constantin Huygens are known. Huygens, who combined a lifetime of political service to his country with a mastery of all the polite accomplishments, was the first to recognize Rembrandt's genius (see S. Slive, "Art Historians and Art Critics—II: Huygens on Rembrandt," *The Burlington Magazine*, XCIV (1952), pp. 261–264). He was Secretary to Prince Frederick Henry of Orange and was probably responsible for obtaining for Rembrandt the commission to paint the five Passion pictures for the Prince, the most important patron in Holland. The paintings are in the Alte Pinakothek, Munich.

sion pictures, which were ordered personally by His Excellency: an *Entombment,* a *Resurrection,* and an *Ascension of Christ,* which will be pendant pictures to the *Elevation* and the *Descent from the Cross.* Of the three aforementioned pictures, one, *Christ's Ascension,* is finished, and the other two are more than half-way completed. And so I beg you My Lord to let me know whether His Excellency would like to have this finished picture [at once] or all three together [later], so that I may best serve the wishes of His Princely Excellency.

I also can not refrain from offering you something of my latest work, in token of my art's being always at your service, trusting that this will be accepted in the right spirit.

With my greetings to Your Eminence. May God keep you all in good health.

My Lord, your obedient and devoted servant,

REMBRANDT

Amsterdam, February, 1636
I live next to Lijonaeus Boereel, Nieuwe Doelstraat.

Third letter to Huygens.

MY LORD: Because of the great joy and devotion which filled me in doing well the two works which His Excellency ordered me to make, the one where the dead body of Christ is put into the grave, and the other where Christ rises from the dead to the great alarm of the guards, these same two pieces are now finished through studious diligence, so that I am now inclined to deliver them to His Excellency in an effort to please him. In both these [paintings] I have concentrated on expressing *die meeste ende die naetuereelste beweechgelickheyt*[4], and that is then the chief reason why these pictures have remained so long under my hands.

[4] Formerly interpreted as "the greatest and most natural movement," critics recently have suggested the correct reading for this phrase is "the greatest inward emotion." See S. Slive, *Rembrandt and His Critics: 1630–1730,* The Hague, 1953, pp. 24–25, 36.

Therefore I ask Your Lordship if you will be so kind as to tell His Excellency about it, and if you will agree that I should send these two pictures first to your house, as I did before. But before I do this, I await an answer by letter.

And since My Lord has troubled himself a second time in these matters, in appreciation I shall add one piece 10 feet long and 8 feet high for My Lord's own home.[5]

And wishing you good luck and happiness, Amen.

My Lord, your obedient and devoted servant,

REMBRANDT

January 12, 1639

[*Written in the margin of the page from top to bottom:*]

Sir, I am living at the Binnen Amstel, the house is called the Sugar Bakery.

Fifth letter to Huygens.

MY LORD: With a singular joy I have read Your Highness' agreeable letter of the fourteenth and find in it Your Highness' good favor and friendliness, so that I remain cordially disposed to repay Your Highness with service and friendship. Such is then my pleasure, that even against My Lord's wishes, I send you this accompanying canvas, hoping that you will not mistrust my motives, because it is the first token which I offer My Lord.

My Lord Uyttenboogaert, the [tax] collector, came to me when I was just busy packing these two pieces. He insisted upon seeing them first. He said that, if it suited Your Highness, he could make me the payments from his office here. So I request you, My Lord, that, whatever His Highness will grant me for these two pieces, I may receive this money at the first opportunity, which would particularly suit my needs. Waiting your answer when it suits your convenience and wishing you and your family welfare and happiness, besides my regards,

Your Highness' obedient and affectionate servant,

REMBRANDT

[5] The painting was probably the *Blinding of Samson* (our fig. 8), now in the Städelsches Kunstinstitut, Frankfurt/M.

In haste

27 January 1639

My Lord, hang this piece in a strong light, so that one may look at it from a distance, and it may appear at its best.

Sixth letter to Huygens.

DEAR LORD: I trust Your Highness with all that is good [Your Highness' intentions in all things], and especially as regards the remuneration of these last two pieces, and I know that if the matter had gone according to your wish and intent no objection would have occurred regarding the price agreed upon. And concerning the earlier delivered pieces, not more than 600 Carolus guilders were paid for each. So if His Excellency can't be moved by good assurances [*vougen*] to a higher price, although the pictures really merit it, then I shall be satisfied with 600 Carolus guilders for each, provided that my expenditures for the two ebony frames and the packing-case, amounting altogether to 44 guilders, will be reimbursed at the same time.

So I request kindly of My Lord, that I may receive as soon as possible the payment due me here in Amsterdam, being sure that through your good favor I may soon enjoy my money, remaining grateful to you for all your friendship. My cordial greetings to My Lord and Your Highness' closest friends, that you all may be commended to God for long-lasting health.

Your Highness' obedient and affectionate servant,

REMBRANDT

LIFE OF REMBRANDT VAN RIJN[6]

Son of Harmen Gerritsson van Rijn and Neeltgen Williams van Suydtbrouck, born within the City of Leyden on the fifteenth of July in the year 1606. His parents placed him in school so that he might learn the Latin language

[6] From J. Orlers, *Beschrijvinge der Stadt Leyden*, 2nd ed., Leyden, 1641, p. 375. Transcribed in Hofstede de Groot, *op. cit.*, No. 86. The first edition of Orlers' book appeared in 1614 and, of course, did not contain this biography.

and in due time might go to Leyden's university in order
that, when he should come of age, he might serve the
town and elevate the community with his learning. But he
had no wish nor mind to do so, since his natural inclination
tended solely to the art of the painter and the draughts-
man. Therefore his people were obliged to take him out
of school and, following his wishes, let him board out with
a painter to learn from him the first fundamentals and
principles of the craft. According to this decision, they
took him to the gifted Jacob Isaaksz van Swanenburgh,
who taught and instructed him, and with whom he re-
mained for three years. During these years he made so
much progress that those who love art were most aston-
ished and foresaw that in the future he might become an
eminent painter.

Thereupon his father found it good to take and board
him out with the celebrated painter, P. Lastman, living in
Amsterdam, so that he might be still better taught and
instructed. He stayed here for about six months, and then
decided that he himself could study and practice the art
of painting, in which he was so gifted that he became one
of the most celebrated painters of our century. Because
his art highly pleased and delighted the burghers and in-
habitants of Amsterdam, and because he was invited so
many times to paint portraits and other subjects there, he
found it best to move to Amsterdam. He departed from
here [Leyden] about the year 1630, and made his home
in Amsterdam, where he was still living in the year 1641.

DISAGREEMENT BETWEEN REMBRANDT AND
DIEGO ANDRADA[7]

Today, being the twenty-third of February 1654, I,
Adriaen Lock, notary, went, at the request of the Portu-

[7] Transcribed in Hofstede de Groot, *op. cit.*, No. 154. The
portrait Andrada refused to accept is not known, nor is it known
how the case was finally settled. The dispute proves that Rem-
brandt refused to satisfy the whim of every patron. But it
would be incorrect to conclude from this single incident that
Rembrandt worked with a public-be-damned attitude. His letters
to Huygens regarding the Passion series prove that he did not

guese merchant, Sir Diego d'Andrada, from here [Amsterdam] to see the painter Sir Rambrandt van Rijn, to announce the following:

The aforementioned Accuser says that some time ago he commissioned you, the Accused, to paint a certain young maiden and that he gave you for this a down payment of 75 guilders, and agreed to pay the rest upon the completion of the painting. Now the Accuser finds that the aforementioned portrait does not at all resemble the face of the young maiden, and the Accuser lets the Accused know, by notary, that he must alter the portrait before the departure of the aforementioned young maiden, and make it into a true likeness. In default of his doing this, he wants him to keep the painting because he has no use for it, but in that case demands the restitution of the money paid in advance.

When all this had been read to the Accused, he [Rembrandt] answered: That he would not touch or complete the painting until the Accuser had paid him the rest of the money, or given him satisfaction. When that has been done, he will complete the painting and submit to the judgment of the heads of the Guild of St. Lucas the question whether or not in resembles the maiden; and if they decide that it does not look like the maiden, he will alter it. And if the Accuser is not satisfied by this, some day he [Rembrandt] will complete it, and will offer it for sale the next time he has an auction of his paintings.

AGREEMENT BETWEEN TITUS VAN RIJN AND HENDRICKJE STOFFELS[8]

On December 15, 1660, Titus, assisted by his father, [Rembrandt van Rijn] and Hendrickje Stoffels, who is of

always refuse to consider his patron's tastes. However, thirty-year-old Rembrandt working for the Prince of Orange had possibly a different attitude from that of fifty-year-old Rembrandt working for a merchant who may have been an unreasonable crank impossible to please.

[8] Transcribed in Hofstede de Groot, op. cit., No. 233. This agreement between Hendrickje and Rembrandt's son, Titus, was made to establish a partnership to enable Rembrandt to

age and is assisted by a guardian chosen by her for the purpose, declare that they agree to carry on a certain company and business, started two years before them, in paintings, pictures on paper, engravings, and woodcuts, the printings of these, curiosities, and all pertaining thereto, until six years after the death of the aforementioned Rembrandt van Rijn, under the following conditions:

Firstly, that Titus van Rijn and Hendrickje Stoffels will carry on their housekeeping and all pertaining thereto at their joint expense, and having jointly paid for all their chattels, furniture, paintings, works of art, curiosities, tools, and the like, and also the rent and taxes, that they will continue to do so. Further, both parties have each brought all they possess into the partnership, and Titus van Rijn in particular has brought his baptismal gifts, his savings, his personal earnings, and other belongings he still possesses. All that either party earns in the future is to be held in common. According to this company's proceedings, each is to receive half of the profits and bear half of the losses; they shall remain true to one another in everything and as much as possible shall procure and increase the company's profit.

But as they require some help in their business, and as no one is more capable than the aforementioned Rembrandt van Rijn, the contracting parties agree that he shall live with them and receive free board and lodging and be excused of housekeeping matters and rent on condition that he will, as much as possible, promote their interests and try to make profits for the company; to this he agrees and promises.

The aforementioned Rembrandt van Rijn will, however, have no share in the business, nor has he any concern with the household effects, furniture, art, curiosities, tools and all that pertains to them, or whatsoever in days and years to come shall be in the house. So the contracting parties will have complete possession and are authorized against those who would make a case against the aforementioned Rembrandt van Rijn. Therefore he will give all he has, or

become an employee of it, and thus prevent his creditors from taking the money earned by the sale of his work.

henceforth may acquire, to the contracting parties, now as well as then, and then as well as now, without having either the slightest claim, action, or title, or reserving anything under any pretext.

As the aforementioned Rembrandt van Rijn has recently become bankrupt and has had to hand over everything he possessed, it has been necessary to support him, and he acknowledges having received from the said parties the sum of 950 guilders from Titus van Rijn and 800 guilders from Hendrickje Stoffels, both sums to be used for necessities and nourishment. He promises to refund the money as soon as he has earned something again by his painting. As security for both these sums, the aforementioned Rembrandt van Rijn assigns to the aforementioned Titus van Rijn and Hendrickje Stoffels all the pictures he paints or sells in their house, or any that may happen to be found there, they to keep them as their own possession until they are paid for in full, without his [Rembrandt van Rijn's] exercising any action, claim, or title of property to them, or reserving them under any pretext.

Moreover the aforementioned parties further agree that no one of them, without the knowledge of the other, is to sell, embezzle, or alienate anything belonging to the company on his individual account, and if such should occur, he who will have been found to have done this must forfeit to the other the sum of 50 guilders. When this happens, this amount shall be paid by Rembrandt van Rijn out of the payments which are due to each of them, by deducting from the delinquent's share that which is due, so that the delinquent will receive so much less and the other so much more; and this will be repeated if it occurs again.

The three aforementioned people present (Titus assisted by his father) promise to abide by these terms and mutually pledge to hold inviolable this deed without contravention, under bond of each person and his good, within the bounds of all rights and the law. In good faith and the requested deed.

That all took place within this aforementioned city. The deed being witnessed by Jacob Leeuw and Frederick

Helderberch, and those present besides me, the notary signed this minute [this day].

> Titus van Rijn
> X the sign placed by Hendrickje Stoffels
> Rembrandt van Rijn
> Jacob Leeuw
> Frederick Helderberch
> N. Listingh, Notary.

SPAIN

VICENCIO CARDUCHO

[Vicencio Carducho (1576–1638], a Florentine, came to Spain as a child accompanying his elder brother Bartolommeo, who, with many other compatriots, had been called there by Philip II to decorate the Escorial. The huge structure of this palace-monastery-church still stands intact, a monument to the severity and sobriety of taste of Philip II the Prudent. Severity and sobriety and, on the other hand, irrationality and a deep emotionalism are basic to the Spanish character, quite in contrast to the Italian tendency toward pleasing idealization. Educated at the Spanish court, Vicencio considered himself a citizen of Madrid and was to all intents and purposes a Spanish painter. He is a typical representative of a generation of painters in the throes of the painful transition from Mannerism to Baroque.

Carducho's book, *Diálogos de la pintura, su defensa, origen, essencia, definición, modos y diferencias* (Dialogues on Painting, its Justification, Origin, Essence, Definition, Classes and Distinction), written in the classical pattern of a dialogue between master and pupil, was first printed in Madrid in 1633. The author attacks the new dramatic realism, the disregard of "beauty," the painting direct from nature as practiced by Caravaggio, which seemed to him nothing short of diabolic. Although he never mentions him by name, he also attacks Velázquez whom he plainly disliked. Strongly under the influence of the Counter-Reformation, that great moving force behind the Baroque, Carducho stresses the moral purpose of art, insisting on the necessity of prayer and inner preparation for the artist about to paint a religious picture. Only paintings done in such a state of mind have power to stir the spectator, an effect which is the supreme aim of the Baroque artist. In his account of the proper subjects to be represented in churches and palaces, he stresses decorum, propriety and

gravity, minimizing the importance of Italianate grotesques and showing himself thoroughly imbued with the Spanish spirit.]

DIALOGUES ON PAINTING[1]

SIXTH DIALOGUE. *On Caravaggio.* In our times, during the pontificate of Pope Clement VIII, Michelangelo Caravaggio rose in Rome. His new dish is cooked with such condiments, with so much flavor, appetite and relish that he has surpassed everybody with such choice tid-bits and a license so great that I am afraid the others will suffer apoplexy in their true principles, because most painters follow him as if they were famished. They do not stop to reflect on the fire of his talent which is so forceful, nor whether they are able to digest such an impetuous, unheard of and incompatible technique, nor whether they possess Caravaggio's nimbleness of painting without preparation. Did anyone ever paint, and with as much success, as this monster of genius and talent, almost without rules, without theory, without learning and meditation, solely by the power of his genius and the model in front of him which he simply copied so admirably? I heard a zealot of our profession say that the appearance of this man meant a foreboding of ruin and an end of painting, and how at the close of this visible world the Antichrist, pretending to be the real Christ, with false and strange miracles and monstrous deeds would carry with him to damnation a very large number of people moved by his [the Antichrist's] works which seemed so admirable (although they were in themselves deceptive, false and without truth or permanence).

[1] Excerpts translated from Carducho, *Diálogos de la pintura,* 2nd ed., Madrid, 1865 (ed. by G. Cruzada Villamil), revised in accordance with F. J. Sánchez Cantón, *Fuentes literarias para la historia del arte español,* Madrid, II, 1933, pp. 94–95. The introduction, selection and translation are by Dr. Martin S. Soria, Michigan State University. See also: Cantón, pp. 61–62; M. Menéndez Pelayo, *Historia de las ideas estéticas en España,* 2nd ed., Madrid, IV, 1901, pp. 74–81; Jacques Lassaigne, *Spanish Painting from Velásquez to Picasso,* Geneva, 1952; G. Kubler and M. Soria, *Art and Architecture in Spain and Portugal and Their American Dominions 1500–1800,* Penguin, Baltimore, 1959.

Thus this Anti-Michelangelo [that is: Caravaggio] with his showy and external copying of nature, his admirable technique and liveliness has been able to persuade such a large number of all kinds of people that his is good painting and that his theory and practice are right, that they have turned their backs on the true manner of perpetuating themselves and on true knowledge in this matter.

SEVENTH DIALOGUE. *Proper Subjects for Churches and Palaces.* Whenever a building is to be decorated one should bear in mind its character in general, and the purpose of each part thereof in particular, and one should also bear in mind the person who will live in it or who commissions it.

If it is a temple, monastery or oratory, one should obviously paint for its decoration or service only scenes from the life and death of Our Lord Jesus Christ, of His most holy Mother and of the saints who are rejoicing in the presence of God in that blessed heavenly mansion. One should pay attention to the appellation of the church and to the special devotion for a patron staint. For a convent no story is more appropriate than that of the life of the sovereign Queen of Angels and of favors and miracles she has bestowed or wrought upon the faithful. It is also appropriate to represent scenes from the life—or miracles— of Virgin Martyrs who have suffered and have toiled in the service of the Heavenly Spouse, offering their chastity to Him, through penitence, solitude, and retreat, and finally giving up their life on earth for the greater glory of eternal life. Everything should be arranged with propriety, modesty, gravity and devotion. If it is necessary to paint some grotesques for decoration, one should take care to invent them with modesty and decorum. They should not be profane and unbecoming for the location and they should be used with great concern for the elegance and gracefulness with which a story is to be told. (Among sacred or serious subjects a grotesque easily becomes a jest.) Grotesques should be used sparingly and with discretion, leaving them for more festive and gay occasions.

When working for royal palaces, one should paint his-

torical subjects, lofty, majestic, exemplary scenes, worthy
of being emulated. For instance, rewards which great
monarchs have bestowed upon those steadfast in courage
and virtue; just punishment for evil-doers and traitors;
deeds of illustrious heroes; exploits of the famous princes
and generals; triumphs, victories and battles: Scipio and
Hannibal, Aeneas and Turnus, Caesar and Pompey, Xerxes
and the Spartans, and similar deeds. Among the modern
battles, of which there are so many, one might paint the
combats of the two Charles, Charlemagne and Charles [V]
the Emperor, whose victories were sublime and whose
battles eminent. If it should by chance be convenient, or
to the taste of the owner, to paint the stories of Virgil,
of Homer, and the fables of Ovid, try to point out, with
liveliness and propriety, the virtuous moral, veiled to the
ignorant, which is contained in such subjects. Do not bring
out any immodest and unchaste rusticity. Bear in mind
human improvement and do not court harm.

In the apartments of a queen or of a lady, paint stories
of wise, chaste and valiant matrons, of whom the Holy
Bible gives us examples, with spiritual and moral admoni-
tions: the stories of Sarah, Rachel, Rebecca, Judith and
Esther. And if we wish pagan stories, those of the chaste
and commendable Penelope, of Lucretia, as brave as she
was faithful to her husband, of Marcia, daughter of Varro,
who was so proud of her needlework (a proper exercise
for chaste women), and who, although a great painter,
never depicted men otherwise than fully clothed. One
could also paint Gaia Caecilia, wife of King Tarquinius
Priscus, who, although a queen, was always busy weaving
in the company of her women, since her modesty and
prudence did not allow her to remain idle. One could paint
all those and many others who provide worthy examples.

In a country pleasure house it will be very appropriate
to paint scenes of hunting, birds, fish, landscapes, fruit,
divers animals, costumes of different countries, cities or
provinces. If everything is composed with some ingenious
fable in mind, or some metaphor or story which pleases
the senses and enlightens the curious, with a little natural
science, you will gain very great praise and admiration. In

everything one must keep a certain wise decorum; a subject for a private individual should not match that for a nobleman, that for a nobleman not that appropriate for a prince, that for a prince not that suitable for the sovereignty of a king or monarch.

Necessity of Prayer and Inner Preparation. Shame on me and on all those who, rash and impudent, without any meditation and without improving our souls, in this world set out to paint a portrait of the most holy Queen of the Angels, Mother of the Almighty, she who was full of grace, she who will be our means for gaining heaven, and who will intercede for us so that we may win grace! How well was all this understood by that holy monastic painter Brother Juan Fesulano! He never started to paint without praying first. He said that he who painted Christ had to be with Christ at all times, and he wept whenever he painted Christ on the Cross. Would we ever paint a worldly queen (or king) without giving our whole mind over to the task and without doing everything in our power to please her? We arrange everything necessary with great care and as perfectly as possible for such portrait, and make it a good likeness, and are ashamed if a picture that does not do justice to her beauty leaves our hands. It is well known how forceful a good piece of painting is and even God shows himself pleased when His images and those of His most sacred Mother and those of His Saints are made in such a way that they are an adequate and fit representation. The philosophers say that the more one thing fits another one, the more friendship and union exists between the two. It necessarily follows from this that such paintings will make for more devotion and that they will move the minds of those who are so inclined to greater fervor, love and passionate desire to act with virtue. Many who were quite far from moral goodness have thus found the right way, so that they finally reached a high degree of perfection. St. Theresa of Jesus thus relates of herself that the ardent love for an image of the very sore and tormented Christ, brought to her convent for a certain holiday, caused such a change in her mind, that from then on she knew what she had made of her

life, and from that time on she was constantly improving herself.

EIGHTH DIALOGUE. *Division of Labor between Master and Assistants.* The expert painter makes sketches, or outlines, and studies each portion in itself. Afterwards he joins everything together in a design or cartoon, finished and precisely arranged. This cartoon and the other drawings he hands over to his assistant. The assistant transfers the outlines or draws the lines by means of the squares marked on the canvas or the wall and makes a rough sketch and applies color, a process called to finish or to clam [*empastar*]. The careful master comes to observe, to correct and to point out the mistakes, orally and with his brush, if he does not agree with the design of the assistant (this is called "to corrupt" the outlines).

After the assistant considers his work finished, the master retouches the painting again and perfects it. This is the last step and the refinement which breathes spirit into a painting. Here, in these brush-strokes and fine finishing touches, the true master is revealed. After drying, the painting is varnished and may be retouched over the varnish. Masters do not always use assistants and sometimes do everything themselves.

FRANCISCO PACHECO

[Francisco Pacheco (1564–1654), erudite painter, teacher, author, classical scholar and amateur theologian, was born in Sanlúcar de Barrameda, and lived practically his entire long life among the distinguished churchmen, writers, scholars and aristocrats of the wealthy Andalusian metropolis of Seville. His painting academy was one of the cultural centers of the city and attracted not only literati but such outstanding pupils as Velázquez, Alonso Cano, and possibly also Zurbarán. His book, *El arte de la pintura, su antigüedad y grandeza* (The Art of Painting, its Antiquity and Greatness), first published in Seville in 1649, contains not only chapters on sacred iconography

and on the theory and practice of painting, but notes on contemporary painters which constitute our most important source for the history of Spanish art published in the seventeenth century.

Belonging to the same transitional generation between Mannerism and Baroque as Carducho, Pacheco is, however, much more favorably inclined towards naturalism. His touching pride in the achievements of his son-in-law, Velázquez, makes him appreciate not only lowly pictures of birds, animals and fish but especially the naturalistic eating pieces, called in Spain *bodegones*, in which Velázquez excelled. In stressing the importance of plastic form and lifelike illusion as compared to mere beauty and delicacy, he very clearly turns away from Mannerism and embraces a Baroque principle. He contrasts the materialist concept of imitation of nature with a thoroughly spiritual, not to say mystic, view: painting shall lead men away from vices and to the true veneration of God. Needless to add, this point of view is not only very Spanish but the most important tenet of the whole Baroque. Naturalism is merely a tool in the service of the passionate spirituality which pervades the entire epoch.]

ART OF PAINTING[1]

BOOK I. CHAPTER XI. *The Aim of Painting is the Service of God.* When dealing with the purpose of painting (as we have set out to do), it is necessary to make use of a dis-

[1] The excerpts are translated from Pacheco, *El arte de la pintura,* 2nd ed., Madrid, 1866 (ed. by G. Cruzada Villamil), revised in accordance with the passages printed in F. J. Sánchez Cantón, *Fuentes literarias para la historia del arte español,* Madrid, II, 1933, pp. 159, 169, 179, 187 and 189. The introductory remarks, selection and translation are by Dr. Martin S. Soria.

See also: F. J. Sánchez Cantón, *op. cit.,* pp. 119–121; F. Asensio y Toledo, *Francisco Pacheco, sus obras artisticas y literarias,* Seville, 1886; M. Menéndez Pelayo, *Historia de las ideas estéticas en España,* 2nd ed., Madrid, IV, 1901, pp. 81–94; F. Rodríguez Marín, *Francisco Pacheco, maestro de Valázquez,* Madrid, 1923; A. L. Mayer, in Thieme-Becker, *Künstlerlexikon,* Leipzig, XXVI, 1932, pp. 118–120. F. J. Sánchez Cantón, Madrid, 1956, re-edited Pacheco's manuscript.

tinction by the Church fathers which will clarify the matter: they say, one purpose is that of the work and another that of the worker. Following this teaching, I say that one aim is that of the painter and another that of painting. The object of the painter, merely as a craftsman, probably is by means of his art to gain wealth, fame or credit, to give enjoyment or to do a service to somebody else, or to work for his own pastime or for similar reasons. The purpose of painting (ordinarily) is probably to depict, through imitation, a certain object with all possible valor and propriety. This is called by some the soul of painting because it makes the painting seem alive, so that the beauty and variety of the colors and the other embellishments are merely accessories. Therefore, Aristotle said that of two paintings—the one adorned with beautiful colors but not resembling the subject, and the other executed in simple lines but very close to the truth—the former is inferior and the latter superior; because the former contains accidental things while the latter embraces the basic truth and the substance. These consist in representing, through good drawing and to perfection, what one wishes to copy. Considering, however, the object of the painter as a Christian craftsman (and it is he with whom we are here concerned), he might have two purposes, one main aim and the other one a secondary or consequent one. The latter, less important, purpose might be to ply his craft for gain or fame or for other reasons (as I have stated above), but which ought to be controlled by the proper circumstances, place, time and form, in such a way that nobody should be able to accuse him of exercising his talent reprehensibly or of working against the highest purpose. The main purpose will be—through the study and toil of this profession and being in the state of grace—to reach bliss and beatitude; because a Christian, born for holy things, is not satisfied in his actions to have his eyes set so low that he strives only for human reward and secular comfort. On the contrary, raising his eyes heavenward he is after a different aim, much greater and more exquisite, committed to eternal things. St. Paul often warned the serfs and all other men that when ministering to others

they should remember that they did it chiefly for the sake of God. He said: "You who are slaves obey your masters on earth not out of duty or reflection but as servants of Christ who know that everyone will receive his reward from the Lord in accordance with his actions." And elsewhere: "Whatever you do, do it from the heart as if you knew that you are serving, but not serving men, and that you will receive the full reward from His Divine Majesty." And if we said of the object of painting (considered as art only) that it must resemble the thing it pretends to copy with propriety, we now add, that since it is practiced as a craft by a Christian gentleman, it acquires another more noble shape, and for this reason is promoted to the supreme order of the virtues. This privilege derives from the grandeur of God's law: thereby all actions (which otherwise might be thought despicable), if they are meditated actions and if they are dedicated to the eternal goal, fortify and adorn themselves with the merits of virtue.

On this account the purpose of art in itself is not destroyed or denied, but on the contrary is exalted and extolled and receives new perfection. Thus, speaking of our problem, painting, which only aimed at resembling what it copied, now as an act of virtue acquires a new and rich garment. In addition to being a likeness it rises to a supreme goal, looking to eternal glory, and trying to keep men away from vices, it leads them to the true veneration of God, our Lord.

BOOK II. CHAPTER X. *Plastic Form more Important than Beauty.* The most important of the three parts into which we divide coloring is relief of which we will speak now. I say it is most important because perhaps sometimes you might find a good painting lacking beauty and delicacy. If it possesses, however, force and plastic power (relief) and seems round like a solid object and lifelike and deceives the eye as if it were coming out of the picture frame, in this case the lack of the other two requirements is forgiven. These other two are not as important as the first one. Many spirited painters, such as Bassano, Michelangelo, Caravaggio and our Spaniard, Jusepe de Ribera, did without beauty and delicacy but not without relief.

We may even count among this group El Greco, because, although we wrote elsewhere against some opinions and paradoxes of his, we cannot exclude him from the great painters, for we see some works by his hand so plastic and so alive (in his characteristic style) that they equal the art of the very best (as I have said elsewhere). The truth of what we are saying can be seen not only in the few names cited as examples but in others who follow in their footsteps, who not only do not paint beautiful things but on the contrary put great care and pains in making a show of ugliness and fierceness.

BOOK III. CHAPTER I. *Better to Paint from Nature than from Lay Figures*. Even a clothed lay figure, since it is dead, does not give much life to the figure, although it is more useful than a live model for keeping a pose. But I stick to a live model for everything and it would be fine if I could have it before me always, not only for the head, body, hands and feet, but also for fabrics and silks and everything else. That is what Michelangelo Caravaggio did and one can see in the *Crucifixion of St. Peter* (although we have only a copy)[2] with what happy results. Jusepe de Ribera [apparently] does the same, since among all the great paintings in the Duke of Alcalá's collection his figures and heads alone seem to be alive, even in comparison to Guido Reni's and everything else seems painted. And with my son-in-law [Velázquez] who follows this method, one can also see the difference from all others because he always works from life.

BOOK III. CHAPTER V. *On the Relative Merits of Sketchy and of Finished Execution*. Some finish the sketch well and obtain an accomplished result. Others only put in the general areas of light and dark and leave their work confused. I belong with the first group and believe that one should execute the sketch all at once as best one can, because by retouching it many portions will become cruder. For this reason Céspedes said that he did not know how

[2] It would be interesting to know who did this copy after Caravaggio and when it reached Spain. Such information might help to clarify the problem of how the Early Baroque developed in the Peninsula.

to retouch, but would start out all over again. But we well
know that the perfection and special advantage of oil
painting resides precisely in the fact that one can retouch
it many times, as Titian was wont to do. Others carefully
work out the sketch and for the finish they use free and
bold strokes wishing to indicate that they work with more
dexterity and ease than others. And although they work
hard in doing this, they cover it up with this device. Who
would believe, for instance, that El Greco took his paint-
ings in hand many times and retouched them over and
over again, in order to give those cruel *à la prima* strokes
feigning valor. I call this working very hard for a poor
result. I have spoken of this elsewhere. Thus the flesh parts
are the first to be sketched and the last to be finished and
retouched. We also advise finishing first (after sketching
the picture and washing it with sponge and water), the
skies, the landscape background, buildings and fields and
all that is decoration of the figures and then to dress them
in their various colors, as behooves each object, as we
shall explain, leaving to the last the finishing of faces and
flesh parts.

BOOK III. CHAPTER VIII. *On Bird, Animal and Fish
Pieces and on Bodegones.*[3] It is important for the all-
around painter to be able to depict all kinds of birds and
animals accurately. Some of these are so common in paint-
ing that it is impossible to get along without them, such
as the horse, the lion, the bull, the eagle and others of
whose proportions and parts we have spoken above. The
diligent artist will have studied these from nature, [paint-
ing] on pieces of canvas, ready for the time when he has
an occasion to use them. He should not paint a cat or dog
instead of a lamb (as some have done). Those things are
not done well simply by practice unless one has recourse
to the paintings of Bassano, who excelled in this respect to
such an extent that it is sometimes safer to copy his animals

[3] The Spanish term *bodegón* indicates an eating piece with
figures as well as a simple still-life with food. [Our *fig.* 9,
"Quince, Cabbage, Melon and Cucumber," is the work of Fray
Juan Sánchez Cotán (1561–1627), an initiator of the realism
practised by Velázquez and Zurbarán.]

than live ones, because he has reduced them to an easy and practical manner. If the painter wants to do them from nature, he will follow Bassano's way of coloring. He studied it not only for all kinds of animals, birds and fish, but also for copper kettles and all kinds of vessels and for human figures: a boy [type], a woman [type], a man [type], and an old man [type]. Those [types] he used in all his sacred story paintings even when in reality different people were involved (a practice in which we ought not to follow him necessarily). He did the same thing with animals, with the vitality which we can observe particularly in the six famous original paintings Don Melchior Maldonado owned in this city, in one of which I always remember a cat mewing in the waters of the Flood.

In Spain our Pedro Orrente[4] has won appreciation for this type of painting, although he distinguishes himself from Bassano's manner and has his own personal style, which can easily be recognized on account of its realism. Orrente's style, with new glory, has been helpful not only to him but to many painters who make a living copying him, and he did good landscapes, in the Italian style and very realistic.

Others like to paint fish pieces with great variety, others dead birds and hunting pieces, others still-lifes with various foods and drinks, others funny figures with diverse and ugly models in order to make you laugh. All those things, when done well and vigorously, are entertaining and show talent in their arrangement and vitality. It is true that it is easier to depict dead fish and birds and animals accurately because they keep their position as long as the painter could wish. The same is true of eating and drinking pieces, and also of painting vessels and fruit. But if the objects are alive, be they fish, birds or animals, they demand more of the painter, since he must realistically depict live movement. Horses running and neighing, or dogs panting with froth and attacking cattle (as a modern Flemish painter does, who likes this sort of subject). . . .

4 See Orrente's *Noah and the Animals Leaving the Ark*, Milo K. Winter Jr. Collection, Providence, R.I., reproduced in the *Art Bulletin*, xxvii, 1945, opp. p. 111, *fig.* 3.

I also wish to praise night scenes. This is a difficult sort of painting in which Bassano and others excelled and which a famous Flemish painter recently used to great advantage in his *St. Peter denying the Lord.*[5] Well then, should we not value still-lifes with food? Obviously yes! Especially if they are painted as my son-in-law [Veláz-quez] painted them (outdoing himself in this sort of painting and outdoing all others). They deserve very great praise. In this type of painting and in portraiture (of which I shall speak later) he found the true imitation of nature, and he spurred on many others with his powerful example. I too once undertook to please a friend of mine, when I was in Madrid in 1625, and painted for him a small picture with two realistic figures, flowers, fruits and other knickknacks. Today it is in the possession of my learned friend Francisco de Rioja and with this picture I was so successful that by comparison other works of mine look as if they were painted. When the figures have force, draftsmanship, coloring and vitality and are as fine as the other objects drawn from nature with which they are represented in these paintings, as we have said, they bring great honor to the painter.

On the Requirements of a Good Portrait. The portraitist has to fulfill two requirements and is worthy of praise if he achieves both. The first is that the portrait must be a very good likeness of the sitter. This is the main reason for which it is painted and if this is accomplished the patron will be satisfied. Any painter, whether good or bad, is bound to satisfy this demand and if he does not achieve it he has not done anything at all. The second requirement is that the sitter be well delineated and painted in good style as far as coloring, power and plastic relief are concerned. This requirement is highly valued among people of the profession and among connoisseurs because such a painting is deemed a good one even if the sitter is not known. It sometimes happens that a simple-minded and ignorant painter does portraits resembling his sitters and recognizable on first sight. But they are flat and like cut-

[5] So the edition of 1866, p. 127, whereas Sánchez Cantón, *op. cit.*, II, p. 187, reads: "St. Paul."

out paper [dolls], crude and lacking in art and without any value as paintings. Those who have painted them are usually so puffed up and conceited, upon seeing their works praised by the rabble, that they lose their senses. To those who know [better] they are a ridiculous and a funny sight.

What shall we say of such portraitists? It seems that the well-known anecdote by Pablo de Céspedes was directed at them: When a friend told him that a portrait which he had just drawn in chalk was not a very good likeness of the sitter, Céspedes answered most nonchalantly: "Do you know now that portraits do not have to be a good likeness? It is sufficient, Sir, that the head has force and animation." Although this answer seems silly, coming from such a master it sets me thinking whether, in his opinion, a good portrait head is better than one resembling the sitter. As far as being true to art is concerned, if the head had another purpose, he would not be wrong. But since it was [intended] to be a portrait, he was wrong. From this I conclude (speaking after careful reflection) that if one had to neglect either the likeness or the quality of painting (if one could not combine both objectives), one should try to paint a good likeness because that is the purpose of a portrait.

Book III. Chapter XI. *How to Paint the Immaculate Conception of Our Lady.*[6] . . . Some say that [the Immaculate Conception of Our Lady] should be painted with the Christ Child in Her arms because some old images of this type have been found. This opinion is probably based (as the learned Jesuit Father Alonso de Flores has pointed out) on the fact that Our Lady enjoyed free-

[6] A large part of Pacheco's book is devoted to instructions on the proper way of painting sacred themes and images. They are a curious mixture of exalted religious prose and heated polemics on dogmatic points that seem of lesser portent today: for instance, whether Christ was nailed to the Cross with three nails or four, or whether St. Ann should be painted teaching the Virgin to read, seeing that it is more probable that Our Lady was instructed by the Holy Spirit, etc. As an example, Pacheco's precepts on the painting of the Immacuate Conception, a dogma particularly popular in Spain, are here translated.

dom from original sin from the very first moment on account of her dignity as Mother of God, although the moment had not yet arrived when she conceived Jesus Christ. Thus from this moment onward (as the Saints know) she was Mother of God and did not cease to be at any time. She was such that it was impossible to be better, just as it was not possible to have a better son. But without disputing the right of painting Her with the Child in Her arms (for those who are devoted to paint Her thus) we side with those who paint Her without the Child. This is the more customary manner. . . . This painting (as learned people know) is derived from the mysterious woman whom St. John saw in the sky, with all these attributes. Therefore the version which I follow is the one most in accord with the Holy Revelation of the Evangelist, approved by the Catholic Church with the authority of the sacred and holy interpreters. In Revelations She is not only found without the Child in Her arms but even before having borne a child, and we give Her a son after She has become pregnant. Accordingly the monk Bernard, his lips moistened by the sweetest milk of the Virgin, calls Her a miraculous symbol. Because She was so from the moment She was conceived. Because the Majesty of the Lord chose Her to testify to His infinite power, His burning love and His profound wisdom, not giving occasion for Her to be touched by original sin. This is a miracle which astounded the heavenly spirits and confounded even hell.

In this most lovely mystery the Lady should be painted in the flower of her youth, twelve or thirteen years old, as a most beautiful young girl, with fine and serious eyes, a most perfect nose and mouth and pink checks, wearing Her most beautiful golden hair loose, in short with as much perfection as a human brush could achieve. Man possesses two beauties, namely body and soul, and the Virgin had both beyond compare. Bodily She was a miracle (as St. Dionysius stated) and no other being more closely resembled Her Son who was the model of all perfection. Other children may entertain themselves by assimilating [the qualities of] their father and mother who represent different principles. But Christ Our Lord, not having an

earthly father, in everything resembled His mother who after Her son was the most beautiful being created by God. She is thus praised by the Holy Spirit: *tota pulchra es amica mea* (a text that is always cited in this painting).[7] She should be painted with a white tunic and a blue mantle, and She appeared thus to Doña Beatrice de Silva, a Portuguese lady, who later entered the Royal Convent of Sto. Domingo in Toledo to found the Order of the Immaculate Conception, confirmed by Pope Julius II in 1511. She is clothed in the sun, an oval sun of whites and ochres which must surround the whole image, sweetly fusing it with the sky. She is crowned by stars, twelve stars arranged in a light circle between rays parting from Her sacred forehead. The stars are painted as very light spots of dry pure white excelling all rays in brightness. The monk Don Luis Pascal painted them better than anyone else in the scenes of St. Bruno he made for the Great Carthusian Monastery. An imperial crown should adorn Her head which should not hide the stars. Under Her feet is the moon. Although it is a solid planet, [I took the liberty to make it] light and transparent above the landscape as a half-moon with the points turned downward. If I am not mistaken I was probably the first to give more majesty to these adornments and others followed me. Especially in the case of the moon I followed the learned opinion of Father Luis del Alcázar, illustrious son of Seville, who says: "The painters usually turn the moon at the feet of this figure upward. But it is evident among mathematicians that if sun and moon face each other, both points of the moon have to be turned downward so that the figure is not standing on a convex form."[8] This was necessary, so that the moon, receiving its light from the sun, would illuminate the feminine figure standing on it. Standing on a solid although translucid body, as has been stated, the figure had to rest on the outer surface. In the upper part of the painting one

[7] *Tota pulchra es amica mea, et macula non est in te*—Thou art all fair, my love; there is no spot in thee. Ca. IV. 7.

[8] So also Greco's friend (see p. 233), Fray Hortensio Félix Paravicino, *Oraciones evangélicas*, Madrid, 1640, fols. 86 verso and 87.

usually arranges God the Father or the Holy Ghost, or both, together with the words spoken by the Heavenly Spouse (referred to above). The attributes of the earth will be suitably distributed in the landscape and those of heaven will be arranged, if desired, among the clouds. Seraphim or entire angels holding some of the attributes may be introduced. [In my painting] I forgot the dragon, the common enemy, whose head the Virgin broke when She triumphed over original sin. I always forget him quite naturally. The truth is that I always paint him much against my will and I shall omit him whenever I can, in order not to embarrass my painting with him. Regarding everything that I have said, the painters are, however, free to do better.

ANTONIO PALOMINO

[Antonio Palomino was born in Bujalance, near Córdoba, in 1655. His interests were most varied. He studied originally for the priesthood, then jurisprudence, later mathematics, and finally painting under Valdés Leal and Alfaro. His systematic, scholarly disposition was never to leave him. In 1725, at the age of seventy and one year before his death, he realized his ecclesiastical ambitions, when, widowed, he became a priest. In 1680 Palomino left Cordoba for Madrid, and eight years later he was named court painter, from 1699 on executing numerous large fresco decorations in churches at Madrid, Valencia, Salamanca, Granada and El Paular. In his decorative schemes Palomino was particularly interested in complicated allegories and in their compositional arrangement.

As in the case of Carducho, Pacheco and Martínez, Palomino's main importance today rests in his writings. His *Museo pictórico y escala óptica* (Pictorial Museum and Optical Scale) was published in Madrid in two volumes, the first (*Theórica de la pintura*) in 1715, the second (*Práctica de la pintura*) in 1724. The second volume is bound together with a third bearing the subtitle *Parnaso*

español pintoresco laureado, being a collection of "lives of the eminent Spanish painters and sculptors, including foreign artists who worked in Spain." This third volume is our most valuable source for the history of Spanish painting in the sixteenth and particularly the seventeenth century. Modelled on the example of Vasari and Van Mander, it uses the notes of Lázaro Díaz del Valle and books now lost, among them a biography of Velázquez no longer extant. Palomino's *Lives* was so successful that a second edition was made in Madrid in 1795–1797. Summaries were published in London in 1739 (in English), in 1744 and 1756 (in Spanish), in Paris in 1749 and 1762 (in French).]

PICTORIAL MUSEUM AND OPTICAL SCALE[1]

VOLUME I. THEORY OF PAINTING

BOOK II. CHAPTER I. §3. *Painting as a Liberal Art.* What is science and what is art and what is the difference between the liberal and the mechanical arts?[2] Science is

[1] The excerpts are translated from Palomino, *El museo pictórico y escala óptica* (with *Vidas de los pintores y estatuarios eminentes españoles*), 2nd ed., Madrid, 1795–1797, reprinted in part in F. J. Sánchez Cantón, *Fuentes literarias para la historia del arte español,* Madrid, IV, 1936, pp. 89–91, 143–148. The introductory remarks, selection and translation are by Dr. Martin S. Soria.

See also: F. J. Sánchez Cantón, *op. cit.,* III, 1934, pp. 145–148, and IV, 1936, pp. v–ix; M. Menéndez Pelayo, *Historia de las ideas estéticas en España,* 2nd ed., Madrid, VI, 1904, pp. 257–271; E. Moya Casals, *El magno pintor del empíreo (Antonio Palomino de Castro),* Melilla, 1928; A. L. Mayer, in Thieme-Becker, *Künstlerlexikon,* Leipzig, XXVI, 1932, pp. 185–186.

[2] This was a burning question for social as well as material reasons. Since no one exercising a trade or mechanical profession could be knighted, painters were anxious to assert and to prove that painting was a liberal, not a mechanical, art. Furthermore, if it could be proven that painters were following a liberal, not a mechanical, profession, they would be free from the *alcabala,* the sales tax. But toward the end of the seventeenth century painters had pretty well won their point. In 1603 El Greco won the first suit against an overeager tax collector (see below, p. 233); in 1658 Velázquez had been admitted

the habit of understanding acquired by practical demonstration. Art is the secure and right way of doing things. Science is therefore essentially concerned with speculative processes (actions), and does not depend on practical or manual operations. Art does not excluded speculative processes and includes those practical and manual actions which are wrought upon external and perceptible matter in order to construct a definite work according to exact rules and infallible teachings.

Art is divided into liberal and into mechanical art. In liberal art, to define it by its essence, speculative processes prevail over practical actions or bodily operations. In mechanical art corporeal operations outweigh speculative processes. Therefore the difference between the two types of art is merely that in liberal art we have more speculation than toil and in merchanical art more toil than speculation. And to make everything clear we may also mention here the base art which is commonly called contemptible occupation: this is an art which, without speculative processes, is learned exclusively by repeating a simple material [not spiritual] practice and a bodily exercise in· humble, lowly and not very decent operations. It is called contemptible or sordid because it stains, lowers and defiles the excellence of the individual's rank and person. Therefore such an occupation is not an art properly speaking but only in the improper and loose sense of the word. Some confuse the mechanical and the sordid arts without drawing the distinction which should justly be made.

There are other definitions applicable to the liberal arts. Although they are, in my opinion, more descriptive than fundamental, it is good to touch on them because of the weight of the authorities who gave them. The first definition is that of St. Augustine who says: "Liberal arts are those which are worthy of a Christian and which show us the way to true knowledge." The second definition is

into the ancient and exalted military order of Santiago; and in 1677 the Spanish Parliament had declared painting a liberal art. For the social position of the artist during the Renaissance, see Blunt, *Theory*, chap. IV. Cf. also Leonardo, *Documentary History of Art*, vol. I, p. 275, note 4.

Seneca's, in letter 88, where he says: "Liberal studies are those which are worthy of being followed by free men."

In this connection one ought to know that the Romans distinguished between free or free-born and slaves or servants. The latter were only allowed to exercise the sordid or mechanical arts which were therefore called servile arts. The noble, so-called liberal arts were reserved for the free or noble and prohibited to the slaves, a distinction of classes which in Spain corresponds to that of noblemen and commoners. . . .

BOOK II. CHAPTER I. §5. *The Definition of Augustine.* If the liberal arts in the definition of St. Augustine are those "worthy of a Christian and those which show us the way to true knowledge," then I ask: Is there any art superior to the one whose mute but eloquent sentences were used by the early Church, to show the faithful the way of truth in the open books of sacred history; and lives and martyrdoms of the Saints, drawn with the silent eloquence of the brush? Is there any art superior to the one which has produced such miraculous effects in converting the most hardened minds to the delicious yoke of our religion and to the fear of God? Is there any art superior to the one whose sacred arrows penetrate the most powerful of the five senses? Such miraculous effects are obtained not only by reverently exposing the sacred images but also through the hidden, powerful force of art in portraits or in purely human or profane images. Is there any art superior to the one where the artist, in representing the highest and most profound mysteries of our faith and of our salvation, must necessarily meditate on the very things which he is representing. An enjoyable diversion for the body thus becomes for him a delicious repast for the soul. Will not the most indifferent mind begin to soar upward when repeatedly exposed to such opportunities to follow the road of true knowledge. This is well proven by the praiseworthy Christian diligence with which many artists proceed: when they are about to represent a sacred subject, and especially before painting representations of Christ our Lord or of His most holy mother, they prepare themselves through prayer, mortification, self-punishment and the sacraments.

BOOK II. CHAPTER VI. §2. *Calderón's Praise of Painting.*
Don Pedro Calderón de la Barca[3] explains why painting is
not listed among the seven liberal arts, grammar, dialectics,
rhetoric, arithmetic, geometry, music and astronomy. This
did not occur through carelessness, but for the sake of
accuracy, since painting is an art of arts to such an extent
that it dominates all other arts and utilizes all of them. Let
grammar be the first witness to this fact, since grammar is
the first constituent principle of the liberal arts and of the
sciences; grammar pays homage to painting in the harmony
with which the shades of colors are reconciled in the peace-
ful union of hues. If grammar did not give the lily its
white, the carnation its red and the leaves their green,
etc., it would, in its mute language, sin against the infallible
dogmas of nature.

Dialectics, is a judge who, by way of argument, distin-
guishes good from bad, the certain from the doubtful, the
true from the false. It is true, however, that to a large
extent, dialectics, being such a great subject, is exposed to
disputes and quarrels which it must sustain and argue,
since dialectics is a learned matter. Now dialectics should
also testify to the superiority of painting which introduces
a syllogism to the lecture halls of dialectics, so that scien-
tific demonstrations may be made more convincing through
mathematical evidence.

Rhetoric, the order of good speech, on which oratory and
poesy depend and which is chiefly concerned with per-
suasion is also serving painting with the energy of its
[rhetoric's] persuasiveness. [Painting] with its painted
tones and articulate shades of color, is not less persuasive,
as a sort of mute rhetoric. Is there any eloquence greater
than that represented by painting? Although you know
that you are standing before a canvas smeared with min-
erals and liquids, you are made to believe—and doubt it if
you can—that the historical event is actually present, that
the fable is real. But when the picture expresses inner
emotions, its noble deception not only acts powerfully on

[3] The great Spanish dramatist and poet (1600–1681). This
passage is a quotation from Calderón's testimony in a lawsuit of
1676 against the levying of sales taxes on painters.

your friends, but enraptures everybody else. If battles are represented, we are incited to heroic enterprises; if fires, [we are] terror-stricken; if torture, miserable; if success, delighted; if ruin, moved to compassion; if landscapes, amused; if gardens, refreshed. If the posthumous fame of noble heroes is depicted, their portraits will remind us of their valor and will move us to pardonable envy of their deeds; learned men will inspire us to equal them in scholarship; saints to imitate their virtues gloriously; and finally, sacred images place before our eyes the most secluded mysteries of our faith. What slumbering heart would not awaken to the silent murmur of worship, religion and veneration? Such is the efficacy of painting's illuminated and shaded lines! And since I mentioned lines, arithmetic with its strict rules should take care of them.

Arithmetic is a subject of mathematics. Architecture, sculpture and the other branches of mathematics reduce themselves to instruction in, and knowledge and use of, arithmetic. They all need arithmetic, while the latter is self-sufficient.

For the perfection of its numbers arithmetic does not need lines, but the other sciences, for the perfection of their lines, need numbers. Although the power of arithmetic is so great, arithmetic is to such an extent a vassal of painting that painting will not produce a single perfect brushstroke without being abetted by an arithmetic rule.

Geometry is accompanied by symmetry—the same as proportion—and by perspective, which combines the effects of both geometry and symmetry. Geometry is concerned with the proportion of sizes and measurements, increasing or diminishing the lineaments of the face in accordance with the figure; not only in accordance with the figure, however, but also in proportion to the distance at which the figure is placed, for sometimes we dislike in a close-up view what we would not dislike if seen from a distance. Those two opposite poles are reconciled by perspective which achieves the effect of foreground and of background in one and the same painting. In the foreground perspective may show the realistic façade of a sumptuous palace

with properly painted architecture and sculpture. Statues and columns projecting from the canvas indicate by their plastic effect that behind them we proceed to the middle ground. There, through optic graduation, the edifice and our view become smaller until we arrive at the background, executed with as much perfection as the foreground. All three planes fuse so harmoniously that they are comparable to music. If music strives to hold the mind in suspense with its language, painting does so with a language no less harmonious. Painting possesses, moreover, the added advantage which the sense of seeing has over the sense of hearing. This is especially true if above the horizon, the picture is crowned with clouds and skies which carry our imagination away, and cause us to speculate on planets and destiny.

Grammar contributes to painting its concordances; dialectics its logical conclusions; rhetoric its persuasion; poesy its inventive power; oratory its figures of speech; arithmetic its numbers; music its harmonies; symmetry its measures; architecture is level planes; sculpture its roundness; perspective and optics their magnification and diminution; and finally astronomy and astrology their talents for the knowledge of the heavenly images. Who can doubt that [painting], the transcendent sum total of all the arts, is the chief art which comprises all the others?

VOLUME III. LIVES OF SPANISH PAINTERS AND SCULPTORS

CHAPTER LVII. *Dominico Greco, Painter, Architect and Sculptor.* Dominico Greco, commonly called El Greco [the Greek] because he was of that nationality, was a great painter and a pupil of Titian. He imitated Titian to such an extent that his paintings were confused with those of his master. This can be seen in many pictures which El Greco painted in Spain. Particularly the famous *Espolio* [*Casting of Lots for Christ's Garments*] in the sacristy of the Cathdral of Toledo, attests to this fact, because it contains some heads which look completely like Titian's; this is also true of the *Apostolado* [series of twelve apostles]

at the same place. But it is borne out especially by the *Burial of Count Orgaz*, Don Gonzalo Ruiz de Toledo, who is laid to rest by St. Augustine and St. Stephen, to both of whom the Count was very devoted. It was for this reason that the Count built the Augustinian monastery at Toledo, dedicated to St. Stephen. This painting is in the parish church of Santo Tomé (founded by the Count), where he is interred and where the story occurred. As he did with many other pictures, El Greco pawned this painting for 2000 ducats, for reasons which we will explain later.[4] Although digressing for a moment, I will not fail to mention that this painting was commissioned in 1584 by His Eminence Don Gaspar de Quiroga, Cardinal-Archbishop of Toledo, at the request of the priest of that parish [Santo Tomé]. The Count had died in 1323.

At the Jesuit church [in Toledo] there is another picture by El Greco, of the same subject but without the glory of angels at the top. This picture was painted by El Greco[5] at the request of the Jesuit fathers, as a token of gratitude because the ground for their church was a legacy from Count Orgaz in 1569. On this plot there had been houses belonging to the family estate of the Counts of Orgaz. The Jesuit church was placed under the patronage of St. Ildefonso, because of an immemorial tradition that the Saint was born in [one of] these houses. Both pictures surely look as if they were by Titian.

I did not wish to omit these notes even if they are a digression, because they are so curious. In the Jeronymite convent of the Queen, of the nuns of the Visitation [at Toledo], there is a life-size *Crucifixion*, with two portraits below, a cleric at the right and a layman at the left, one of the most sumptuous paintings ever done by El Greco.[6] He was beyond all doubt superior, particularly in portrait painting. This can be seen in many of his portraits at this court [Madrid], where the heads strangely resemble those by Titian. This is not less true of a Mary Magdalen, more

[4] See p. 233.

[5] Now in the Prado, Madrid. This picture is a copy, probably by El Greco's son Jorge Manuel Theotocopuli.

[6] In the Louvre, Paris.

than half length, in a private collection.[7] I have not seen anything better by him or of greater refinement of coloring.

The life-size *Resurrection of Christ*, in the sacristy of the Atocha Church [at Madrid], is also an excellent painting.[8] All the paintings of the main altar of the parish church of Bayona [now called Titulcia], near Ciempozuelos, are by his hand. They represent scenes from the life of the Magdalen[9] and are so excellent that His Eminence Cardinal Portocarrero, upon seeing them, offered this church 5000 pesos for these paintings and that he would have them replaced with paintings by Luca Giordano. They did not accept the deal; I do not know whether they were right. There are excellent paintings by El Greco in the monastery of La Sisla at Toledo and in the *Hospital de Afuera*, and especially, a small painting of the *Last Judgment*,[10] in the Escorial in the small Chapel of the Virgin near the exit from the sacristy to the church. One cannot paint better than this [picture].

But El Greco, seeing that his paintings were confused with those of Titian, endeavored to change his style, with such extravagance that he finally made his paintings contemptible and ludicrous, because his design became disjointed and his coloring harsh. This is evident in the paintings of the famous altar of the College of Doña María of Aragón at Madrid,[11] where he did the sculpture and plans of the whole retable and even of the whole church, and [it is evident] also in many other paintings which do not deserve to be mentioned. For instance, in the case of a picture El Greco did for the Escorial of the *Martyrdom of*

[7] Perhaps the picture now in the Museum of Art, Worcester, Mass.

[8] Probably the picture now in the Prado.

[9] These paintings have since been scattered all over the world, except for the *Ascension of the Magdalen* still in place. They are now considered to have been done by El Greco's son Jorge Manuel; see Elizabeth du Gué Trapier, "The Son of El Greco," *Notes Hispanic*, III, 1943, pp. 4, 8–15.

[10] The picture represents the *Adoration of the Name of Jesus,* also called *The Dream of Philip II.*

[11] Now in the Prado.

St. Maurice and of his Companions, King Philip II ordered
that the artist should be paid, but that the picture should
not be hung. The artist succeeded, however, on account
of his reputation in having the picture put up in the chap-
ter hall, but the painting for the Chapel of St. Maurice
was done by Romulo Cincinnato, as we pointed out in the
life of this painter. That El Greco was not only an experi-
enced master of painting but a great philosopher and a
master of witty sayings, and that he wrote on painting,
sculpture and architecture[12] is stated by Pacheco, . . . He
was not only a great painter and sculptor but an accom-
plished architect, because in the convent of Sto. Domingo
el Antiguo at Toledo he did the plan of the church, altars,
paintings and statues,[13] all with great excellence. This is
also true of the church, altars and statues of Our Lady
of Charity at Illescas. This is the reason why a tax collector
of that city pressed him for sales taxes. And from this de-
veloped the first lawsuit of this kind levelled at the art of
painting. El Greco defended painting so well that in 1600
[rightly: 1603] he won the suit in favor of painting, as we
mentioned. . . . All painters, therefore, owe immortal grati-
tude to El Greco because he was the first to take up the
fight in defense of the immunity of our art from sales
taxes. All other court decisions were based on that prece-
dent. For this reason, it is said, El Greco did not wish to
sell his paintings, but would pawn them while the tax suit
was on, because the sales tax is only levied on what is
sold and if one does not sell no tax is due.[14] It is therefore
said that the above-mentioned picture of the *Casting of
Lots for Christ's Garments,* in the sacristy of the Cathedral
of Toledo, as we said, was pawned, and even pawned by
contract made before a notary public.

It would not be fair to omit the famous portrait, praise-
worthy for so many reasons, which El Greco did of that
rare genius Father Fray Hortensio Félix Paravicino, mem-

[12] Unfortunately El Greco's writings must be presumed lost.
[13] The main painting for that church, *The Assumption of the
Virgin,* is now at the Art Institute of Chicago.
[14] Documents have so far failed to confirm the story of El
Greco's pawning his pictures instead of selling them.

ber of the Holy Order of Trinitarians and pride of his cen-
tury.[15] It is a most distinguished picture and now belongs
to His Grace the Duke of Arcos. In recognition this Father
Fray Félix dedicated a famous sonnet to El Greco, re-
corded in the posthumous works, entitled *Works of Don
Félix de Artiaga*. . . . This sonnet is preceded by another
one, not less excellent, which the same author wrote in
praise of the great catafalque designed by El Greco in
Toledo to honor the memory of Queen Margareta. This
sonnet is equally worthy of our attention because of its
author and its subject. . . .

El Greco finally died in Toledo around 1625 at the age
of seventy-seven,[16] although others say that he died at an
older age. He is buried in this parish church of St. Barthol-
omew. On his grave they put, I know not why, an iron
grate instead of a flagstone, so that nobody else would
be buried there. The grate is no longer there because the
church fell in and they took the grate away when the
church was rebuilt. El Greco left a son named Jorge
Manuel who was architect-in-chief of the cathedral. El
Greco also left, among others, two great pupils, Luis
Tristán and Fray Juan Bautista Maino, whom we shall
mention later in greater detail.

Francisco Pacheco, in his book on the *Art of Painting*,
displays amazement over El Greco's bad opinion of the art
of Michelangelo. To tell the truth, I am not surprised.
Because if El Greco was satisfied with his own very ex-
travagant compositions and nudes, he surely would be
displeased with something that was diametrically opposed
to him. El Greco was so studious, however, that Pacheco
reports that El Greco showed him a large cupboard with
clay models made by him to serve in his work; and a large
room full of small paintings in oil of all the pictures he had
ever painted in his life.[17]

[15] One of the great treasures of the Museum of Fine Arts in
Boston. [Our *fig. 10.*]

[16] El Greco was born in 1541 in the village of Phodele, near
Candia, Crete, and died at Toledo on April 7, 1614.

[17] It is assumed, with good reason that these small sketches
were kept as models, so that large paintings could be done

CHAPTER CVI. *Birth, Parents, Native Country and Education of Velázquez in the Art of Painting.* Don Diego Velázquez de Silva was born in 1594[18] at the city of Seville, the most famous city upon which the sun shines. His parents were Juan Rodríguez de Silva and Gerónima Velázquez. Both were endowed with virtue, rank and nobility and both were natives of Seville. The artist generally used his mother's family name [Velázquez], a misusage current in some parts of Andalusia causing great difficulty when it is a question of obtaining legal evidence.

His paternal ancestors came from the Kingdom of Portugal, of the noble family of Silva, whose family name is derived from Silvius Postumus, son of Silvius Aeneas. They proceed, according to immemorial tradition, from the Kings of Albalonga. The artist's ancestors served the Portuguese Kings and learned to know the hand of fate: they ascended to great rank, but fortune showed its adversity and changed their station, forcing them to descend from their eminence and suffer misfortune. Finally the only family inheritance they had left was their services and their valor, always guided by the merits of their ancestors.

Nobility is derived from the virtue of some of our ancestors, but hereditary nobility stems from an adherence to that first virtue. Velázquez, from his first years on, gave signs of his fine natural disposition and of the noble blood in his veins, although he found himself in modest circumstances.

His parents brought him up in the fear of God, without frills and ostentation. He studied the humanities, surpassing many of his contemporaries in languages and philosophy. He gave evidence of special inclination toward painting. Although he was talented, nimble-witted and docile in almost any branch of knowledge, he was the most gifted in the field of painting to such an extent that the school notebooks sometimes became sketchbooks for his ideas. His perspicacity greatly impressed his parents with his genius and in time he was to redeem this early promise

after them at any time by the master and, particularly, by his assistants.

[18] 1599.

most brilliantly. They allowed him to follow his inclination without pressing other studies because they found him inclined [to painting] by nature or the power of fate. They turned him over to the instruction of Francisco de Herrera who is called Herrera the Elder in Andalusia, a strict man, little given to charity, but of very good taste in painting and in other arts.

Velázquez soon left his studio and entered that of Francisco Pacheco, a person of singular virtue and great erudition. He knew a great deal about painting, wrote several books and very elegant verse on that subject, and was praised by all the writers of his time.

Pacheco's house was a gilded cage of the arts, an academy and school for the best talents of Seville. Thus Diego Velázquez led a pleasant life, training himself continuously in drawing, the first element of painting and main door to this art. This we know from Pacheco who tells the story with his customary sincerity and plainness, and with the objectivity of a teacher. He says: "My son-in-law Diego Velázquez de Silva, as a boy, followed this method. He hired a country lad who served him as a model in diverse poses and positions: sometimes weeping, other times laughing, without omitting any difficult pose. He made many [drawings] of him in charcoal heightened with white on blue paper, and he drew other objects from nature whereby he acquired dexterity in portrait painting." He was fond of painting animals, fish, birds and still-life, with handsome landscapes and figures, copying nature to perfection with rare originality and notable talent. He painted various foods and drinks, fruit, and modest and humble pieces of furniture, with so much vitality, draftsmanship and coloring that they seemed to be truly lifelike. In this sort of painting he was superior to all others, and thereby gained great fame. These works were valued highly and among them we must not pass in silence the picture called the *Water-carrier*. It represents an old man very shabbily dressed in a tattered garment which through its rents uncovers naked parts of his chest and abdomen, covered with hard calluses and scabs, and next to him

stands a boy to whom he offers a drink. This painting is so famous that it has survived to this day in the Buen Retiro Palace.[19]

He made another picture of two poor men eating at a lowly table on which are various clay vessels, oranges, a piece of bread and other things, all observed with rare diligence. Similar to this one is another painting, which was very carefully done, of a poorly dressed boy wearing a cap, counting money on a table, and computing it with the fingers of his left hand. Behind the boy is a dog prying among some shells and other seafood such as sardines, on the table. On this table there is also a head of Roman lettuce, which they call heart lettuce in Madrid, and a small kettle turned upside down. Two kitchen shelves project [from the wall] at the left. On the first are some large red herrings and a loaf of Sevillian-style bread on a white piece of cloth. On the second are two dishes of white clay and a small oil bottle of clay with green glaze. This picture is signed although the name has become almost illegible with time. Similar to this painting is another one where you see a counter serving as a table. It has a small stove with a round pot aboiling covered by a small bowl. The glow, the fire, and the blaze are vividly seen [in] the metal bowl lined with tin. A jar with two handles, some plates and small bowls, a glazed jug, a mortar with its pestle, and a bulb of garlic next to it. On the wall, hung by a hook, a two-handled frail with a piece of cloth, and other knickknacks. Watching all this, a boy with a jar in his hand and a light coif on his head, a funny and amusing figure in such a lowly dress.[20] At that time, in order to distinguish himself from all others and to follow new ways, Velázquez made all his works of this type. Aware that

[19] This is the picture in the Apsley House, now Wellington Museum, London. *Water-carrier* is fully and neatly dressed so Palomino was here carried away by his imagination.

[20] This picture, the *Servant* [our *fig. 11*], somewhat cut, is at the Art Institute of Chicago.

Titian, Dürer, Raphael and others held an advantage over
him and that their reputation had increased after their
deaths, he availed himself of his fanciful inventive genius
and began to paint rough and homely pieces with great
pretension and with odd lighting and coloring. Some
remonstrated with him because he did not paint, with
delicacy and beauty, subjects of a more serious nature so
as to emulate Raphael of Urbino. He vindicated himself
elegantly, saying: "I would rather be the first in this
coarse stuff than the second in nicety." Those who have
been outstanding and accomplished in this kind of painting
have been famous. Not only did our own Velázquez follow
such a low notion, but there have been many who shared
this inclination and particular disposition of the mind.
Pliny says that Pyreicus, a famous painter of antiquity, by
painting subjects of low life won great fame and apprecia-
tion for his works. For this reason he was called "Rhyparo-
graphos," a Greek word meaning painter of low and mean
subjects.

With these beginnings and with the portraits which he
did so well—he was not content that they were extremely
good likenesses but, so great was his excellence, he made
them express the air and movement of the sitter—Veláz-
quez found the true imitation of nature. With his power-
ful example he encouraged many to follow him, as Pacheco
relates, since he himself happened to paint this kind of
stuff in imitation of Velázquez. Velázquez competed with
Caravaggio in the energy of his brushwork and equalled
Pacheco in imagination. The first Velázquez esteemed for
his excellence and keen talent, and the latter [Pacheco]
Velázquez chose for his master because of his [Pacheco's]
knowledge and experience which made him worthy of this
choice. When some paintings were brought from Italy to
Seville, Velázquez was greatly encouraged to attempt
similar undertakings with his own talent. Those paintings
were by contemporary artists such as Pomerancio, Ba-
glione, Lanfranco, Ribera, Reni and others. The paintings
which seemed most congenial to Velázquez were by Luis
Tristán, a painter of Toledo and pupil of El Greco. He
found them to be agreeable to his own mood, because of

their strange ideas and vivid thoughts.[21] Velázquez therefore declared himself a follower of Tristán and ceased to
paint in the style of his master [Pacheco], since he understood right from the start that Pacheco's very tame, although most erudite, style of painting and drawing did
not suit him.[22] Both were contrary to his high-minded
nature, which inclined toward grandeur. Velázquez was
called a second Caravaggio, because in his works he depicted nature with great success and very accurately. [He
was able to do this] because he painted from nature at all
times and in every detail. In portraits Velázquez followed
El Greco, believing that El Greco's heads could never be
praised sufficiently. This is true of all of Greco's works
except those tainted by the extravagance into which El
Greco lapsed in his last years, and we may say of El
Greco: "What he did well, no one did better, and what
he did poorly, no one did worse." Thus [we may say]
Velázquez outdid himself in art, combining the energy of
the Greeks, the diligence of the Romans, and the tenderness of the Venetians and Spaniards. He epitomizes the
latter to such an extent that if we were without the vast
number of Spanish paintings, we should know them
through the small galaxy of his own works.

Velázquez trained himself by reading various authors
who wrote accomplished books on the art of painting.[23]

[21] Many of Velázquez' paintings reveal influences from El
Greco, while later on Goya was to receive suggestions from
El Greco as well as from Velázquez.

[22] Already his contemporaries noticed Pacheco's dry and
graceless manner. When he painted a *Christ Picking Up His
Garments After the Flagellation,* an anonymous wit gibed:

Who painted you thus, oh Lord,
So dry and so insipid?
You will tell me that pure Love,
But I can tell you Pacheco did it!

[23] For the exact titles see F. J. Sánchez Cantón, "La librería
de Velázquez," *Homenaje a Menéndez Pidal,* Madrid, III, 1925,
pp. 379–406. Some titles also in Sir W. Stirling-Maxwell,
Annals of the Artists of Spain, 2nd ed., London, 1891, II, pp.
683–684. See further *Archivo español de arte,* no. 50, 1942,
pp. 84–86. Sánchez Cantón, *loc. cit.,* stresses the fact that
Velázquez' library contained no imaginative books, no plays,

In Albrecht Dürer he studied proportion of the human body; in André Vésale, anatomy; in Giovanni Battista Porta, physiognomy; in Daniele Barbaro, perspective; in Euclid, geometry; in Moya, arithmetic; in Vitruvius, Vignola and others, architecture. From all these authors Velázquez with the care of a bee ingeniously selected what was most suitable and perfect for his own use and for the benefit of posterity. Velázquez examined the nobility of the art of painting in Romano Alberti, written, at the request of the Academy [of Painting] of Rome and of the venerable Brotherhood of St. Luke. With Federigo Zuccaro's "Idea of Painters" Velázquez illustrated his own painting and embellished it with the teachings of Giovanni Battista Armenini. From Michelangelo Biondo he learned to paint fast and quickly. Vasari stimulated him with the "Lives of Famous Painters" and Raffaele Borghini's *Riposo* made a learned painter out of him. He also studied sacred literature and belles-lettres and other important subjects to enrich his mind with all sorts of learning and a complete knowledge of the arts. Thus advises Leon Battista Alberti: "I should prefer the Painter to be learned, if possible, in all the liberal arts; but above all it is necessary that he be well versed in geometry." Velázquez was also acquainted with, and a close friend of, poets and orators, because from such talents he received great assistance in his compositions.

Finally, Velázquez was untiring in practicing [painting], as the great difficulty of this art requires. He persevered without any other aim than that of the glory and praise acquired by experience, and trusting time and hard work which always justly reward him who labors for it. He remained an apprentice for five years, during which time

only one unimportant novel. There were, however, Ovid, Horace, Petrarch, Ariosto and Castiglione: hardly any religious or philosophical books, except for Aristotle; half a dozen works related to astrology and almost twenty on astronomy, cosmography, maps, and explorations; many books on mathematics, mechanics, medicine, horsemanship, ballistics, history and archaeology. Among books on art Velázquez' library was particularly rich in works on perspective, architecture, and anatomy, besides the books on paintings cited by Palomino in the text.

he progressed according to his age. He married, and with good taste and honor to himself, chose for his wife, Juana Pacheco. She was the daughter of Francisco Pacheco, officer of the Holy Inquisition, and of a ranking family.

Velázquez outdid his teacher and father-in-law in art without causing the latter to change his style or to become envious. On the contrary, Pacheco considered it, and rightfully so, a feather in his own cap. Pacheco, himself, confides this [in a passage] where he also complains of someone who wanted to claim the honor of having been [Velázquez's] teacher, thus attempting to take [from Pacheco] the chief glory of his last years. Pacheco was more than seventy years old when he wrote about this. Having praised Romulo Cincinnato and Peter Paul Rubens, Pacheco writes: "My son-in-law, Diego Velázquez, rightfully occupies the third place. After teaching and educating him for five years, I married him to my daughter, moved thereto by his virtue, good family and endowments, and by the hopefulness of his talents and great genius. Since the honor of being a teacher is greater than that of being [merely] a father-in-law, I have to speak out against the daring attempt someone has made who wishes to usurp this honor [of being Velázquez's teacher] and thus to steal the chief glory of my last years. I do not consider it a disgrace when the pupil outdoes the teacher, as long as I tell the truth which is none other. Leonardo da Vinci did not lose anything in having Raphael for a pupil, nor Giorgione in Titian, nor Plato in Aristotle, since it did not [even] cause him to lose the surname of 'the Divine.'

"All this is written not so much in order to praise the individual in question [Velázquez]—that belongs on another page—but on account of the greatness of the art of painting, and especially out of gratitude and veneration for His Catholic Majesty, our great ruler, Philip IV, to whom heaven may grant unending years, because from his generous hands he [Velázquez] has received, and continues to receive, so many honors."[24]

[24] See J. Lopez-Rey, *Velazquez: Catalogue Raisonné of his Oeuvre*, London, 1963; E. Trapier, *Velazquez*, New York, 1948.

III. THE EIGHTEENTH
CENTURY

ENGLAND

ANTHONY ASHLEY COOPER,
THIRD EARL OF SHAFTESBURY

[The first earl, famous liberal statesman of the Revolution and Restoration, bred his grandson, the third earl (1671–1713), from the earliest childhood to the championship of national and popular liberty. These two motives colored all his writing and public activity. Typical of his general outlook was his first published work, *A Letter Concerning Enthusiasm* (1707) which pleaded for the restraint of religious fanaticism by the humane discipline of humor rather than imprisonment and torture. The works included in the three volumes of *Characteristics of Men, Manners, Opinion, Times* teach the naturalness of the social affections, the affinity between aesthetic harmony in the arts and in a virtuous life, and also constantly furnish a stoic background of General Providence and the "harmony in the whole piece of nature." Though tutored by John Locke, a lifelong friend and member of the Shaftesbury household, the third earl repudiated as barren and as showing ignorance of Greek thought the new empirical method with its empirical implications. Locke's argument against innate ideas did not touch, he thought, the fact of nature's gift to man of benevolent and aesthetic affections and passions. By prolonged residence in Italy, Shaftesbury developed wide knowledge of the polite arts. He preached the ideal of the virtuoso—the philosopher artist—and became a practical patron of the arts, commissioning and

supervising engravers in the production of emblematic pictures. His *Notion of the Historical Draught or Tablature of the Judgment of Hercules* was written as instructions to the Neapolitan painter, Paolo de Matteis, for a painting of the "Judgment of Hercules," and an engraving by Gribelin after Matteis' painting (our *fig.* 12) was included with the "Notion" in the third volume of the revised edition of the *Characteristics* published in 1714. In the essay Shaftesbury stated and applied the doctrine of the "pregnant moment," later made famous by Lessing's *Laocoön.*]

NOTION OF THE HISTORICAL DRAUGHT OR TABLATURE OF THE JUDGMENT OF HERCULES[1]

INTRODUCTION. (1). Before we enter on the Examination of our Historical Sketch, it may be proper to remark, that by the word *Tablature* (for which we have yet no name in English besides the general one of *Picture*) we denote, according to the original word *Tabula,* a Work not only distinct from a mere *Portraiture,* but from all those wilder sorts of Painting which are in a manner absolute and independent; such as the Paintings in *Fresco* upon the Walls, the Ceilings, the Stair-cases, the Cupola's, and other remarkable places either of Churches or Palaces.

(2). Accordingly we are to understand, that it is not merely the Shape or Dimension of a Cloth or Board which denominates the *Piece* or *Tablature;* since a Work of this kind may be compos'd of any colour'd Substance, as it may of any Form, whether square, oval, or round: but it is then that in Painting we may give to any particular Work the name of *Tablature,* when the Work is in reality

[1] The text is from Anthony, Earl of Shaftesbury, *An Essay on Painting, being a Notion of the Historical Draught or Tablature of the Judgment of Hercules,* London, 1713. Dr. Katharine Gilbert kindly wrote this biographical sketch.
See also: Edgar Wind, "Shaftesbury as a Patron of Art," *Journal of the Warburg Institute,* II, 1938–1939, pp. 185 ff.; E. Panofsky, *Hercules am Scheidewege* (Studien der Bibliothek Warburg, XVIII), Leipzig/Berlin, 1930, pp. 62 and 131; R. L. Brett, *The Third Earl of Shaftesbury,* London, 1951.

"a *single Piece*, comprehended in one *View*, and form'd according to one single Intelligence, Meaning, or Design; which constitutes a real *Whole*, by a mutual and necessary Relation of its Parts, the same as of the Members in a natural Body." So that one may say of a Picture compos'd of any number of Figures differently rang'd, and without any regard to this Correspondency or Union describ'd, that it is no more a real Piece or *Tablature*, than a Picture wou'd be a *Man's Picture*, or proper *Portraiture*, which represented on the same Cloth, in different places, the Legs, Arms, Nose, and Eyes of such a Person, without adjusting them according to the true Proportion, Air, and Character which belong'd to him.

(3). This Regulation has place even in the inferiour degrees of Painting; since the mere Flower-Painter is, we see, oblig'd to study the Form of *Festons*, and to make use of a peculiar Order, or Architecture of *Vases, Jars, Cannisters, Pedestals,* and other Inventions, which serve as *Machines* to frame a certain proportionate Assemblage, or united Mass; according to the Rules of Perspective, and with regard as well to the different shapes and sizes of his several Flowers, as to the harmony of Colours resulting from the whole: this being the only thing capable of rendering his Work worthy the name of a *Composition* or *Real Piece*.

(4). So much the more therefore is this Regulation applicable to History-Painting, where not only *Men*, but *Manners*, and human Passions are represented. Here the Unity of Design must with more particular exactness be preserv'd, according to the just Rules of Poetick Art; that in the Representation of any Event, or remarkable Fact, the *Probability*, or seeming Truth (which is the real Truth of Art) may with the highest advantage be supported and advanc'd: as we shall better understand in the Argument which follows, on the historical *Tablature* of the *Judgment* of HERCULES; who being young, and retir'd to a *solitary* place, in order to deliberate on the choice he was to make of the different ways of Life, was accosted (as our Historian relates) by the two Goddesses, *Virtue* and *Pleasure*. 'Tis on the issue of the Controversy between these *two*,

that the Character of HERCULES depends; so that we may naturally give to this Piece and History, as well the Title of the *Education* as the *Choice* or *Judgment* of HERCULES.

CHAPTER I. *On the general Constitution or Ordonnance of the Tablature.* (1). This Fable or History may be variously represented according to the Order of Time.

Either in the instant when the two Goddesses (*Virtue* and *Pleasure*) accost HERCULES.

Or when they are enter'd on their Disputes.

Or when their Dispute is already far advanc'd and *Virtue* seems to gain her Cause.

(2). According to the *first* Notion, HERCULES must of necessity seem surpriz'd on the first appearance of such miraculous Forms; he admires, he contemplates, but is not yet ingag'd or interested. According to the *second* Notion, he is interested, divided, and in doubt. According to the *third,* he is wrought, agitated, and torn by contrary Passions. 'Tis the last Effort of the vicious one, striving for possession over him. He agonizes, and with all his strength of Reason endeavours to overcome himself:

Et premitur ratione animus, vincique laborat.

(3). Of these different periods of Time, the latter has been chosen, as being the only one of the three, which can well serve to express the *Grand Event,* or consequent Resolution of HERCULES, and the *Choice* be actually made of a Life full of Toil and Hardship, under the Conduct of *Virtue,* for the deliverance of Mankind from Tyranny and Oppression. And 'tis to such a Piece of Tablature as represents this issue of the Ballance in our pondering Hero, that we may justly give the title of the *Decision* or *Judgment* of HERCULES.

(4). The same History may be represented yet according to a *fourth* Date or Period, as at the time when HERCULES is intirely won by *Virtue*: but then the signs of this resolute Determination reigning absolutely in the Attitude, and Air of our young Hero, there wou'd be no room left to represent his Agony or inward Conflict, which indeed makes the principal Action *here*; as it wou'd do in a *Poem,* were this Subject to be treated by a good Poet. Nor wou'd

there any more be room left in this case, either for the persuasive Rhetorick of *Virtue*, (who must have already ended her Discourse) or for the insinuating Address of *Pleasure*, who having lost her Cause, must necessarily appear displeas'd, or out of humour; a Circumstance which wou'd no way suit her Character.

(5). In the original Story or Fable of this Adventure of our young HERCULES, 'tis particularly noted, that *Pleasure* advancing hastily before *Virtue*, began her Plea, and was heard with prevention; as being first in turn. And as this Fable is wholly *Philosophical* and *Moral*, this Circumstance in particular is to be consider'd as essential.

(6). In this *third* Period therefore of our History (dividing it, as we have done, into four successive Dates or Points of Time) HERCULES being Auditor, and attentive, speaks not, *Pleasure* has spoken, *Virtue* is still speaking. She is about the middle, or towards the end of her Discourse; in the place where, according to just Rhetorick, the highest Tone of Voice and strongest Action are employ'd.

(7). 'Tis evident that every Master in Painting, when he has made choice of the determinate Date or Point of Time, according to which he wou'd represent his History, is afterwards debar'd the taking advantage from any other Action than what is immediately present, and belonging to that single Instant he describes: for if he passes the present only for a moment, he may as well pass it for many years; and by this reckoning he may with as good right repeat the same Figure several times over, and in one and the same Picture represent HERCULES in his Cradle struggling with the Serpents, and the same HERCULES of full Age fighting with the *Hydra*, with *Anteus*, and with *Cerberus*: which wou'd prove a mere confus'd Heap, or knot of Pieces, and not a single intire Piece, or *Tablature* of the Historical kind.

(8). It may however be allowable, on some occasions, to make use of certain *Enigmatical* or Emblematical Devises, to represent a future Time: as when HERCULES, yet a mere Boy, is seen holding a small Club, or wearing the Skin of a young Lion, for so we often find him in the best

Antiques. And tho History had never related of HERCULES, that being very young he kill'd a Lion with his own hand, this Representation of him wou'd nevertheless be entirely conformable to *Poetick Truth;* which not only admits, but necessarily presupposes *Prophecy* or *Prognostication,* with regard to the Actions and Lives of Hero's and great Men. Besides that as to our Subject in particular, the natural Genius of HERCULES, even in his tenderest Youth, might alone answer for his handling such Arms as these, and bearing, as it were in play, these early tokens of the future Hero.

(9). To preserve therefore a just Conformity with *Historical Truth,* and with the *Unity of Time* and *Action,* there remains no other way by which we can possibly give hint of any thing future, or call to mind any thing past, than by setting in view such Passages or Events as have actually subsisted, or according to Nature might well subsist, or happen together in *one* and the *same* instant. And this is what we may properly call the *Rule of Consistency.*

(10). How is it therefore possible, says one, to express a Change of Passion in any Subject, since this Change is made by Sucession; and that in this case the Passion which is understood as present, will require a Disposition of Body and Feature wholly different from the Passion which is over and past? To this we answer, that notwithstanding the Ascendency or Reign of the principal and immediate Passion, the Artist has power to leave still in his Subject the Tracks or Footsteps of its Predecessor: so as to let us behold not only a rising Passion together with a declining one, but, what is more, a strong and determinate Passion, with its contrary already discharg'd and banish'd. As for instance, when the plain tracks of Tears new fallen, with other fresh tokens of Mourning and Dejection, remain still in a Person newly transported with joy at the sight of a Relation or Friend, who the moment before had been lamented as one deceas'd or lost.

(11). Again, by the same means which are employ'd to call to mind the past, we may anticipate the *future*: as wou'd be seen in the case of an able Painter, who shou'd

undertake to paint this History of HERCULES according to the third Date or Period of Time propos'd for our historical Tablature. For in this momentary Turn of Action, HERCULES remaining still in a situation expressive of Suspence and Doubt, wou'd discover nevertheless that the Strength of this inward Conflict was over, and that Victory began now to declare her-self in favour of *Virtue*. This Transition, which seems at first so mysterious a Performance, will be easily comprehended, if one considers that the Body, which moves much slower than the Mind, is easily out-strip'd by the latter; and that the Mind on a sudden turning it-self some new way, the nearer situated and more sprightly parts of the Body (such as the Eyes and Muscles about the Mouth and Forehead) taking the alarm, and moving in an instant, may leave the heavier and more distant parts to adjust themselves, and change their Attitude some moments after.

(12). This different Operation may be distinguish'd by the names of *Anticipation* and *Repeal*.

(13). If by any other method an Artist shou'd pretend to introduce into his Piece any portion of Time future or past he must either sin directly against the Law of *Truth* and *Credibility*, in representing things contrary and incompatible; or against that Law of *Unity* and *Simplicity* of *Design*, which constitutes the very Being of his Work. This particularly shews it-self in a Picture, when one is necessarily left in doubt, and unable to determine readily, *which* of the distant successive parts of the History or Action is that *very one* represented in the Design. For even here the case is the same as in the other Circumstances of Poetry and Painting: "That what is principal and chief, shou'd immediately shew itself, without leaving the Mind in any uncertainty."

(14). According to this Rule of the *Unity of Time*, if one shou'd ask an Artist, who had painted this History of the *Judgment of* HERCULES, "which of these four Periods or Dates of Time above propos'd he intended in his Picture to represent"; and it shou'd happen that he cou'd not readily answer, 'twas this or that; it wou'd appear plainly he had never form'd a *Real Notion* of his Workmanship,

or of the History he intended to represent: so that when he had executed even to a miracle all those other Beautys requisite in a *Piece,* and had fail'd in this single one, he wou'd from hence alone be prov'd to be in truth no *History-Painter,* or Artist in the kind, who understood not so much as how to form the real Design of a *Historical Piece.*

CHAPTER II. *Of the First or Principal Figure.* (1). To apply therefore what has been said above to our immediate Design or *Tablature* in hand, we may observe, in the first place, with regard to HERCULES, (the *first* or *principal Figure* of our Piece) that being plac'd in the midst, between the two Goddesses, he shou'd by a skilful Master be so drawn, as even setting aside the Air and Features of the Face, it shou'd appear by the very Turn, or Position of the Body alone, that this young Hero had not wholly quitted the ballancing or pondering part. For in the manner of his turn towards the worthier of these Goddesses, he shou'd by no means appear so averse or separate from the other, as not to suffer it to be conceiv'd of him, that he had ever any inclination for her, or had ever hearken'd to her Voice. On the contrary, there ought to be some hopes yet remaining for this latter Goddess *Pleasure,* and some regret apparent in HERCULES. Otherwise we shou'd pass immediately from the *third* to the *fourth* Period; or at least confound one with the other.

(2). HERCULES in this Agony describ'd, may appear either sitting or standing: tho it be more according to probability for him to appear standing, in regard to the presence of the two Goddesses, and by reason the case is far from being the same *here* as in *the Judgment of* PARIS; where the interested Goddesses plead their Cause befor their Judg. Here the Interest of HERCULES himself is at stake, 'tis *his own* Cause which is trying; he is in this respect not so much the *Judg,* as he is in reality the *Party judg'd.*

(3). The superiour and commanding Passion of HERCULES may be express'd either by a strong Admiration, or by an Admiration which holds chiefly of *Love.*

Ingenti perculsus amore.

(4). If the latter be us'd, then the reluctant Passion, which is not yet wholly overcome, may shew it-self in Pity and Tenderness, mov'd in our Hero by the thought of those Pleasures and Companions of his Youth, which he is going for ever to abandon: and in this sense HERCULES may look either on the one or the other of the Goddesses, with this difference, that if he looks on *Pleasure,* it shou'd be faintly, and as turning his eyes back with pity; having still his Action and Gesture turn'd the other way towards *Virtue.* If, on the contrary, he looks on *Virtue;* it ought to be earnestly and with extreme attention, having some part of the Action of his Body inclining still towards *Pleasure,* and discovering by certain Features of Concern and Pity, intermix'd with the commanding or conquering Passion, that the Decision he is about to make in favour of *Virtue,* costs him not a little.

(5). If it be thought fit rather to make use of Admiration, merely to express the *commanding* Passion of HERCULES: then the *reluctant one* may discover it-self in a kind of horrour, at the thought of the Toil and Labour to be sustain'd in the rough rocky way apparent on the side of *Virtue.*

(6). Again, HERCULES may be represented as looking neither towards *Virtue* nor *Pleasure;* but as turning his eyes either towards the mountainous rocky way pointed out to him by *Virtue,* or towards the flowry way of the Vale and Meadows recommended to him by *Pleasure*: and to these different Attitudes may be apply'd the same Rules for the Expression of the *Turn* or Ballance of Judgment in our pensive Hero.

(7). Whatever may be the manner chosen for the designing of this Figure of HERCULES, according to that part of the History in which we have taken him; 'tis certain he shou'd be so drawn, as neither by the opening of his mouth, or by any other sign, to leave it in the least dubious whether he is speaking or silent: for 'tis absolutely requisite that Silence shou'd be distinctly characteriz'd in HERCULES, not only as the natural effect of his strict Attention, and the little leisure he has from what passes at this time within his breast; but in order withal to give

that appearance of Majesty and Superiority becoming the Person and Character of pleading *Virtue,* who by her Eloquence and other Charms has e'er this made her-self mistress of the Heart of our enamour'd Hero.

Pendetque iterum narrantis ab ore.[2]

This Image of the Sublime, in the Discourse and Manner of *Virtue* wou'd be utterly destroy'd, if in the instant that she employ'd the greatest Force of Action, she shou'd appear to be interrupted by the ill-tim'd Speech, Reply, or Utterance of her Auditor. Such Design or Representation as this, wou'd prove contrary to Order, contrary to the History, and to the *Decorum,* or Decency of Manners. Nor can one well avoid taking notice here of that general Absurdity committed by many of the esteem'd great Masters in Painting; who in one and the same Company or Assembly of Persons jointly employ'd, and united according to the History in one single or common Action, represent to us not only *two* or *three,* but several, and sometimes all, speaking at once: which must naturally have the same effect on the Eye, as such a Conversation wou'd have upon the Ear, were we in reality to hear it. . . .

CHAPTER V. *Of the Ornaments of the Piece, and Chiefly of the Drapery and Perspective.* (1). 'Tis sufficiently known how great a liberty Painters are us'd to take, in the colouring of their Habits and other parts of the Drapery belonging to their historical Pieces. If they are to paint a *Roman* People, they represent 'em in different Dresses; tho it be certain the common People among 'em were habited very near alike, and much after the same colour. In like manner, the *Egyptians, Jews,* and other antient Nations, as we may well suppose, bore in this particular their respective Likeness or Resemblance one to another, as at present the *Spaniards, Italians,* and several other People of *Europe.* But such a Resemblance as this wou'd, in the way of Painting, produce a very untoward effect; as may be easily conceiv'd. For this reason the Painter makes no scruple to introduce *Philosophers,* and even *Apostles,* in various Colours, after a very extraordinary manner. 'Tis here that

[2] Virg. Aen. Lib. 4, ver. 79.

the *historical Truth* must of necessity indeed give way to that which we call *Poetical*, as being govern'd not so much by Reality as by *Probability*, or plausible Appearance: so that a Painter who uses his Privilege or Prerogative in this respect, ought however to do it cautiously, and with discretion; and when occasion requires that he shou'd present us his *Philosophers* or *Apostles* thus variously colour'd, he must take care at least so to mortify his Colours, that these plain poor Men may not appear in his Piece adorn'd like so many Lords or Princes of the modern Garb.

(2). If, on the other hand, the Painter shou'd happen to take for his subject some solemn Entry or Triumph, where, according to the Truth of *Fact*, all manner of Magnificence had without doubt been actually display'd, and all sorts of bright and dazling Colours heap'd together and advanc'd, in emulation, one against another; he ought on this occasion, in breach of the *historical Truth*, or Truth of *Fact*, to do his utmost to diminish and reduce the excessive Gayety and Splendour of those Objects, which wou'd otherwise raise such a Confusion, Oppugnancy, and Riot of Colours, as wou'd to any judicious Eye appear absolutely intolerable.

(3). It becomes therefore an able Painter in this, as well as in the other parts of his Workmanship, to have regard principally, and above all, to the Agreement or Correspondency of things. And to that end 'tis necessary he shou'd form in his Mind a certain Note or Character of *Unity*, which being happily taken, wou'd out of the many Colours of his Piece, produce (if one may say so) *a particular distinct Species* of an original kind: like those Compositions in Musick, where among the different Airs (such as *Sonatas, Entrys,* or *Sarabands*) there are different and distinct species; of which we may say in particular, as to each, "That it has its own proper Character or Genius, peculiar to itself."

(4). Thus the Harmony of Painting requires, that in whatever Key the Painter begins his Piece, he shou'd be sure to finish it in the same.

(5). This Regulation turns on the principal Figure, or on the two or three which are eminent, in a Tablature

compos'd of many: for if the Painter happens to give a certain Height or Richness of Colouring to his principal Figure, the rest must in proportion necessarily partake of this Genius. But if, on the contrary, the Painter shou'd have chanc'd to give a softer Air, with more Gentleness and Simplicity of colouring, to his principal Figure, the rest must bear a Character proportionable, and appear in an extraordinary Simplicity, that one and the same Spirit may without contest reign through the whole of his Design. . . .

(9). Another Reason against the *Perspective*-part, the Architecture, or other study'd Ornaments of the *Landskip*-kind, in this particular Piece of ours, is, That in reality there being no occasion for these Appearances, they wou'd prove a mere Incumbrance to the Eye, and of necessity disturb the Sight, by diverting it from that which is principal, the *History* and *Fact*. Whatsoever appears in a historical Design, which is not essential to the Action, serves only to confound the Representation and perplex the Mind; more particularly, if these *Episodick* parts are so lively wrought, as to vie with the principal Subject, and contend for Precedency with the Figures and human Life. A just Design, or Tablature, shou'd at first view discover what *Nature* it is design'd to imitate; what Life, whether of the higher or lower kind, it aims chiefly to represent. The Piece must by no means be equivocal or dubious; but must with ease distinguish it-self, either as *historical* and *moral*, or as perspective and merely *natural*. If it be *the latter* of these Beautys, which we desire to see delineated according to its perfection, then *the former* must give place. The *higher* Life must be allay'd, and in a manner discountenanc'd and obscur'd; whilst the *lower* displays it-self, and is exhibited as principal. Even that which according to a Term of Art we commonly call *Still-Life*, and is in reality of the last and lowest degree of Painting, must have its Superiority and just Preference, in a Tablature of its own species. 'Tis the same in *Animal-Pieces*; where Beasts, or Fowl are represented. In *Landskip*, Inanimates are principal: 'Tis the Earth, the Water, the Stones, and Rocks which live. All other Life becomes sub-

ordinate. Humanity, Sense, Manners, must in this place yield, and become inferiour. 'Twou'd be a fault even to aim at the Expression of any real Beauty in this kind, or go about to animate or heighten in any considerable degree the accompanying Figures of Men, or Deitys which are accidentally introduc'd, as Appendices, or Ornaments, in such a Piece. But if, on the contrary, the *human Species* be that which first presents it-self in a Picture, if it be the intelligent Life which is set to view, 'tis the other *Species*, the other Life, which must then surrender and become subservient. The *merely natural* must pay homage to the *historical* or *moral*. Every Beauty, every Grace must be sacrific'd to the real Beauty of this first and highest Order; for nothing can be more deform'd than a Confusion of many Beautys: And the Confusion becomes inevitable, where the Subjection is not compleat.

(10). By the word *Moral* is understood in this place all sorts of judicious Representations of the human Passions, as we see even in *Battel*-Pieces; excepting those of distant Figures, and the diminutive kind, which may rather be consider'd as a sort of Landskip. In all other martial Pieces, we see express'd in lively Action, the several degrees of Valour, Magnanimity, Cowardice, Terrour, Anger, according to the several Characters of Nations and particular Men. 'Tis here that we may see *Heroes* and *Chiefs* (such as the ALEXANDERS or CONSTANTINES) appear, even in the hottest of the Action, with a Tranquillity and Sedateness of Mind peculiar to them-selves; which is indeed, in a direct and proper sense, profoundly *moral*.

(11). But as the *Moral* part is differently treated in a Poem from what it is in *History*, or in a *Philosophical* Work; so must it, of right, in *Painting*, be far differently treated, from what it naturally is either in the *History* or *Poem*. For want of a right understanding of this Maxim, it often happens that by endeavouring to render a Piece highly *moral* and learned, it becomes thorowly ridiculous and impertinent.

(12). For the ordinary Works of Sculpture, such as the *Low-Relieves*, and Ornaments of Columns and Edifices,

great allowance is made. The very Rules of Perspective are here wholly revers'd, as necessity requires; and are accommodated to the Circumstance and Genius of the Place or Building, according to a certain Oeconomy or Order of a particular and distinct kind; as will easily be observ'd by those who have thorowly study'd the *Trajan* and *Antoninus*-Pillars, and other Relieve-Works of the Antients. In the same manner, as to Pieces of ingrav'd Work, Medals, or whatever shews it-self in one Substance (as Brass or Stone) or only by Shade and Light (as in ordinary Drawings, or Stamps) much also is allow'd, and many things admitted, of the *fantastick, miraculous,* or *hyperbolical* kind. 'Tis here, that we have free scope withal for whatever is learned, *emblematical,* or *emigmatick.* But for the compleatly imitative and illusive Art of PAINTING, whose character it is to employ in her Works the united Force of different Colours, and who surpassing, by so many Degrees and in so many Privileges, all other human Fiction or imitative Art, aspires in a directer manner towards Deceit and a Command over our very Sense; she must of necessity abandon whatever is over-*learned, humorous,* or *witty*; to maintain her-self in what is *natural, credible,* and *winning* of our *Assent*: that she may thus acquit her-self of what is her chief Province, *the specious Appearance of the Objects she represents.* Otherwise we shall naturally bring against her the just Criticism of HORACE, on the scenical Representation so nearly ally'd to her:

Quodcunque ostendis mihi sic, incredulus odi.

(13). We are therefore to consider this as a sure Maxim or Observation in Painting, "That a *historical* and *moral* Piece must of necessity lose much of its natural Simplicity and Grace, if any thing of the *emblematical* or *enigmatick* kind be visibly and directly intermix'd." As if, for instance, the Circle of the *Zodiack*, with its twelve Signs, were introduc'd. Now this being an Appearance which carrys not any manner of similitude or colourable resemblance to any thing extant in real Nature; it cannot possibly pretend to

win the Sense, or gain Belief by the help of any *Poetical Enthusiasm, religious History* or *Faith.* For by means of these, indeed, we are easily induc'd to contemplate as Realitys those divine Personages and miraculous Forms, which the leading Painters, antient and modern, have speciously design'd, according to the particular Doctrine or Theology of their several religious and national Beliefs. But for our Tablature in particular, it carrys nothing with it of the mere *emblematical* or *enigmatick* kind: since for what relates to the double Way of the Vale and Mountain, this may naturally and with colourable appearance be represented at the mountain's foot. But if on the Summet or highest Point of it, we shou'd place the Fortress, or Palace of *Virtue,* rising above the Clouds, this wou'd immediately give the enigmatical mysterious Air to our *Picture,* and of necessity destroy its persuasive Simplicity and natural Appearance.

(14). In short, we are to carry this Remembrance still along with us, "That the fewer the Objects are, besides those which are absolutely necessary in a Piece, the easier it is for the Eye, by one simple Act and in one View, to comprehend the *Sum* or *Whole.*" The multiplication of Subjects, the subaltern, renders the Subordination more difficult to execute in the Ordonnance or Composition of a Work: And if the *Subordination* be not perfect, the *Order* (which makes the Beauty) remains imperfect. Now the *Subordination* can never be perfect, "unless when the Ordonnance[3] is such, that the Eye not only runs over with ease the several Parts of the Design, (reducing still its View each moment to the principal Subject on which all turns) but when the same Eye, without the least detainment in any of the particular Parts, and resting, as it were, immovable in the middle, or center of the Tablature, may see at once, in an agreeable and perfect Correspondency, all which is there exhibited to the Sight."

CHAPTER VI. *Of the Casual or Independent Ornaments.*

(1). There remains for us now to consider only of the separate Ornaments, independent both of Figures and

[3] *This is what the Grecian Masters so happily express'd by that single word* Εὐσύνοπτον [seen at a glance].

Perspective, such as the *Machine-Work*[4] or *Divinitys* in the Sky, the Winds, Cupids, Birds, Animals, Dogs, or other loose Pieces which are introduc'd without any absolute necessity, and in a way of Humour: but as these belong chiefly to the *ordinary Life,* and to the *Comick,* or *mix'd* kind; our Tablature, which on the contrary is wholly *Epick, Heroick,* and in the *Tragick* Stile, wou'd not so easily admit of any thing in this light way.

(2). We may besides consider, that whereas the Mind is naturally led to fancy Mystery in a Work of such a Genius or Stile of Painting as ours, and to confound with each other the two distinct kinds of the *Emblematick* and merely *Historical* or *Poetick;* we shou'd take care not to afford it this occasion of Error and Deviation, by introducing into a Piece of so uniform a Design, such Appendices, or supplementary Parts, as under pretext of giving light to the History or characterizing the Figures, shou'd serve only to distract or dissipate the Sight, and confound the Judgment of the more intelligent Spectators. . . .

CONCLUSION. (1). We may conclude this Argument with a general Reflection, which seems to arise naturally from what has been said on this Subject in particular; "That in a real *History-Painter,* the same Knowledge, the same Study and Views are requir'd, as in a real Poet." Never can the Poet (whilst he justly holds the name) become a Relator or *Historian* at large. He is allow'd only to describe a single Action, not the Action of a single Man or People. The Painter is a Historian at the same rate, but still more narrowly confin'd, as in fact appears; since it wou'd certainly prove a more ridiculous Attempt to comprehend two or three distinct Actions or Parts of History in one Picture; than to comprehend ten times the number in one and the same Poem.

(2). 'Tis well known, that to each Species of Poetry, there are natural Proportions and Limits assign'd. And it wou'd be a gross Absurdity indeed to imagine, that in a Poem there was nothing which we cou'd call *Measure* or

[4] *This is understood of the* Machine-Work, *when it is merely ornamental, and not essential in the Piece; by making part of the History, or Fable it-self.*

Number, except merely in the Verse. An Elegy, and an Epigram have each of 'em their Measure and Proportion, as well as a Tragedy or Epick Poem. In the same manner, as to Painting, Sculpture, or Statuary, there are particular Measures which form what we call a *Piece*: as for instance, in mere Portraiture, a *Head,* or *Bust,* the former of which must retain always the whole, or at least a certain part of the Neck, as the latter the Shoulders, and a certain part of the Breast; if any thing be added or retrench'd, the Piece is destroy'd. 'Tis then a mangled Trunk, or dismember'd Body, which presents it-self to our Imagination; and this too not thro use merely, or on the account of custom, but of necessity, and by the nature of the Appearance: since there are such and such parts of the human Body, which are naturally match'd and must appear in company the Section, if unskilfully made, being in reality horrid, and representing rather an Amputation in Surgery, than a seemly Division or Separation according to Art. And thus it is that in general, thro all the plastick Arts or Works of Imitation, "Whatsoever is drawn from Nature, with the intention of raising in us the Imagination of the natural Species or Object according to real Beauty and Truth, shou'd be compriz'd in certain compleat Portions or Districts, which represent the Correspondency or Union of each part of Nature, with intire Nature her-self." And 'tis this natural Apprehension or anticipating Sense of Unity, which makes us give even to the Works of our inferiour Artizans, the name of *Pieces* by way of Excellence, and as denoting the Justness and Truth of Work.

(3). In order therefore to succeed rightly in the Formation of any thing truly beautiful in this higher Order of Design; 'twere to be wish'd that the Artist, who had Understanding enough to comprehend what a real *Piece* or *Tablature* imported, and who in order to this had acquir'd the Knowledg of a Whole and Parts, wou'd afterwards apply himself to the Study of *moral* and *poetick Truth*: that by this means the Thoughts, Sentiments, or Manners, which hold the first rank in historical Work, might appear suitable to the higher and nobler Species of Humanity in which he practis'd, to the Genius of the Age which he

described, and to the principal or main Action which he chose to represent. He wou'd then naturally learn to reject those false Ornaments of affected Graces, exaggerated Passions, hyperbolical and prodigious Forms; which equally with the mere *capricious* and *grotesque,* destroy the just *Simplicity,* and *Unity,* essential in a PIECE. And for his *Colouring;* he wou'd then soon find how much it became him to be reserv'd, severe, and chaste, in this particular of his Art; where Luxury and Libertinism are, by the power of Fashion and the modern Taste, become so universally establish'd.

(4). 'Tis evident however from Reason it-self, as well as from History[5] and Experience, that nothing is more fatal, either to Painting, Architecture, or the other Arts, than this *false Relish* which is govern'd rather by what immediately strikes the Sense, than by what consequently and by reflection pleases the Mind, and satisfies the Thought and Reason. So that whilst we look on Painting with the same eye, as we view commonly the rich Stuffs and colour'd Silks worn by our Ladys, and admir'd in Dress, Equipage, or Furniture, we must of necessity be effeminate in our Taste, and utterly set wrong as to all Judgment and Knowledg in the kind. For of this *imitative Art* we may justly say, "That tho it borrows help indeed from Colours, and uses them, as means, to execute its Designs; it has nothing, however, more wide of its real Aim, or more remote from its Intention, than to make a *shew* of Colours, or from their mixture, to raise a Separate[6] and flattering Pleasure to the SENSE."

[5] *See* VITRUVIUS *and* PLINY.

[6] *The Pleasure is plainly foreign, and separate; as having no concern or share in the proper Delight or Entertainment which naturally arises from the Subject, and Workmanship it-self. For the Subject in respect of Pleasure, as well as Science, is absolutely compleated, when the Design is executed, and the propos'd Imitation once accomplish'd. And thus it always is the best, when the Colours are most subdu'd, and made subservient.*

WILLIAM HOGARTH

[William Hogarth (1697–1764), was an English en-
graver, painter and social satirist. Son of a poor school-
master, but with a talent for drawing, Hogarth was early
apprenticed to a silversmith. His ambition to do original
copper engraving and his gift for quick, graphic portrayal
of the surrounding human scene, led him first to set up
independently as an engraver of commercial plates, next
to paint a few serious conversation pieces, and then to
caricature the vices and follies of the London of his time.
He is best known for several vivid series showing progres-
sive moral decay: *A Harlot's Progress, A Rake's Progress,*
and *Marriage à la Mode.* Though he did a few successful
portraits (of himself, Garrick, Lord Lovat) and historical
pieces, his genius was for caricature. He attacked the
dominant neoclassic taste by burlesquing William Kent
and the academicians of Burlington House. Hogarth also
wrote an aesthetic treatise against neoclassic dogma, Pal-
ladian architecture, as well as "the broad and beaten path
of moral beauty." In this *Analysis of Beauty,* Hogarth pro-
fesses to fix the fluctuating ideas of taste by a permanent
standard of beauty in the precise serpentine line. This line
was composed of two contrasted curves, moving in opposite
directions and having a mean depth. The line could be
generated by twisting a fine wire in a sweeping curve
around a cone touching the base at one end and the
vertex at the other. He claimed his magic line as the
concrete basis of attractive ornament, the country dance,
and even the texture of flesh color. Though Hogarth's
parade of the derivation of his standard from Pythagoras,
Lomazzo, and Michelangelo has only antiquarian interest,
he actually connects the standard interestingly with the
principle of variety and the essence of movement. Ho-
garth's aesthetic theory and artistic practice had little in
common; his drawings and paintings while showing force-
ful draftsmanship, good color sense, and independence of
the reigning mode is important for its historical and liter-
ary content rather than for formal excellence.]

THE ANALYSIS OF BEAUTY[1]

PREFACE. If a preface was ever necessary, it may very likely be thought so to the following work; the title of which (in the proposals publish'd some time since) hath much amused, and raised the expectation of the curious, though not without a mixture of doubt, that its purport could ever be satisfactorily answered. For though beauty is seen and confessed by all, yet, from the many fruitless attempts to account for the cause of it being so, enquiries on the head have almost been given up; and the subject generally thought to be a matter of too high and too delicate a nature to admit of any true or intelligible discussion. Something therefore introductory ought to be said at the presenting a work with a face so entirely new; especially as it will naturally encounter with, and perhaps may overthrow, several long received and thorough establish'd opinions: and since controversies may arise how far, and after what matter this subject hath hitherto been consider'd and treated, it will also be proper to lay before the reader, what may be gathered concerning it, from the works of the ancient and modern writers and painters.

It is no wonder this subject should have so long been thought inexplicable, and since the nature of many parts of it cannot possibly come within the reach of mere men of letters; otherwise those ingenious gentlemen who have lately published treatises upon it (and who have written much more learnedly than can be expected from one who never took up the pen before) would not so soon have been bewilder'd in their accounts of it, and obliged so suddenly to turn into the broad, and more beaten path of moral beauty; in order to extricate themselves out of the difficulties they seem to have met with in this: and withal forced for the same reasons to amuse their readers with

[1] The excerpts are from William Hogarth, *The Analysis of Beauty*, London, 1753. The footnotes, except those in brackets, are from the text. The biographical sketch was written by Dr. Katharine Gilbert.

See also: William Hogarth, *The Analysis of Beauty*, ed. Joseph Burke, Oxford, 1955.

amazing (but often misapplied) encomiums on deceased painters and their performances; wherein they are continually discoursing of effects instead of developing causes; and after many prettinesses, in very pleading language, do fairly set you down just where they first took you up; honestly confessing that as to GRACE, the main point in question, they do not even pretend to know anything of the matter. And indeed how should they? when it actually requires a practical knowledge of the whole art of painting (sculpture alone not being sufficient) and that too to some degree of eminence, in order to enable any one to pursue the chain of this enquiry through all its parts: which I hope will be made to appear in the following work.

It will then naturally be asked, why the best painters within these two centuries, who by their works appear to have excelled in grace and beauty, should have been so silent in an affair of such seeming importance to the imitative arts and their own honour? to which I answer, that it is probable, they arrived at that excellence in their works, by the mere dint of imitating with great exactness the beauties of nature, and by often copying and retaining strong ideas of graceful antique statues; which might sufficiently serve their purposes as painters, without their troubling themselves with a farther enquiry into the particular causes of the effects before them. It is not indeed a little strange, that the great Leonardo da Vinci (amongst the many philosophical precepts which he hath at random laid down in his treatise on painting) should not have given the least hint of any thing tending to a system of this kind; especially, as he was contemporary with Michel Angelo, who is said to have discover'd a certain principle in the trunk only of an antique statue, (well known from this circumstance by the name of Michel Angelo's Torso, or Back) (fig. 54, plate 1 [our *fig.* 13]) which principle gave his works a grandeur of gusto equal to the best antiques. Relative to which tradition, Lamozzo [*sic*] who wrote about painting at the same time, hath this remarkable passage, vol. 1, book 1.

"And because in this place there falleth out a certaine precept of *Michel Angelo* much for our purpose, I wil not conceale it, leaving the farther interpretation and understanding thereof to the judicious reader. It is reported then that *Michel Angelo* up on a time gave this observation to the Painter *Marcus de Sciena* his scholler; *that he should alwaies make a figure Pyramidall, Serpent-like, and multiplied by one two and three.* In which precept (in mine opinion) the whole mysterie of the arte consisteth. For the greatest grace and life that a picture can have, is, that it expresse *Motion*: which the painters call the *spirite* of a picture: Nowe there is no form so fitte to expresse this *motion,* as that of the flame of fire, which according to *Aristotle* and the other Philosophers, is an elemente most active of all others: because the forme of the flame thereof is most apt for motion: for it hath a *Conus* or sharpe pointe wherewith it seemeth to divide the aire, that so it may ascende to his proper sphere. So that a picture having this forme will bee most beautifull."[2]

Many writers since Lamozzo have in the same words recommended the observing this rule also; without comprehending the meaning of it: for unless it were known systematically, the whole business of grace could not be understood.

Du Fresnoy, in his art of painting, says "large flowing, gliding outlines which are in waves, give not only a grace to the part, but to the whole body; as we see in the Antinous, and in many other of the antique figures: a fine figure and its parts ought always to have a serpent-like and flaming form: naturally those sort of lines have I know not what of life and seeming motion in them, which very much resembles the activity of the flame and of the serpent." Now if he had understood what he had said, he could not speaking of grace, have expressed himself in the following contradictory manner—"But to say the truth, this is a difficult undertaking, and a rare present, which the

[2] See Haydock's translation printed at Oxford, 1598 [see above, p. 78.]

artist rather receives from the hand of heaven than from his own industry and studies."[3]

But De Piles, in his lives of the panters, is still more contradictory, where he says, "that a painter can only have it (meaning grace) from nature, and doth not know that he hath it, nor in what degree, nor how he communicates it to his works: and that grace and beauty are two different things; beauty pleases by the rules, and grace without them."

All the English writers on this subject have echo'd these passages; hence *Je ne sçai quoi,* is become a fashionable phrase for grace.

By this it is plain, that this precept which Michel Angelo deliver'd so long ago in an oracle-like manner, hath remain'd mysterious down to this time, for ought that has appear'd to the contrary. The wonder that it should do so will in some measure lessen when we come to consider that it must all along have appeared as full of contradiction as the most obscure quibble ever delivered at Delphos, because, *winding lines are as often the cause of deformity as of grace,* the solution of which, in this place, would be an anticipation of what the reader will find at large in the body of the work.

There are also strong prejudices in favour of straight lines, as constituting true beauty in the human form, where they never should appear. A middling connoisseur thinks no profile has beauty without a very straight nose, and if the forehead be continued straight with it, he thinks it is still more sublime. I have seen miserable scratches with the pen, sell at a considerable rate for only having in them a side face or two, like that between fig. 22 and fig. 105, plate 1 [our *fig.* 13] which was made, and any one might do the same, with the eyes shut. The common notion that

[3] See Dryden's translation of his Latin poem on Painting, verse 28, and the remarks on these very lines, page 155, which run thus, "It is difficult to say what this grace of painting is, it is to be conceiv'd and understood much more easy than to be expressed by words; it proceeds from the illuminations of an excellent mind, (but not to be acquired) by which we give a certain turn to things, which makes them pleasing" [see above, p. 169, verse xxvii].

a person should be straight as an arrow, and perfectly erect is of this kind. If a dancing-master were to see his scholar in the easy and gracefully turned attitude of the Antinous (fig. 6, plate 1), he would cry shame on him, and tell him he looked as crooked as a ram's horn, and bid him to hold up his head as he himself did. See fig. 7, plate 1.

The painters, in like manner, by their works, seem to be no less divided upon the subject than the authors. The French, except such as have imitated the antique, or the Italian School, seem to have studiously avoided the serpentine line in all their pictures, especially Anthony Coypel, history painter, and Rigaud, principal portrait painter to Lewis the 14th.

Rubens, whose manner of designing was quite original, made use of a large flowing line as a principle, which runs through all his works, and gives a noble spirit to them; but he did not seem to be acquainted with what we call the *precise line;* which hereafter we shall be very particular upon, and which gives the delicacy we see in the best Italian masters; but he rather charged his contours in general with too bold and S-like swellings.

Raphael, from a straight and stiff manner, on a sudden changed his taste of lines at sight of Michael Angelo's works, and the antique statues; and so fond was he of the serpentine line, that he carried it into a ridiculous excess, particularly in his draperies: though his great observance of nature suffer'd him not long to continue in this mistake.

Peter de Cortone form'd a fine manner in his draperies of this line.

We see this principle no where better understood than in some pictures of Corregio, particularly his Juno and Ixion: yet the proportions of his figures are sometimes such as might be corrected by a common sign painter.

Whilst Albert Durer, who drew mathematically, never so much as deviated into grace, which he must sometimes have done in copying the life, if he had not been fetter'd with his own impracticable rules of proportion.

But that which may have puzzled this matter most, may be, that Vandyke, one of the best portrait painters in

most respects ever known, plainly appears not to have thought of this kind. For there seems not to be the least grace in his pictures more than what the life chanced to bring before him. There is a print of the Duchess of Wharton engraved by Van Gunst, from a true picture by him, which is thoroughly divested of every elegance. Now, had he known this line as a principle, he could no more have drawn all the parts of this picture so contrary to it, than Mr. Addison could have wrote a whole spectator in false grammar; unless it were done on purpose. However, on account of his other great excellencies, painters choose to style this want of grace in his attitudes, etc. *simplicity*, and indeed they do often very justly merit that epithet.

Nor have the painters of the present times been less uncertain and contradictory to each other, than the masters already mentioned, whatever they may pretend to the contrary: of this I had a mind to be certain, and therefore, in the year 1745, published a frontispiece to my engraved works, in which I drew a serpentine line lying on a painter's pallet, with these words under it, The Line of Beauty. The bait soon took; and no Egyptian hieroglyphic ever amused more than it did for a time, painters and sculptors came to me to know the meaning of it, being as much puzzled with it as other people, till it came to have some explanation; then indeed, but not until then, some found it out an old acquaintance of theirs, tho' the account they could give of its properties was very near as satisfactory as that which a day-labourer who constantly uses the leaver, could give of that machine as a mechanical power.

Others, as common face painters and copiers of pictures, denied that there could be such a rule either in art or nature, and asserted it was all stuff and madness; but no wonder that these gentlemen should not be ready in comprehending a thing they have little or no business with. For though the *picture copier* may sometimes to a common eye seem to vie with the original he copies, the artist himself requires no more ability, genius or knowledge of nature, than a journeyman-weaver at the goblins, who in working after a piece of painting, bit by bit, scarcely knows what he is about, whether he is weaving a man or

a horse, yet at last almost insensibly turns out of his loom a fine piece of tapestry, representing, it may be, one of Alexander's battles painted by Le Brun.

As the above-mention'd print thus involved me in frequent disputes by explaining the qualities of the line, I was extremely glad to find it (which I had conceiv'd as only part of a system in my mind) so well supported by the above precept of Michael Angelo. . . .

I am in some measure saved the trouble of collecting an historical account of these arts among the ancients, by accidentally meeting with a preface to a tract, call'd the *Beau Ideal*: this treatise[4] was written by Lambert Hermanson Ten Kate, in French, and translated into English by James Christopher le Blon; . . .

. . . I was in hopes from the title of the book (and the assurance of the translator, that the author had by his great learning discover'd the secret of the ancients) to have met with something there that might have assisted, or confirm'd the scheme I had in hand; but was much disappointed in finding nothing of that sort, and no explanation, or even after-mention of what at first agreeably alarm'd me, the word *Analogy*. I have given the reader a specimen, in his own words, how far the author has discover'd this grand secret of the ancients, or *great key of knowledge,* as the translator calls it.

"The sublime part that I so much esteem, and of which I have begun to speak, is a real *Je ne sçai quoi,* or an unaccountable something to most people, and it is the most important part to all the connoisseurs, I shall call it an harmonious propriety, which is a touching or moving unity, or a pathetick agreement or concord, not only of each member to its body, but also of each part to the member of which it is a part: *It is also an infinite variety of parts,* however conformable, with respect to each different subject, so that all the attitude, and all the adjustment of the draperies of each figure ought to answer or correspond to the subject chosen. Briefly, it is a true decorum, a bienseance or a congruent disposition of ideas, as well for the face and stature, as for the attitudes. A bright genius, in

[4] Publish'd in 1732.

my opinion, who aspires to excel in the ideal, should propose this to himself, as what has been the principal study of the most famous artists. 'Tis in this part that the great masters cannot be imitated or copied but by themselves, or by those that are advanced in the knowledge of the ideal, and who are as knowing as those masters in the rules and laws of the pittoresque and poetical nature, altho' inferior to the masters in the high spirit of invention."

The words in this quotation "*It is also an infinite variety of parts,*" seem at first to have some meaning in them, but is entirely destroy'd by the rest of the paragraph, and all of the other pages are filled, according to custom, with descriptions of pictures.

Now, as everyone has a right to conjecture what this discovery of the ancients might be, it shall be my business to shew it was a key to the thorough knowledge of variety both in form, and movement. Shakespeare, who had the deepest penetration into nature, has sum'd up all the charms of beauty in two words, INFINITE VARIETY; where, speaking of Cleopatra's power over Anthony, he says (Act 2. Scene 3):

> Nor custom stale
> Her infinite variety.

It has been ever observed, that the ancients made their doctrines mysterious to the vulgar, and kept them secret from those who were not of their particular sects, and societies, by means of symbols, and hieroglyphics. Lamozzo says, chapter 29, book 1. "The Grecians in imitation of antiquity searched out the truly renowned proportion, wherein the exact perfection of most exquisite beauty and sweetness appeareth; dedicating the same in a triangular glass to Venus the goddess of divine beauty, from whence all the beauty of inferior things is derived."

If we suppose this passage to be authentic, may we not also imagine it probable, that the symbol in the triangular glass, might be similar to the line Michael Angelo recommended; especially, if it can be proved, that the triangular form of the glass, and the serpentine line itself, are the two

most expressive figures that can be thought of to signify not only beauty and grace, but the whole *order of form*.

There is a circumstance in the account Pliny gives of Apelles's visit to Protogenes, which strengthens this supposition. I hope I may have leave to repeat the story. Apelles having heard of the fame of Protogenes, went to Rhodes to pay him a visit, but not finding him at home asked for a board, on which he drew a *line*, telling the servant maid, that line would signify to her master who had been to see him; we are not clearly told what sort of a line it was that could so particularly signify one of the first of his profession; if it was only a stroke (tho' as fine as a hair as Pliny seems to think) it could not possibly, by any means, denote the abilities of a great painter. But if we suppose it to be a line of some extraordinary quality, such as the serpentine line will appear to be, Apelles could not have left a more satisfactory signature of the complement he had paid him. Protogenes when he came home took the hint, and drew a finer *or rather more expressive line* within it, to shew Apelles if he came again, that he understood his meaning. He, soon returning, was well-pleased with the answer Protogenes had left for him, by which he was convinced that same had done him justice, and so correcting the line again, perhaps by making it more precisely elegant, he took his leave. The story thus may be reconcil'd to common sense, which, as it has been generally receiv'd, could never be understood but as a ridiculous tale.

Let us add to this, that there is scarce an Egyptian, Greek, or Roman deity, but hath a twisted serpent, twisted cornucopia, or some symbol winding in this manner to accompany it. The two small heads (over the busto of the Hercules, fig. 4, in plate 1) [our *fig*. 13] of the goddess Isis, one crowned with a globe between two horns, the other with a lily,[5] are of this kind. Harpocrates, the god of

[5] The leaves of this flower as they grow, twist themselves various ways in a pleasing manner, as may be better seen by figure 43, in plate 1, but there is a curious little flower called the Autumn Cyclamen, fig. 47, the leaves of which elegantly twist one way only.

silence, is still more remarkably so, having a large twisted horn growing out of the side of his head, one cornucopia in his hand, and another at his feet, with his finger placed on his lips, indicating secrecy: (see Montfaucon's antiquities) and it is as remarkable, that the deities of barbarous and gothic nations never had, nor have to this day, any of these elegant forms belonging to them. How absolutely void of these turns are the pagods of China, and what a mean taste runs through most of their attempts in painting and sculpture, notwithstanding they finish with such excessive neatness; the whole nation in these matters seem to have but one eye: this mischief naturally follows from the prejudices they imbibe by copying one another's works, which the ancients seem seldom to have done. . . .

CHAPTER V. *Of Intricacy.* The active mind is ever bent to be employ'd. Pursuing is the business of our lives; and even abstracted from any other view, gives pleasure. Every arising difficulty, that for a while attends and interrupts the pursuit, gives a sort of spring to the mind, enchances the pleasure, and makes what would else be toil and labour, become sport and recreation.

Wherein would consist the joys of hunting, shooting, fishing, and many other favourite diversions, without the frequent turns and difficulties, and disappointments, that are daily met with in the pursuit?—how joyless does the sportsman return when the hare has not had fair play? how lively, and in spirits, even when an old cunning one has baffled, and outrun the dogs!

This love of pursuit, merely as pursuit, is implanted in our natures, and design'd, no doubt, for necessary, and useful purposes. Animals have it evidently by instinct. The hound dislikes the game he so eagerly pursues; and even cats will risk the losing of their prey to chase it over again. It is a pleasing labour of the mind to solve the most difficult problems; allegories and riddles, trifling as they are, afford the mind amusement: and with what delight does it follow the well-connected thread of a play, or novel, which ever increases as the plot thickens, and ends most pleas'd, when that is most distinctly unravell'd?

The eye hath this sort of enjoyment in winding walks,

the serpentine rivers, and all sorts of objects, whose forms, as we shall see hereafter, are composed principally of what, I call, the *waving* and *serpentine* lines.

Intricacy in form, therefore, I shall define to be that peculiarity in the lines, which compose it, that *leads the eye a wanton kind of chace,* and from the pleasure that gives the mind, intitles it to the name of beautiful: and it may be justly said, that the cause of the idea of grace more immediately resides in this principle, than in the other five, except variety; which indeed includes this, and all others.

That this observation may appear to have a real foundation in nature, every help will be requir'd, which the reader himself can call to his assistance, as well as what will here be suggested to him.

To set the matter in somewhat a clearer light, the familiar instance of a common jack, with a circular fly, may serve our purpose better than a more elegant form: preparatory to which, let the figure (fig. 14, plate 1) be consid'r'd, which represents the eye, at a common reading distance viewing a row of letters, but fix'd with most attention to the middle letter A.

Now as we read, a ray may be supposed to be drawn from the center of the eye to that letter it looked at first and to move successively with it from letter to letter, the whole length of the line: but if the eye stops at any particular letter, A, to observe it more than the rest, these other letters will grow more and more imperfect to the sight, the farther they are situated on either side of the A, as is express'd in the figure: and when we endeavour to see all the letters in a line equally perfect at one view, as it were, this imaginary ray must course it to and fro with great celerity. Thus though the eye, strictly speaking, can pay only due attention to these letters in succession, yet the amazing ease and swiftness, with which it performs this task, enables us to see considerable spaces with sufficient satisfaction at one sudden view.

Hence, we shall always suppose some such principal ray moving along with the eye, and tracing out the parts of every form, we mean to examine in the most perfect man-

ner: and when we would follow with exactness the course
any body takes, that is in motion, this ray is always to be
supposed to move with the body.

In this manner of attending to forms, they will be found
whether *at rest,* or *in motion,* to give *movement* to this
imaginary ray; or, more properly speaking, to the eye
itself, affecting it *thereby* more or less *pleasingly,* accord-
ing to their different *shapes* and *motions.* Thus, for
example, in the instance of the jack, whether the eye (with
the imaginary ray) moves slowly down the line, to which
the weight is fix'd, or attends to the slow motion of the
weight itself, the mind is equally fatigu'd: and whether
it swiftly courses round the circular rim of the flyer, when
the jack stands; or nimbly follows one point to its circum-
ference whilst it is whirling about, we are almost equally
made giddy by it. But our sensation differs much from
either of these unpleasant ones, when we observe the
curling worm, into which the wormwheel is fixt (fig. 15,
plate 1): for this is always pleasing, either at rest or in
motion, and whether that motion is slow or quick.

SIR JOSHUA REYNOLDS

[Son of an obscure Devonshire clergyman and appren-
ticed in youth to the mediocre portrait painter, Hudson,
Reynolds (1723–1792) was definitely formed for his
"grand style" by prolonged, close study at Rome of the
sublime conceptions and grand execution of Raphael and
Michelangelo. Upon returning to London, he was favored
in his ambition to be "the first painter of his age and time"
by the patronage of Lord Edgecombe and his own social
gifts. In 1768, Reynolds, now a fashionable portrait painter,
became the first president of the Royal Academy. His
fifteen presidential *Discourses* not only outlined the theory
of an artist's education, the characteristics of the "grand
style," and the excellencies and defects of particular schools
and artists, but demonstrated a literary skill which sug-

gested to his contemporaries authorship by one of his literary friends, Johnson or Burke.

Concerning the education of a painter, Reynolds taught initial submission to "the Rules of Art established by the practice of the Great Masters." This practice and these rules are, in turn, founded on nature, which must ultimately be the student's guide and exemplar. To imitate nature, however, is not to represent particularities of time, place and custom, but the perfect beauty in the invariable, the great, and general ideas "which are fixed and inherent in universal Nature." Since, however, the great artists of the past had been thus related to nature, Reynolds recommended the substitution for the direct study of nature, the study of antique statues and the great Italian paintings. Such study, however, must not be servile, but analytical. The primacy of the grand style is not fixed and absolute, either custom or genius can modify it: custom by causing us to admire the familiar as well as the strictly beautiful; genius, by transcending the rules.]

DISCOURSES[1]

THE THIRD DISCOURSE. . . . The first endeavours of a young Painter, as I have remarked in a former discourse, must be employed in the attainment of mechanical dexterity, and confined to the mere imitation of the object before him. Those who have advanced beyond the rudiments, may, perhaps, find advantage in reflecting on the advice which I have likewise given them, when I recommended the diligent study of the works of our great predecessors; but I at the same time endeavoured to guard them against an implicit submission to the authority of any one

[1] The excerpts are from Edmond Malone, *The Works of Sir Joshua Reynolds,* London, 1797. The biographical sketch is by Dr. Katharine Gilbert.

See also: W. H. Hilles, *The Literary Career of Sir Joshua Reynolds,* Cambridge, England, 1936; Sir Joshua Reynolds, *Discourse on Art,* ed. Robert Wark, San Marino, Cal., 1959; Lee, "Ut Pictura Poesis," pp. 198–240 *passim.*

master however excellent: or by a strict imitation of his manner, precluding themselves from the abundance and variety of Nature. I will now add that Nature herself is not to be too closely copied. There are excellencies in the art of painting beyond what is commonly called the imitation of nature: and these excellencies I wish to point out. The students who, having passed through the initiatory exercises, are more advanced in the art, and who, sure of their hand, have leisure to exert their understanding, must now be told, that a mere copier of nature can never produce any thing great; can never raise and enlarge the conceptions, or warm the heart of the spectator.

The wish of the genuine painter must be more extensive: instead of endeavouring to amuse mankind with the minute neatness of his imitations, he must endeavour to improve them by the grandeur of his ideas; instead of seeking praise, by deceiving the superficial sense of the spectator, he must strive for fame by captivating the imagination.

The principle now laid down, that the perfection of this art does not consist in mere imitation, is far from being new or singular. It is, indeed, supported by the general opinion of the enlightened part of mankind. The poets, orators, and rhetoricians of antiquity, are continually enforcing this position; that all the arts receive their perfection from an ideal beauty, superior to what is to be found in individual nature. They are ever referring to the practice of the painters and sculptors of their times, particularly Phidias (the favourite àrtist of antiquity), to illustrate their assertions. As if they could not sufficiently express their admiration of his genius by what they knew, they have recourse to poetical enthusiasm: they call it inspiration; a gift from heaven. The artist is supposed to have ascended the celestial regions, to furnish his mind with this perfect idea of beauty. "He," says Proclus, "who takes for his model such forms as nature produces, and confines himself to an exact imitation of them, will never attain to what is perfectly beautiful. For the works of nature are full of disproportion, and fall very short of the true standard of beauty. So that Phidias, when he formed his Jupiter, did not copy any object ever presented to his sight; but contemplated only

that image which he had conceived in his mind from Homer's description."[2] And thus Cicero, speaking of the same Phidias: "Neither did this artist," says he, "when he carved the image of Jupiter or Minerva, set before him any one human figure, as a pattern which he was to copy; but having a more perfect idea of beauty fixed in his mind, this he steadily contemplated, and to the imitation of this all his skill and labour were directed."

The Moderns are no less convinced than the Ancients of this superior power existing in the art; nor less sensible of its effects. Every language has adopted terms expressive of this excellence. The *gusto grande* of the Italians, the *beau ideal* of the French, and the *great style, genius,* and *taste* among the English, are but different appellations of the same thing. It is this intellectual dignity, they say, that ennobles the painter's art; that lays the line between him and the mere mechanick; and produces those great effects in an instant, which eloquence and poetry, by slow and repeated efforts, are scarcely able to attain. . . .

It is not easy to define in what this great style consists; nor to describe, by words, the proper means of acquiring it, if the mind of the student should be at all capable of such an acquisition. Could we teach taste or genius by rules, they would be no longer taste and genius. But though there neither are, nor can be, any precise invariable rules for the exercise, or the acquisition, of these great qualities, yet we may truly say, that they always operate in proportion to our attention in observing the works of nature, to our skill in selecting, and to our care in digesting, methodizing, and comparing our observations. There are many beauties in our art, that seem, at first, to lie without the reach of precept, and yet may easily be reduced to practical principles. Experience is all in all; but it is not every one who profits by experience; and most people err, not so much from want of capacity to find their object, as from not knowing what object to pursue. This great ideal perfection and beauty are not to be sought in the heavens, but upon the earth. They are about us, and upon every

[2] Lib. 2 in Timæum Platonis, as cited by Junius, *De Pictura Veterum* (footnote from the text).

side of us. But the power of discovering what is deformed in nature, or in other words, what is particular and uncommon, can be acquired only by experience; and the whole beauty and grandeur of the art consists, in my opinion, in being able to get above all singular forms, local customs, particularities, and details of every kind.

All the objects which are exhibited to our view by nature, upon close examination will be found to have their blemishes and defects. The most beautiful forms have something about them like weakness, minuteness, or imperfection. But it is not every eye that perceives these blemishes. It must be an eye long used to the contemplation and comparison of these forms; and which by a long habit of observing what any set of objects of the same kind have in common, has acquired the power of discerning what each wants in particular. This long laborious comparison should be the first study of the painter, who aims at the greatest style. By this means, he acquires a just idea of beautiful forms; he corrects nature by herself, her imperfect state by her more perfect. His eye being enabled to distinguish the accidental deficiencies, excrescences, and deformities of things, from their general figures, he makes out an abstract idea of their forms more perfect than any one original; and what may seem a paradox, he learns to design naturally by drawing his figures unlike to any one object. This idea of the perfect state of nature, which the Artist calls the Ideal Beauty, is the great leading principle by which works of genius are conducted. By this Phidias acquired his fame. He wrought upon a sober principle what has so much excited the enthusiasm of the world; and by this method you, who have courage to tread the same path, may acquire equal reputation.

This is the idea which has acquired, and which seems to have a right to the epithet of *divine*; as it may be said to preside, like a supreme judge, over all the productions of nature; appearing to be possessed of the will and intention of the Creator, as far as they regard the external form of living beings. When a man once possesses this idea in its perfection, there is no danger, but that he will be

sufficiently warmed by it himself, and be able to warm and ravish every one else. . . .

Here then, as before, we must have recourse to the Ancients as instructors. It is from a careful study of their works that you will be enabled to attain to the real simplicity of nature; they will suggest many observations, which would probably escape you, if your study were confined to nature alone. And, indeed, I cannot help suspecting, that in this instance the ancients had an easier task than the moderns. They had, probably, little or nothing to unlearn, as their manners were nearly approaching to this desirable simplicity; while the modern artist, before he can see the truth of things, is obliged to remove the veil, with which the fashion of the times has thought proper to cover her.

Having gone thus far in our investigation of the great style in painting; if we now should suppose that the artist has formed the true idea of beauty, which enables him to give his works a correct and perfect design; if we should suppose also, that he has acquired a knowledge of the unadulterated habits of nature, which give him simplicity; the rest of his task is, perhaps, less than is generally imagined. Beauty and simplicity have so great a share in the composition of a great style, that he who has acquired them has little else to learn. It must not, indeed, be forgotten, that there is a nobleness of conception, which goes beyond any thing in the mere exhibition even of perfect form; there is an art of animating and dignifying the figures with intellectual grandeur, of impressing the appearance of philosophick wisdom, or heroick virtue. This can only be acquired by him that enlarges the sphere of his understanding by a variety of knowledge, and warms his imagination with the best products of ancient and modern poetry. . . .

THE FIFTH DISCOURSE. . . . If we put these great artists in a light of comparison with each other, Raffaelle had more Taste and Fancy, Michael Angelo more Genius and Imagination. The one excelled in beauty, the other in energy. Michael Angelo has more of the Poetical Inspiration; his ideas are vast and sublime; his people are a superior order of beings; there is nothing about them,

nothing in the air of their actions or their attitudes, or the style and cast of their limbs or features, that reminds us of their belonging to our own species. Raffaelle's imagination is not so elevated; his figures are not so much disjoined from our own diminuative race of beings, though his ideas are chaste, noble, and of great conformity to their subjects. Michael Angelo's works have a strong, peculiar, and marked character: they seem to proceed from his own mind entirely, and that mind so rich and abundant, that he never needed, or seemed to disdain, to look abroad for foreign help. Raffaelle's materials are generally borrowed, though the noble structure is his own. The excellency of this extraordinary man lay in the propriety, beauty, and majesty of his characters, the judicious contrivance of his Composition, his correctness of Drawing, purity of Taste, and skilful accommodation of other men's conceptions to his own purpose. Nobody excelled him in that judgment, with which he united to his own observations on Nature, the Energy of Michael Angelo, and the Beauty and Simplicity of the Antique. To the question therefore, which ought to hold the first rank, Raffaelle or Michael Angelo, it must be answered, that if it is to be given to him who possessed a greater combination of the higher qualities of the art than any other man, there is no doubt but Raffaelle is the first. But if, as Longinus thinks, the sublime, being the highest excellence that human composition can attain to, abundantly compensates the absence of every other beauty, and atones for all other deficiencies, then Michael Angelo demands the preference.

These two extraordinary men carried some of the higher excellencies of the art to a greater degree of perfection than probably they ever arrived at before. They certainly have not been excelled, nor equalled since. Many of their successors were induced to leave this great road as a beaten path, endeavouring to surprise and please by something uncommon or new. When this desire of novelty has proceeded from mere idleness or caprice, it is not worth the trouble of criticism; but when it has been the result of a busy mind of a peculiar complexion, it is always striking and interesting, never insipid.

Such is the great style, as it appears in those who possess it at its height: in this, search after novelty, in conception or in treating the subject, has no place. . . .

DISCOURSE XIII. . . . I observe, as a fundamental ground, common to all the Arts with which we have any concern in this discourse, that they address themselves only to two faculties of the mind, its imagination and its sensibility.

All theories which attempt to direct or to control the Art, upon any principles falsely called rational, which we form to ourselves upon a supposition of what ought in reason to be the end or means of Art, independent of the known first effect produced by subjects on the imagination, must be false and delusive. For though it may appear bold to say it, the imagination is here the residence of truth. If imagination be affected, the conclusion is fairly drawn; if it be not affected, the reasoning is erroneous, because the end is not obtained; the effect itself being the test, and the only test, of the truth and efficacy of the means.

There is in the commerce of life, as in Art, a sagacity which is far from being contradictory to right reason, and is superior to any occasional exercise of that faculty; which supersedes it; and does not wait for the slow progress of deduction, but goes at once, by what appears a kind of intuition, to the conclusion. A man endowed with this faculty, feels and acknowledges the truth, though it is not always in his power, perhaps, to give a reason for it; because he cannot recollect and bring before him all the materials that gave birth to his opinion; for very many and very intricate considerations may unite to form the principle, even of small and minute parts, involved in, or dependent on, a great system of things: though these in process of time are forgotten, the right impression remains fixed in his mind.

This impression is the result of the accumulated experience of our whole life, and has been collected, we do not always know how or when. But this mass of collective observation, however acquired, ought to prevail over that reason, which however powerfully exerted on any particular occasion, will probably comprehend but a partial view

of the subject; and our conduct in life as well as in the Arts, is, or ought to be, generally governed by this habitual reason: it is our happiness that we are enabled to draw on such funds. If we were obliged to enter into a theoretical deliberation on every occasion, before we act, life would be at a stand, and Art would be impracticable.

It appears to me therefore, that our first thoughts, that is, the effect which any thing produces on our minds on its first appearance, is never to be forgotten; and it demands for that reason, because it is the first, to be laid up with care. If this be not done, the Artist may happen to impose on himself by partial reasoning; by a cold consideration of those animated thoughts which proceed, not perhaps from caprice or rashness (as he may afterwards conceit), but from the fullness of his mind, enriched with the copious stores of all the various inventions which he had ever seen, or had ever passed in his mind. These ideas are infused into his design, without any conscious effort; but if he be not on his guard, he may reconsider and correct them, till the whole matter is reduced to a common-place invention.

This is sometimes the effect of what I mean to caution you against; that is to say, an unfounded distrust of the imagination and feeling, in favour of narrow, partial, confined, argumentative theories; and of principles that seem to apply to the design in hand; without considering those general impressions on the fancy in which real principles of *sound reason,* and of much more weight and importance, are involved, and, as it were, lie hid, under the appearance of a sort of vulgar sentiment.

If we suppose a view of nature represented with all the truth of the camera obscura, and the same scene represented by a great Artist, how little and mean will the one appear in comparison of the other, where no superiority is supposed from the choice of the subject. The scene shall be the same, the difference only will be in the manner in which it is presented to the eye. With what additional superiority then will the same Artist appear when he has the power of selecting his materials, as well as elevating his style? Like Nicolas Poussin, he transports us to the

environs of ancient Rome, with all the objects which a literary education makes so precious and interesting to man: or, like Sebastian Bourdon, he leads us to the dark antiquity of the Pyramids of Egypt; or, like Claude Lorrain, he conducts us to the tranquillity of Arcadian scenes and fairy land.

Like the history-painter, a painter of landscapes in this style and with this conduct, sends the imagination back into antiquity; and, like the Poet, he makes the elements sympathise with his subject: whether the clouds roll in volumes like those of Titian or Salvator Rosa,—or, like those of Claude, are gilded with the setting sun; whether the mountains have sudden and bold projections, or are gently sloped; whether the branches of his trees shoot out abruptly in right angles from their trunks, or follow each other with only a gentle inclination. All these circumstances contribute to the general character of the work, whether it be of the elegant, or of the more sublime kind. If we add to this the powerful materials of lightness and darkness, over which the Artist has complete dominion, to vary and dispose them as he pleases; to diminish, or increase them, as will best suit his purpose, and correspond to the general idea of his work; a landscape thus conducted, under the influence of a poetical mind, will have the same superiority over the more ordinary and common views, as Milton's *Allegro* and *Pensoroso* have over a cold prosaick narration or description; and such a picture would make a more forcible impression on the mind than the real scenes, were they presented before us. . . .

And here I must observe, and I believe it may be considered as a general rule, that no Art can be engrafted with success on another art. For though they all profess the same origin, and to proceed from the same stock, yet each has its own peculiar modes both of imitating nature, and of deviating from it, each for the accomplishment of its own particular purpose. These deviations, more especially, will not bear transplantation to another soil.

If a Painter should endeavour to copy the theatrical pomp and parade of dress and attitude, instead of that simplicity, which is not a greater beauty in life, than it is

in Painting, we should condemn such Pictures, as painted in the meanest style.

So also Gardening, as far as Gardening is an Art, or entitled to that appellation, is a deviation from nature; for if the true taste consists, as many hold, in banishing every appearance of Art, or any traces of the foot-steps of man, it would then be no longer a Garden. Even though we define it, "Nature to advantage dress'd," and in some sense is such, and much more beautiful and commodious for the recreation of man; it is however, when so dressed, no longer a subject for the pencil of a Landscape-Painter, as all Landscape-Painters know, who love to have recourse to Nature herself, and to dress her according to the principles of their own Art; which are far different from those of Gardening, even when conducted according to the most approved principles; and such as a Landscape-Painter himself would adopt in the disposition of his own grounds, for his own private satisfaction.

I have brought together as many instances as appear necessary to make out the several points which I wished to suggest to your consideration in this Discourse; that your own thoughts may lead you further in the use that may be made of the analogy of the Art; and of the restraint which a full understanding of the diversity of many of their principles ought to impose on the employment of that analogy.

The great end of all those arts is, to make an impression on the imagination and the feeling. The imitation of nature frequently does this. Sometimes it fails, and something else succeeds. I think therefore the true test of all the arts, is not solely whether the production is a true copy of nature, but whether it answeres the end of art, which is to produce a pleasing effect upon the mind.

It remains only to speak a few words of Architecture, which does not come under the denomination of an imitative art. It applies itself, like Musick, (and I believe we may add Poetry,) directly to the imagination, without the intervention of any kind of imitation.

There is in Architecture, as in Painting, an inferior branch of art, in which the imagination appears to have no

concern. It does not, however, acquire the name of a polite and liberal art, from its usefulness, or administering to our wants or necessities, but from some higher principle: we are sure that in the hands of a man of genius it is capable of inspiring sentiment, and of filling the mind with great and sublime ideas.

It may be worth the attention of Artists to consider what materials are in their hands, that may contribute to this end; and whether this art has it not in its power to address itself to the imagination with effect, by more ways than are generally employed by Architects.

To pass over the effect produced by that general symmetry and proportion, by which the eye is delighted, as the ear is with musick, Architecture certainly possesses many principles in common with Poetry and Painting. Among those which may be reckoned as the first, is, that of affecting the imagination by means of association of ideas. Thus, for instance, as we have naturally a veneration for antiquity, whatever building brings to our remembrance ancient customs and manners, such as the Castles of the Barons of ancient Chivalry, is sure to give this delight. Hence it is that *towers and battlements* are so often selected by the Painter and the Poet, to make a part of the composition of their ideal Landscape; and it is from hence in a great degree, that in the buildings of Vanbrugh,[3] who was a Poet as well as an Architect, there is a greater display of imagination, than we shall find perhaps in any other, and this is the ground of the effect we feel in many of his works, notwithstanding the faults with which many of them are justly charged. For the purpose, Vanbrugh appears to have had recourse to some of the principles of the Gothick Architecture; which, though not so ancient as the Grecian, is more so to our imagination, with which the Artist is more concerned than with absolute truth.

[3] [Sir John Vanbrugh (1664–1726) was a very successful playwright before becoming the architect of such great mansions as Castle Howard and Blenheim Palace. See L. Whistler, *Sir John Vanbrugh, Architect and Dramatist,* London, 1938; *idem, The Imagination of Vanbrugh and His Fellow Artists,* London, 1954.]

The Barbarick splendour of those Asiatick Buildings, which are now publishing by a member[4] of this Academy, may possibly, in the same manner, furnish an Architect, not with models to copy, but with hints of composition and general effect, which would not otherwise have occurred.

It is, I know, a delicate and hazardous thing, (and as such I have already pointed it out,) to carry the principles of one art to another, or even to reconcile in one object the various modes of the same Art, when they proceed on different principles. The sound rules of the Grecian Architecture are not to be lightly sacrificed. A deviation from them, or even an addition to them, is like a deviation or addition to, or from, the rules of other Arts—fit only for a great master, who is thoroughly conversant in the nature of man, as well as all combinations in his own Art.

It may not be amiss for the Architect to take advantage *sometimes* of that to which I am sure the Painter ought always to have his eyes open, I mean the use of accidents; to follow when they lead, and to improve them, rather than always to trust to a regular plan. It often happens that additions have been made to houses, at various times, for use or pleasure. As such buildings depart from regularity, they now and then acquire something of scenery by this accident, which I should think might not unsuccessfully be adopted by an Architect, in an original plan, if it does not too much interfere with convenience. Variety and intricacy is a beauty and excellence in every other of the arts which address the imagination; and why not in Architecture?

The forms and turnings of the streets of London, and other old towns, are produced by accident, without any original plan or design; but they are not always the less pleasant to the walker or spectator, on that account. On the contrary, if the city had been built on the regular plan of Sir Christopher Wren, the effect might have been, as we know it is in some new parts of the town, rather unpleasing; the uniformity might have produced weariness, and a slight degree of disgust.

I can pretend to no skill in the detail of Architecture. I

[4] Mr. Hodges.

judge now of the art, merely as a Painter. When I speak of Vanbrugh, I mean to speak of him in the language of our art. To speak then of Vanbrugh in the language of a Painter, he had originality of invention, he understood light and shadow, and had great skill in composition. To support his principal object, he produced his second and third groups or masses; he perfectly understood in his Art what is the most difficult in ours, the conduct of the back-ground; by which the design and invention is set off to the greatest advantage. What the back-ground is in Painting, in Architecture is the real ground on which the building is erected; and no Architect took greater care than he that his work should not appear crude and hard: that is, it did not abruptly start out of the ground without expectation or preparation.

This is a tribute which a Painter owes to an Architect who composed like a Painter; and was defrauded of the due reward of his merit by the Wits of his time, who did not understand the principles of composition in poetry better than he; and who knew little, or nothing, of what he understood perfectly, the general ruling principles of Architecture and Painting. His fate was that of the great Perrault;[5] both were the objects of the petulant sarcasms of factious men of letters; and both have left some of the fairest ornaments which to this day decorate their several countries; the façade of the Louvre, Blenheim, and Castle-Howard.

Upon the whole, it seems to me, that the object and intention of all the Arts is to supply the natural imperfection of things, and often to gratify the mind by realising and embodying what never existed but in the imagination.

It is allowed on all hands, that facts, and events, however they may bind the Historian, have no dominion over the Poet or the Painter. With us, History is made to bend and conform to this great idea of Art. And why? Because these Arts, in their highest province, are not addressed to the gross senses, but to the desires of the mind, to that spark of divinity which we have within, impatient of being circumscribed and pent up by the world which is about

[5] [See p. 135.]

us. Just so much as our Art has of this, just so much of dignity, I had almost said of divinity, it exhibits; and those of our Artists who possessed this mark of distinction in the highest degree, acquired from thence the glorious appellation of DIVINE.

DISCOURSE XV . . . I have taken every opportunity of recommending a rational method of study, as of the last importance. The great, I may say sole, use of an Academy is, to put and for some time to keep, Students in that course; that too much indulgence may not be given to peculiarity, and that a young man may not be taught to believe, that what is generally good for others is not good for him.

I have strongly inculcated in my former Discourses, as I do in this my last, the wisdom and necessity of previously obtaining the appropriated instruments of the Art, in a first correct design, and a plain manly colouring, before anything more is attempted. But by this I would not wish to cramp and fetter the mind, or discourage those who follow (as most of us may at one time have followed) the suggestion of a strong inclination: something must be conceded to great and irresistible impulses: perhaps every Student must not be strictly bound to general methods, if they strongly thwart the peculiar turn of his own mind. I must confess, that it is not absolutely of much consequence, whether he proceeds in the general method of seeking first to acquire mechanical accuracy, before he attempts poetical flights, provided he diligently studies to attain the full perfection of the style he pursues; whether like Parmegiano, he endeavours at grace and grandeur of manner before he has learned correctness of drawing, if like him he feels his own wants, and will labour, as that eminent Artist did, to supply those wants; whether he starts from the East or from the West, if he relaxes in no exertion to arrive ultimately at the same goal. The first publick work of Parmegiano is the St. Eustachius, in the church of St. Petronius in Bologna, and was done when he was a boy; and one of the last of his works is the Moses breaking the tables at Parma. In the former there is certainly something

of grandeur in the outline, or in the conception of the figure, which discovers the dawnings of future greatness; of a young mind impregnated with the sublimity of Michael Angelo, whose style he here attempts to imitate, though he could not then draw the human figure with any common degree of correctness. But this same Parmegiano, when in his more mature age he painted the Moses, had so completely supplied his first defects, that we are here at a loss which to admire most, the correctness of drawing, or the grandeur of the conception. As a confirmation of its great excellence, and of the impression which it leaves on the minds of elegant spectators, I may observe, that our great Lyrick Poet, when he conceived his sublime idea of the indignant Welch bard, acknowledged, that though many years had intervened, he had warmed his imagination with the remembrance of this noble figure of Parmegiano.

When we consider that Michael Angelo was the great arche-type to whom Parmegiano was indebted for that grandeur which we find in his works, and from whom all his contemporaries and successors have derived whatever they have possessed of the dignified and the majestick; that he was the bright luminary, from whom Painting has borrowed a new lustre; that under his hands it assumed a new appearance, and is become another and superior art; I may be excused if I take this opportunity, as I have hitherto taken every occasion, to turn your attention to this exalted Founder and Father of modern Art, of which he was not only the inventor, but which, by the divine energy of his own mind, he carried at once to its highest point of possible perfection. . . .

The sublime in Painting, as in Poetry, so overpowers, and takes such a possession of the whole mind, that no room is left for attention to minute criticism. The little elegancies of art in the presence of these great ideas thus greatly expressed, lose all their value, and are, for the instant at least, felt to be unworthy of our notice. The correct judgment, the purity of taste, which characterise Raffaelle, the exquisite grace of Correggio and Parmegiano, all disappear before them.

That Michael Angelo was capricious in his inventions,

cannot be denied; and this may make some circumspection necessary in studying his works; for though they appear to become him, an imitation of them is always dangerous, and will prove sometimes ridiculous. "Within that circle none durst walk but he." To me, I confess, his caprice does not lower the estimation of his genius, even though it is sometimes, I acknowledge, carried to the extreme: and however those eccentrick excursions are considered, we must at the same time recollect, that those faults, if they are faults, are such as never occur to a mean and vulgar mind; that they flowed from the same source which produced his greatest beauties, and were therefore such as none but himself was capable of committing; they were the powerful impulses of a mind unused to subjection of any kind, and too high to be controlled by cold criticism.

Many see his daring extravagance, who can see nothing else. A young Artist finds the works of Michael Angelo to be so totally different from those of his own master, or of those with whom he is surrounded, that he may be easily persuaded to abandon and neglect studying a style, which appears to him wild, mysterious, and above his comprehension, and which he therefore feels no disposition to admire; a good disposition, which he concludes that he should naturally have, if the style deserved it. It is necessary therefore that Students should be prepared for the disappointment which they may experience at their first setting out; and they must be cautioned, that probably they will not, at first sight approve.

It must be remembered, that as this great style itself is artificial in the highest degree, it presupposes in the spectator, a cultivated and prepared artificial state of mind. It is an absurdity therefore to suppose that we are born with this taste, though we are with the seeds of it, which, by the heat and kindly influence of his genius, may be ripened in us. . . .

COLEN CAMPBELL

[Colen Campbell (d. 1729) was influential in the formation of the Palladian architectural revival. He published one of the first of the several great English architectural books of the eighteenth century, *Vitruvius Britannicus,* a folio of one hundred engravings of his designs and classical buildings in Britain with a brief commentary. The first two volumes appeared in 1717, a supplementary volume was added in 1729, and they were widely circulated both in England and on the Continent. As a result of this work, Campbell became a protégé of Lord Burlington, the amateur architect, devoted follower of Palladio and sponsor for the Leoni translation and publication of Andrea Palladio's *The Four Books of Architecture* in 1715. This translation and Campbell's book laid the basis for the new taste to which Lord Burlington added his prestige. Campbell was employed to design the famous Burlington House façade incorporating Palladian principles. Equally influential, but unfortunately demolished in 1822, was Wanstead House for which Campbell conceived the town house as a palatial unit. He is known as the creator of the "Palladian House."]

VITRUVIUS BRITANNICUS[1]
OR
The British Architect

The Introduction: The general Esteem that Travellers have for Things that are Foreign is in nothing more conspicuous than with Regard to Building. We travel, for the the most part, at an Age more apt to be imposed upon by the Ignorance or Partiality of others, than to judge truly

[1] Colen Campbell, *Vitruvius Britannicus, or The British Architect,* 3 volumes, London, 1717. See also E. Kaufmann, *Architecture in the Age of Reason,* Cambridge, 1955, pp. 4–15; J. H. Summerson, *Architecture in Britain 1530–1830,* London, 4th ed., 1963, pp. 189–200.

of the Merit of Things by the Strength of Reason. It's owing to this Mistake in Education, that so many of the *British* Quality have so mean an Opinion of what is performed in our own Country; tho', perhaps, in most we equal, and in some Things we surpass, our Neighbours.

I have therefore judged, it would not be improper to publish this Collection, which will admit of a fair Comparison with the best of the *Moderns*. As to the *Antiques,* they are out of the Question; and, indeed, the *Italians* themselves have now no better Claim to them than they have to the Purity of *Latin.*

We must, in Justice, acknowledge very great Obligations to those Restorers of *Architecture,* which the Fifteenth and Sixteenth *Centuries* produced in *Italy. Bramante, Barbaro, Sansovino, Sangallo, Michel Angelo, Raphael Urbin, Julio Romano, Serglio, Labaco, Scamozzi,* and many others, who have greatly help'd to raise this Noble Art from the Ruins of Barbarity: But above all, the great *Palladio,* who has exceeded all that were gone before them, and surpass'd his Contemporaries, whose ingenious Labours will eclipse many, and rival most of the Ancients. And indeed, this excellent *Architect* seems to have arrived to a *Ne plus ultra* of his Art. With him the great manner and exquisite Taste of Building is lost; for the *Italians* can no more now relish the Antique Simplicity, but are entirely employed in capricious Ornaments, which must at last end in the *Gothick.*

For Proof of this Assertion I appeal to the Productions of the last *Century*: How affected and licentious are the Works of *Bernini* and *Fontana?* How wildly Extravagent are the Designs of *Boromini,* who has endeavour'd to debauch Mankind with his odd and chimerical Beauties, where the Parts are without Proportion, Solids without their true Bearing, Heaps of Materials without Strength, excessive Ornaments without Grace, and the Whole without Symmetry? And what can be a stronger Argument, that this excellent Art is near lost in that Country, where such Absurdities meet with Applause?

It is then with the Renowned *Palladio* we enter the Lists, to whom we oppose the famous *Inigo Jones*: Let the

Banqueting-house,[2] those excellent Pieces at *Greenwich,*[3] with many other Things of this great Master, be carefully examined, and I doubt not but an impartial Judge will find in them all the Regularity of the former, with an Addition of Beauty and Majesty, in which our *Architect* is esteemed to have out-done all that went before; and when those Designs he gave for *Whitehall,* are published, which I intend in the Second Volume, I believe all Mankind will agree with me, that there is no Palace in the World to rival it.

And here I cannot but reflect on the Happiness of the *British* Nation, that at present abounds with so many learned and ingenious Gentlemen, as Sir *Christopher Wren,* Sir *William Bruce,* Sir *John Vanbrugh,* Mr. *Archer,* Mr. *Wren,* Mr. *Wynne,* Mr. *Talman,* Mr. *Hawksmore,* Mr. *James,* &c. who are daily embellishing it more.

I hope, therefore, the Reader will be agreeably entertained in viewing what I have collected with so much Labour. All the Drawings are either taken from the Buildings themselves, or the original Designs of the Architects, who have very much assisted me in advancing this Work: And I can, with great Sincerity, assure the Publick, That I have used the utmost Care to render it acceptable; and that nothing might be Wanting, I have given the following Explanation to each Figure.

S. Paul's *Church*, London.[4]

This Noble Fabrick was begun by Sir *Christopher Wren, Anno* 1672, and happily finish'd by him, 1710. I have made two Plates, the Plan and West Front; and did intend the Section, but was prevented by the Architect, who proposed to publish it himself. I have omitted the Rusticks and fluting of the Columns in both Orders, to avoid the Confusion of so many Lines in so small a Scale. Here is a Rustick Basement that carries two entire Orders, the first is *Corinthian,* four Foot in Diameter, with a plain Entablature; there is an Arcade all round the Building, that serves for Lights. The second Order is Composite,

[2] Built in 1616 at Whitehall.
[3] The Queen's House, built in 1639.
[4] [Our *fig.* 14; the Plan is omitted.]

proportionably diminished with regard to the interior; here a very rich Tabernacle reigns throughout the whole Inter-Columnations, very like that excellent Model in the *Rotunda* at Rome, but with this Difference, that in this the Pedestal is pierced, to give Light. A more particular Account is to be taken from the Design by the Scale and Compass, which would be too tedious in this Introduction. The whole Fabrick is perform'd in Stone by those excellent and judicious Artists, Mr. *Edward Strong, Senior* and *Junior,* whose consummate Knowledge in their Profession has greatly contribute to adorn the Kingdom; and it's beyond Exception, that this is the second Church in the World.

S. Peter's *at* Rome.[5]

I thought it would not be improper to present the Curious with the Plan, Elevation, and Section of this Majestick Building; and the more that I dare safely aver, that it's the most correct, with respect to the Truth of Architecture, or Cleanness of Engraving, that was ever published; and the Reader may have the Satisfaction to view both reduced to *British* Measure. The Criticks generally condemn the excessive Height of the *Attick,* which they confine to a third of the inferior Column: That the Pediment, supported by a Tetrastyle, is mean for so great a Front, which at least would demand an Hexastyle: That the Breaks are trifling, and the Parts without any Proportion: That the great Body of the Church, projected by *Carlo Maderno,* has extreamly injured the august Appearance of the *Cupola,* which is very much lost by being removed so far from the East Front, contrary to *Michel Angelo*'s Design, who conformed the whole Plan to a Square, wherein he described a *Grecian* Cross. But all agree, that the Width is noble, and the *Cupola* admirable. It was begun *Anno* 1513, and finished 1640.

A *new Design for a Church* in Lincoln's-Inn Fields.[6]

This Design I made, at the Desire of some Persons of Quality and Distinction, when it was proposed to have a

[5] [Our *fig.* 15.]
[6] [Our *fig.* 16.]

Church in this Noble Square. The Plan is reduced to a Square and Circle in the Middle, which, in my weak Opinion, are the most perfect Figures. In the Front I have removed the Angular Towers at such a distance, that the great *Cupola* is without any Embarrass. Here is a regular Hexastyle that commands the Front, which, with the other Parts, are all in certain Measures of Proportion. I have introduced but one single *Corinthian* Order, supported by a full Basement, and finished with an Attick and Ballustrade. The *Cupola* is adorned with a single Colonade of detached Columns; the whole is dress'd very plain, as most proper for the sulphurous Air of this City, and, indeed, most conformable to the Simplicity of the Ancients. Done *Anno* 1712.

SIR WILLIAM CHAMBERS

[Sir William Chambers (1726–1796) was, as a young man, a member of the Swedish East India Company and spent nine years traveling in the Orient where he became interested in Chinese architecture. He left the company and took up the study of architecture first in Paris where he probably attended Jacques François Blondel's famous lectures, and then in Rome. He established himself as an architect in London in 1755. He became the architect to the Dowager Princess who commissioned him to lay out Kew Gardens and erect numerous small buildings there in 1757. For these he utilized motives he had observed in China. Simultaneously he published, in French and English, *Designs for Chinese Buildings, Furniture, Dresses, Machines, and Utensils,* including also a brief essay on Chinese gardens. This work, one of the first to give accurate details of Chinese architecture, contributed substantially to the popularity of "chinoiseries" in England and on the Continent. The first two volumes of a projected six-volume work, *A Treatise on Civil Architecture,* appeared in 1759 and reaffirmed the traditional forms based on Palladian principles, but also indicated a wide range of

Italian architects as worthy of study as the monuments of antiquity. They were republished with the more accurate title *A Treatise on the Decorative Part of Architecture* in 1791. *Plans . . . of Gardens and Buildings at Kew*, which he published at Royal expense in 1763, was influential on the Continent because of its popularity.

Invited to become architectural tutor to the Prince of Wales, on his succession as George III, Chambers became his architect, a Commissioner of the Board of Works, and in 1782, Surveyor General. He designed many mansions and buildings, among them the Casino at Marino near Dublin, Duddington House near Edinburgh, and the gates at Blenheim and at Wilton, for which he utilized Palladian principles in the plans and eclectic elements in the details. His best-known work is the Government Offices Building, Somerset House (1776–1780), on the bank of the Thames River.

He was associated with Sir Joshua Reynolds in the foundation of the Royal Academy of Art in 1768 and served as its first Treasurer. Decorated by the King of Sweden, knighted by George III, he did much to increase the prestige of the architects and to secure recognition of architecture as a profession.]

DESIGNS OF CHINESE BUILDINGS, FURNITURE, DRESSES, MACHINES, AND UTENSILS[1]

PREFACE: It is difficult to avoid praising too little or too much. The boundless panegyrics which have been lavished upon the Chinese learning, policy, and arts, show with what power novelty attracts regard, and how naturally esteem swells into admiration.

I am far from desiring to be numbered among the exaggerators of Chinese excellence. I consider them as great, or wise, only in comparison with the nations that surround them; and have no intention to place them in

[1] The text is from Sir William Chambers, *Designs of Chinese Buildings, Furniture, Dresses, Machines, and Utensils*, London, 1757. See also: J. H. Summerson, *Architecture in Britain, 1530–1830*, 4th ed., London, 1963, pp. 253–259.

competition either with the antients, or with the moderns of this part of the world: yet they must be allowed to claim our notice as a distinct and very singular race of men; as the inhabitants of a region divided by its situation from all civilized countries; who have formed their own manners, and invented their own arts, without assistance of examples.

Every circumstance relating to so extraordinary a people must deserve attention; and though we have pretty accurate accounts of most other particulars concerning them, yet our notions of their architecture are very imperfect: many of the descriptions hitherto given of their buildings are unintelligible; the best convey but faint ideas; and no designs worth notice have yet been published.

These which I now offer to the publick are done from sketches and measures taken by me at Canton some years ago, chiefly to satisfy my own curiosity. It was not my design to publish them; nor would they now appear, were it not in compliance with the desire of several lovers of the arts, who thought them worthy the perusal of the publick, and that they might be of use in putting a stop to the extravagancies that daily appear under the name of Chinese, though most of them are mere inventions, the rest copies from lame representations found on porcelain and paper-hangings.

Whatever is really Chinese has at least the merit of being original: these people seldom or never copy or imitate the inventions of other nations. All our most authentick relations agree in this point, and observe that their form of government, language, character, dress, and almost every other particular belonging to them, have continued without change for thousands of years: but their architecture has this farther advantage that there is a remarkable affinity between it and that of the antients, which is the more surprising as there is not the least probability that the one was borrowed from the other.

In both the antique and Chinese architecture the general form of almost every composition has a tendency to the pyramidal figure: In both, columns are employed for support; and in both, these columns have diminution and bases, some of which bear a near resemblance to each

other; fretwork, so common in the buildings of the antients, is likewise very frequent in those of the Chinese; the disposition observed in the Chinese Ting[2] is not much different from that in the Peripteros of the Greeks; the Atrium, and the Monopteros and Prostyle temples, are forms of building that nearly resemble some used in China; as the Chinese manner of walling is upon the same principle with the Revinctum and Emplecton described by Vitruvius. There is likewise a great affinity between the antient utensils and those of the Chinese; both being composed of similar parts combined in the same manner.

Though I am publishing a work of Chinese Architecture, let it not be suspected that my intention is to promote a taste so much inferiour to the antique, and so very unfit for our climate: but a particular so interesting as the architecture of one of the most extraordinary nations in the universe cannot be a matter of indifference to a true lover of the arts, and an architect should by no means be ignorant of so singular a stile of building: at least the knowledge is curious, and on particular occasions may likewise be useful; as he may sometimes be obliged to make Chinese compositions, and at others it may be judicious in him to do so. For though, generally speaking, Chinese architecture does not suit European purposes; yet in extensive parks and gardens, where a great variety of scenes are required, or in immense palaces, containing a numerous series of apartments, I do not see the impropriety of finishing some of the inferiour ones in the Chinese taste. Variety is always delightful; and novelty, attended with nothing inconsistent or disagreeable, sometimes takes place of beauty. History informs us that Adrian, who was himself an architect, at a time when the Grecian architecture was in the highest esteem among the Romans, erected in his Villa, at Tivoli, certain buildings after the manner of the Egyptians and of other nations.

The buildings of the Chinese are neither remarkable for magnitude or richness of materials; yet there is a singu-

[2] A Ting is the great hall of a house, the room in which guests are entertained, the hall where the Mandarins sit in judgment; also the great halls in a Pagoda or temple.

larity in their manner, a justness in their proportion, a simplicity, and sometimes even beauty, in their form, which recommend them to our notice. I look upon them as toys in architecture: and as toys are sometimes, on account of their oddity, prettyness, or neatness of workmanship, admitted into the cabinets of the curious, so may Chinese buildings be sometimes allowed a place among compositions of a nobler kind.

It may be objected that the suburbs of a sea-port cannot furnish the proper means for deciding the taste of a nation. But when we reflect that Canton is one of the most considerable cities in Asia, and in many respects inferiour to none in China, that objection will lose much of its weight. Had I been admitted to range over the whole empire, no doubt I could have swelled my work with more examples: but if I may be allowed to judge from such imperfect things as Chinese paintings, they would all have been in the same stile; and, with regard to their general form and disposition, nearly resembling those contained in this work. Beside, my intention being only to give an idea of Chinese architecture, not designs of particular buildings, any farther than they contribute to that purpose, it were a trespass on the patience of the publick to offer many examples, when a few properly chosen are sufficient. I have even omitted the greatest part of those I met with in Canton, either because they were mere repetitions of the same thing, or presented nothing more remarkable.

Du Halde observes that there is such a resemblance between the cities of China, that one is almost sufficient to give an idea of all; and the same remark may be made on their buildings: for in all the paintings I ever saw, which were very numerous, and in all the descriptions I ever read, I do not remember to have met with any forms of building greatly differing from those which I have represented.

To my designs of Chinese buildings I have added some of their furniture, utensils, machines, and dresses. Those of the furniture were taken from such models as appeared to me the most beautiful and reasonable: some of them are pretty, and may be useful to our Cabinet-makers.

The Chinese utensils, notwithstanding the humble pur-

poses to which they are applied, deserve to be considered.
I have therefore inserted two plates of them in this work:
several of the thoughts are ingenious, the forms simple
and elegant, and the ornaments natural and judiciously
applied. They are, as I before observed, composed in the
spirit of the antique; but want that graceful turn observ-
able in the works of some of the ancient and modern
Europeans; which is owing to the Chinese being less expert
in the practical part of design than the Europeans.

An accident hath prevented my giving more designs of
Chinese machines; but our knowledge of mechanics in
Europe so far exceeds theirs that the loss is not of much
consequence. Among them I have inserted several of their
boats.

It was not my intention to touch on any thing that did
not immediately belong to my profession. However, as I
had by me designs of the Chinese dresses, drawn with a
good deal of accuracy, I judged it would not be amiss to
publish them, as I believe they are the exactest that have
hitherto appeared. Some of them are picturesque, and may
be useful in masquerades, and other entertainments of
that kind, as well as in grotesque paintings.

The Chinese excell in the art of laying out gardens. Their
taste in that is good, and what we have for some time
past been aiming at in England, though not always with
success. I have endeavoured to be distinct in my account
of it, and hope it may be of some service to our Gardeners.

The Plates are engraved by some of the most eminent
English masters, who in their different branches are in-
feriour to none in Europe: and I have spared no expence
to make the performance complete.

I cannot conclude without observing that several of my
good friends have endeavoured to dissuade me from pub-
lishing this work, through a persuasion that it would hurt
my reputation as an Architect; and I pay so much defer-
ence to their opinion, that I should certainly have desisted,
had it not been too far advanced before I knew their sen-
timents: yet I cannot conceive why it should be criminal
in a traveller to give an account of what he has seen worthy
of notice in China, any more than in Italy, France, or any

other country; nor do I think it possible that any man should be so void of reason as to infer that an Architect is ignorant in his profession, merely from his having published designs of Chinese buildings.

OF THE TOWERS

The towers, called by the Chinese *Taa*, and which the Europeans call likewise pagodas, are very common in China. In some provinces, says Du Halde, you find them in every town, and even in the large villages. The most considerable of them all are the famous porcelain-tower at Nang-King, and that of Tong-Tchang-Fou, both of which are very magnificent structures.

In regard to their form, the *Taas* are all nearly alike: being of an octagonal figure, and consisting of seven, eight, and sometimes ten stories, which grow gradually less both in height and breadth all the way from the bottom to the top. Each story is finished with a kind of cornish, that supports a roof, at the angles of which hang little brass bells; and round each story runs a narrow gallery, inclosed by a rail or balustrade. These buildings commonly terminate in a long pole, surrounded with several circles of iron, hanging by eight chains fixed to the top of the pole, and to the angles of the covering of the last story.

Fig. 1, Plate V.[3] is copied from one of those towers, that stands on the banks of the Ta-Ho,[4] between Canton and Hoang-Pou. It is raised on three steps, and consists of seven stories. The first story is entered by four arched doors, and contains one room of an octagonal figure, in the middle of which is the stair that leads to the second story, as expressed in the plan fig. 2, Plate V. The stairs that lead to all the other stories are placed in the same manner; the cornishes that finish the different stories are all alike, and composed of a fillet and large cavetto, enriched with ornaments representing scales of fish; which is common in the Chinese buildings as well as in those of the ancients. The

[3] [Our *fig.* 17.]
[4] I.e., Great River, which is the name given to the river that runs by Canton.

roofs are all turned up at the angles, and all but the lower-
most are adorned with foliages and bells. The building is
finished with a pole, at the top of which is a ball, and
round it nine circles of iron suspended by chains fixed to
the angles of the uppermost roof. I have omitted repre-
senting, in the elevation, the stairs that lead to the different
stories, because it would have rendered the design con-
fused.

OF THE ART OF LAYING OUT GARDENS AMONG THE CHINESE[5]

The gardens which I saw in China were very small;
nevertheless from them, and what could be gathered from
Lepqua, a celebrated Chinese painter, with whom I had
several conversations on the subject of gardening, I think
I have acquired sufficient knowledge of their notions on
this head.

Nature is their pattern, and their aim is to imitate her
in all her beautiful irregularities. Their first consideration
is the form of the ground, whether it be flat, sloping, hilly,
or mountainous, extensive, or of small compass, of a dry
or marshy nature, abounding with rivers and springs, or
liable to a scarcity of water; to all which circumstances
they attend with great care, chusing such dispositions as
humour the ground, can be executed with the least ex-
pence, hide its defects, and set its advantages in the most
conspicuous light.

As the Chinese are not fond of walking, we seldom
meet with avenues or spacious walks, as in our European
plantations: the whole ground is laid out in a variety of
scenes, and you are led, by winding passages cut in the
groves, to the different points of view, each of which is
marked by a seat, a building, or some other object.

The perfection of their gardens consists in the number,
beauty, and diversity of these scenes. The Chinese gar-

[5] [See Marie Luise Gothein, *A History of Garden Art*, London,
1928, and ed., vol. II, pp. 291–294. *Fig.* 18 gives a general idea
of the garden in relation to a Chinese house, shown here in a
cross-section.]

deners, like the European painters, collect from nature the most pleasing objects, which they endeavour to combine in such a manner, as not only to appear to the best advantage separately, but likewise to unite in forming an elegant and striking whole.

Their artists distinguish three different species of scenes, to which they give the appellations of pleasing, horrid, and enchanted. Their enchanted scenes answer, in a great measure, to what we call romantic, and in these they make use of several artifices to excite surprize. Sometimes they make a rapid stream, or torrent, pass under ground, the turbulent noise of which strikes the ear of the new-comer, who is at a loss to know from whence it proceeds: at other times they dispose the rocks, buildings, and other subjects that form the composition, in such a manner as that the wind passing through the different interstices and cavities, made in them for that purpose, causes strange and uncommon sounds. They introduce into these scenes all kinds of extraordinary trees, plants, and flowers, form artificial and complicated echoes, and let loose different sorts of monstrous birds and animals.

In their scenes of horror, they introduce impending rocks, dark caverns, and impetuous cataracts rushing down the mountains from all sides; the trees are ill-formed, and seemingly torn to pieces by the violence of tempests; some are thrown down, and intercept the course of the torrents, appearing as if they had been brought down by the fury of the waters; others look as if shattered and blasted by the force of lightning; the buildings are some in ruins, others half-consumed by fire, and some miserable huts dispersed in the mountains serve at once to indicate the existence and wretchedness of the inhabitants. These scenes are generally succeeded by pleasing ones. The Chinese artists, knowing how powerfully contrast operates on the mind, constantly practise sudden transitions, and a striking opposition of forms, colours, and shades. Thus they conduct you from limited prospects to extensive views; from objects of horror to scenes of delight; from lakes and rivers to plains, hills, and woods; to dark and gloomy colours they oppose such as are brilliant, and to com-

plicated forms simple ones; distributing, by a judicious arrangement, the different masses of light and shade, in such a manner as to render the composition at once distinct in its parts, and striking in the whole. . . .

When there is a sufficient supply of water, and proper ground, the Chinese never fail to form cascades in their gardens. They avoid all regularity in these works, observing nature according to her operations in that mountainous country. The waters burst out from among the caverns, and windings of the rocks. In some places a large and impetuous cataract appears; in others are seen many lesser falls. Sometimes the view of the cascade is intercepted by trees, whose leaves and branches only leave room to discover the waters; in some places, as they fall down the sides of the mountain. They frequently throw rough wooden bridges from one rock to another, over the steepest part of the cataract; and often intercept its passage by trees and heaps of stones that seem to have been brought down by the violence of the torrent.

In their plantations they vary the forms and colours of their trees; mixing such as have large and spreading branches, with those of pyramidal figures, and dark greens, with brighter, interspersing among them such as produce flowers; of which they have some that flourish a great part of the year. The Weeping-willow is one of their favorite trees, and always among those that border their lakes and rivers, being so planted as to have its branches hanging over the water. They likewise introduce trunks of decayed trees, sometimes erect, and at other times lying on the ground, being very nice about their forms, and the colour of the bark and moss on them.

Various are the artifices they employ to surprize. Sometimes they lead you through dark caverns and gloomy passages, at the issue of which you are, on a sudden, struck with the view of a delicious landscape, enriched with every thing that luxuriant nature affords most beautiful. At other times you are conducted through avenues and walks, that gradually diminish and grow rugged, till the passage is at length entirely intercepted, and rendered impracticable, by bushes, briars, and stones; when unex-

pectedly a rich and extensive prospect opens to view, so much the more pleasing as it was less looked for.

Another of their artifices is to hide some part of a composition by trees, or other intermediate objects. This naturally excites the curiosity of the spectator to take a nearer view, when he is surprised by some unexpected scene, or some representation totally opposite to the thing he looked for. The termination of their lakes they always hide, leaving room for the imagination to work; and the same rule they observe in other compositions, wherever it can be put in practice.

Though the Chinese are not well versed in opticks, yet experience has taught them that objects appear less in size, and grow dim in colour, in proportion as they are more removed from the eye of the spectator. These discoveries have given rise to an artifice, which they sometimes put in practice. It is forming prospects in perspective, by introducing buildings, vessels, and other objects, lessened according as they are more distant from the point of view; and that the deception may be still more striking, they give a greyish tinge to the distant parts of the composition, and plant in the remoter parts of these scenes trees of a fainter colour, and smaller growth, than those that appear in the front or fore-ground; by these means rendering what in reality is trifling and limited, great and considerable in appearance.

The Chinese generally avoid streight lines; yet they do not absolutely reject them. They sometimes make avenues, when they have any interesting object to expose to view. Roads they always make streight; unless the unevenness of the ground, or other impediments, afford at least a pretext for doing otherwise. Where the ground is entirely level, they look upon it as an absurdity to make a serpentine road: for they say that it must either be made by art, or worn by the constant passage of travellers: in either of which cases it is not natural to suppose men would chuse a crooked line when they might go by a streight one.

What we call clumps, the Chinese gardeners are not unacquainted with; but they use them somewhat more

sparingly than we do. They never fill a whole piece of ground with clumps: they consider a plantation as painters do a picture, and group their trees in the same manner as these do their figures, having their principal and subservient masses.

This is the substance of what I learnt during my stay in China, partly from my own observation, but chiefly from the lessons of Lepqua: and from what has been said it may be inferred, that the art of laying out grounds, after the Chinese manner, is exceedingly difficult, and not to be attained by persons of narrow intellects. For though the precepts are simple and obvious, yet the putting them in execution requires genius, judgment, and experience; a strong imagination, and a thorough knowledge of the human mind. This method being fixed to no certain rule, but liable to as many variations, as there are different arrangements in the works of the creation.

FRANCE

JEAN DE JULLIENNE

[Jean de Jullienne (1686–1767), the son of a successful dry goods merchant located near the Gobelin tapestry establishment, wished at an early age to become a painter. He began his studies in Claude Audran's studio where he met Watteau, who became a lifelong friend. Watteau persuaded him to abandon painting and to enter instead the dye works associated with the Gobelin manufacture directed by Jullienne's uncle, the famous dyer, Glucq. Jullienne ultimately succeeded his uncle as director and was knighted in 1736 in recognition of his excellence in this position. From his position of wealth and influence, Jullienne assisted and encouraged many young artists. It was to him that Watteau bequeathed a portion of his drawings. Jullienne published engravings of Watteau's paintings and drawings in four volumes known as the *Recueil Jullienne*. The engravings were executed by Boucher, Cochin, Liotard and others. The first two volumes, with the summary of Watteau's life as an introduction, appeared in 1726–1728 under the title *Figures de différents caractères*, with three hundred fifty engravings. The last two volumes, *L'Oeuvre* with two hundred seventy-one engravings, were published 1728–1739. Jullienne's biography of Watteau has served as the principal source for subsequent ones.]

A SUMMARY OF THE LIFE OF ANTOINE WATTEAU[1]

Antoine Watteau was born in Valenciennes in 1684. His parents, although of little wealth and position, neglected

[1] Translated from the text as given in H. Adhémar, *Watteau*, Paris, 1950, pp. 167–168. See also E. Goncourt, *French XVIII Century Painters*, Trans. by R. Ironside, New York, 1948.

nothing for his education. They consulted solely his bent in the choice of the profession he wished to embrace. As he had shown since childhood signs of the natural aptitude he had for painting, his father, who had no knowledge of this art, but wished to further his son's desire to devote himself to it, apprenticed him to a rather bad painter of the same town to learn its basic principles.

Watteau, who then was only ten or eleven, studied with so much ardor that after a few years—his master seeming to him little able to satisfy his ideas and carry him to the point he could attain—he made the acquaintance of another artist who claimed to be skilled in stage sets and who, on the strength of this reputation, was called to the Opera of Paris in 1702. The young Watteau, who desired nothing more than to perfect himself, judging that only a residence in this great city could procure him the means of improving himself, obtained the permission of his new master to accompany him there. At first he toiled under him at this kind of métier, but the painter, who was not succeeding in his affairs as he had expected, was obliged to return to his home where his pupil did not consider it opportune to follow him.

Although Watteau then showed admirable gifts for his art, yet being too young to make them known, he was obliged, in order to subsist, to adapt himself to a master painter who worked for dealers in those common paintings that are sold by the dozen, which gave him work but for so little money that he only dared mention it in confidence. And, as a crowning misfortune, he saw himself obliged to copy the miserable products of this master. At last tired of work as repugnant as it was fruitless, he left him and made the acquaintance of Gillot,[2] a painter recently accepted by the Academy.

The latter, having seen some of his drawings and paintings which pleased him, invited Watteau to come and live with him. This proposal being pleasing to Watteau, he accepted it and from then on he began to work with

[2] [Claude Gillot (1673–1722) was famous as the innovator of the *fêtes champestres,* scenes depicting festive occasions in a rustic setting.]

a little more comfort and pleasure. He profited from the wisdom of this skilled man in such a way that in a short time he had taken on much of his style, and one may say that even from the beginning he invented and drew in the style of Gillot, treating more or less the same subjects as he. But one must recognize that if he had a taste for *fêtes champestres,* theatrical subjects and modern dress in imitation of his master, it is no less true to say that eventually he treated them in a manner that was his own and just as nature, whom he always worshiped, made him preserve them.

Some time later—be it that Gillot was impelled only by a generous desire to aid his disciple, or that, having been until then unique in this type of painting, he regarded this imitator with a jealous eye and as a rival whose rapid progress should alarm him—he separated himself from Watteau to have him go to the Luxembourg under M. Audran,[3] an excellent painter of decoration, who kept him busy making figures in his works and whose good taste served not a little to give him new inspiration.

Watteau, inclined more and more to study, and excited by the beauties of the gallery of this palace painted by Rubens, often went to study the color and the composition of this great master. This in a short time gave him a taste much more natural and very different from that which he had acquired with Gillot.

It was about this time that he created [a painting] for the prize the Royal Academy of Painting offers every year and in which he carried off the second place. One saw shining in the painting he did for this the sparks of that beautiful fire he subsequently made visible.

After such an honor one would have believed that Watteau would have resolved to stay in Paris to make himself more and more well-known there and to perfect the talent he had for painting. However, as his income had been less than mediocre and as he saw his works were not gaining in favor because of the slight understanding people had of his new style of painting, he became disgusted with

[3] [Claude Audran (1657–1734) was also the keeper of the Royal collections at the Luxembourg.]

Paris and resolved to return to his home. But whether he did not find there what he sought or whether because of the inconsistency which was natural to him, he did not stay there long, and after having done a few paintings—among others several studies of camps and soldiers from life—he went back to Paris where he busied himself with work for several friends who understand his talent.

Some time after his return, the Royal Academy of Painting proposed to choose the most able among the young men who had won prizes in order to send them to Rome as Royal scholars. Watteau, who always strained for the highest perfection and who regarded the trip to Italy as very useful to his advancement, presented, like the others, drawings and paintings to the gentlemen of the Academy, who were so surprised by them that he was made to understand that, distinguished from his competitors by his merit, far from being sent to Rome to study, he would be received into this illustrious company, if he wanted to take the necessary steps to be admitted. He took them and was received with all imaginable honors. It was then that he strengthened himself greatly in the fine style which, one may say, he invented and became so skillful that there was not a person among the interested or in the arts who did not wish to have some paintings by him. Gillot could not then but acknowledge his superiority; he not only yielded first place to him, but leaving the field completely open to him, Gillot dropped the brush to confine himself to engraving and drawing.

A testimonial so glorious and so authentic as that which the Academy had just paid Watteau's merit considerably increased the number of his admirers. This brought upon him such frequent visits that there scarcely remained time for him to work; but he, who was by nature cold and indifferent to people he did not know, was wearied by such importunity. Thus, Monsieur Croizat[4] having proposed that he take up residence with him, he took advantage of this offer, all the more willingly as he hoped to be able to work more undisturbed and to draw from the treasures in

[4] His collections included 400 paintings and 19,000 drawings.

his fine collection the best in painting and sculpture and especially to see among other beautiful objects the rare drawings of which Monsieur Croizat is the possessor. And indeed, it must be agreed that since then the pictures of Watteau expressed the inspiration placed within his reach by this precious collection. When he left this house, he lodged with Monsieur Vleughels,[5] his friend, who is at present Director of the Academy of Painting and Sculpture which the King maintains in Rome and who has just been honored with the Order of Saint Michel. There he worked with much success until 1718.

Watteau's reputation was then among the greatest. It acquired for him the friendship of several influential persons and he could flatter himself that he could make a profitable business for himself in a short time had he wanted to stay in Paris. But again he showed a trait of his instability in leaving for a second time all his hopes in order to go to England. This trip was not fortunate for him, for, as he had a very delicate constitution, the change of climate combined with the intemperate air which is very heavy in that country so undermined his health that he was almost always ill there. He did not fail, however, to do there several paintings which drew to him the admiration of the connoisseurs.

After an absence of about a year, he came back to Paris where he dragged out only a languishing and tedious existence. He scarcely had a day of good health, but although his continual infirmities gave him not a moment's despite, nevertheless he worked from time to time; this he continued to do until he finally died at Nogent near Paris the 18th of July, 1721, at the age of thirty-seven.

Watteau was of medium height and weak constitution. He had a quick and penetrating mind and elevated sensibilities. He spoke little but well, and wrote likewise. He almost always meditated. A great admirer of nature and of all the masters who have copied her, assiduous work had made him a little melancholy. Cold and awkward in demeanor, which sometimes made him difficult to his

[5] [Nicolas Vleughels (1668–1737) was named Director of the Academy in Rome in 1724.]

friends and often to himself, he had no other fault than that of indifference and of a liking for change. It can be said that no painter ever had more fame than he during his life as well as after his death. His paintings which have risen to a very high price are today still eagerly sought after. They may be seen in Spain, in England, in Germany, in Prussia, in Italy, and in many places in France, especially in Paris. Also one must concede that there are no more agreeable pictures for small collections than his. They incorporate the correctness of drawing, truth of color and an inimitable delicacy of brushwork. He not only excelled in *gallant* and rustic compositions, but also in subjects of the army, of marches, and bivouacs of soldiers, whose simple and natural character makes this sort of pictures very precious. He even left a few historical pieces whose excellent taste shows well enough that he would have been equally successful in this genre if he had made it his principal objective.

Although Watteau's life was very short, the great number of his works could make one think that it was very long, whereas it only shows that he was very industrious. Indeed, even his hours of recreation and walking were never spent without his studying nature and drawing her in the situations in which she seemed to him most admirable.

The quantity of drawings produced by his study and which have been chosen to be engraved and to form a separate work is a proof of this truth.[6]

DENIS DIDEROT

[Denis Diderot (1713–1784), whom his father had destined for the clergy, received his education from the Jesuits. Because of a stubborn preference for letters rather than canonical law, he was forced to support himself as best he could by translations and lessons. His first original work, *Philosophical Thoughts* (*Pensées Philosophiques*,

[6] [See our *fig.* 19.]

1746), was burned for its attack on Christian dogma and morals. For the expression of an atheistic, materialistic philosophy in *The Letter on the Blind* (1749), Diderot was thrown into prison. There he began that gigantic task, the *Encyclopedia*, which occupied him for twenty years and which associated him with Voltaire, D'Alembert, Rousseau, Helvetius and others. His unbridled curiosity led him into every field of thought and he endeavored to free knowledge from its dogmatic and doctrinal prejudices. In spite of vigorous opposition from Church and State, the *Encyclopedia* appeared in 1772. Although Diderot enjoyed great popularity and exercised great influence in France, he was denied official recognition. Catherine of Russia granted him a pension, and at her invitation he went to St. Petersburg (1773-1774).

In 1737, with the establishment of the *Salons*, or annual expositions, art theory was freed from the guardianship of the Academy and opened to the public. This change resulted in art criticism by men more or less informed on the subject. Especially characteristic of this tendency is Diderot, who in his *Salons* (1765) assumes a role similar to a journalistic critic and expresses the current opinion in France that "it is the chief business of art to touch and to move, and to do this by getting close to 'nature.'" (See Gilbert and Kuhn, *A History of Esthetics*, New York, 1939, p. 208.)]

ESSAY ON PAINTING[1]

CHAPTER I. *My Eccentric Thoughts on Drawing.*[2] . . .
None but you, my friend,[3] will read these papers; hence I
can write all I wish. Now these seven years spent at the
Academy drawing from the model, do you consider them
well employed—and would you like to know what I think
about it? It is there, during those seven laborious and
cruel years, that you adopt *mannerism* in drawing. All
these academic positions, strained, prepared, arranged, all
these poses coldly and awkwardly taken up by some poor
devil, and always the same poor devil, hired to come three
times a week to undress and let a professor set him up as
a lay figure—what have these to do with the positions and
actions of nature? The man drawing water at the well in
your courtyard, and the one awkwardly pretending to do
so without the same load—both arms raised, on the school
platform—what have they in common? Or this one there
who acts out dying, and the one breathing his last in his
bed, or beaten down on the street, what have they in
common? What has this school fighter in common with
the one on my street-corner? This man imploring, begging,

[1] The *Essay* is translated by Creighton Gilbert from *Oeuvres
complètes de Diderot*, Paris, 1876, x, pp. 464–467; the footnotes
are his. The *Salon* is from Beatrix L. Tollemache, *Diderot's
Thoughts on Art and Style*, London, 1893; the footnotes are
mine.
 See also: Venturi, *History*, pp. 146–149; Denis Diderot,
Salons, Texte établi et présenté par J. Seznec et J. Adhémar,
Oxford, 1967, 4 vols.; L. G. Crocker, *Diderot, The Embattled
Philosopher*, New York, 1966.
[2] Each chapter of the work has a playful self-deprecatory title,
such as "All that I have learned of Chiaroscuro in my life" and
"What everybody knows about expression and something that not
everybody knows." These phrases typify its half-serious rambling.
[3] The German-Parisian man of letters, Friedrich Grimm
(1723–1807), made a profession of collecting notes of literary
and artistic events in Paris for which German and other Franco-
phile princes in Europe subscribed. From 1759 his close friend
Diderot contributed notes on the biennial Salon, thus perhaps
inventing the program note, and in 1765 attached a short
Essai sur la peinture in the MS sent to his friend.

sleeping, reflecting, fainting at his convenience, what has he in common with the peasant stretched out in weariness on the ground, with the philosopher meditating at his fireside, with the choked man fainting in the crowd? Not a thing, my friend, not a thing.

I should be as pleased if, to make the absurdity complete, they would send the pupils when they left there to Marcel or Dupré to learn grace or to any other dancing master you like. Meanwhile the truth of nature is forgotten; the imagination is crammed with actions, positions, and forms that are false, prepared, ridiculous, and cold. They are in stock there, and will come forth to get fixed to the canvas. Every time the artist takes up pencils or brush, these dull ghosts will awake and appear before him; he will not be able to divert his attention from them, and if he succeeds in exorcising them to run them out of his head, it will be a miracle. I knew a young man of much taste who, before touching the least stroke to his canvas, would fall on his knees and say, "Lord, deliver me from the model." If today it is rare to see a picture made up of a certain number of figures without finding in it, here and there, some of these academic figures, positions, actions, attitudes, that mortally offend a man of taste and can impose only on those unacquainted with truth, blame it on the endless study of the school model.

It is not in school that you learn the general fitting into each other of movements, a fitting that is felt and seen, that extends and winds from head to foot. Suppose a weary woman drops her head forward—all her members obey this weight; she raises it and holds it straight—the same obedience from the rest of the machine.

Oh yes indeed, it's an art, and a great art, to pose the model; you must see how proud of it the Professor is. Never fear that he will think of telling the poor hired devil: "My friend, pose yourself by yourself; do what you like." He much prefers giving him some unusual attitude to letting him take a simple and natural one; still, one must put up with it.

A hundred times I have tried to tell the young students that I found on the way to the Louvre, their portfolios

under their arms: "My friends, how long have you been drawing there? Two years? Well! That's more than one should. Leave this stock-in-trade of *mannerism* with me. Go off to the Carthusians', and there you will see the real attitude of piety and contrition. Today is a great holiday eve; go to the parish church, prowl about the confessionals, and there you will see the true attitude of self-collectedness and repentance. Go tomorrow to the public-house, and you will see the true action of man in anger. Seek out public sights, be observers in the streets, in parks, in markets, in houses, and you will gain just ideas of true movement in the actions of life. Now! Look at your two comrades quarrelling, see how it is the very quarrel that establishes the position of their limbs, all unknown to them. Study them closely and you will be contemptuous of your insipid professor's teaching and of imitating your inspid model. How sorry I am for you, my friends, lest one day you must substitute for all the errors you have learned, the simplicity and truth of Le Sueur![4] And you must indeed, if you want to be something.

"An attitude is one thing, and action is another thing. Every attitude is false and little; every action is beautiful and true.

"Ill-understood contrast is one of the most fatal causes of the mannered. The only real contrast arises from the basis of the action, or from the difference either in organism or in interest. Look at Raphael, Le Sueur; they sometimes place three, four, or five figures upright one beside the other, and the effect of it is sublime. At mass or vespers at the Carthusians', you see forty or fifty monks in two long parallel rows, same stalls, same function, same vestment, and yet no two of the monks are alike; look for no other contrast than this that distinguishes them. Here is the truth; all else is mischievous and false."

If these students were a little inclined to profit by my advice, I should tell them further: "Isn't it true that for quite a while you have only seen a part of the thing you copy? Try to imagine, my friends, that the whole figure is

[4] French painter (1616–1655), a pupil of Vouet and a founder of the Academy.

transparent, and to place your eye in the middle; from there you will note all the outward play of the machine, you will see how some parts stretch, while others contract, how some swell as others collapse, and, continually engaged with a complete whole, you will succeed in showing in the part of the object that your drawing shows, all the due correspondence with the unseen part, and, offering me only one side, you will nonetheless force my imagination to see the opposite side also,—and then it is that I will cry out that you are an astonishing draughtsman."

But it is not enough to have fixed the whole well, it is a question of bringing details into it without destroyed the mass; that is the work of heat, of genius, of feeling, and of exquisite feeling.

Here, then, is how I would have a school of drawing run. When the student knows how to draw easily from prints and busts, I keep him for two years before the academic model of man and woman. Then I expose to him children, adults, men in the prime of life, old men, subjects of all ages and sexes, taken from all walks of society, in a word all kinds of characters; the subjects will offer themselves in crowds at the door of my academy, if I pay them well—if I am in a slave country, I shall make them come. In these different models the professor will be careful to have him note the accidents that daily activities, the way of living, status, and age have introduced into the forms. My student will see the academic model again only once every two weeks, and the professor will leave it to the model to take care of posing himself by himself. After the drawing hour an able anatomist will explain the skinned body to my student, and will have him apply his lessons on the living, breathing nude—and he will draw from the skinned body once a month at most. That will be enough to let him feel that flesh upon bone and unsupported flesh are not drawn in the same way, that here the stroke is round, there, so to speak, angular; and that if he neglects these refinements the whole will have the air of a blown bladder or a ball of cotton.

There would be no mannerism either in drawing or color if nature were scrupulously imitated. Mannerism comes

from the master, the academy, the school, and even from the antique.

SALON OF 1765
THREE SKETCHES BY GREUZE[5]

A sketch is generally more spirited than a picture. It is the artist's work when he is full of inspiration and ardour, when reflection has toned down nothing, it is the artist's soul expressing itself freely on the canvas. His pen or skillful pencil seems to sport and play; a few strokes express the rapid fancy, and the more vaguely art embodies itself the more room is there for the play of imagination. In singing we must listen to the words of a song; but I can put any feelings I please into a well-composed symphony, and as I know better than anyone else what touches my heart, I am generally more affected by my own interpretation of the music according to the mood I am in, whether grave, or tender, or gay, than I should be by the interpretation of anyone else. There is the same sort of difference between a sketch and a picture; in the latter the subject is fully worked out for us to look at; in the former I can imagine so many things which are only suggested.

The Beloved Mother. The composition of *The Beloved Mother* is so natural and simple that the careless observer might think that he could have done as well himself, and that it did not require much thought or cleverness. I will only answer such persons by saying, "Yes, of course you would have grouped all these children around their mother, lavishing their caresses on her, and you would

[5] Jean Baptiste Greuze (1725–1805), received his early training in Lyons. He came to Paris in 1750 and in 1755 was admitted conditionally to the Academy. He did not become a member until 1769 and then was admitted only as a genre painter. His popularity was due to the moralizing representation of the simple, honest virtues of country people in such pictures as *Reading the Bible* (1755), *The Village Wedding* (1761), *The Father's Curse* and a series depicting the good and bad ways of life. The sentiment of his pictures is similar to that found in Rousseau's *Nouvelle Héloïse*.

have represented one of them crying because he was not noticed more than the others; and you would, of course, have introduced the husband coming in at the moment, looking cheerful and happy at having such a wife, and proud of being the father of so many children. And, of course, you would have remembered to bring the grandmother into the scene."

Let us describe the composition. It is in the country; in a large, low room we see a bed, in front of the bed a cat sits on a footstool, while the beloved mother is lying back on a couch with all her children round her. There are six at least; the youngest is in her arms, the second clings to her on one side, and the third on the other; the fourth has climbed up the back of the couch and is kissing her forehead; the fifth kisses her cheek; the sixth, standing up, hangs his head down and looks dissatisfied. The mother's countenance is full of joy and tenderness, yet she seems as if rather overcome by the caresses and presence of such a number of children, which would be too much for her if continued long. It is the attitude and expression of the mother lying with her head a little back, and weakness manifesting itself in spite of happiness and tenderness, that gives its charm and originality to this one figure taken apart from the rest of the composition. In front of this charming group lies a child's bodice and a little cart. Farther back in the room sits the grandmother in her armchair near the fireplace; she has a truly grandmotherly cap and dress, and is smiling at the scene before her. More to the left in the foreground a dog is barking with joy, as if he partook of the general happiness. Farther still to the left the husband appears, just come from shooting; he stretches out his arms and throws his body slightly back as he laughs; he is a fine, well-grown young man, and is evidently proud and happy at the sight of his group of children; his dog is at his side; farther back is a basket of linen, and we catch a glimpse of a maid leaving the room.

The picture is excellent as a work of art and as a portrait of what a happy home should be. It preaches this lesson to every sensible man: "Keep your family in comfort, and take care to have a happy home to which to return."

The Ungrateful Son. Imagine a room only lighted by the door when it is open or by a square opening above the door when it is shut. Look round, and the room will reveal to you nothing but poverty. Still there is a well-furnished bed in the right corner; on the same side in front is a large and comfortable black leather chair; the father of the ungrateful son is sitting there; near the door is a low cupboard, and a little table by the old man's side with a bowl of soup. Although the eldest son might have stayed at home to help his old father, he has enlisted, and is now come with an old soldier to ask his family for some money. His father is indignant. He reproaches his son for forgetting his duties to his father and mother, and the unnatural son returns insulting words to these severe reproofs. He stands erect in the center of the picture, his hat on his head, with an angry, insolent air; his right arm is raised on the side next to his father, and above the head of one of his sisters, and with his hand he makes menacing gestures. The good old man, who had been a kind but not too indulgent father, tries to stand up, but one of his daughters who is kneeling before him catches hold of his coat tails to prevent him. The young scoundrel is surrounded by his eldest sister, his mother, and one of his little brothers. His mother puts her arms round him, but he brutally pushes her away and tries to escape from her embrace. The poor mother is overcome with grief; she and the eldest sister try to interpose between the young man and his father and to hide them from each other. The sister has seized her brother's coat as if to say, "O, what are you doing; you drive away your mother and you threaten your father; kneel down, rather, and ask their pardon." The little brother meanwhile is crying and rubbing his eyes, and hanging on to his tall brother's arm, tries to drag him from the house. The youngest of all stands behind the father's chair, looking puzzled and frightened. At the other side of the picture the old soldier who had enlisted and accompanied the young man walks away with his head down and his sword under his arm, and his back to the scene. I forgot to say that a dog in the foreground adds to the tumult by barking.

Everything is clearly thought out and well grouped in this sketch; the grief of the mother and her tenderness for a spoiled child, the old man's indignation, the different actions of the sisters and of the little children, the insolence of the youth, and the old soldier's feeling of shame, as he shrugs his shoulders and goes off, are all well depicted; and the barking dog is one of those minor accessories which Greuze knows how to invent. Yet this sketch, though very fine, does not please me as much as the following:

The Bad Son's Punishment. He has been to the wars, he comes back, but at what a moment. His father has just died. Everything is much changed in the old home. There was poverty before; now there is grief and want. There is no mattress on the bed where the old man is laid out. The light falls from an opening, but only on his face, the rest is in shadow. At his feet on a straw chair is a burning taper and a vase of holy water. The eldest daughter lies back in the old leather chair in an attitude of despair, one hand resting on her forehead, the other raised and still holding the crucifix which she gave her dying father to kiss. One of the little children has hidden its face on her bosom. The other, with hands and arms stretched out, seems to gather its first impressions of death. The younger sister, sitting between the window and the bed, cannot realize that she has no longer a father; she bends toward him, she seems trying to meet his last looks; she raises her arm, and her half open mouth exclaims, "My father, my father, don't you hear me any more?" The poor mother stands against the wall near the door; her knees give way under her, she is overcome with grief. This is the sight which meets the eyes of the ungrateful son. He comes forward, he is on the threshold; he has lost the leg with which he spurned his mother, the arm which he raised against his father is maimed. His mother meets him at his entrance; she is silent, but with her hand points to the corpse as if to say: "See what you have done."

The ungrateful son is struck with amazement; his head falls forward and he strikes his forehead with his hand. What a lesson is here depicted for fathers and children! The minor details are as carefully thought out as the

principal figure. I can imagine from the book lying on the table before the eldest daughter that it was her sad task to read the prayers for the dying, while the phial by the book probably contained a cordial. The same dog appears as in the other sketch, and he seems doubtful whether he is to recognize this maimed fellow as the son of the house or to take him for a beggar.

I do not know what effect this short and simple description of the sketch will produce on others, but for my own part I could not write it without emotion. But as no one makes anything quite perfect, even in these beautiful sketches I find something to criticize; first, I think that the mother's gesture is not quite natural at the moment. Would she not have covered her eyes with one hand as if to hide from her sight both her son and her husband's corpse, while she pointed to the latter with her other hand? It seems to me that this gesture would have added to the pathos, and the lower part of the face would have sufficiently shown the violence of her grief. Secondly, I think that in one trifling detail Greuze has gone wrong, though he is usually very particular; the vessel for holy water and the asperser are such as the church would put at the foot of the bier, but in a cottage it would only be a jug of water with a piece of box blessed on Palm Sunday.[6]

For the rest I consider that these sketches are masterpieces of composition; there is nothing labored or artificial about them, but the interest is simple and striking, yet appeals to all. But nowadays there is so little real feeling for art that perhaps these sketches will never be painted as pictures, and if they were, Boucher would sooner sell fifty of his commonplace indecent puppets than Greuze these two sublime compositions. But now with regard to Greuze's style, let me ask you a few questions. First, what is true poetry? Secondly, is there poetry in these two last sketches by Greuze? Thirdly, what difference is there between this poetry and that of the sketch of *The Tomb of Artemisia?* Fourthly, of two painted cupolas, of which one would be

[6] The sketch described here was a study for the picture now in the Louvre (our *fig.* 20).

recognized as painted, and the other would be mistaken for a real cupola, which is the finer work of art? And lastly, of two letters written, we will say, from a mother to a daughter—the one full of fine sentiments, eloquent and pathetic, which everyone admires but which no one would take for a real letter, the other so simple and natural that everyone takes it for a letter really written by a mother to a daughter—tell me which is the one we ought to admire; and also which was the more difficult to write? You may be certain that I shall not go further with these questions and answers, for it would lead me to writing a book within a book.

COUNT OF CAYLUS

[Count of Caylus (1692–1765) was a member of a distinguished military family. His mother, a niece of Madame de Maintenon, wrote the valuable *Souvenirs* of Louis XIV's court edited by Voltaire. After a military career, Count Caylus' interest in archaeology led him to travel for the purpose of studying and collecting in Italy, Greece and other countries. On his return to Paris he wrote numerous books, the most influential probably being *Recueil d'antiquités égyptiennes, étrusques, grecques, romaines et gauloises* (1752–55). He learned drawing and engraving in order to illustrate his publications and thereby gained admission as an Honorary Member to the Royal Academy of Painting and Sculpture where he played an active role in establishing the standards of classicism. His interest was not limited only to ancient art. He arranged for the engraving of the drawings in the Royal Collections, which were published as a part of the *Chalcographie* (1806?). He wrote a biography of the contemporary sculptor, Edmé Bouchardon, and gave a critical summary of Watteau's life and work to the Academy. In other writings he gives a vivid picture of life in Paris at that time.]

LECTURE ON DRAWINGS[1]

Since the part of the inquiry which concerns drawings is naturally included in the scheme of your lectures, I thought I might communicate to you some reflections I have made not about drawing in particular, which I regard as the basis of an art in which I can only receive lessons here, but about drawings in general, their attraction, their usefulness and the knowldge of them. Such is my project and the subject I shall discuss with you.

All that great men bring to light is with reason to be recommended to their contemporaries but still more to those who succeed them. This general reflection pertains perhaps more to the arts and to painting in particular than to all the other products of the mind. Thus we observe that for a long time the drawings of the great masters have been esteemed and sought after and we are indeed fortunate that since the very infancy of painting there have been lovers of the arts zealous enough to have preserved them for us. Our obligation to them is all the greater to my mind because drawings are one of the most attractive things for a painter or for an amateur of the arts and it is certain that one is well advanced in connoisseurship of the arts when one knows how to read them well.

What is more agreeable than to follow an artist of the first rank in the need he had to produce, or in the first idea which struck him for a production, whose final execution one can compare, to delve into the different changes his reflections caused him to make before arresting his work, to seek to appraise them, to see oneself finally in his very studio and to be able to form one's taste by examining the reasons that prompted him to make changes. After having examined these first thoughts, with what pleasure does one not see studies correctly made from Nature, the nude parts of a draped figure, the details of this same

[1] Translated from the text given in "Discours du Comte de Caylus sur les dessins," *Revue universelle des arts*, 1859, vol. 9, pp. 316–323. The lecture was given June 7, 1732. See André Fontaine, *Les Doctrines d'Art en France*, Paris, 1909, p. 215 ff.

drapery? Finally, all the parts that have contributed to the perfection of the painting or of the work which the Universe admires. It also seems to me that the great artists make us experience impressions similar to those they themselves have felt. Poetry warms us in their first conceptions, Wisdom and Truth strike us in the finished things. [See our *fig. 21*]

It seems to me that a simple stroke often determines a passion and proves how much at that time the mind of the author felt the force and the truth of the expression. The inquisitive eye and the animated imagination are pleased and flattered to finish what often is only sketched. The difference found in my opinion between a beautiful drawing and a beautiful painting is that in one, one may read in proportion to his ability all that the greater painter has wanted to represent and in the other, one has himself finished the object offered you. Consequently one is often more stimulated by the sight of one than by that of the other, for, the reasons for satisfaction and for the preference men accord to something must always be looked for in self-esteem. The only drawback to be found in this charming section of the art you practice, Gentlemen, is the way in which several painters have let themselves be carried away by the pleasure of drawing. They have neglected painting to attach themselves solely to drawing. They have yielded entirely to the pleasing attraction of quickly tossing their ideas on paper, as well as to that of imitating nature in landscapes and in the other beauties with which she so well knows how to pique the taste of her admirers.

However well these persons whom I have just mentioned have drawn, one must recognize that it is always a kind of licentiousness which should be censured. It is an ill consequence into which one must always prevent especially the young from falling with even more severity as this lazy process increases each day one's aversion to painting. On this subject, Gentlemen, I will bring you the example furnished me by a Frenchman and an Italian, both eminent; one is the Parmesan,[2] and the other La

[2] [Parmignianino (Fran. Mazzola), 1503–1540. See de Piles, p. 186.]

Fage,[3] and their works are an obvious proof of what I
have just set forth. The first did very few pictures, the
second none at all, and even the drawings that he wished
to finish have constantly lost therefrom, their initial fire
being extinguished. Without going into details of their
styles, I will only tell you that it seems to me that one of
them took up the graceful side of Raphael, or, to express
it better, he was so possessed by this aspect of the works
of that great man, that through the desire to make it
perceptible to himself, he fell into the error of those who
exaggerate. As for the other artist, he produced with an
almost supernatural ardor the way of delineating muscles
and his emphasized contours sometimes recall the concep-
tion of Michelangelo. Be that as it may, they both drew
well, their pen was charming, and La Fage knew, so to
speak, how to represent torrents of figures. But it seems to
me that in recognizing the pleasure given by this sort of
drawing, one must admit after all that they lack the solidity
one finds in the great painters. The latter have as founda-
tion the indication of color and that Economy, wise and
majestic, which must rule in the compositions of pictures.
So, strictly speaking, one could refuse to the Parmesan
and La Fage the name of Painter, for in an examination
of their drawings one finds neither that primal idea nor
that reflection which proves that the work was composed
in the mind before being put on paper. Harmony, this gift
from heaven, the understanding of chiaro-scuro, and per-
haps the habit of using color are therefore alone able to
contribute to the beauty of the work I am discussing with
you. These reflections prove to me the necessity to study
these aspects and of never setting them aside. I flatter
myself to have proved to you, Gentlemen, how much they
are to be recommended to a painter, since they make
themselves felt with pleasure when perceived and wished
for when they are not found in those very drawings which
appear at first sight not to need them in order to please.

Harmony and the understanding of chiaro-scuro, which
emanate solely from a greater profundity in art, seem to

[3] [Raymond La Fage (1656–1690), some of whose drawings
were engraved by Caylus.]

me lacking therefore not only in the sketches of those I have just named but in those of artists who only draw. One will see in their works a beautiful outline they will have given to a figure. They will make a beautiful grouping of nudes but true taste will not be fully satisfied by the study of their works.

This would be the place to speak of the abuse of sketches without straying too far from my subject, but it is not for me to teach. I have only resolved to test a few reflections. I am but an amateur and the amateur and the master must speak differently. The one may reflect, the other must give lessons, and I await them from you, Gentlemen.

I believe I have shown you in general what produces the attraction in the study and the knowledge of drawings. Now I will consult you on the usefulness that I believe they may have for the painter or for the amateur.

I am convinced that the great man is formed only by the gifts of nature; but this nature, beautiful as she may be, needs cultivation and adornments and the sight of beautiful drawings is one of the means that should be all the more employed for this purpose, as it smooths away a great number of the difficulties present at each step in the practice of an art so extensive as that of painting. Nothing so excites the genius of a Painter or gives him that inner fire so necessary to composition as the examination of a fine drawing. Here is already a useful purpose of considerable worth. In drawings one sees exposed and without any deception the manner in which the painter has known how to read nature and the manner in which he has sometimes known how to take a pleasing liberty [with it].

This reflection again makes the study of drawings commendable for me, but one of the most considerable arguments to my mind is that affectation reveals itself completely in drawings. Consequently they can prevent one from falling into this capital fault and they can correct a bad education as well as a false taste to which one has yielded. Color can sometimes make one excuse the fault of affectation in a picture, while a drawing with, so to

speak, no covering, can invite and convince him who studies it to recognize the full extent of this drawback, even more so as the comparison one can make with similar works easily makes one sensitive to the true and to the beautiful imitation of Nature.

When I criticize affectation here, I do not mean to speak of the style and of the technique by which one distinguishes works of one man from those of another. I only wish to speak to you of the abuse of that manner which makes one draw from memory even though after nature. An abuse one has seen only too much at all times in the works of those who neglect Nature, or who submit her to habit; of those finally who sacrifice [her] to the imagination.

Moreover, the study of drawings uncovers the different routes that so many able persons have taken to arrive at the same goal. These routes are infinite and prove that when Nature has endowed a man with feelings he only has to give free rein to his inspiration and to the lessons that Nature alone can give. Thereafter he will deserve admirers in one domain or another of all those which compose this art.

All these reasons would lead me to counsel a Painter to possess drawings and to study them. Rubens often did so and his example is particularly good to follow since there are moments when the more dormant genius needs to be awakened. One can study without becoming a slave and the criticism one can make of the weakest part of a drawing is often a marvellous lesson. I said that a Painter should abandon himself to the talent given him by nature. I am far from denying this, but at the same time I believe that an artist whose aim is the perfection of his art should not scorn or ignore the works of others. If he wishes to owe absolutely nothing to anyone but himself, he walks a road that is bound to lead him astray.

As for the identification of drawings, at first it seems strange and even difficult to believe that a work so simple, which is often expressed by a single stroke and which is sometimes commendable only for its spark of imagination, —it seems strange, I say, that such a thing should be as

well copied as we see it every day. The great number of originals in this genre of which every collection, in rivalry with others, claims to possess a considerable part, is proof of the quantity of copies. However, if one will consider that the fewer operations for the copyist, the easier it is for him to arrive at a perfect imitation, one will no longer be surprised at this quantity of copies and will admit that since so many skillful men have been fooled on the originality of pictures whose execution is much more difficult because it is more complex, there is all the more reason for one to be fooled by drawings. But this reflection is only good for dealers or for those who are unable to discard in the formation of their collection the ideas planted by greed or vanity. A copy that has been determined to be original by wise persons and connoisseurs is to my mind an original; it is still more authentic when it has been so judged by painters.

I insist, Gentlemen, on this deference owed to the masters of art and I regard it as a profession of faith that I as an amateur owe to the public, because of the almost general feeling of interested persons in all countries who boldly say that painters are not good judges of paintings any more than of drawings. Permit me to refer you here to what one of you gentlemen and my friend (Monsieur Ch. Coypel)[4] read to you in one of your last meetings on the names and the prices of paintings that you may and even should ignore.

It only remains for me to prove by one last reflection that the great painters are not always responsible for the faults they can be accused of in the composition of their finished works and that the examination of their drawings can very often serve to excuse them.

Those who give work to artists, whether they be Princes or men of wealth, should have the choice and the direction of the work proposed by them; this is the least, but however just and natural their decision may be, it has often spoiled very beautiful tastes and hampered the talent and the performance of the authors.

[4] [Antoine Charles Coypel (1694–1752) became Director of the Academy in 1747.]

Nothing is so rarely to be found as naturally good taste. It is even more rare to encounter someone who defers entirely to the taste of another, however enlightened. the latter may be, and the more so as there is not one who does not flatter himself and who is not himself convinced that he has good taste. Such is and always will be the position of society people without one's being able to demand anything else of their judgment. However, this general and necessary situation results in a disadvantage for the arts that will often cause their misfortune in later times as it has done until now. This cannot be corrected except by leaving the artist the absolute master of his creation in all its parts. . . .

JACQUES-FRANÇOIS BLONDEL

[Jacques-François Blondel (1705–1774) was an architect, teacher and prolific writer. He supplied the designs for numerous buildings, especially in Metz (1764–1770), where he designed the principal administration buildings as well as the bishop's palace and the main portal and great sacristy of the Cathedral. Prior to this, Blondel was active in Paris as an architect and teacher. He opened a school of architecture in 1739 and in 1759 was named a professor at the Academy of Architecture. In 1737, he published *De la distribution des maisons de plaisance et de la décoration des édifices en général.* He planned a magnificent *L'Architecture Française,* a folio of engravings of the principal buildings with a commentary; four of the six volumes planned were published between 1752 and 1756. In 1771, he published four volumes of his lectures *Cours d'architecture,* a fifth volume was completed posthumously by Pierre Patte, with a sixth volume containing the illustrations for the series. In these lectures given over an extended period of time—Blondel's discussion of architectural monuments, theories and contemporary artists and architects—is recorded the transition from Baroque architectural principles to an advocacy of a conformity of forms

to their purpose and their material that took place in his lifetime. His more progressive ideas are reflected in the work and writings of two of his pupils, Etienne-Louis Boullée (1728–1799) and Claude Nicolas Ledoux (1736–1806). A last work, *L'homme du monde éclairé par les arts*, 1774, gives a summary of his ideas to the general public.]

A BRIEF DESCRIPTION OF THE CHURCH OF SAINT SULPICE[1]

The parish church of Saint Sulpice seen today[2] was begun in 1655 from the designs of Louis Le Vau.[3] Queen Anne of Austria laid the first stone of it. After the death of this architect, its execution was confided to Gittard,[4]

[1] Translated from J. F. Blondel, *Cours d'architecture*, Paris, 1772. Vol. III, pp. 330 ff. The footnotes are from the text, except those in brackets which are those of the editor. See also: E. Kaufmann, *Architecture in the Age of Reason*, Cambridge, 1955; *idem*, "Three Revolutionary Architects, Boullée, Ledoux, and Lequeu," *Transactions of American Philosophical Society*, Vol. 42, Part 3, 1952.

[2] In 1646, noticing that the original church of this parish built in 1211, was falling into ruin, it was decided to build another according to the designs of Gamard, of which Gaston d'Orleans laid the first stone. But having recognized that the project of this architect was too small for this parish whose size grew daily, it was decided in 1655 to build the one of which we speak. [It was resumed by Oppenort who completed the north portal, begun by Gittard, and built the south portal. The nave was completed in 1736, the principal façade by Servandoni in 1733–1745, the south tower by Maclaurin, and the north tower by Chalgrin in 1777. See our *fig.* 22 for cross-section of the church.]

[3] Louis Le Vau [1612–1670], architect of Louis XIV, directed the building of the Louvre from 1653 to 1670. He furnished the designs for one part of the Palace of the Tuileries, and built the Chateau neuf of Vincennes; the Chateau de Vau-le-Vicomte; the Hotel de Lambert on the Ile Saint Louis, that of Colbert; and several others.

[4] Daniel Gittard [1625–1686], Royal Architect in the last century, had considerable reputation. It was he who succeeded Le Vau and who had to build the choir of Saint Sulpice, the side-aisles, the largest part of the transept, and the first order of the northern portal. The portal of Saint Jacques-du-haut-

but work on it was suspended from 1675 until 1719, when the completion of this monument was undertaken. Nevertheless, one did not begin to build the principal portal, of which we have already spoke, until 1733, with the designs and direction of Chevalier Servandoni.[5] Several architects were also called upon to beautify this edifice. Gilles Oppenort,[6] sieur Laurent, and several others are of this number. In explaining in detail this edifice, one perceives that these different directors have contributed not a little to spread a change of style in its parts, which essentially damages the whole. Each of these architects, wishing to separate himself from the one who proceeded him, applied himself more to creating than to following the same plan and the same direction. It would have been desirable if Le Vau had composed a general project, of which he was most certainly able, and that this project, once approved, after having been discussed and submitted

Pas, Faubourg Saint Jacques, is also the work of this architect. [Our fig. 22.]

[5] Jean Servandoni [1695–1766], Chevalier of the Order of Christ, born in Florence [Lyons] 2 May 1695, was a pupil of Jean Paul Pasimi for painting and of Jean J. de Rossi for architecture. Among the buildings that we have by this artist in France, we cite the parish church of Coulanges in Burgundy, the high altar of the cathedral of Sens, that of the Charteux of Lyons, etc. Also it is this artist who built in Paris the portal of Saint Sulpice, and the ingenious staircase of the Hotel d'Auvergne. He was called upon to exercise his superior talents in the decoration of theatres in different parts of Europe. One always recalls with please the admirable spectacles which he gave in Paris in the Salles des Machines, at the Tuileries. This great artist died universally regretted in Paris in 1767.

[6] Gilles-Marie Oppenort [1672–1742], born in Paris where he died about 1733, first architect of my lord, the Duke of Orleans, who was considered a great draughtsman. Upon his return from Rome, where he had been as a Royal Pensionaire, he was kept fully occupied. The southern portal, the second order of the northern portal of the church of Saint Sulpice, as well as the interior decoration at the back of these portals, the high altar à la Romaine of this church, and baldachin of Saint Germain-des-Près are by this architect. It is he who decorated the gallery of the Hotel of the Grand Prior of France at the Temple; the Choir and the altar of the church of Saint Victor, etc. [Our fig. 22.]

for examination to the different directors of this enterprise, could have served as a base for all the architects who in the future would have been charged to continue the execution of the building. Thereby, one would not be in a position today to remark the faults that one perceives in the whole. Indeed, this space limited to a rather inconsequential size, being only about fifty toises[7] long and twenty-five toises wide, measured at the crossing, finds itself made still smaller by the too great width of the aisles and by the size of the piers separating the openings, which communicate from the nave and the choir with these same aisles. Nothing is so shocking in every type of building, and most of all in our churches, as to annihilate, so to say, the grandeur of the place by an inordinate architecture and an affectation of heaviness in the piers. From then on these parts preserve no proportion and no relationship to the general dimensions.

We will remark that the width of the aisles of which we have spoken not only contributes to make the nave too narrow, even though it is forty-one feet in width, but renders insupportable the small size of the Virgin's Chapel, placed at the back of this church in such a manner that one notices at the two extremities of this parish church, on the one end, a façade perhaps too colossal, and on the other, a chapel of much too small a diameter. A disparity in the relationship of the parts to the whole and the whole to the parts that one can certainly not approve. . . .

We will say nothing of the plan of this church. It is quite simple, and in that merits some esteem. We would only have desired, as we have already mentioned, a better relationship between the width of the nave and that of the side aisles, and that in general, the chapels placed around the interior of this edifice had been a little less large so that the nave could have been larger, and, on the other hand, that the chapel of the Virgin had been larger. This fault of the whole arises, no doubt, from the reasons we have reported at the beginning of this description and of which it is well to remind oneself when composing a project. . . .

[7] [*Toise* is a measure equal to six feet.]

The principal portal of Saint Sulpice[8] is too colossal perhaps for the size of the space it enters, but one must at least recognize in the beauty of its arrangement, the well-taught architect who drew the designs as a man of taste, in a word, an artist enlightened and nourished by the proceedings of the ancients. We have already said something about this architect's important work, and we will report here, without fear of repeating ourselves, that this portal is perhaps one of the productions of the type which most honors our French architecture. When once the Seminary that hides this monument is demolished, one will not hesitate to applaud the proud, masculine beauty which characterizes it. Indeed the firm style one perceives reveals the vigorous genius of Chevalier Servandoni who in the competition carried away the prize with his models. . . .

We would like to be able to make some remarks on the several projects given by the architects who entered the competition with Chevalier Servandoni. But as we have already said, such dissertations without pictures are absolutely insufficient. Perhaps one day we will show the projects we have received in a new work that we have already announced that will have as its object different examples of edifices arising from civil, naval and military architecture. Let us only cite here that one made by Meissonier,[9] the picturesque form of which gives at least

[8] [Our *fig.* 24.]

[9] Juste Aurèle Meissonier, born in Turin in 1695, died in Paris in 1750, united all talents originating in the *Beaux Arts*. He was draughtsman, painter, sculptor, architect and goldsmith. It is without contradiction that in this last he excelled. His genius always carried where architecture was concerned. Also he did not execute other than some interior decorations. One can judge the fertility of his imagination from the engraved design of the portal of which we speak. It is found *chez* Huquier, rue des Maturins. The movement of the plan and the tormented and licentious forms which one observes in these elevations are more reminiscent of the skillful goldsmith's chisel than of the ruler and compass by which the architect penetrates the mysteries of his art. [See F. Kimball, "J. A. Meissonier and the beginning of the 'Genre Pittoresque'," *Gaz. des Beaux Arts*, ser. 6, vol. 22, Oct. 1942, p. 27.]

an idea of the talents of this architect or rather, of this artist famous in the jeweller's art. This artist was without a rival in his time except for the famous Germain,[10] who, like Meissonier had a decided taste for architecture.

The design[11] of the portal we cite is, perhaps, an example which proves that genius is not sufficient where a monument such as we speak of is concerned and that simplicity, regularity and beauty of proportion should be preferred to anything the most fertile imagination can suggest to the architect. Meissonier had as a principle, he said, to create something new. Like Borromini, he enjoyed being singular in his compositions. Sometimes this turned out well for him, but in general, he is not to be imitated. And so the artists of his time followed him to too great lengths to be applauded. It is in following this master, one can not doubt it, that they have had the greatest part of the triflingness of the ornaments with which our modern

[10] Thomas Germain, born in Paris in 1673, where he died in 1748, was regarded as one of the most skillful men in his art who lived at the beginning of this century. He made a trip to Italy where he nourished himself with the masterpieces of all kinds that are scattered there in profusion. On his return, he was greeted with rapture and sustained his reputation to the end of his life. We had occasion to live familiarly with this famous man whose urbanity rendered him accessible to all young people. We take this occasion to publicize our obligation to this excellent genius who introduced us to LeMoine, the celebrated painter, in such a way, that it is to these two artists of the first order, each in his kind, that we owe the taste in the arts and the zeal which animates us for their perfection. Germain gave the designs from which the church at Livourne was built. One also owes to him the church of Saint Louis-du-Louvre, which he supervised himself and in [whose] plan one remarks much taste, but perhaps too much movement in the floor plan and the elevation and too many projections in the compartments of the vault.

[11] [Our *fig.* 24. Meissonier's design, executed in 1726, has a relationship with A. Pozzo's project for San Giovanni in Laterano and Bernini's for Sant' Andrea del Quirinale (our *fig.* 4). See F. Kimball, *op. cit.*, and A. E. Brinckmann, *Die Baukunst d.17.u. 18. Jhhts. in den romanischen Ländern*, Berlin, 1919, p. 259.]

decoration has been affected. A mistake, nevertheless, that men of true merit, particularly Servandoni, a contemporary of Meissonier, guarded themselves against. Full of the beauties of the antique, he was wise enough to sustain the Greek style in all his productions, while in his time Paris gave birth only to chimeras. Sometimes, even interesting productions, not having been put in their correct place, have furnished dangerous examples which turned all heads. The outside of our edifices, and above all our churches, should not display anything which is not august. One has placed there ornaments which should only be employed for public festival processions, on our theatres, and in the interior decoration of some of our apartments.

For the rest, the design of Meissonier, as we have just remarked, is not absolutely without merit. One sees that it was composed by a man of taste, who only lacked an attachment for the beauties of the Greeks and Romans. Without doubt, his project should not have been preferred to that of Servandoni.

GERMANY

JOHANN J. WINCKELMANN

[Johann J. Winckelmann (1717–1768), the son of a poor shoemaker, studied theology at Halle and, after having held various positions, became librarian to Count Henerich von Notenitz in 1754. In this office he was able to further his studies in the art and literature of the Ancients. His desire to visit Rome led to his conversion to Catholicism. In recognition of his first work, *Gedanken über die Nachahmung der griechischen Werke in der Malerei und Bildhauerkunst* (Thoughts on the Imitation of Greek Art in Painting and Sculpture, Dresden, 1755), August III of Saxony, King of Poland, granted him a pension so that he might continue his studies in Rome.

Through his patron, Cardinal Albani, Winckelmann was given the opportunity of studying the collections of antique statuary and gems; these studies culminated in his great work, *History of Ancient Art* (1764). Of great importance to his contemporaries were his descriptions of Herculaneum, then recently discovered (1762–1764). In 1764 he was named Superintendent of the Antiquities of Rome. Three years later he published *Monumenti antichi inediti* (Unpublished Ancient Monuments). On his return from a short trip to Vienna, where he was honored by Marie Theresa, Winckelmann was murdered by a common thief in Trieste (1768).

Winckelmann was the first to conceive the history of art not merely as a sequence of anecdotes and artists' lives, but as an aspect of the general evolution of human thoughts. The works of art themselves are used as a basis for determining qualities of style. Therefore, the term "style" is applied not only to the personal manner of individual artists but to the art of an entire period, which is thought of as reflecting its philosophy and the general tenor of its civilization. He had enormous influence on

the eighteenth and nineteenth centuries and contributed greatly, by his exceedingly popular publications on ancient art, to the establishment of the neoclassic style.]

THOUGHTS ON THE IMITATION OF GREEK ART IN PAINTING AND SCULPTURE[1]

Good taste, which is spreading more and more throughout the world, had its beginning under a Greek sky. Minerva, so legend goes, assigned to the Greeks this land, which because of its moderate climate would be likely to produce a people of intelligence. Thus the Greeks, although they received the seeds of inventions from other nations, gave them an entirely new character.

The style with which this nation has endowed her works has remained hers exclusively. It has rarely spread far beyond Greece without losing something, and did not become known under distant skies until recently. The style was undoubtedly entirely foreign to northern countries in the days when the two arts of which the Greeks are masters found few admirers there and when the most noteworthy works of Correggio were used to cover the windows of the Royal Stables at Stockholm.

One must admit that the reign of the Great August [of Saxony] was the fortunate moment when the arts, like a foreign colony, were to be introduced into Saxony. Under his successor, the German Titus, the arts took root in this country, and through them good taste is becoming general. It is an eternal monument to the greatness of this prince that during his reign the greatest art treasures from Italy and the most perfect paintings from other countries have been exhibited to the eyes of all the world to stimulate good taste. His zeal to glorify the arts was not satisfied until authentic first-rate works of Greek masters had

[1] The excerpt is translated from J. J. Winckelmann, *Gedanken über die Nachahmung der griechischen Werke in der Malerei und Bildhauerkunst*, Dresden, 1755. I am indebted to H. W. Janson for his assistance with this translation.

See also: Venturi, *History*, pp. 142, 153–157; Gilbert and Kuhn, *A History of Esthetics*, New York, 1939, p. 298; Schlosser, *Lett. art.*, p. 582, and *Kunstlit.*, p. 585.

been procured as models for the artists. Now the purest sources of art are open; fortunate he who knows how to find them and taste them. To seek these sources once meant to go to Athens; but from now on, Dresden will be the Athens of artists.

To take the ancients for models is our only way to become great, yes, unsurpassable if we can. As someone has said of Homer: he who learns to admire him, learns to understand him; the same is true of the art works of the ancients, especially the Greeks. One must become acquainted with them as with a friend in order to realize that the *Laocoön* is as superb as Homer. If one is as familiar with these works as that, then one will adopt the reply which Nicomachus made to an ignoramus trying to find fault with a picture of Helen of Troy by Zeuxis: "Could you but use my eyes, she would appear a goddess to you."

Michelangelo, Raphael, and Poussin have looked at the works of the ancients with the eyes of Nicomachus. They studied good taste at its source and, in the case of Raphael, even in its native country. He is known to have sent young artists to Greece to sketch for him the remains of antiquity.

A statue by a Roman master compares with its Greek prototype as Virgil's Dido compares with the Nausicaa of Homer on whom she is modelled.

For the artists of ancient Rome, the *Laocoön* meant what it means to us: the canon of Polycletus, the perfect canon of all art.

I need not cite certain examples of negligence found among the most famous works of Greek artists, such as the dolphin of the Medicean Venus with the playing putti and the work of Dioscorides, except for the main figure, in the intaglio of Diomedes with the Palladio. Also it is known that even on their finest coins the portraits of the Egyptian and Syrian kings rarely bear any resemblance. But great artists are wise even where they are careless; they are instructive even when they fail. One should regard their works as Lucian would have us regard the *Jupiter* of Phidias: namely by considering the statue itself, not the stool beneath its feet.

To those who know and study the works of the Greeks, their masterpieces reveal not only nature in its greatest beauty, but something more than that; namely, certain ideal beauties of nature which, as an old commentator of Plato teaches us, exist only in the intellect.

The most beautiful bodies found among us today might, perhaps not be more similar to the Greek bodies than Iphicles was to Hercules, his brother. The influence of a mild clear climate determined the earliest development of the Greeks, but physical exercise from infancy gave this development its noble form. Take a young Spartan, bred, by a hero and heroine, never bound by swaddling clothes, who has slept on the bare ground from the age of seven and has been trained in wrestling and swimming from earliest infancy; put him beside a young Sybarite of our day and then decide which one the artist would choose as a model for a youthful Theseus, and Achilles, or even a Bacchus. Were he to choose a Sybarite, the result would be a "Theseus raised on rose petals" while the young Spartan would make a "Theseus raised on meat," as one Greek painter phrased the difference between two possible concepts of that hero.

The Greek youths were spurred to athletic prowess by the great Olympic games; and the laws demanded for these ten months' training to take place at Elis where the games themselves were held. The largest prizes were not always awarded to mature men, but often to youths, as we know from Pindar's odes. The highest ambition of Greek youth was to resemble the divine Diagoras.

Look at the swift Indian, as he hunts the stag on foot: how easily the blood courses through his veins; how supple and swift will be his nerves and muscles, how lithe his whole body! Thus Homer depicts his heroes, and his Achilles is characterized especially by his fleetness.

Through these exercises the bodies, free from superfluous fat, acquired the noble and manly contours that the Greek masters gave to their statues. Every ten days the young Spartans had to show themselves naked before the Ephores, and those who showed signs of fat, had to follow a stricter diet. Indeed, one of the laws of Pythagoras was

to beware of all excess weight. Perhaps this was the reason why the Greek youths of the earliest times were permitted only dairy dishes while they were in training for wrestling contests. Everything that disfigured the body was carefully avoided; Alcibiades refused to play the flute in his youth because it might distort his face, and the Athenian youths followed his example. Furthermore, the clothing of the Greeks was so designed as not to interfere with the natural growth of the body, while today our tight and binding dress makes the natural beauty of our bodies suffer, especially at the neck, waist, and thighs. Even the fair sex of the Greeks refused any restricting fashions. The young Spartan girls were so lightly and scantily clothed that they were called "hip-revealers."

It is also well known what great care the Greeks took to have beautiful offspring. Even Quillet, in his *Callipaedia*, knows of fewer ways to achieve this than the Greeks did. They went so far as to try changing the color of the eyes from blue to black. Another means of furthering this aim was the establishment of beauty contests. They were held at Elis and the prizes consisted of weapons that were displayed in the temple of Minerva. There could be no lack of thorough and expert judges for these contests, since the Greeks, as Aristotle relates, had all their children taught how to draw, for they believed this would help them to appreciate physical beauty.

Even today the inhabitants of most Greek islands, and especially the women of the island of Scios, are a beautiful race despite the fact they are mixed with various foreign strains. Thus they strongly suggest the beauty of their forebears, who claimed to be of a race more ancient than the moon.

Even today there are whole peoples among whom beauty is no distinction because everyone is beautiful. All travellers relate this of the Georgians, and also of the Kabardinski, a nation in the Crimean Tartary.

The diseases that destroy so much beauty and spoil even the noblest countenance were still unknown among the Greeks. In none of the writings of the Greek physicians do we find a mention of smallpox. The literary descrip-

tions of Greeks, as Homer so frequently gives them in the most minute detail, never refer to such obvious blemishes as smallpox scars. The venereal diseases, and their result, the English *malaise,* did not devastate the beautiful bodies of the Greeks. Generally speaking everything that nature and knowledge could contribute to the growth and development of a beautiful body was used to full advantage by the Greeks, from the moment of birth to full physical maturity. The superior beauty of their bodies as compared to ours, then, is a fact that can be maintained with the greatest assurance.

In a country where the work of nature was hampered by strict laws, as in Egypt, which was the original home of the arts and of science, nature's most perfect products were likely, for the most part, to remain unknown to the artists. In Greece, however, where people devoted themselves to joy and pleasure from infancy, and where the prosperity of the citizens never affected the freedom of their customs, nature revealed itself in all its beauty, to the great benefit of the artist.

The school of the artist was the gymnasium, where the youths, ordinarily clothed because of modesty, exercised quite naked. It was the gathering place of philosophers as well as artists: Socrates visited it to teach Charmides, Artolycus and Lysis; Phidias went there to enrich his art with these magnificent figures. There one learned the movement of muscles, and studied the contours of the body, or the impressions the young wrestlers had made in the sand. The most beautiful aspects of the nude revealed themselves here in many varied and noble poses unattainable by hired models such as are used in our academies.

Only the inner sensation brings forth the essence of truth; the draftsman who wants truth in his figures will not even grasp a shadow of it unless he interpolates those elements that the soul of an indifferent model cannot possibly experience or express through passionate gestures. The introductions to many of Plato's dialogues are placed in the gymnasium of Athens and give us a conception of the noble souls of Greek youth. They permit us to assume

equally harmonious actions and poses in their exercises. The most beautiful young people danced nude on the stage, and the great Sophocles in his youth was the first to do so. At the Eleussinian games, Phyrene bathed nude in public, and, rising from the waters, became to the artists the model for a Venus Anadyomene. It is also well known that at certain celebrations the Spartan girls danced naked in front of the young people. Strange as this may seem, one only has to recall that among the early Christians, men and women were baptized naked by simultaneous immersion in the same font. Thus every celebration in Greece became an opportunity for the artists to study beautiful natural forms in detail. Their generous human nature prevented the Greeks from introducing brutal spectacles. If it is true, as some say, that such entertainments were common in Ionic Asia, they must have been abolished at an early date. When Antiochus Epiphanes, king of Syria, imported Roman gladiators, the Greeks at first were filled with horror at these miserable creatures. Gradually, however, human compassion waned and these spectacles, too, became subjects for artists. From them Etesilas modelled his dying warrior, "in which one could see how much of his soul yet remained in his body."

These frequent opportunities for observing nature caused the Greek artists to go even further: they began to form general concepts of beauty for the individual parts of the body as well as for its proportions: concepts that were meant to rise above nature, being taken from a spiritual realm that existed only in the mind.

In this way Raphael formed his Galathea. As he says in his letter to Count Balthasar Castiglione, "Since beauty is rare among women, I follow a certain idea formed in my imagination."

According to such concepts, the Greeks made their gods and human beings superior to the ordinary form of material things. With gods and goddesses, the forehead and nose formed an almost straight line. The portraits of famous women on Greek coins show the same type of profile, although in these cases ideal concepts did not readily offer themselves. Or should one surmise that this was

as typical a feature among the Greeks as the flat nose among the Calmucks (Tartars) or the small eyes among the Chinese? The large eyes of Greek heads on reliefs and coins might support this assumption. The Roman empresses were portrayed on Greek coins in exactly the same manner. The profiles of Livia and Agrippina resemble those of Artemisia and Cleopatra.

Nevertheless, one finds that Greek artists generally observed the law that the Thebans had made for their artists: namely, to follow nature as best they knew under threat of punishment. Where they could not employ the graceful Greek profile without prejudicing the likeness, the Greeks followed nature without modification, as can be seen in the beautiful head of Julia, daughter of the Emperor Titus, by Evodus. However, the law "to achieve portrait likeness and beauty at the same time" was always the highest rule recognized by the Greek artist and presupposed, of necessity, his intention of achieving something more beautiful and more perfect than nature. Polygnotus always observed this law. Thus I do not believe that Praxiteles deviated from this general precept of art when he fashioned the Cnidian Venus after his mistress, Cratina, nor did other masters when they took Lais as a model for the Three Graces. Work of this kind mirrors the sensuous beauty of the model while it retains the grandeur inspired by the artist's lofty concept of perfection; its human aspect derives from the first, its divine from the second source.

Anyone sufficiently enlightened to contemplate the essence of art will discover many new beauties by comparing the structure of Greek figures with that of modern works, especially when they follow nature rather than the old style. In most modern statues, one finds many small and altogether too minute wrinkles in places where the skin is pinched. On the other hand, the analogous parts of Greek statues show these wrinkles merging into each other in gentle, wavy curves that unify the whole area. The skin of these masterpieces shows no strains but only gentle tension: it is supported by healthy flesh without bulges. Thus it follows even the fullest contours with perfect

smoothness and never produces those particular, willful little wrinkles that we observe on our bodies. Similarly, modern works display too many and too sensuous dimples, while in ancient statuary dimples are used with subtlety and wisdom, reflecting the physical perfection of the Greeks. Often only the trained eye can discover them.

Here, again, it appears probable that the bodies of the Greeks possessed more regularity, nobler proportions, and a fuller contour, without the drawn tensions and hollows found in our own bodies. Certainly, in these matters, it is impossible to go beyond the realm of probability. However, even the probability merits the attention of our artists and connoisseurs, especially since it is necessary to remove the prejudice with which many regard those who admire these monuments, and to avoid the impression that we value them as models because of their age only.

The opinions of artists vary on this subject; it demands more thorough treatment than it can receive in this context. The great Bernini is known to have been one of those who wanted to deny that the Greeks had the advantage of a more beautiful body, as well as a higher ideal of beauty. He thought that nature endowed all things with beauty; that it was the function of art to discover it. He prided himself on having lost his preconceived opinion of the superiority of the Greeks, which he had originally held because of the beauty of the Medicean Venus, when after thorough study he discovered the same beauty in nature itself.

It was, then, the statue of Venus that suggested to Bernini the appreciation of those beauties that he at first had perceived only in it and for which he would not otherwise have sought in the realm of nature. Does this not prove that it is easier to recognize the beauty of Greek statues than the beauty of nature, and that consequently the beauty of Greek statues is more moving, less diffused, and more unified? Therefore, the study of nature is a more troublesome and tortuous approach to beauty than the study of antique statuary, and Bernini did not show his students the most direct way.

The imitation of natural beauty either focuses upon a

single model or it collects data from many models and combines them. The first produces a faithful copy, a portrait; it leads to the shapes and figures of Dutch art. The second, however, leads to universal beauty and its ideal images, and this is the path taken by the Greeks. But there is this difference between them and us: even assuming that the Greeks did not have more beautiful bodies than we do, they could form these ideal images because they were able to observe the beautiful in nature every day; we have this opportunity only on rare occasions, and rarely does it conform to the wishes of the artist. Our race is not likely to produce as perfect a body as the "Antinous Admirandus," nor can our ideas conceive anything beyond the superhuman and harmonious proportions of a god as they have taken shape in the "Apollo Belvedere." Here is the consummation of the best that nature, art, and the human mind can produce.

I believe that imitating the Greeks can teach us to become wise more quickly, since in their works we find not only the essence of whatever is beautiful throughout nature but also the extent to which even the highest form of natural beauty can be wisely and boldly transcended. Following the Greeks will teach us assurance in conceiving and designing works of art, since they have marked for us the utmost limits of human and divine beauty.

When the artist starts from this basis, when his hand and mind are guided by Greek principles, then he is on the safe road to the true imitation of nature. The ancient concepts of the unity and perfection of nature will clarify our concepts of nature in its diversity. The artist will discover the beauty of nature and combine it with beauty in the absolute; the constant presence of the noble forms of Greek art will help him to find his own rules.

Only then and not before can the artist, especially the painter, afford to imitate nature directly, and even then if deviation from the sculptural model and greater freedom do not violate the standards of his art; Poussin has treated his draperies in this manner. As Michelangelo says, "he who constantly follows the others will never make headway; and if he is not creative in his own right, he

will be unable to put the inventions of others to any good use." Only those whose souls have been favored by nature have access to this sphere of genius, they

Quibus arte benigna
Et meliore luto finxit praecordia Titan[2]

It is in this sense that we have to interpret de Piles, who tells us that Raphael, shortly before his death, tried to leave sculptural models completely and follow nature alone. The true taste of antiquity would have guided him throughout the realm of nature, and whatever he observed in it would have been elevated as if by a chemical transformation to the heights of his personality.

He might have endowed his painting with more variety and color, more chiaroscuro and more voluminous drapery; yet his figures would have gained less in this way than they did by the noble contour and the august spirit that he had taken from the Greeks. Nothing would demonstrate more clearly the advantage of following the ancients rather than nature than to take two equally gifted youngsters and have one study the antique, the other nature alone. The second would depict nature as he found it; were he an Italian, he would perhaps paint like Caravaggio; were he a Fleming, he might at best approach Jordaens; as a Frenchman, he would paint like Stella. The first, however, would recreate nature in its essence; his figures would be like Raphael's.

Even if the imitation of nature could give the artist everything else, it would not yield him the essential truth of forms. That he can acquire only from the Greeks. In the statuary of the Greeks all aspects of natural and ideal beauty are merged and defined by the most noble of contours; or rather, this contour represents the highest concept of both. Euphranor, who flourished after the time of Zeuxis, is regarded as the first artist to have developed the grander style of contour. Among the modern artists, many have attempted to imitate the contour of the Greeks, but hardly anyone has succeeded. The great Rubens nowhere

[2] [One whose soul the Titan has fashioned with kinder skill and of a finer clay. Juvenal, Satire, xiv, 34–35.]

approached the Greek proportions, and those of his works that he did before his Italian journey and his study of antique art are the farthest removed from the Greek ideal.

Only a thin line divides nature in its perfection from whatever is superfluous in it, and the greatest modern masters have swerved in both directions from this often imperceptible line; those that wanted to avoid a meager contour have tended toward the bombastic, while the others often approach emaciation. Michelangelo was perhaps the only artist who can be said to have approached antiquity, and he only in his strong athletic figures, from his heroic period; he did not succeed with tender youthful bodies, nor with female figures, which turned into Amazons under his hand.

With the Greek artist, on the other hand, the contour of each figure is in the most subtle balance, even in the most delicate and painstaking works, like gems. One has to consider only the *Diomedes* and *Perseus* of Dioscorides or the *Hercules* and *Iole* of Teucers in order to admire the unsurpassable skill of the ancients. Parrhasius is generally regarded as the creator of the most powerful contour. Even when it appears underneath the garments, a masterly contour remains the prime concern of the Greek sculptor; the beautiful form of the body is perceptible beneath the surface as if seen through a Chioian garment. The high relief of the Agrippina or the three figures of Vestal Virgins in the Royal collection of antiques in Dresden deserve mention as masterpieces in this respect. The Agrippina probably represents not the mother of Nero, but Agrippina the Elder, wife of Germanicus. It shows great similarity to a supposed portrait statue of Agrippina the Elder in the vestibule of the Library of St. Mark's in Venice. Ours is a seated figure, over life-size, supporting her head with the right hand. Her beautiful face reveals a soul steeped in profound contemplation that appears insensitive to superficial sorrow and anguish. One might imagine that the artist wanted to represent the heroine at the sad moment when she had received the news of her exile to the Isle of Pandataria.

The three Vestal Virgins are to be admired in two

ancients. Carlo Maratta and Francesco Solimena may be said to have attained greatest perfection here. The new modern Venetian school has exaggerated this style and, by showing nothing but bold drapery schemes, has succeeded only in producing rigid and tinny garments.

Finally, the most prominent general characteristic of the Greek masterpieces is a noble simplicity and silent greatness in pose as well as in expression. As the depths of the sea remain always at rest, however the surface may be agitated, so the expression in the figures of the Greeks reveals in the midst of passion a great and steadfast soul.

Such a soul is depicted in the countenance of the Laocoön, under sufferings the most intense. Nor is it depicted in the countenance only: the agony betrayed in every nerve and muscle,—we almost fancy we could detect it in the painful contraction of the abdomen alone, without looking at the face and other parts of the body,—this agony, I say, is yet expressed with no violence in the face and attitude. He raises no terrible cry, as Virgil sings of his Laocoön. This would not be possible, from the opening of the mouth, which denotes rather an anxious and oppressed sigh as described by Sadolet. Bodily anguish and moral greatness are diffused in equal measure through the whole structure of the figure; being as it were balanced against each other. Laocoön suffers, but he suffers like the Philoctetes of Sophocles. His sufferings pierce us to the soul, but we are tempted to envy the great man his power of endurance.

To express so noble a soul far outruns the constructive art of natural beauty. The artist must have felt within himself the mental greatness which he has impressed upon his marble. Greece united in one person artist and philosopher, and had more than one Metrodorus. Wisdom joined hands with art and inspired its figures with more than ordinary souls.[3]

The sculptor has refused to swathe his Laocoön in the robes of a priest, so that his anguish might strike us with greater force. Bernini has even tried to visualize the action

[3] See Lessing's comments on this passage, p. 353.

of the snake's venom in the rigidity of the thigh of Laocoön.

Not all Greek statues bear the mark of this wise restraint; their actions and poses are too wildly passionate, a fault which the ancient artists call "parenthyrsus." The quieter the stance of the body, the more it will convey the true character of the soul; in all those poses they deviate too much from a state of quiet, the soul is not in its true state, but in a forced and violent one. Great passions, it is true, disclose a soul more freely and graphically, but only in repose and in harmony is the soul great and noble. The suffering of the Laocoön when shown by itself would have been "parenthyrsus"; therefore the artist showed him in a pose that was as close as possible to repose under these conditions, in order to depict his soul as composed yet expressive. In doing this, however, the artist had to endow Laocoön's soul with very individual traits; otherwise it might have appeared indifferent or drowsy.

The exact opposite, in fact, the other extreme, is the taste most common among the modern artists, especially the famous ones. Nothing earns their applause but exaggerated poses and actions, accompanied by an insolent "dash" that they regard as spiritedness, or "franchezza," as they say. Their favorite concept is "contrapposto," which to them is the essence of everything that makes for artistic perfection. They want their figures to have souls as eccentric as comets; to them every figure is an Ajax and Capaneus.

The fine arts seem to have had their infancy just like human beings, and their earliest phase resembles the beginnings of an artist's career, when only the extraordinary and astonishing attract him. Such was the tragic must of Aeschylus, and his hyperbolic style has made his Agememnon more obscure than anything written by Heraclitus. Perhaps the draughtsmanship of the earliest Greek painters resembled the style of their first fine tragic poet.

In all human activity the violent and transitory develops first; pose and profundity appear last. The recognition of these latter qualities requires time; only great

masters have them, while their pupils have access only to violent passions. The masters of art know how difficult it is to acquire the poise and profundity which at first seem so easy to imitate. *Ut sibi quivis speret idem, sudet multum frustraque laboret ausus idem.*[4]

La Fage,[5] the great draughtsman, was unable to attain the style of the ancients. Everything in his works is movement, and the spectator is distracted and confused, as at a party when everyone talks at once.

The noble simplicity and silent grandeur of Greek statues are also truly characteristic of Greek literature of the best period, that is, the writings of the school of Socrates. These traits, more than anything else, give Raphael the greatness that he attained through using the ancients for his models. It took a soul as beautiful as his, in a body as beautiful as his, to experience and rediscover the true character of the ancients in modern times; it was his greatest fortune to have done that at an age when ordinary and immature souls are insensitive to true greatness. . . .

LESSING

[Gotthold Ephraim Lessing (1729–1781), like many other German intellectual leaders of his times, was the son of a Protestant minister. After a thorough training in the classics, having studied theology as well as a little medicine and archaeology, he turned to the field of letters and worked as a poet, dramatist, critic, essayist, novelist, and religious reformer. In every field he made notable contributions. Of his many plays the comedy *Minna von Barnhelm* (1767) is the greatest; *Miss Sara Sampson* (1755) is important as the first German "tragedy of common life." His last great work, *Nathan the Wise* (1778–1779), expresses his plea for religious tolerance. In the essay *Laoc-*

[4] Horace, *Ars Poetica*, 240–242: That anybody may hope for the same success, may sweat much yet toil in vain when attempting the same.

[5] See Caylus, p. 324, footnote 3.

oön or *Concerning the Limitations of Painting and Poetry*
(1766) Lessing established a clear distinction between
poetry and painting by calling painting, sculpture, and
architecture the figurative arts rather than the fine arts.
For him the figurative arts must meet the requirements of
plastic beauty, which prohibit the excessive violence of
action allowed the poet.

Until he accepted the post of Librarian at Wolfenbüttel
in 1770, offered him by the Duke of Brunswick, Lessing
had led a restless life, living in Leipzig, Berlin, Witten-
berg, Breslau and Hamburg, struggling to support himself
by his literary efforts. He settled at Wolfenbüttel until his
death in 1781.]

LAOCOON[1]

CHAPTER I. The chief and universal characteristic of
the Greek masterpieces in painting and sculpture consists,
according to Winckelmann, in a noble simplicity and
quiet grandeur, both of attitude and expression. "As the
depths of the sea," he says,[2] remain always at rest, however
the surface may be agitated, so the expression in the figures
of the Greeks reveals in the midst of passion a great and
steadfast soul.

"Such a soul is depicted in the countenance of the Lao-
coön, under sufferings the most intense. Nor is it depicted
in the countenance only; the agony betrayed in every nerve
and muscle,—we almost fancy we could detect it in the
painful contraction of the abdomen alone, without looking
at the face and other parts of the body,—this agony, I
say, is yet expressed with no violence in the face and atti-
tude. He raises no terrible cry, as Virgil sings of his
Laocoön. This would not be possible, from the opening of
the mouth, which denotes rather an anxious and oppressed

[1] The excerpt is from Gotthold Ephraim Lessing, *Laocoön*,
translated by Ellen Frothingham, Boston, 1893.
See also: Claudio Schaefer, "El sentido y los origenes de la
teoria de art de G. E. Lessing," *Revista Nacional literatura, arte,
ciencia* (Uruguay), XXVIII, 1944, pp. 40–67; J. Schlosser, *Lett.
art.*, p. 583, and *Kunstlit.*, p. 586.
[2] See above, pp. 349–350.

sigh, as described by Sadolet. Bodily anguish and moral greatness are diffused in equal measure through the whole structure of the figure; being, as it were, balanced against each other. Laocoön suffers, but he suffers like the Philoctetes of Sophocles. His sufferings pierce us to the soul, but we are tempted to envy the great man his power of endurance.

"To express so noble a soul far outruns the constructive art of natural beauty. The artist must have felt within himself the mental greatness which he has impressed upon his marble. Greece united in one person artist and philosopher, and had more than one Metrodorus. Wisdom joined hands with art and inspired its figures with more than ordinary souls."

The remark which lies at the root of this criticism—that suffering is not expressed in the countenance of Laocoön with the intensity which its violence would lead us to expect—is perfectly just. That this very point, where a shallow observer would judge the artist to have fallen short of nature and not to have attained the true pathos of suffering, furnishes the clearest proof of his wisdom, is also unquestionable. But in the reason which Winckelmann assigns for this wisdom, and the universality of the rule which he deduced from it, I venture to differ from him.

Winckelmann's depreciatory allusion to Virgil was, I confess, the first thing that aroused my doubts, and the second was his comparison of Laocoön with Philoctetes. Using these as my starting points, I shall proceed to write down my thoughts in the order in which they have occurred to me.

"Laocoön suffers like the Philoctetes of Sophocles." How does Philoctetes suffer? Strange that his sufferings have left such different impressions upon our minds. The complaints, the screams, the wild imprecations with which his pain filled the camp, interrupting the sacrifices and all offices of religion, resounded not less terribly through the desert island to which they had been the cause of his banishment. Nor did the poet hesitate to make the theatre ring with the imitation of these tones of rage, pain, and despair. . . .

. . . A cry is the natural expression of bodily pain. Homer's wounded heroes not infrequently fall with a cry to the ground. Venus screams aloud at a scratch, not as being the tender goddess of love, but because suffering nature will have its rights. Even the iron Mars, on feeling the lance of Diomedes, bellows as frightfully as if ten thousand raging warriors were roaring at once, and fills both armies with terror.

High as Homer exalts his heroes in other respects above human nature, they yet remain true to it in their sensitiveness to pain and injuries and in the expression of their feelings by cries or tears or revilings. Judged by their deeds they are creatures of a higher order; in their feelings they are genuine human beings.

We finer Europeans of a wiser posterity have, I know, more control over our lips and eyes. Courtesy and decency forbid cries and tears. We have exchanged the active bravery of the first rude ages for a passive courage. Yet even our ancestors were greater in the latter than the former. But our ancestors were barbarians. To stifle all signs of pain, to meet the stroke of death with unaverted eye, to die laughing under the adder's sting, to weep neither over our own sins nor at the loss of the dearest of friends, are traits of the old northern heroism. The law given by Palnatoko to the Jomsburghers was to fear nothing, nor even to name the word fear.

Not so the Greek. He felt and feared. He expressed his pain and his grief. He was ashamed of no human weakness, yet allowed none to hold him back from the pursuit of honor or the performance of a duty. Principle wrought in him what savageness and hardness developed in the barbarian. Greek heroism was like a spark hidden in the pebble, which sleeps till roused by some outward force, and takes from the stone neither clearness nor coldness. The heroism of the barbarian was a bright, devouring flame, ever raging, and blackening, if not consuming, every other good quality. . . .

. . . It is worthy of notice that, among the few tragedies which have come down to us from antiquity, there should be two in which bodily pain constitutes not the least part

of the hero's misfortunes. Besides Philoctetes we have the
dying Hercules, whom also Sophocles represents as wail-
ing, moaning, weeping, and screaming. Thanks to our
well-mannered neighbors, those masters of propriety, a
whimpering Philoctetes or a screaming Hercules would
now be ridiculous and not tolerated upon the stage. One
of their latest poets,[3] indeed, has ventured upon a Philoc-
tetes, but he seems not to have dared to show him in his
true character.

Among the lost works of Sophocles was a Laocoön. If
fate had but spared it to us! From the slight references
to the piece in some of the old grammarians, we cannot
determine how the poet treated his subject. Of one thing
I am convinced,—that he would not have made his Laoc-
oön more of a Stoic than Philoctetes and Hercules. Every-
thing stoical is untheatrical. Our sympathy is always pro-
portionate with the suffering expressed by the object of our
interest. If we behold him bearing his misery with mag-
nanimity, our admiration is excited; but admiration is a
cold sentiment, wherein barren wonder excludes not only
every warmer emotion, but all vivid personal conception of
the suffering.

I come now to my conclusion. If it be true that a cry,
as an expression of bodily pain, is not inconsistent with
nobility of soul, especially according to the views of the
ancient Greeks, then the desire to represent such a soul
cannot be the reason why the artist has refused to imi-
tate this cry in his marble. He must have had some other
reason for deviating in this respect from his rival, the poet,
who expresses it with deliberate intention.

CHAPTER II. Be it truth or fable that Love made the
first attempt in the imitative arts, this much is certain:
that she never tired of guiding the hand of the great
masters of antiquity. For although painting, as the art
which reproduces objects upon flat surfaces, is now prac-
tised in the broadest sense of that definition, yet the wise
Greek set much narrower bounds to it. He confined it
strictly to the imitation of beauty. The Greek artist repre-
sented nothing that was not beautiful. Even the vulgarly

[3] Chateaubrun.

beautiful, the beauty of inferior types, he copied only incidentally for practice or recreation. The perfection of the subject must charm in his work. He was too great to require the beholders to be satisfied with the mere barren pleasure arising from a successful likeness or from consideration of the artist's skill. Nothing in his art was dearer to him or seemed to him more noble than the ends of art.

"Who would want to paint you when no one wants to look at you?" says an old epigrammatist to a misshapen man. Many a modern artist would say, "No matter how misshapen you are, I will paint you; though people may not like to look at you, they will be glad to look at my picture; not as a portrait of you, but as a proof of my skill in making so close a copy of such a monster."

The fondness for making a display with mere manual dexterity, ennobled by no worth in the subject, is too natural not to have produced among the Greeks a Pauson and a Pyreic. They had such painters, but meted out to them strict justice. Pauson, who confined himself to the beauties of ordinary nature, and whose depraved taste liked best to represent the imperfections and deformities of humanity, lived in the most abandoned poverty; and Pyreicus, who painted barbers' rooms, dirty workshops, donkeys, and kitchen herbs, with all the diligence of a Dutch painter, as if such things were rare or attractive in nature, acquired the surname of Rhyparographer, the dirt-painter. The rich voluptuaries, indeed, paid for his works their weight in gold, as if by this fictitious valuation to atone for their insignificance.

Even the magistrates considered this subject a matter worthy their attention, and confined the artist by force within his proper sphere. The law of the Thebans commanding him to make his copies more beautiful than the originals, and never under pain of punishment less so, is well known. This was no law against bunglers, as has been supposed by critics generally, and even by Junius himself,[4] but was aimed against the Greek Ghezzi, and condemned the unworthy artifice of obtaining a likeness

[4] *De Pictura Veterum*, II, IV. [See above, p. 158, note 31.]

by exaggerating the deformities of the model. It was, in fact, a law against caricature.

From this same conception of the beautiful came the law of the Olympic judges. Every conqueror in the Olympic games received a statue, but a portrait-statue was erected only to him who had been thrice victor. Too many indifferent portraits were not allowed among works of art. For although a portrait admits of being idealized, yet the likeness should predominate. It is the idea of a particular person, not the ideal of humanity.

We laugh when we read that the very arts among the ancients were subject to the control of civil law; but we have no right to laugh. Laws should unquestionably usurp no sway over science, for the object of science is truth. Truth is a necessity of the soul, and to put any restraint upon the gratification of this essential want is tyranny. The object of art, on the contrary, is pleasure, and pleasure is not indispensable. What kind and what degree of pleasure shall be permitted may justly depend on the law-giver.

The plastic arts especially, besides the inevitable influence which they exercise on the character of a nation, have power to work one effect which demands the careful attention of the law. Beautiful statues fashioned from beautiful men reacted upon their creators, and the state was indebted for its beautiful men to beautiful statues. With us the susceptible imagination of the mother seems to express itself only in monsters. . . .

. . . But I am wandering away from my purpose, which was simply to prove that among the ancients beauty was the supreme law of the imitative arts. This being established, it follows necessarily that whatever else these arts may aim at must give way completely if incompatible with beauty, and, if compatible, must at least be secondary to it.

I will confine myself wholly to expression. There are passions and degrees of passion whose expression produces the most hideous contortions of the face, and throws the whole body into such unnatural positions as to destroy all the beautiful lines that mark it when in a state of

greater repose. These passions the old artists either refrained altogether from representing, or softened into emotions which were capable of being expressed with some degree of beauty.

Rage and despair disfigured none of their works. I venture to maintain that they never represented a fury. Wrath they tempered into severity. In poetry we have the wrathful Jupiter, who hurls the thunderbolt; in art he is simply the austere.

Anguish was softened into sadness. Where that was impossible, and where the representation of intense grief would belittle as well as disfigure, how did Timanthes manage? There is a well-known picture by him of the sacrifice of Iphigenia, wherein he gives to the countenance of every spectator a fitting degree of sadness, but veils the face of the father, on which should have been depicted the most intense suffering. This has been the subject of many petty criticisms. "The artist," says one, "had so exhausted himself in representations of sadness that he despaired of depicting the father's face worthily."[5] "He hereby confessed," says another, "that the bitterness of extreme grief cannot be expressed by art."[6] I, for my part, see in this no proof of incapacity in the artist or his art. In proportion to the intensity of feeling, the expression of the features is intensified, and nothing is easier than to express extremes. But Timanthes knew the limits which the graces have imposed upon him. He knew that the grief befitting Agamemnon, as father, products contortions which are essentially ugly. He carried expression as far as was consistent with beauty and dignity. Ugliness he would gladly have passed over, or have softened, but since his subject admitted of neither, there was nothing left him but to veil it. What he might not paint he left to be imagined. That concealment was in short a sacrifice to beauty; an example to show, not how expression can be carried beyond the limits of art, but how it should be subjected to the first law of art, the law of beauty.

Apply this to the Laocoön and we have the cause we

[5] Pliny, xxv, 35.
[6] Valerius Maximus, viii, 2.

were seeking. The master was striving to attain the greatest beauty under the given conditions of bodily pain. Pain, in its disfiguring extreme, was not compatible with beauty, and must therefore be softened. Screams must be reduced to sighs, not because screams would betray weakness, but because they would deform the countenance to a repulsive degree. Imagine Laocoön's mouth open, and judge. Let him scream, and see. It was, before, a figure to inspire compassion in its beauty and suffering. Now it is ugly, abhorrent, and we gladly avert our eyes from a painful spectacle, destitute of the beauty which alone could turn our pain into the sweet feeling of pity for the suffering object.

The simple opening of the mouth, apart from the violent and repulsive contortions it causes in the other parts of the face, is a blot on a painting and a cavity in a statute productive of the worst possible effect. Montfaucon showed little taste when he pronounced the bearded face of an old man with wide open mouth, to be a Jupiter delivering an oracle. Cannot a god foretell the future without screaming? Would a more becoming posture of the lips cast suspicion upon his prophecies? Valerius cannot make me believe that Ajax was painted screaming in the above-mentioned picture of Timanthes. Far inferior masters, after the decline of art, do not in a single instance make the wildest barbarian open his mouth to scream, even though in mortal terror of his enemy's sword.

This softening of the extremity of bodily suffering into a lesser degree of pain is apparent in the works of many of the old artists. Hercules, writhing in his poisoned robe, from the hand of an unknown master, was not the Hercules of Sophocles, who made the Locrian rocks and the Euboean promontory ring with his horrid cries. He was gloomy rather than wild. The Philoctetes of Pythagoras Leontinus seemed to communicate his pain to the beholder, an effect which would have been destroyed by the slightest disfigurement of the features. . . .

GOETHE

[Johann Wolfgang von Goethe (1749–1832), who was born in Frankfurt a. M., and died in Weimar, belongs to the rare men of genius who were productive in many fields. He was a poet, dramatist and novelist, and was also outstanding as a scientist in the fields of physics, especially in the field of the theory of color, botany, osteology. He was a philosopher, historian, biographer, and historian of literature and art. In public administration he served effectively as minister of state in the little Grand Duchy of Weimar.

Goethe's spiritual development was partly determined by the ideas in his lifetime but it can also be said that he did much to determine the ideas of his time. In his youth he belonged to the movement of "Sturm und Drang" (storm and stress), later he became the strong supporter of German Classicism and still later he favored Romanticism which he earlier had repudiated. To some extent this was a return to what had stimulated him during the period of "Sturm and Drang."

In the literature of art his short article "Von Deutscher Baukunst" contributed to the romantic enthusiasm for Gothic in Germany which had begun long before in England, and was to result in the completion of old cathedrals like Cologne, Ulm, and Regensburg and the Gothic Revival in new buildings. It was written between 1770 and 1773, while Goethe was a student at Strasbourg. Here he entered a circle of friends who were filled with an interest for German literature and culture. The dominant figure was Johann Gottlieb von Herder (1744–1803). He was a follower of the French exponents of nature, Diderot and Rousseau. Three years before his arrival in Strasbourg, Herder had published (1767) *Fragmente über die neuere deutsche Literatur*. It was he who stimulated Goethe to assert his natural predilection and to discard complete obedience to the classics and French rococo culture. The great Strasbourg cathedral towering above the town arrested his attention and demanded his study. Herder pub-

lished Goethe's essay in *Blätter für deutsche Art und Kunst* (1773). Goethe had written it in answer to the Abbé Laugier's (1713–1769) *Essay sur l'architecture*—which had been translated into German and was widely read.

Dr. Paul Frankl is of the opinion that it was the Abbé Laugier who actually influenced Goethe to express the ideas he does. He has noticed striking parallels between Goethe's essay and passages in Laugier's work and believes that Goethe in his irritation with Laugier's dependence on classic models forgot what he himself had learned from the Abbé. In Goethe's classic period he excluded the essay from his own edition of his collected writings.]

OF GERMAN ARCHITECTURE[1]

D. M. ERVINI A STEINBACH[2]

When I wandered around your grave, noble Erwin, seeking the stone which would point to me: "Anno Domini 1318, xvi. Kal. Febr. obiit Magister Ervinus, Gubernator Fabricae Ecclesiae Argentinensis," and I did not find it and none of your countrymen could show it to me so that I might pour out my veneration for you on the holy spot, I was deeply grieved in my soul. My heart, younger, warmer, more foolish, and better than now, promised you a memorial in marble or standstone—as I might be able— when I would come into the peaceful enjoyment of my possession.

Of what use is a memorial to you! You have erected to yourself the most glorious one; and although the ants who crawl there worry little about your name, you have

[1] The selection is translated from *Goethe's Werke* (Sophien Ausgabe), Weimar, 1896, 1 Abth., xxxvii, pp. 137 ff. Dr. Paul Frankl checked the translation.

See also: J. W. Goethe, *Kleine Jugendschriften in Prosa* (Deutsche Nationalliteratur, vol. 107), Introduction, pp. 149– 169; text, pp. 173–183; and J. E. Spingarn, *Goethe's Literary Essays*, New York, 1921, pp. 3–13; W. Herrmann, *Laugier and the Eighteenth-Century French Theory*, London, 1962.

[2] [The letters D. M. are the abbreviation for "Divis Manibus," the blessed spirit of Erwin from Steinbach.]

the same fate as the architect who piled up the mountains into the clouds.

To few was it given to conceive in their souls an idea of Babel so complete, so great, and necessarily beautiful to the smallest detail, like the trees of God. To fewer was it given to encounter a thousand willing hands, to dig the rocky ground, to conjure thereon steep heights, and then dying say to their sons: "I remain with you in the works of my spirit, complete the beginning in the clouds."

Of what use is a memorial to you! And from me! When the rabble utters sacred names it is superstition or blasphemy. Before your greatness insipid dilettantes will always swoon and the perfect souls will recognize you without an interpreter.

Therefore, excellent man, before I dare to put my little mended ship to sea again—more likely to encounter death than win fortune—look here in this grove where round about the names of my beloved ones grow green, I carve yours in a beech as slender and soaring as your tower, and hang by its four corners a handkerchief full of gifts not unlike the cloth let down from the clouds to the apostle, full of clean and unclean animals as well as flowers, blossoms, leaves, some dried grass and moss, and mushrooms sprung up over night; all that I coldly gathered on a walk through an ordinary countryside for my diversion in botany, I now dedicate until their corruption in your honor.

"It is in trivial taste," says the Italian, and passes by. "Childishness," stammers the Frenchman and triumphantly snaps his snuff-box à la Grecque. What have you done that you dare to scorn?

Did not the genius of the ancients rising from its grave enslave yours, you Latins? Crawling on the mighty remains to beg the proportions, you pieced together your pavilions from the sacred fragments and consider yourselves as guardian of the art secrets because you can give an account of the minute measurements and lines of gigantic buildings. Had you felt more than you measured, the spirit of the mighty pile at which you gazed would have come over you, then you would have not only imitated it

because they did it and it is beautiful. You would have created your plans necessary and true, and living beauty would have surged from them.

This way you have whitewashed your necessity with a semblance of truth and beauty. The magnificent effect of columns impressed you and you too wanted to use them and immured them. You also wanted to have rows of columns and surrounded the forecourt of St. Peter's with marble passageways, which lead here and there to nowhere. Mother Nature, who despises and abhors the inappropriate and the unnecessary, drove your rabble to desecrate this magnificence by using it as a public toilet so that before the wonder of the world the eyes are turned away and the nose held.

Now, all this takes its course: the whim of the artist serves the caprice of the rich, the writer of travel books gapes, and even now our *bels esprits,* called philosophers, artificially twist from protoplastic fairy tales principles and history of art, and the evil spirit murders the genuine men in the forecourt of the sanctuary.

To the genius, principles are more detrimental than examples. Before him, individual men may have worked on single parts; he is the first from whose soul issues the parts welded into one eternal whole. All the power of realization and activity is fettered by school and principles. What is it to us, you modern French philosophizing connoisseur, that the first man—inventive in answer to a need —drove four stakes connected by four poles on top of them, and then covered them with branches and moss? From this you decide the adequacy of our present day needs, just the same as if you wanted to rule your new Babylon by the simple patriarchal, *pater familias* spirit.

It is also wrong to believe that your hut is the world's first born. Two poles in front crossing at the top, two in back, and a ridgepole across them is and remains a far more primitive discovery, as you can daily recognize from the huts in the fields and vineyards, from which, however, you would be unable to abstract a single principle for your pigsty.

Thus none of your conclusions can rise to the realm of

truth; they all float in the atmosphere of your system. You want to teach us what we should use, because what we do use cannot be justified according to your principles.

The column is very dear to your heart and in other regions of the world you would be a prophet. You say: the column is the first essential ingredient of the building and the most beautiful. What sublime elegance of form, what pure manifold greatness if they stand in rows! Only beware lest you employ them improperly; their nature is to stand free. Woe to the wretches who have bound their slender growth to clumsy walls!

And nevertheless it seems to me, dear abbé, that the frequent repetition of this impropriety of walling in columns, so that the moderns even stuff the intercolumnia of ancient temples with masonry, might have excited you to some thought. Had your ear not been deaf to truth, these stones would have preached it to you.

The column is not an ingredient of our dwelling, rather it contradicts the essential character of all our buildings. Our houses do not originate from four columns at four corners. They originate from four walls on four sides, which are there instead of all columns, excluding all columns, and where they are patched on to the walls, they are an encumbering superfluity. The same holds true for our palaces and churches, which—except for a few cases— I do not need to consider.

Your buildings represent to you then surfaces, which, the wider they spread out, the bolder they ascend toward heaven, the more they must oppress the soul with intolerable monotony! Indeed! if the genius which prompted Erwin von Steinbach did not come to our aid: "Diversify the overwhelming wall which you are to build toward heaven so that it rises like a tall, sublime, wide-spreading tree of God, which, with a thousand branches, millions of twigs and leaves as the sands of the sea, proclaims to the country round about the glory of the Lord, its Master."

When I went to the minster the first time, my head was full of the general knowledge of good taste. By hearsay, I honored the harmony of mass, the purity of form, and was a sworn enemy of the confused capriciousness of

Gothic decorations. Under the heading *Gothic,* as an article in a dictionary, I accumulated all the synonymous misunderstandings which had ever passed through my head of the undefined, the disorderly, the unnatural, the stuck-together, the plastered-upon, and the overladened. No cleverer than a people which calls *barbaric* the entire unknown world, I called everything *Gothic* that did not fit into my system, from the turned, colorful dolls and paintings with which our bourgeois nobility dressed up their houses to the stern remains of the older German architecture, over which, because of certain bizarre scrolls, I agreed with the common chant, "Completely smothered by ornament!" And therefore as I went I shuddered as before the sight of a misshapen, curly-bristled monster.

With what unexpected emotion did the sight surprise me as I stepped before it. A complete and total impression filled my soul, which, since it was composed of a thousand harmonizing details, I could easily relish and enjoy, but could by no means comprehend and explain. They say it is thus with the joys of heaven. And how often did I return to enjoy this heavenly-earthly joy, to embrace the gigantic spirit of our older brothers in their works! How often did I return from all sides, from all distances, in every light of the day, to gaze at its dignity and splendor! It is hard for man's spirit when his brother's work is so exalted that he must only bow and worship. How often did the evening twilight refresh with friendly quiet my eyes made weary by their seeking, for the twilight made the innumerable parts melt into complete masses! These now standing simple and great before my soul, my strength unfolded itself rapturously to enjoy and comprehend simultaneously! There the genius of the great builder revealed itself to me in gentle intimations. "What astonishes you?" he whispered across to me. "All these masses were necessary, and don't you see them in all old churches of my city? Only their arbitrary size have I raised to a harmonizing proportion. How over the main entrance, which dominates two smaller ones on the sides, the wide circle of the window opens, echoing the nave of the church and was otherwise only a hole for daylight; how the belfry high

above demands the smaller windows! All that was necessary, and I formed it beautifully. But ah, if I float through the dark lofty openings here on the sides which seem to stand there empty and useless! In their bold slender form have I concealed the mysterious strength which should lift those two towers high into the air, of which, alas, only one stands there sadly, without the five-tower crowning decoration which I had intended for it, so that the surrounding provinces would do homage to it and its kingly brother!" And so he left me and I sank into sympathetic sadness until the birds of the morning, who live in its thousand openings sang joyfully to the sun and woke me from slumber. How fresh the tower shines toward me in the fragrant morning light! How joyfully I could stretch out my arms to it, could gaze upon the great harmonious mass alive in countless small parts, as in the works of eternal nature, alive to the smallest thread, all form, all meaningful for the whole; how the firmly founded immense building lifts itself lightly into the air; how all is broken up and yet how eternal! To your teaching I owe it, Genius, that I am no longer dizzy at your depths, that one drop of the beautiful calmness of spirit sinks into my soul, which can look down on such a creation and like God can say "It is good!"

And now I should not be angry, holy Erwin, when the German art scholar, upon the hearsay of jealous neighbors, does not appreciate his superiority, belittles your work with the misunderstood word "Gothic," when he should thank God to be able to proclaim aloud that that is German Architecture, our architecture, when the Italian can boast of none of his own, much less the Frenchman. If you do not wish to admit this superiority to yourself, then prove to us that the Goths really had already built thus, at that point some difficulties will arise. And at the very end, if you cannot prove that there was a Homer before Homer, we gladly leave to you the story of less successful and unsuccessful attempts and proceed worshipping before the work of the master who first created the scattered elements into a living whole. And you, my dear brother in spirit, in the search after truth and beauty, close your ears to

verbose boasting about the plastic arts. Come, look and enjoy. Take care lest you desecrate the name of your noblest artist, and hurry here to gaze upon his excellent work! If it makes an unpleasant impression on you or none at all, then be gone, let the horses be hitched to the carriage and so on to Paris!

But I associate myself with you, beloved Youth, who stands there moved, and who cannot unite the contradictions which cross in your soul, who almost feels the irresistible power of the great whole and almost calls me a dreamer for the beauty I see there, where you see only strength and crudeness. Do not let a misunderstanding separate us, do not let the soft teaching of newer so-called beauty spoil you for the significant ruggedness lest in the end your sickly emotions can endure only meaningless smoothness. They want to make you believe that the beautiful arts originated from the inclination that we should have to beautify things around us. That is not true! For in the sense in which it might be true, the bourgeoise and the artisan use the word, not the philosopher.

Art is image forming long before it is beautiful. Yet it is true, great art, often even truer and greater than the beautiful art. For there is an image forming nature in man, which becomes active as soon as his existence is assured. As soon as he has nothing to worry about and to fear, this half-God, efficient in his calm, reaches around for material in which to breathe his spirit. And so the savage models with odd features, hideous figures, and with loud colors, his coconuts, his feathers and his body. Even though this picturing is composed from the most arbitrary forms, it will harmonize in spite of the fact that the forms themselves are not in proportion; for one intuitive feeling created them into a characteristic whole.

This characteristic art is the only art. When it acts upon itself out of a fervent, unified, particular and independent feeling, unconcerned and even ignorant of everything foreign, then art may be born out of cruel savagery or out of educated sensitivity. It is entire and living. This you see among nations and individual men in innumerable degrees. The more the soul elevates itself to the feeling of the

proportions which alone are beautiful and eternal, whose main chords one can prove, whose mystery one can only feel, and in which alone the life of the godlike genius circles around in blissful melodies; the more this beauty penetrates into the being of a spirit, so that beauty appears to have originated with the spirit, so that nothing suffices the spirit but beauty, so that the spirit creates nothing from itself but beauty, the happier is the artist, the more magnificent he is, and the more we stand bowed low and worship the anointed of God.

No one will push Erwin from the level to which he has climbed. Here is his work: approach and recognize the deepest feeling of truth and beauty of proportion emanating from a strong, vigorous German soul on the restricted, dark monks' stage of the *medii aevi*.

And our *aevum*? He has renounced his genius, and has sent his sons about to gather foreign plants,—to their detriment. The frivolous Frenchman, who gleans still worse, at least has a kind of talent for putting his booty together in one whole. He now builds his Madeleine—a wonder temple—out of Greek columns and German vaults. I have seen a model of perfect, stately, antique column work by one of our artists when he was asked to design a door for an old German church.

I do not want to recite how hateful our powdered doll painters are to me. They have captured the eyes of the women through theatrical poses, false complexions, and colorful clothes. Manly Albrecht Dürer—mocked by the novices—your most "wood carver-ish" figure is more welcome to me.

And you yourselves, excellent people, who are allowed to enjoy the greatest beauty, and who now step down to proclaim your happiness, you damage the Genius. He does not wish to be lifted up and moved away on any foreign wings, even if they were the wings of the rosy dawn. It is the power of Genius that unfolds in the dream of the child, is cultivated in youth, until, agile and strong, he rushes out to plunder like the lion of the mountains. Therefore Nature mostly educates Genius to act always and to enjoy to the present degree of his strength because you

pedagogues can never artificially create for him the diversified stage.

Hail to you, Youth, who is born with a sharp eye for proportions to practice with facility on all forms. If then the joy of life wakes around you and you feel jubilant human pleasure after work, fear, and hope such as the spirited cry of the vintager when the abundance of the autumn swells his vessels, the lively dance of the mower, when he has fastened the idle sickle high to the beam: if then the mighty nerve of desire and suffering lives more manfully in your breast, and if you have striven and suffered enough and have enjoyed enough, and if you are satiated with earthly beauty and are worthy to rest in the arms of the goddess, worthy to rest on her bosom—to feel what brought the rebirth of the deified Hercules. Accept this boy, Heavenly Beauty, you mediatrix between gods and men, so that more than Prometheus, he may transmit the blissfulness of the gods to earth.

INDEX

Abrégé de la vie des peintres. Idée du peintre parfait, 176

Accademia (Venice), 66

Accademia degli Incamminati, 70–71

Accademia delle Belle Arti, 11n.

Academies of Art, Past and Present, 87n., 94n., 130n., 161n.

Academy of Architecture (Paris), 328

Academy of St. Luke (Rome), 93, 94

Adhémar, H., 305n.; *Watteau,* 305n.

Adulterous Woman, 139

Aeneas and Anchises, 112

Agrippa, Marcus, 42

Alberti, Leon Battista; *Trattato della pitteria,* 80n., 98

Aldobrandini, Hippolito, 93

Alembert, Jean Le Rond d', 311

Alexander VII, Pope, 118; and Bernini, 119

Alte Prinakothek (Munich), 191n., 192n., 199n.

Ammannati, Bartolomeo, 17n.–18n.

Analysis of Beauty, The, 261–72

Anatomy Lesson of Dr. Tulp, 198

Andrada, Diego, 203–204

Andrea, Corporal, 71

Andrea Palladio, 47n.

Andromeda Rescued by Perseus, 137

Angeloni, Francesco, 93

Anne, Queen of Austria, 329

Antichità di Roma, 47

"Antike Götter in der Spätrenaissance," 82n.

"Antiquarian of Rome," 93. *See also* Bellori, G. P.

Antiquities, 41–43

Antoine column (Rome), 51

Apollo, 28

Apollonius of Tyana, 98

Apostolado, 230

Apostolic Church, *See* Catholic Church

Architectural criticism. *See The Entire Works on Architecture and Perspective* (Serlio)

Architecture, 38–39, 47, 260, 282–83, 328–29; abuses, 52–54; decoration, 210–12; Chinese, 293–300; English, 47; *Four Books of Architecture,* 47–62; French, 37; German, 361–69; *and Ideas,* 102–6; order, 25; Palladian revival, 289; proportion, 25, 26; recognition of, 294; and religion, 61–62; rule, 25; Saint Sulpice, 329–34. *See also* Buildings, manner of

Architecture in the Age of Reason, 289n., 329n.

Architecture in Britain, 289n., 294n.

Aretino, George Vasari, 49

Arezzo, Italy, 24

Ariosto: *Orlando furioso,* 100n.

Aristotle, 91, 97, 101, 103, 143; *Poetics,* 143n.

Art: and Catholic Church, 61–65; definition of, 325; Dutch, 344; gardening, 282; of Greece, 336–51; history of, 335–36; *Ideas,* 94–106; and nature, 143; Protestantism, 63

Art Bulletin, 38n., 71n., 219n.